The thoughtfulness
in what we do
seems to show.

The face responds
to thoughts

*Isamu Noguchi*

I had a number of reactions leafing through Chris Felver's extraordinary photographs of writers and artists. First of all, I looked to see if I had made the list — yes, to my relief, though the vast number of fellow writers is such that it was the kind of relief one feels on finding one's name has made it into the New York telephone directory.

I am reminded that William F. Buckley (who's not on the list) once sent a nonfiction book of his to Norman Mailer (who is on the list). He couldn't resist scribbling "Hi, Norman!" next to Mailer's name in the index, in the sure knowledge that the author would first turn to the index to see if he had been included!

Now, what about this portraitist of the intellectually mobile?

First of all, Christopher Felver is certainly blessed with what one would imagine to be the necessary requirements to pin the entire literary and artistic establishment: exuberance, determination, energy. There are very few who have not submitted to the Felver charm ... his excitable, fragmented, elliptical, dragonfly manner of speaking. The only writer to turn him down has been James Merrill, who plaintively, if effectively, announced that he simply "hadn't consulted his Ouija board."

Felver was born in Pittsburgh and now lives in San Francisco. When he was fourteen his grandmother, who had worked for John F. Kennedy in Ohio during his presidential campaign, took the young boy to Washington for the inaugural ceremonies. There, on that freezing day, Felver looked upon his first poet, Robert Frost. Did he snap a picture of him? No, but it was a pivotal moment indeed!

Of course, there were the early distractions. Golf was one. He started golf when he was eight, and he turned out to be prodigiously good at it — a professional golf career was certainly an option. But he has kept his amateur status because, as he says, he "may want to stage a comeback."

His career as a photographer was interrupted by army service during the Vietnam War, which he spent as an optical technician in the Fitzsimmons General Hospital in Denver, Colorado. "Man. I looked at the worst cases from the war ... my Mathew Brady, Walt Whitman period," he says.

The camera became such a fixation that Felver went to film school in London in 1975. Photographing writers started in earnest in San Francisco in the '70s— the poets he met through Lawrence Ferlinghetti, Neeli Cherkovski, Richard Brautigan. "I loved café society—their public poetry," Felver says.

When he went to Europe in 1988, a major influence remained Man Ray, whose work, Felver feels, was inspired by his association with fellow artists: "His portraits particularly gave me a direction." Suiting action to words, Felver set out from the American Academy in Rome and began traveling around Europe, corralling artists whose work he admired. He was particularly fascinated by their studios—half-finished canvasses, sculptures in progress—the creative force on display. "It inspired me to make my own 'checkerboard' like Man Ray's... of reminiscences, portraits, films of the people who interested me the most," he says.

Indeed, much of the impetus for doing his work is obviously the simple pleasure of being in the company of artistic people. Sometimes he forgets why he's there: "I was so fascinated by Tennessee Williams that making a portrait was the last thing on my mind. Same thing with Warhol. I was just happy to be in their company."

Nothing seems to deter Felver from the pleasure of these meetings with his "muses," as he refers to them in his high-spirited manner. He strode uninvited into Norman Mailer's house in Provincetown to find him watching a football game. "Norris, his wife, came down the stairs and volunteered to hold an airline blanket—I've got about ten of them—behind Norman's chair," he recalls.

Apparently, Chris often likes to "formalize" a face by having it come out of black, a backdrop that is perfectly provided by such a blanket.

The actual photography lasts only minutes. "I like to take people when they're fresh," Felver says. Ann Beattie and Robert Pinsky both told me that they spent four hours with a photographer. Can't imagine that. You go flat. Really. To get a likeness you have to work rapidly. When you meet someone initially, you get a real take on them...it's the moment to make your move."

His pictures are in any number of collections—the New York Public Library has over 250 of them. And there will be more. If ever a picture is taken of J. D. Salinger, or Thomas Pynchon, both famous recluses, or even Ambrose Bierce, who mysteriously vanished in Mexico in 1914 on a reportorial assignment (his last recorded sentiment being prophetic: "To be a gringo in Mexico, ah, that is euthanasia"), it will almost surely be snapped (with the possible exception of the last) by Chris Felver.

—George Plimpton, March 15, 2001

**F**elver's epitaph is going to read: "How did Felver do it?" And they will still be asking that a hundred years after Felver's tombstone piles up on top of Richard Avedon's, Annie Leibovitz's, and countless other nameless portraitists'. By the way, burying all the greats of a profession together would simplify enormously the work of future adulators. I spent a whole year once looking up Keats (in Rome), Whitman (in New Jersey), Emily Dickinson (in Boston), Apollinaire (in Paris); it would have been a lot easier if they were all in one place, the way they are in Felver's picture books. Which brings me back to the questions: How did Felver, this fast-talking, short (but cute) shutterbug, get so many great writers to spill their essence for him? What made them trust him? How did he get them like that, at their best (mostly), rising from within their own psyches like flowers called forth by spring? The answer, of course, is that Felver is himself one of them, or one of us, a great who knows one when he sees one. And he really sees. How, no one knows. The gift of sight, like the gift of insight, is a mystery, sayeth the race, and there it rests. Personally, he surprised me at the New Orleans Museum of Art, catching me sneaking up on a naked nymph from behind and holding both her cold, white breasts in my hot little hands . I always sneak up on museum nymphs, and there is no one there usually. Felver was. My own mother, a studio photographer, believed only in the strictly formal pose. I've spent a lifetime eluding her, running from her lens, making ugly faces and derogating the not-so-respectable profession of soul thieving. I hid behind nymphs and lay down in dark gutters, and just when I relaxed, thinking myself out of the eye, there he was, Chris Felver. Well, once anyway. There are hundreds of times I've looked interesting with no Felver there. But look at all these others he caught like trout in a fountain. Here are some classics: Patti Smith looking like the wedge of the crash pad revolution; Salman Rushdie looking like a demon pastry staring down the maw of greedy hell; Willem de Kooning so old and sensitive you just want to kiss him; Norman Mailer looking like he just got out of bed and can't remember what number wife he was just with; Abbie Hoffman being very Abbie; and so on. People idealized past the fear of their own image. In the end, no one will know how Felver did it, but everyone he did it to will be grateful. I tried that with lovers, and it worked only half the time.

—Andrei Codrescu

Editor, *Exquisite Corpse: A Journal of Letters & Life*

Here are two facts of remarkable poignance: the unique power of a photograph to evoke a "cigarette that bears a lipstick's traces," and now all these images of dreamers and friends from a past fading all too quickly. In back of all the layers and echoes of subsequent events, like they say, theirs was the bedrock company made a human presence that still can move the heart in the most unexpected way. Is it the painful admiration we Americans have for the outcast, the marginal, the *fellahin* as Amiri Baraka called them? Is there a sense that theirs was a kind of happiness we'll never know?

Always in Christopher Felver's portraits the subject seems altogether open to being seen and is, in fact, both intimate and comfortable, often welcoming. In this way Felver's art comes close to his people. He has no interest in a specious objectivity nor is there a dogmatic judgment, too often met with in such an undertaking, blurring all it sees. There is no contest here, rather a delight that looks both ways. How else would John Wieners, for one, ever be at home in such a "place," or Gregory Corso be utterly the complex power of person he truly is? Beyond whatever we might say of these two great poets of a timeless moment, here they stand or sit or look out at us still with eyes of a patiently humorous, acknowledged life, neither sentimental nor quizzical. Again and again these people are at home in the place Felver finds them, either directly responsive or else with hands or body turned simply to some other preoccupation of the usual kind.

Perhaps the juxtaposition of those images that are particularly casual—people together, talking, affectionate—make those that are then the singular, intensive look of these same persons all the more emphasized. It is literally haunting to see Richard Brautigan's eyes, with their humor, his slight smile, the confidence of his charming headgear. Or to feel again Abbie Hoffman's embracing, irresistible energy, his playfulness and humor. Or Allen Ginsberg so close that his head almost bends to accommodate the camera, looking in and out at one and the same time. There are so many here we can recognize as what we all hoped for and wanted, just to be for real, to care about the kind of world we lived in, to go for broke.

Time, of course, has its way with everyone. These dear images are already moving away toward other memories and meanings. But for these moments when each was just so there, it was Christopher Felver who saw them impeccably. He was there too.

—Robert Creeley

Chris Felver is a magician. The portrait photographer does not necessarily have to be a magician, but it helps. The photographer who specializes in portraits of writers and artists will tend to be either a sadist or a magician. There are writers and artists who are physically beautiful, who are natural performers, who can walk into a three-camera shoot and always know where the red light is. These people, however, are exceptional. More typical are the writers and artists who, however resounding the fame of their bylines or signatures, sleep in gamy lairs and wear their spleens like a crown. The average portrait of one of them will look like a surveillance photograph. The sadist's portrait will either present them in all their mange and gristle or will pretty them up so that they look like halfwits. Chris Felver's portraits manage the impossible feat of making artists and writers look as profound and glamorous and seductive and finally unknowable as their works.

And who shaves the barber? In other words, who portrays the portraitist? If, using spectranalysis and computer enhancement, you were to magnify the eye of one of his subjects some thousandfold, you might see reflected within it the vague image of a middle-aged golf hustler, but more probably you would just come up with a blur. Chris Felver, like Dennis the Menace in the cartoon title sequence of the old TV series, is a human whirlwind. He may or may not project a shadow in broad daylight. You are more likely to remember his voice: When he calls you, you get the impression that the conversation already started before you picked up. His patter sounds like something you might have heard along the bar at The Three Deuces in 1947, or maybe it was twenty years later in some far-flung bungalow of the Chateau Marmont. His antecedents could include not just Nadar and Bill Brandt but also Harry the Horse, Yellow Kid Weill, Jack Teagarden, and Big Daddy Roth. Whatever it is about his line of talk, it is certainly a key ingredient of his art, the part of portraiture that requires not just a cinematographer but a devilishly resourceful actors' director as well.

But, anyway, the portrait photographer always comes to resemble his work. When you try to picture Nadar, for example, you're less likely to imagine the countenance of the real Félix Tournachon than some composite of Sarah Bernhardt, Baudelaire, and a white-faced Pierrot. In the same way, Felver inherits Bill Burroughs's icy stare, Philip Whalen's bodhisattva serenity, Bob Kaufman's thousand-year-old geological strata, Abbie Hoffman's slapstick

bravery, Kathy Acker's aching vulnerability cloaked as menace. The portrait photographer's magic consists in part of the ability to look into the subject's face as if into a mirror, to be both a chameleon and a sort of reverse chameleon, who takes on colorings and at the same time invisibly imparts them.

The selection of faces (mugs, pans, clocks, biscuits) in the pages that follow represents a weird kind of honor roll. Some of them are very famous, some you won't have heard of, others are rumors, proof of whose existence is established here. What they all have in common, besides the fact that they made some kind of art or literature in the latter half of the twentieth century, is that they all held some kind of line in intransigent idiosyncrasy. Nobody here groomed themselves for popular approval; few, assuming they cared, would have had a clue as to how to do so. And I'm talking about the work as much as the physiognomy, of course. Felver understands that kind of stubbornness in his bones, which is why he's photographing poets rather than starlets or politicians, at the cost of several tons of lifestyle. Felver is a poet, a magician, a great photographer who can make his camera invisible as he works, a biographer of two or three generations of oddballs and heroes, a champ, a prince, and a sport. This book is his passport, and its inhabitants are his country.

—Luc Sante

*T*he *Importance of Being.* This title refers to both the what for and the wherefrom Chris Felver thinks of the human face. The face is where we first recognize our being within the human world. In photography, it shines forth with simple presence and insists upon being heard, though its language is the stillness of silence. Felver reveals that recognition through people who, for the most part, have already been recognized for what they do in the world. He presents them to us as others who, like ourselves, simply are. That is his what for. He carries them to us from their moments of repose; that is, he imports them for us from their own thoughtful harbors. That is his wherefrom. Thus the *Importance of Being* is also an affirmation of not only the wonder of being with and among human beings but also of the import of *being* itself, through his hearing-seeing of them.

—Jack Hirschman

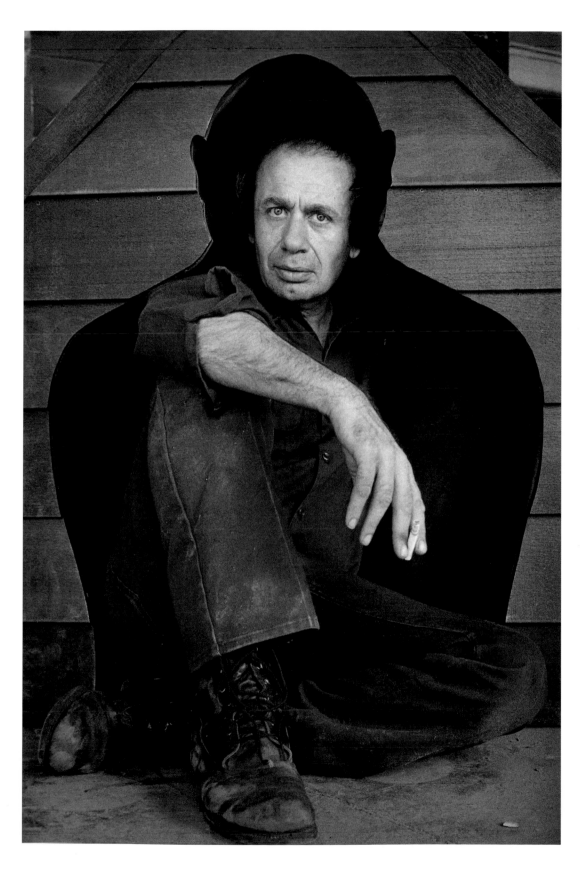

Vito Acconci  Performance/body artist

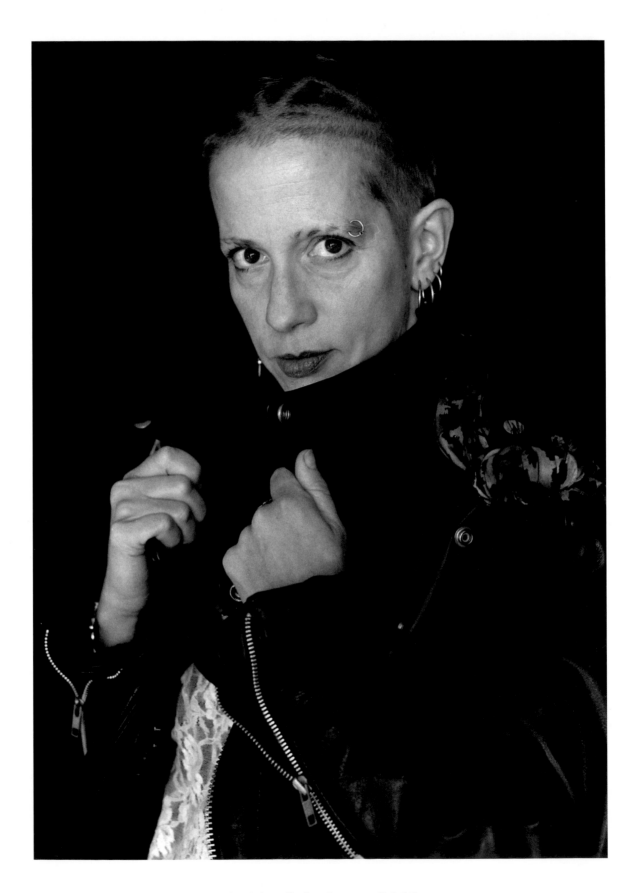

Kathy Acker  Postmodern novelist, biker

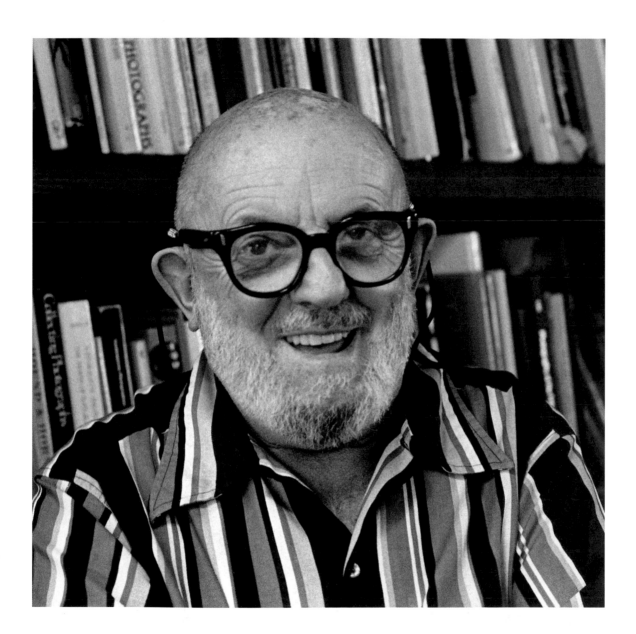

Ansel Adams  Photographer, conservationist

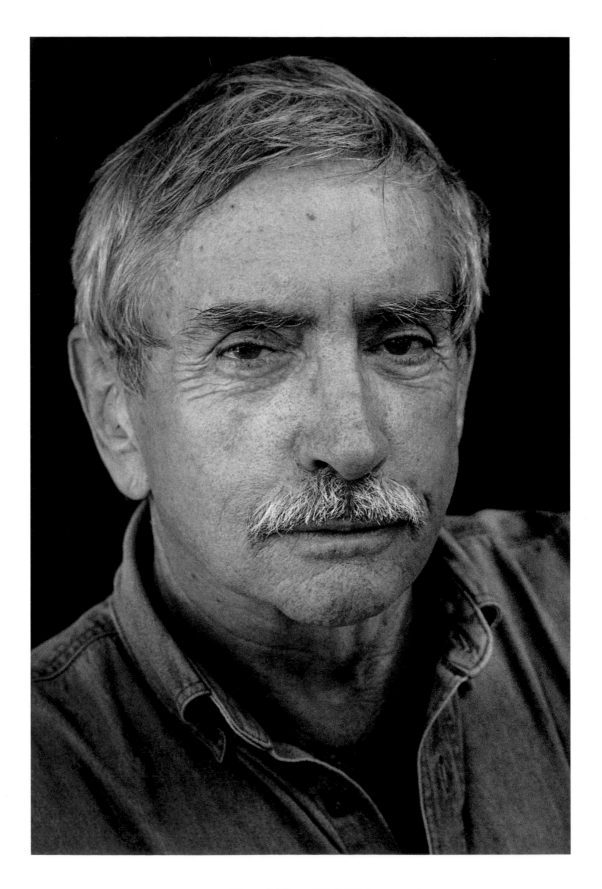

Edward Albee  Playwright

John Alexander  Painter

Miguel Algarín  Nuyorican poet

Terry Allen  Country/folk songwriter, visual artist

-22-

Mose Allison  Blues songwriter, jazz pianist

**Dave Alvin**  Grammy-winning musician

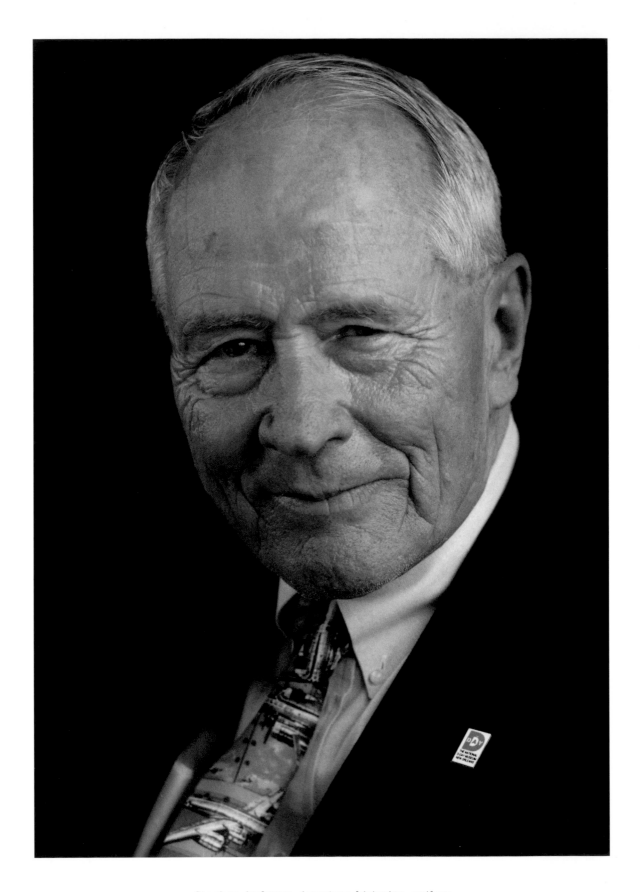

-24-

Stephen Ambrose  American historian, author

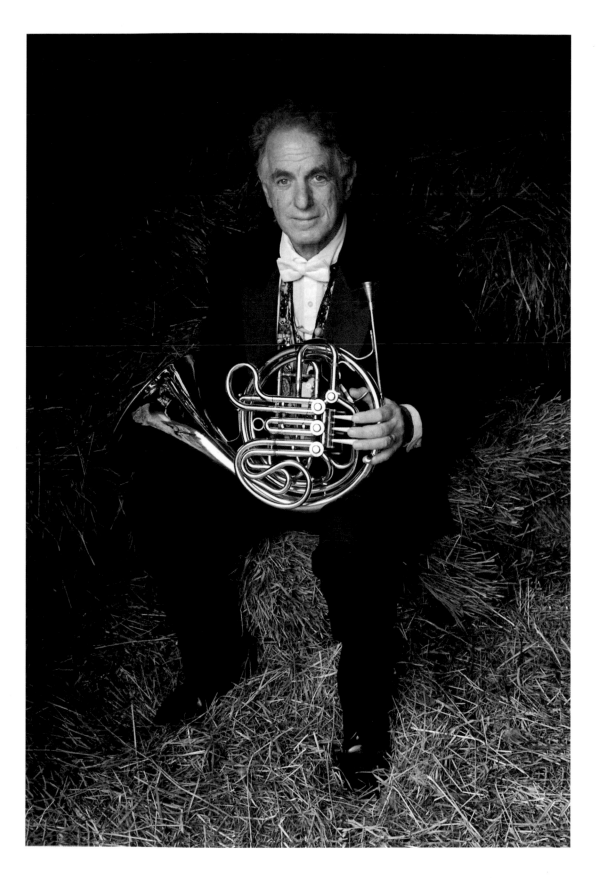

David Amram   Composer, multi-instrumentalist, Beat collaborator

Laurie Anderson  Performance, recording artist

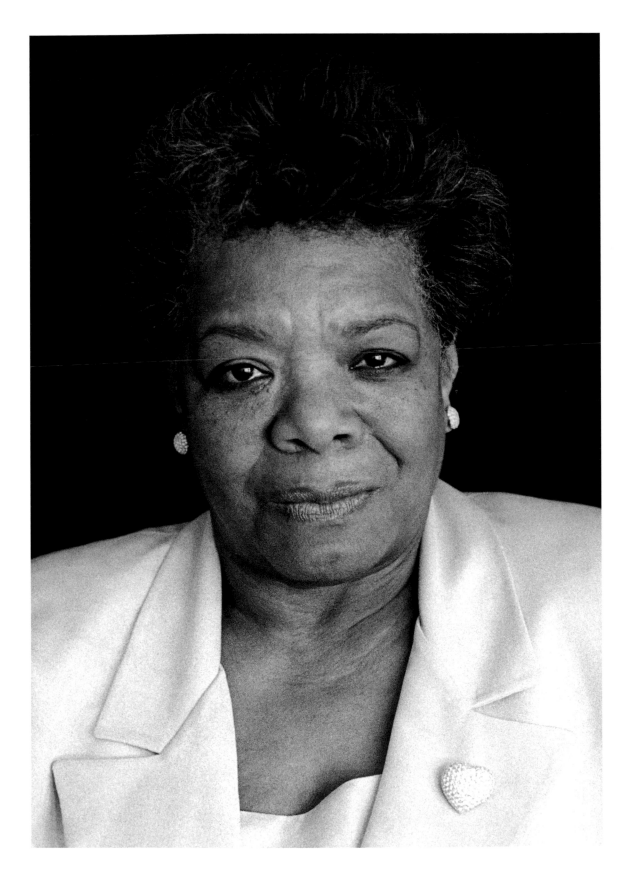

Maya Angelou  Poet, writer, actress

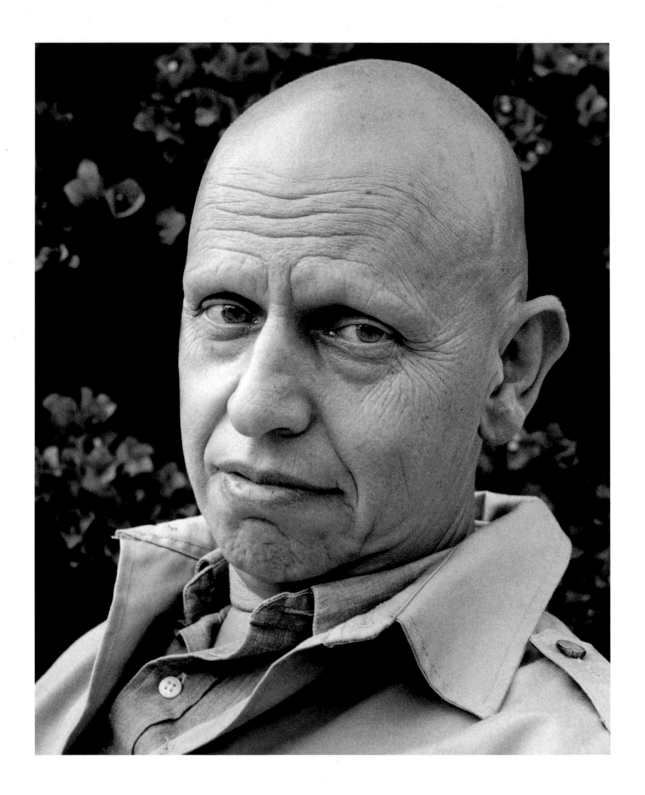

-28-

David Antin  "Talking" poet, critic

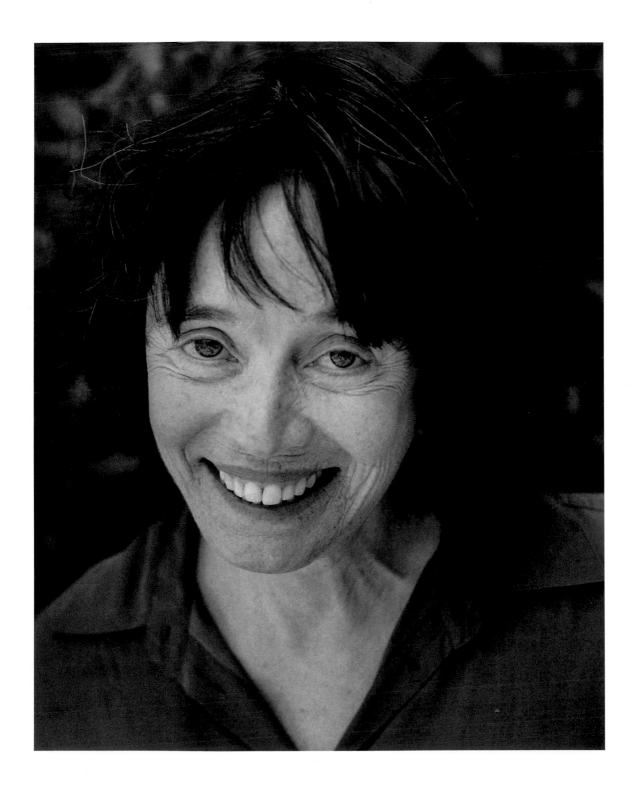

Eleanor Antin  Performance/video artist

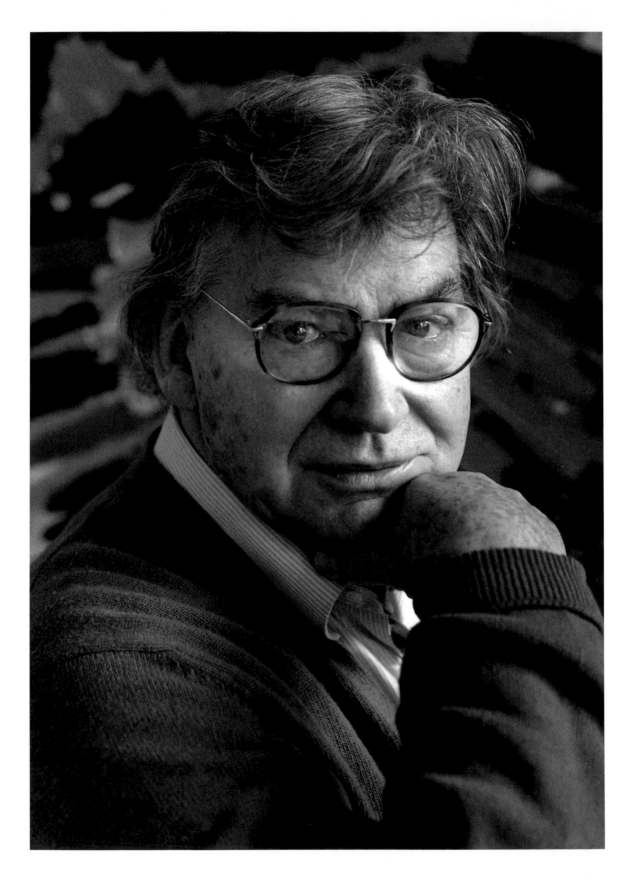

Karel Appel  "Cobra group" artist

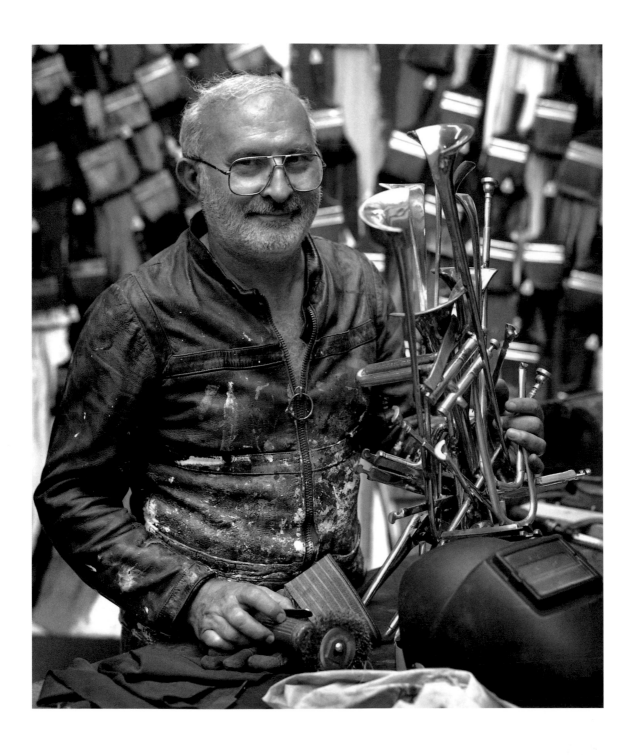

**Arman**  *Nouveaux Réalistes* assemblagist

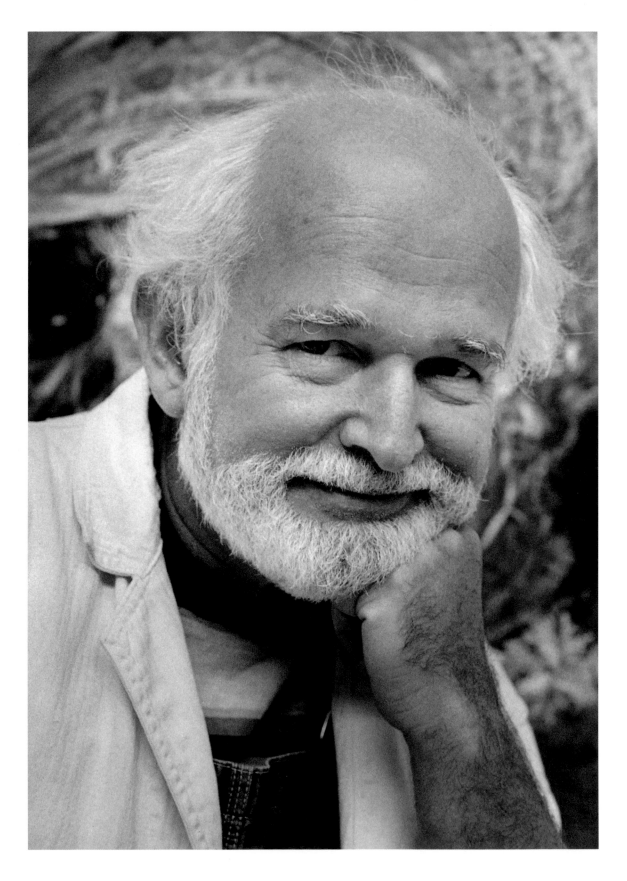

Robert Arneson  California Funk ceramic sculptor

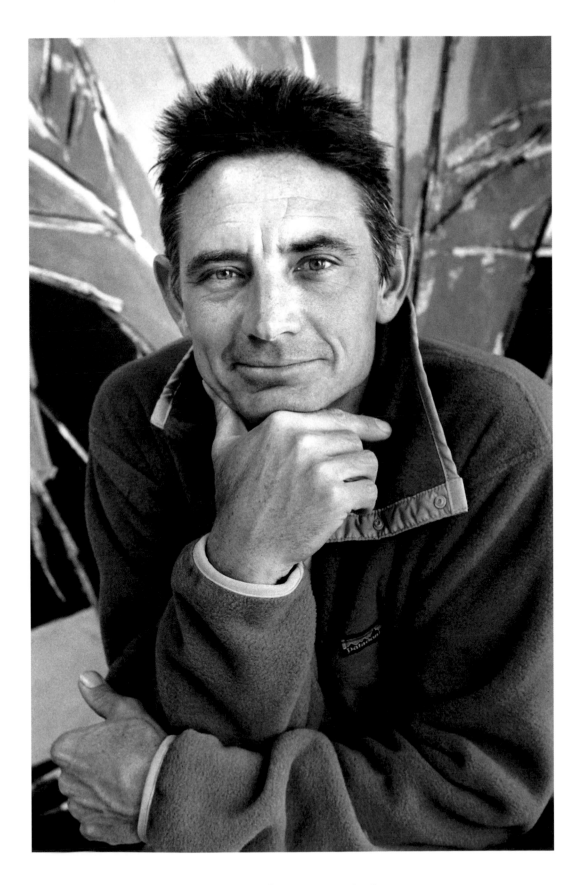

Chuck Arnoldi  Painter, printmaker

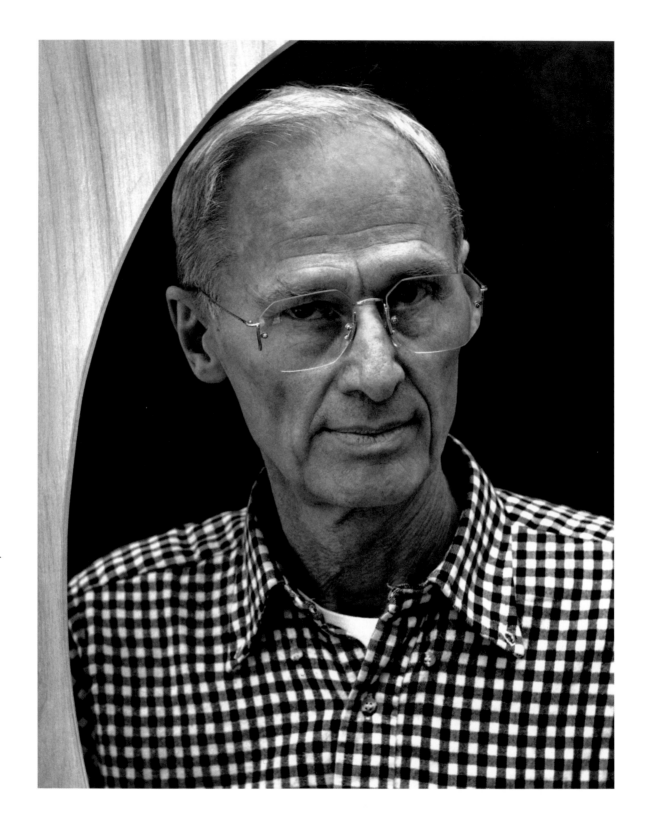

Richard Artschwager  Pop/minimalist artist

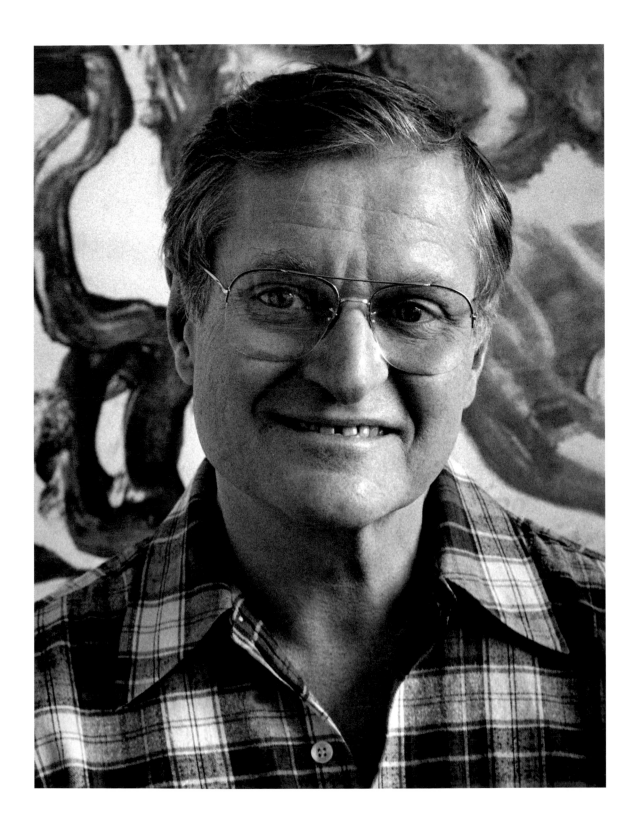

**John Ashbery**  Poet, art critic, Pulitzer Prize 1976

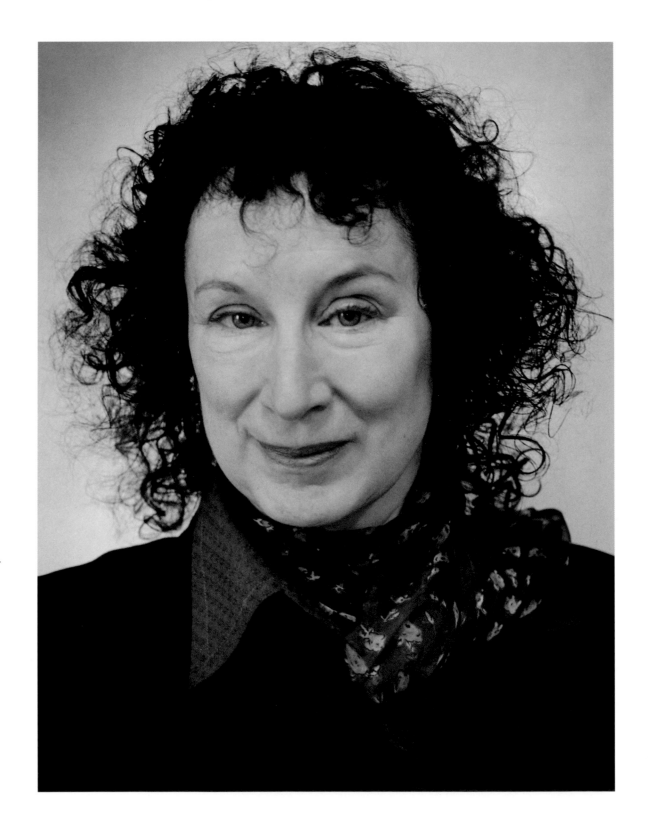

Margaret Atwood  Canadian novelist, poet

Alice Aycock  Large-scale sculptor

Don Bachardy  Figurature artist

Joan Baez  Folksinger, peace activist

John Baldessari  Conceptual artist, educator

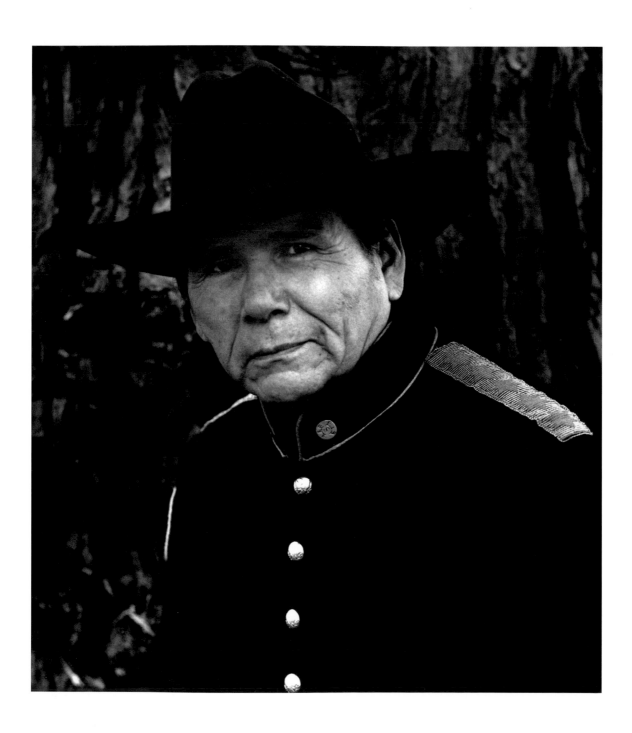

Dennis Banks  American Indian Movement cofounder

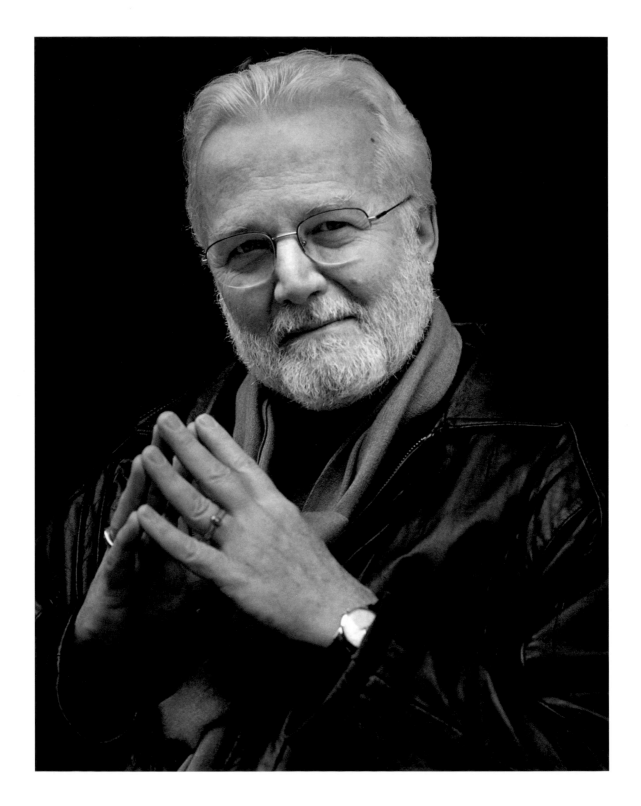

Russell Banks  Novelist

**Amiri Baraka** Poet, playwright, essayist

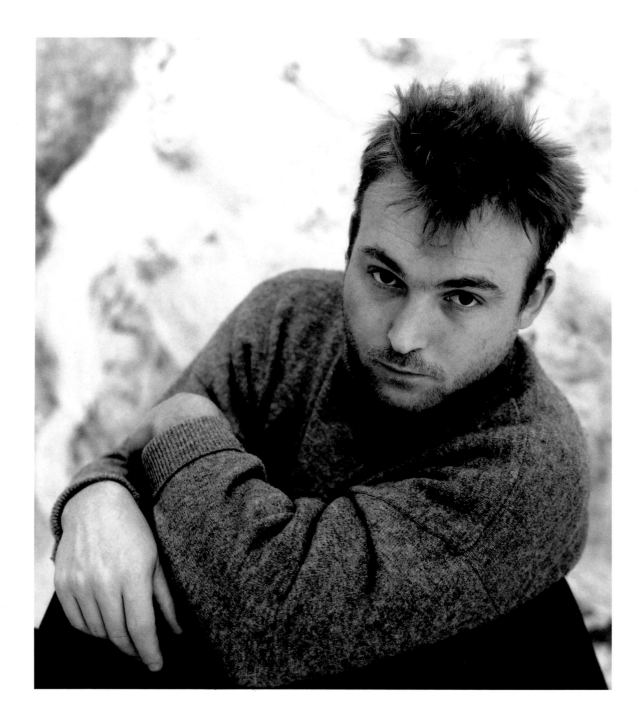

Miquel Barceló  Spanish painter

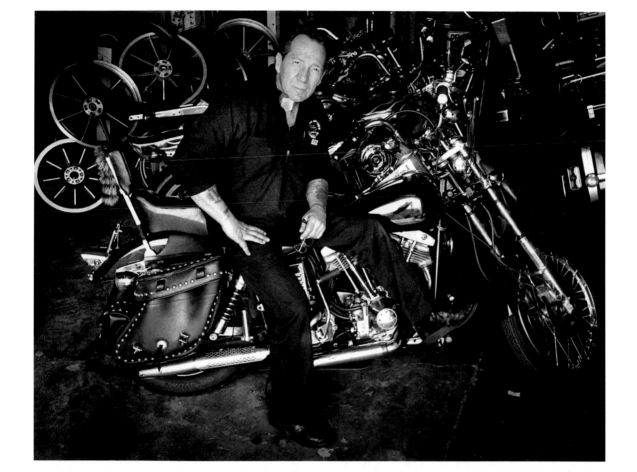

Sonny Barger  Founder, Hell's Angels, Oakland

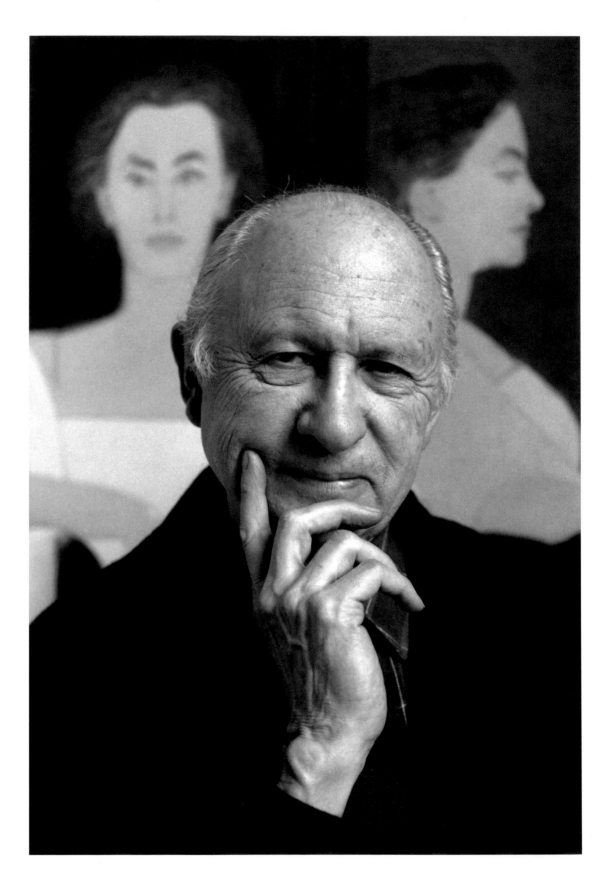

Will Barnett  Painter

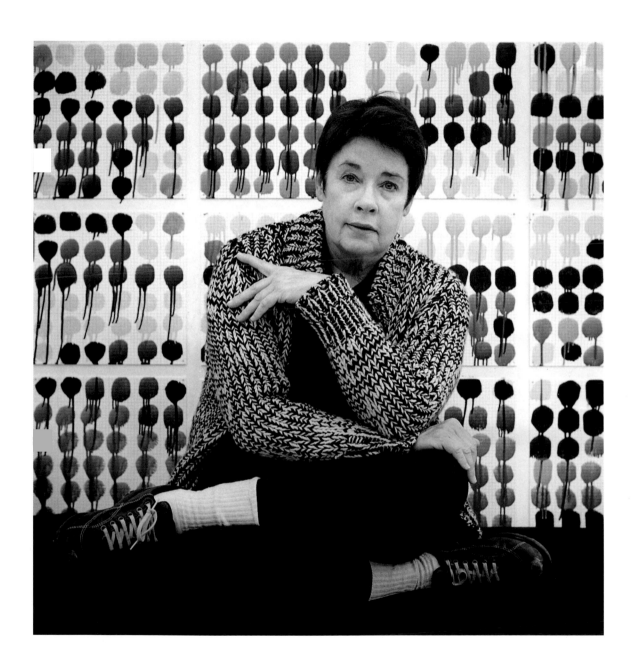

Jennifer Bartlett  Painter

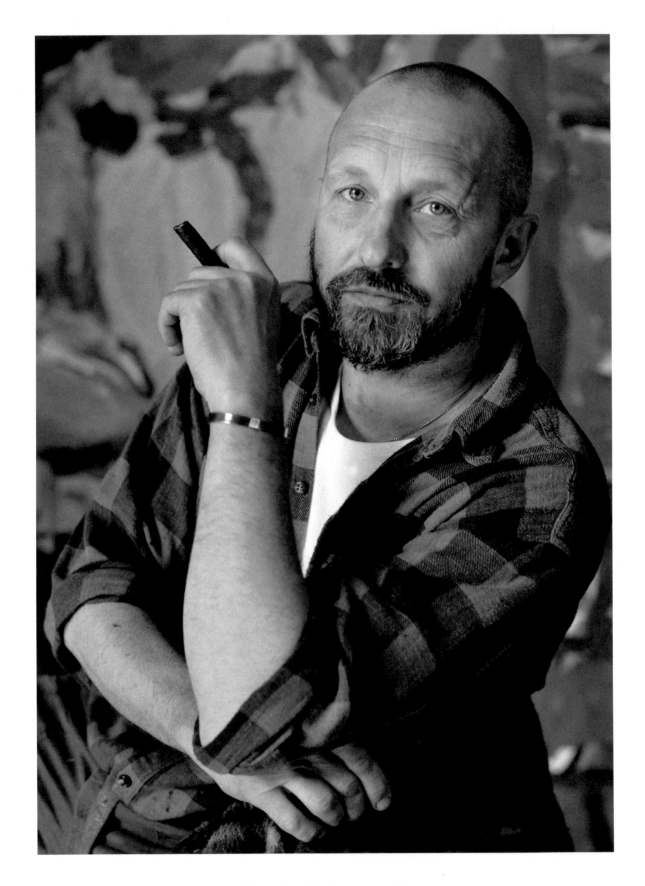

Georg Baselitz  German artist

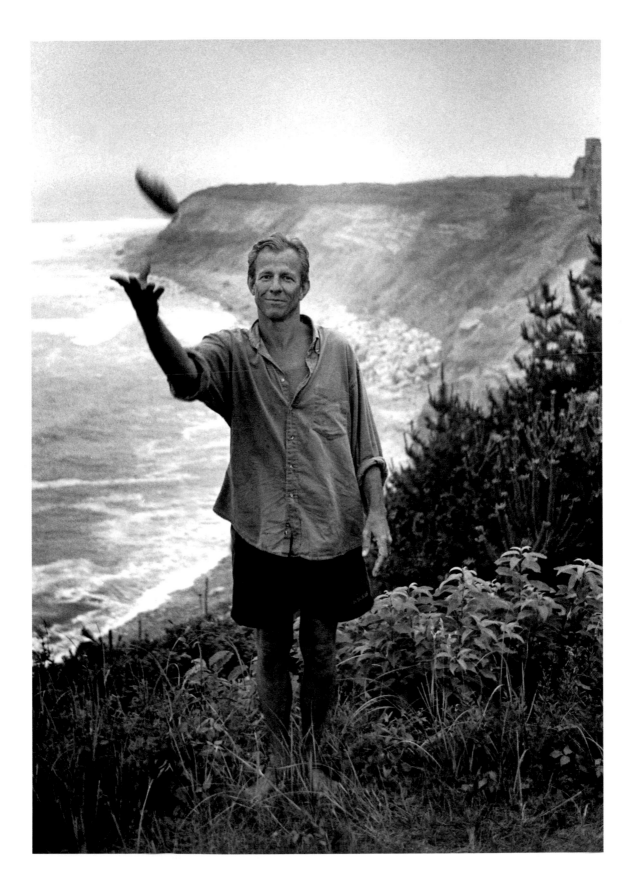

Peter Beard  African wildlife photographer, diarist

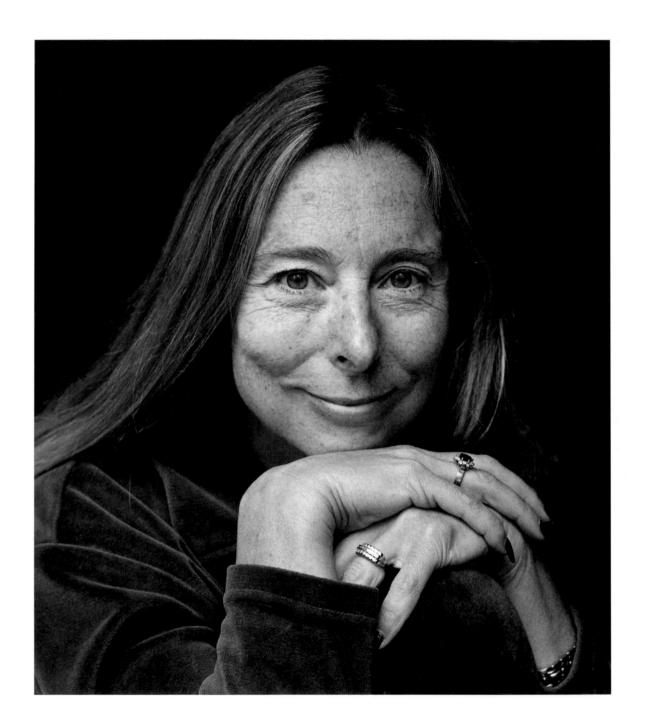

Ann Beattie  Novelist, short story writer

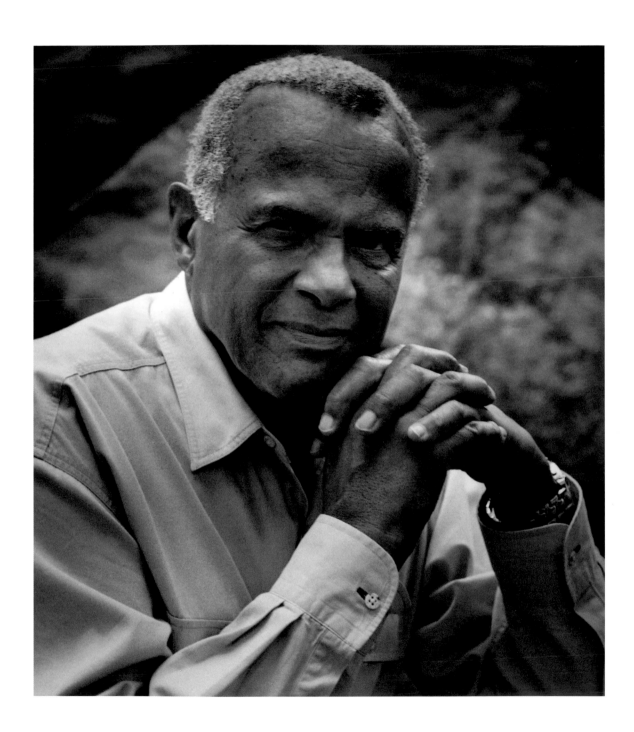

Harry Belafonte  Singer, actor

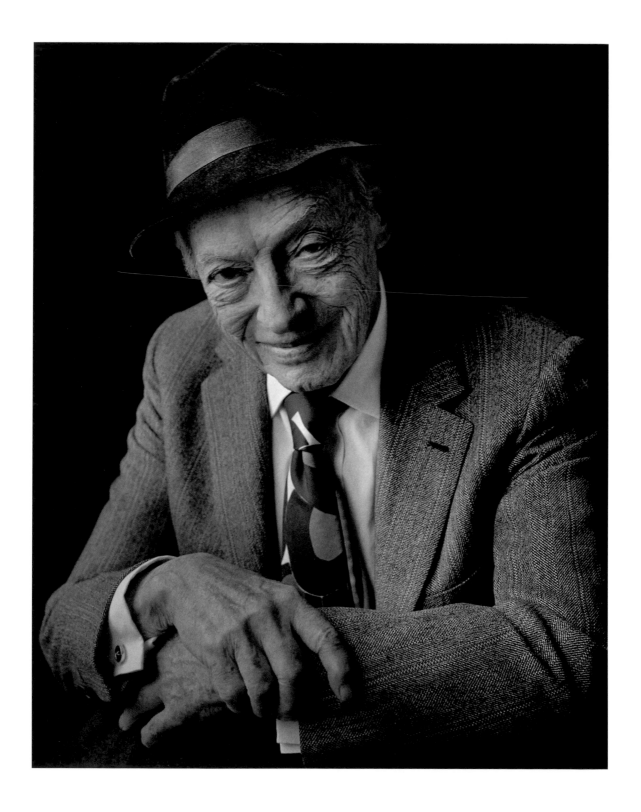

Saul Bellow  Novelist, Nobel laureate 1976

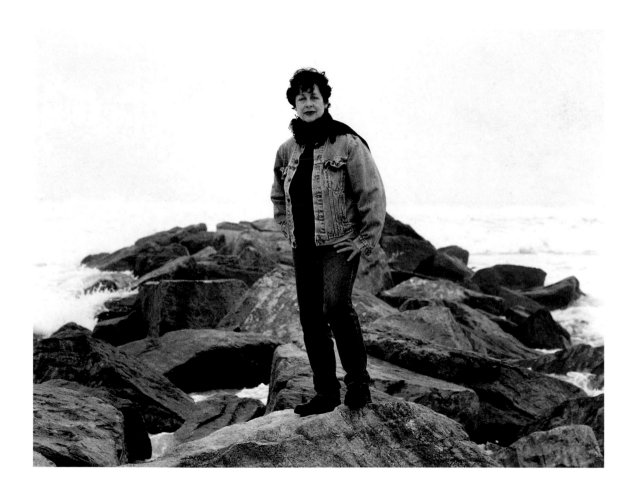

Lynda Benglis  Sculptor, video artist

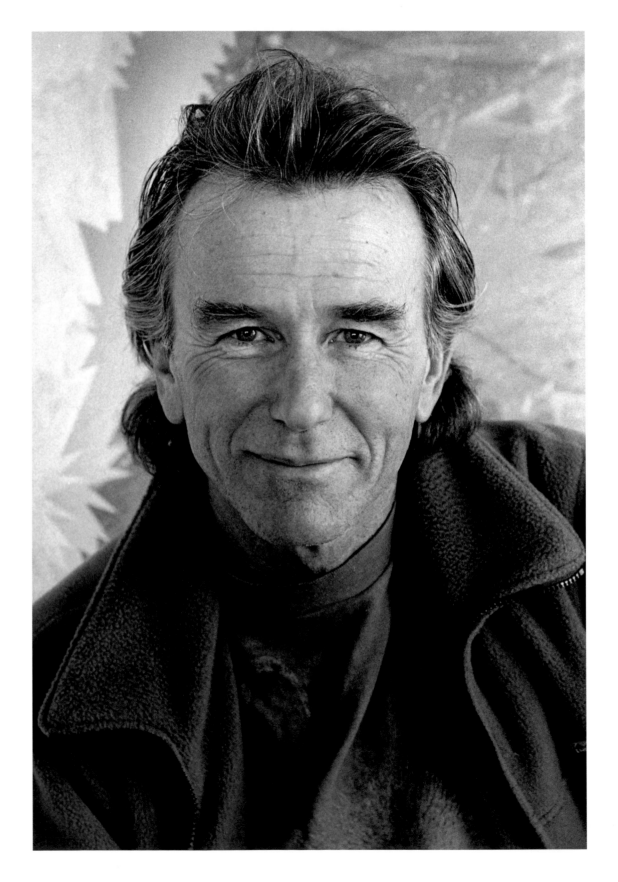

Billy Al Bengston  California artist

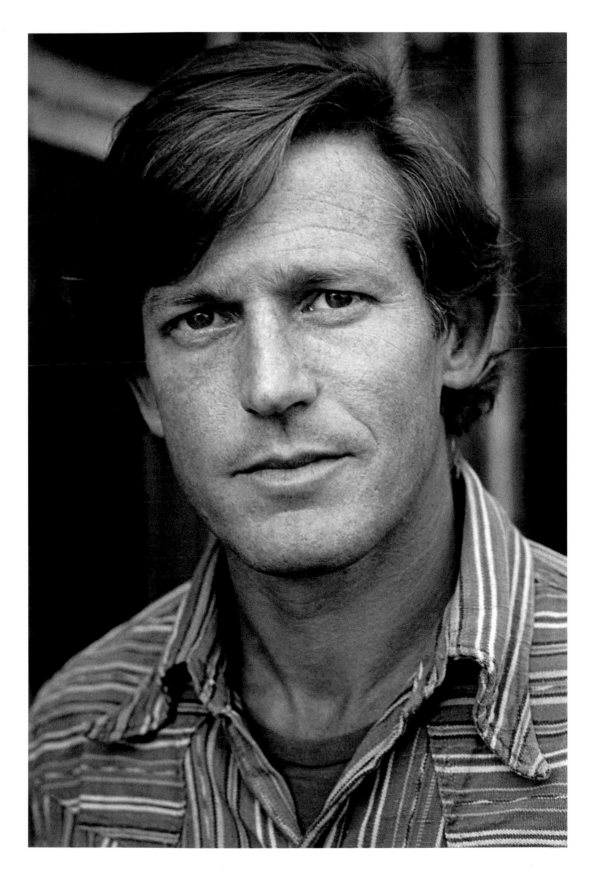

Bill Berkson  Poet, art critic

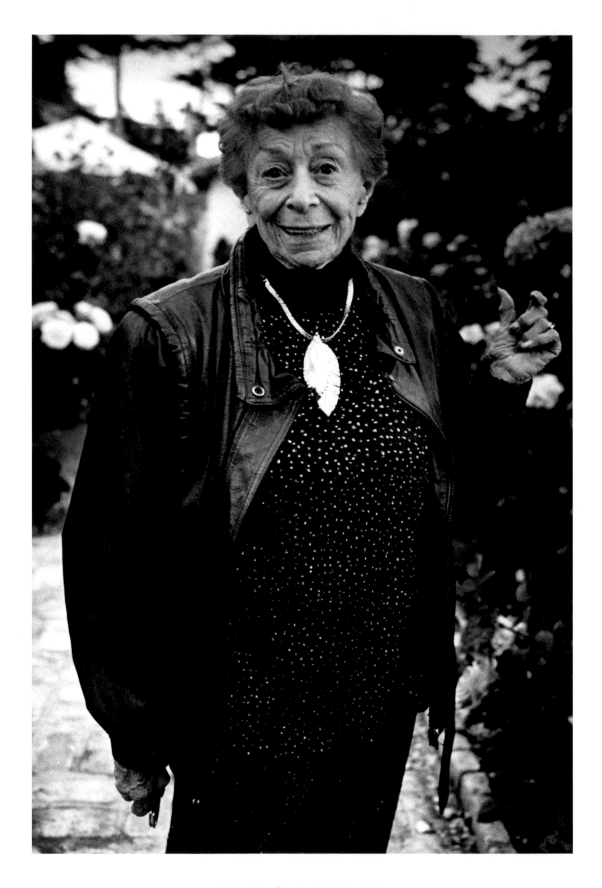

Ruth Bernhard  Photographer

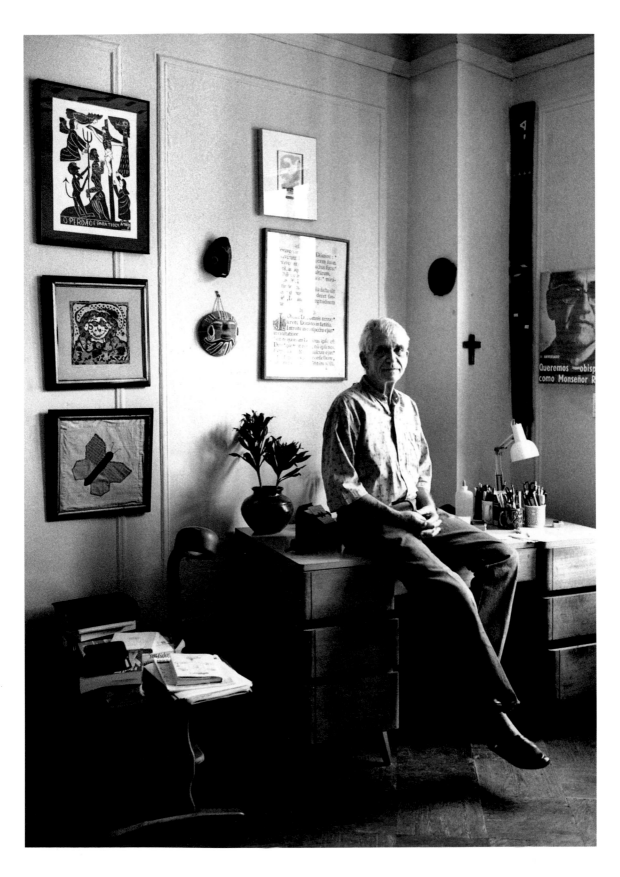

Daniel Berrigan  Peace activist, poet, Jesuit priest

Ted Borrigan  New York School poet

Chuck Berry  Rock 'n' roll trailblazer

Mei-mei Berssenbrugge  Experimental poet

Les Blank  Independent filmmaker

Ross Bleckner  New York painter

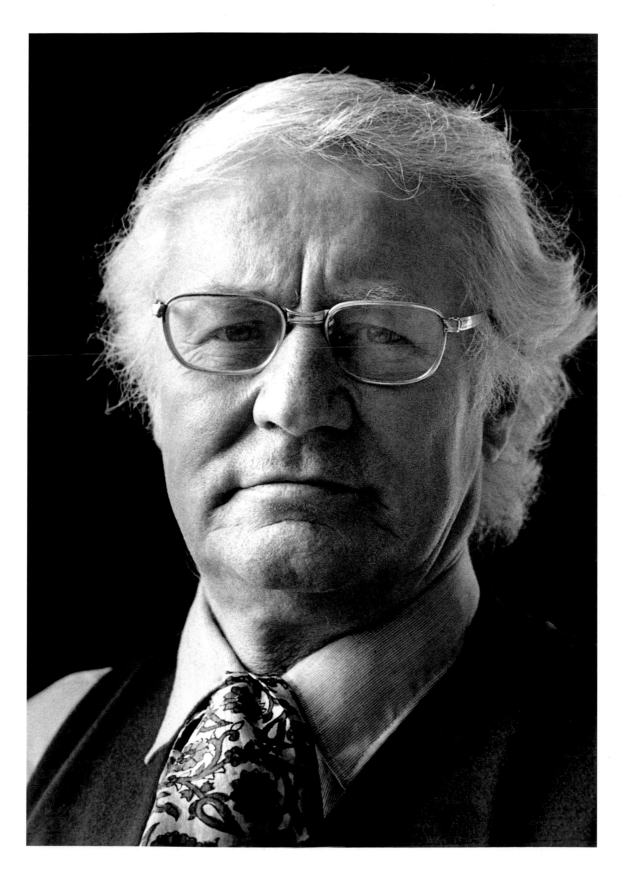

Robert Bly  Poet, translator

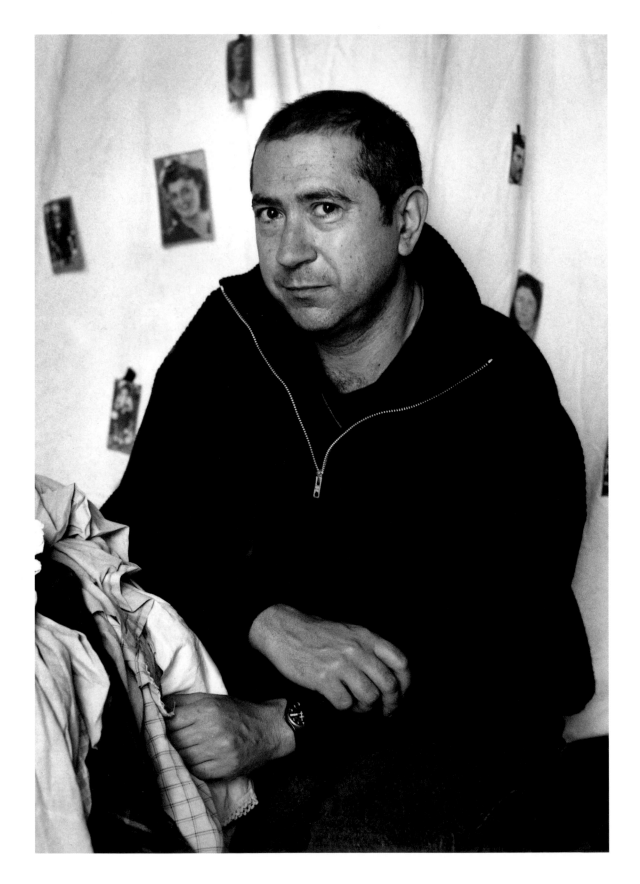

Christian Boltanski  French artist

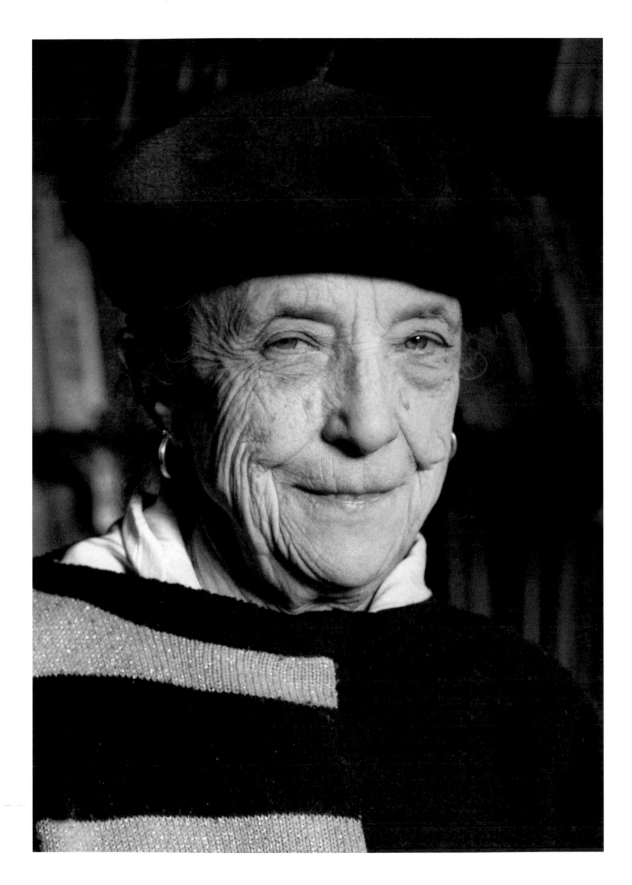

Louise Bourgeois  Artist, sculptor

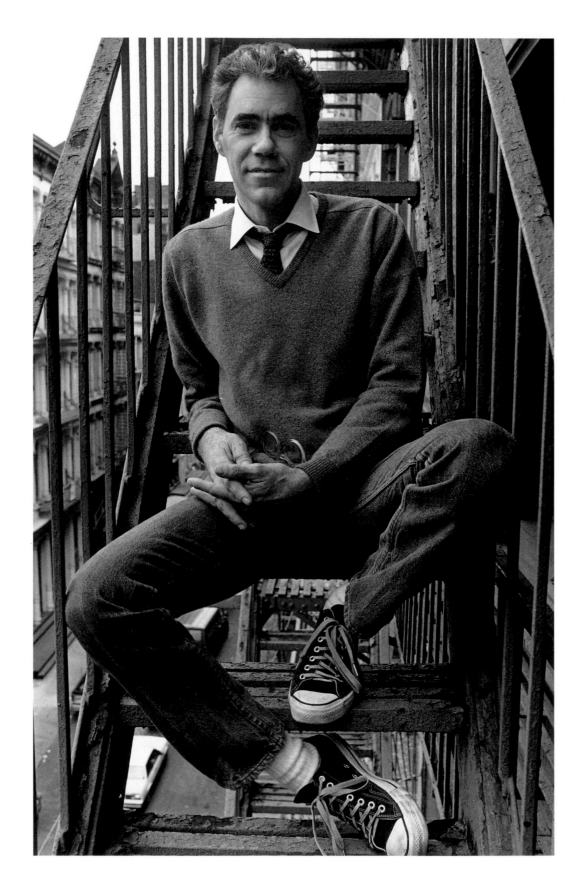

Joe Brainard  Painter, writer

Stan Brakhage  Independent filmmaker

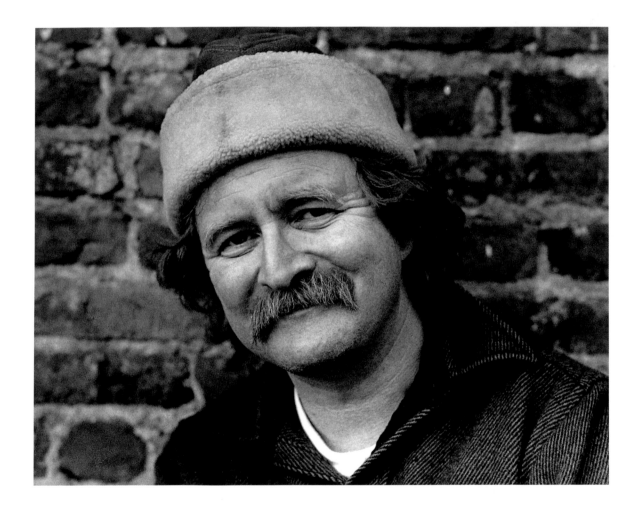

Richard Brautigan  Novelist, poet

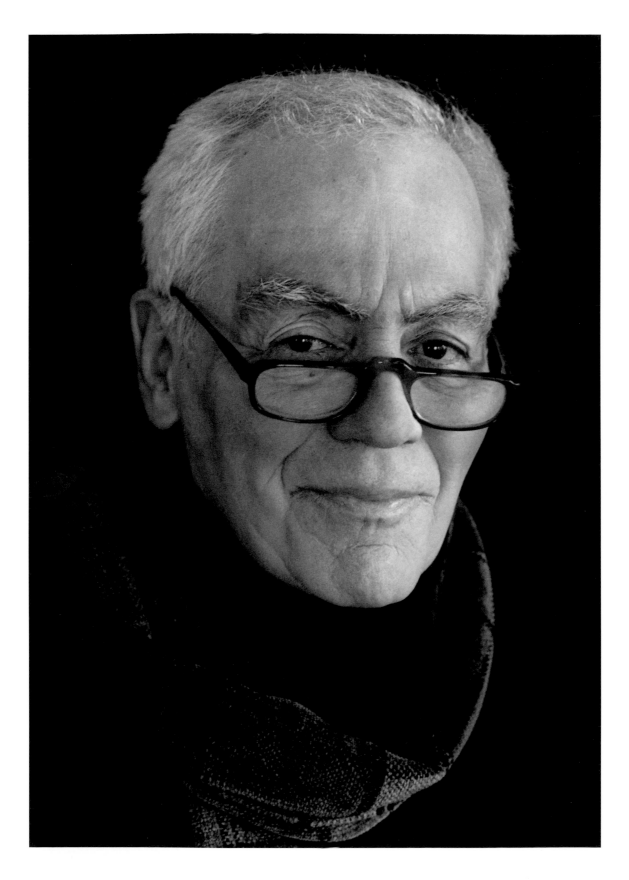

Jimmy Breslin  Columnist, Pulitzer Prize 1986

Douglas Brinkley  American cultural historian, author

James Broughton  Poet, filmmaker

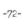

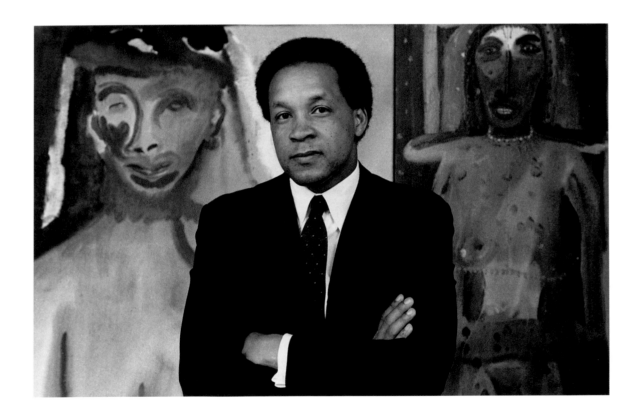

Fred Brown  Artist

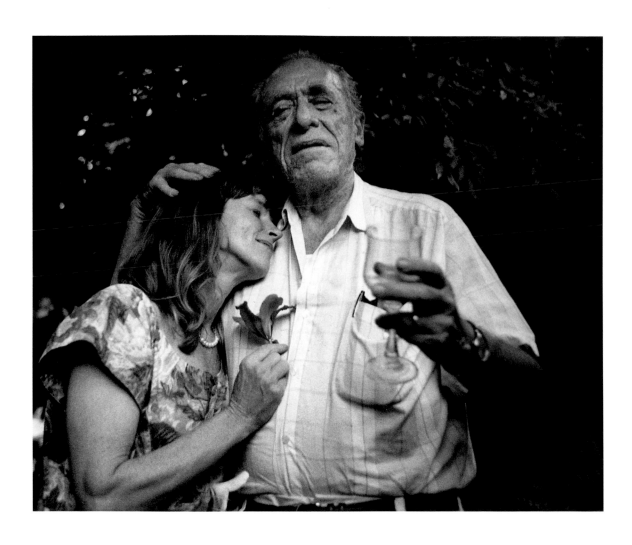

Charles & Linda Lee Bukowski  Poet/novelist & wife

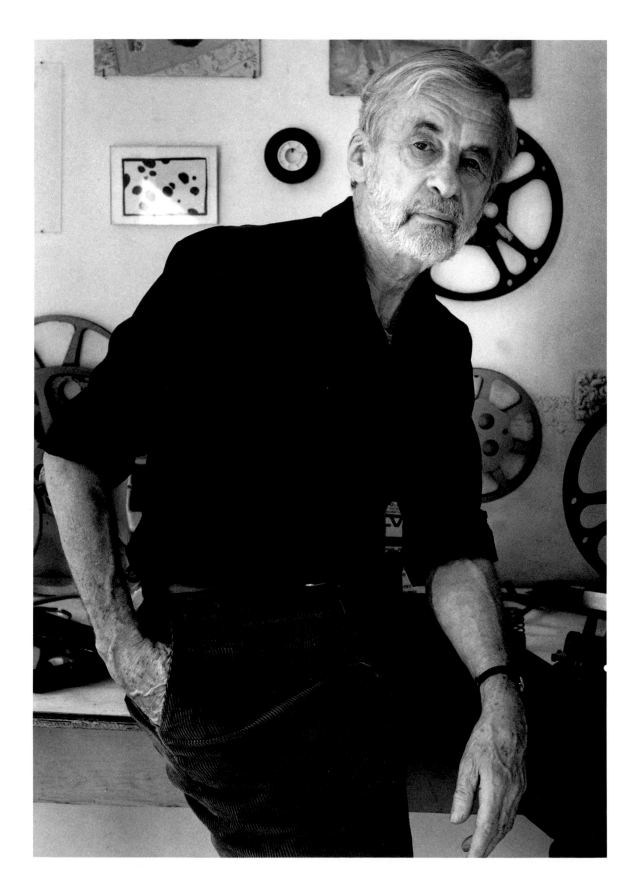

Rudy Burckhardt  New York filmmaker, photographer

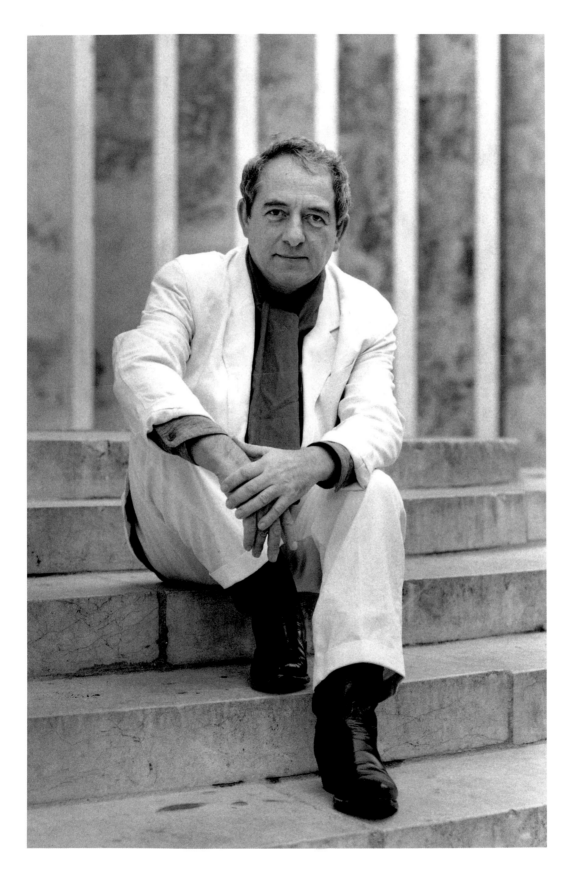

Daniel Buren  French artist

Ken Burns  Documentary filmmaker

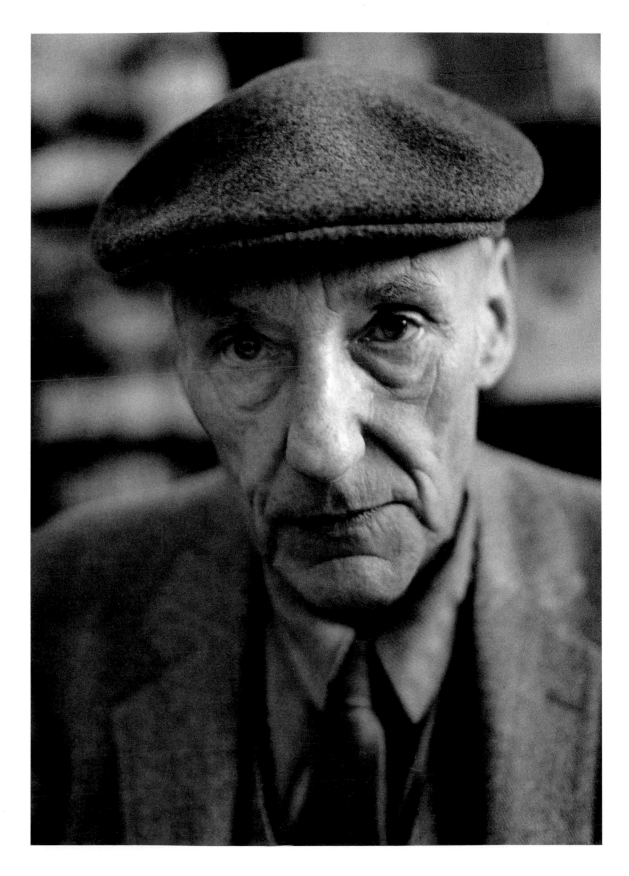

William S. Burroughs  Beat novelist

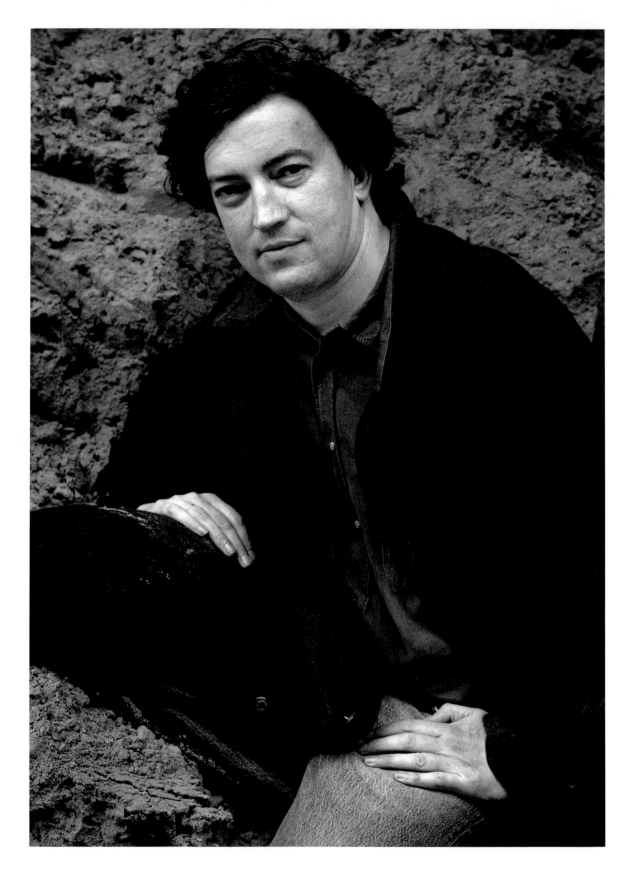

Jean Marc Bustamante  French sculptor, photographer

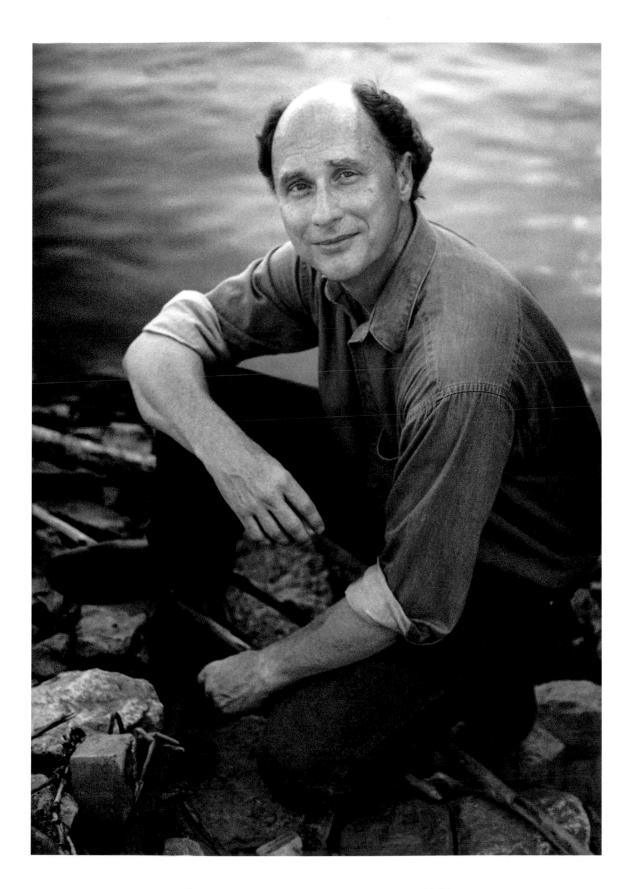

Robert Olen Butler  Novelist, Pulitzer Prize 1993

-80-

James Lee Byars  Sculptor

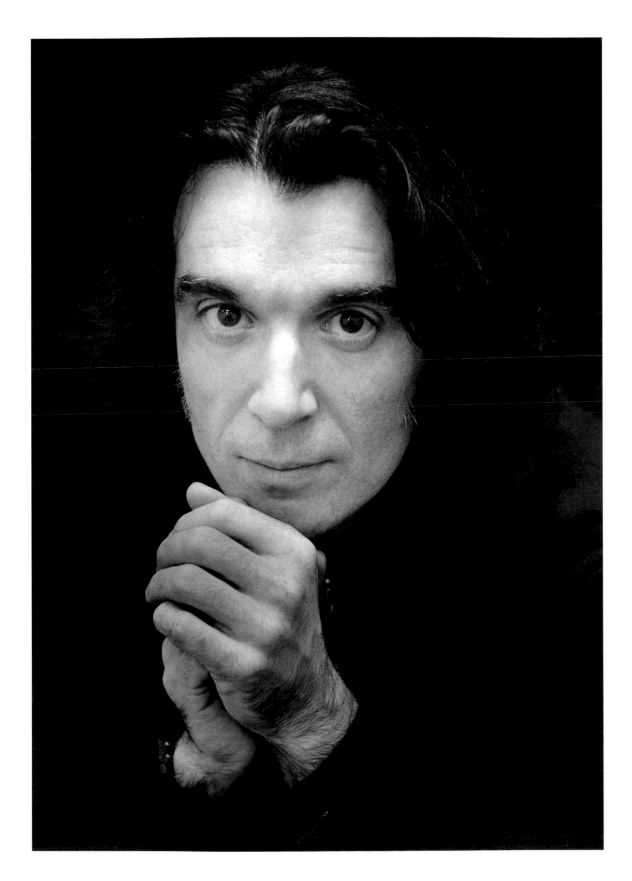

David Byrne  Musician, photographer

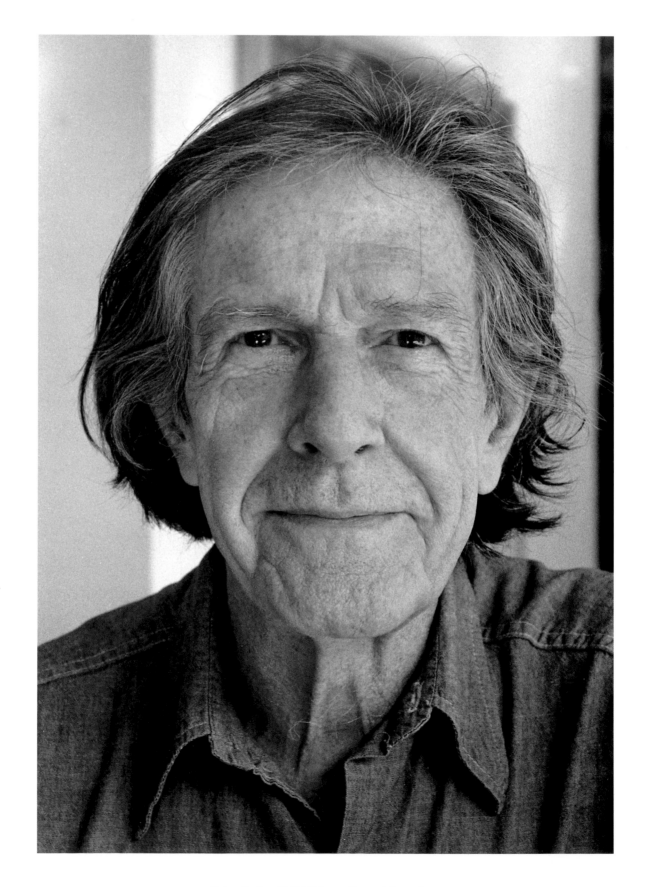

John Cage  Composer, writer, philosopher

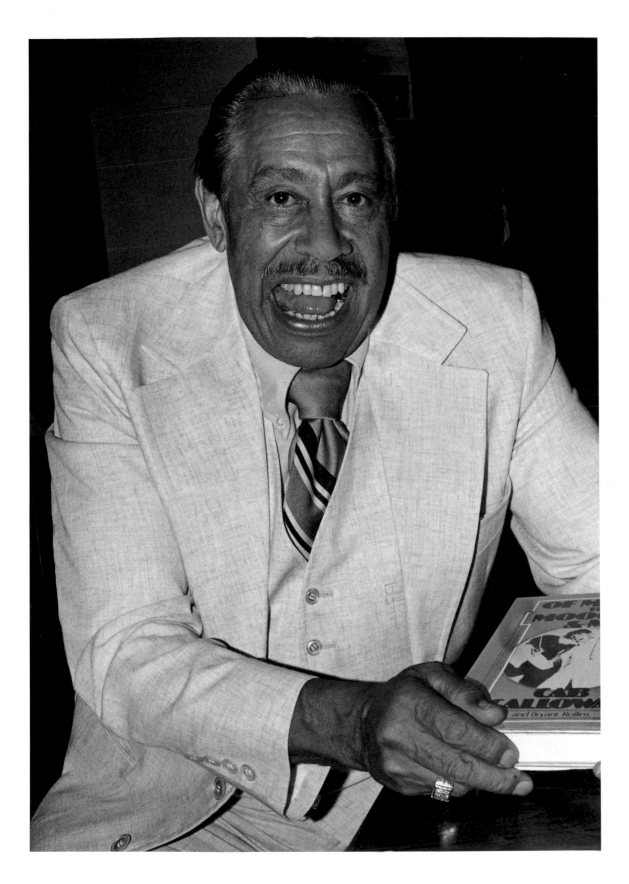

Cab Calloway  Bandleader, singer, actor

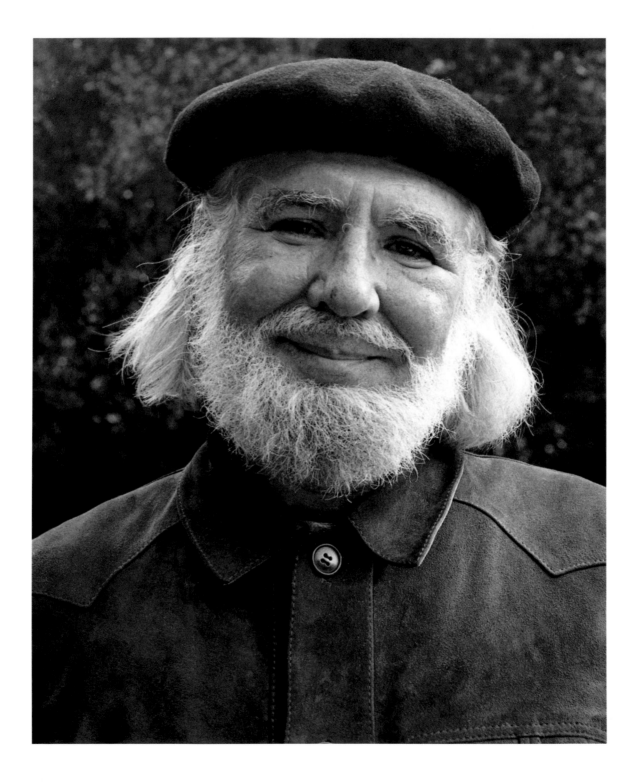

Ernesto Cardenal  Nicaraguan poet

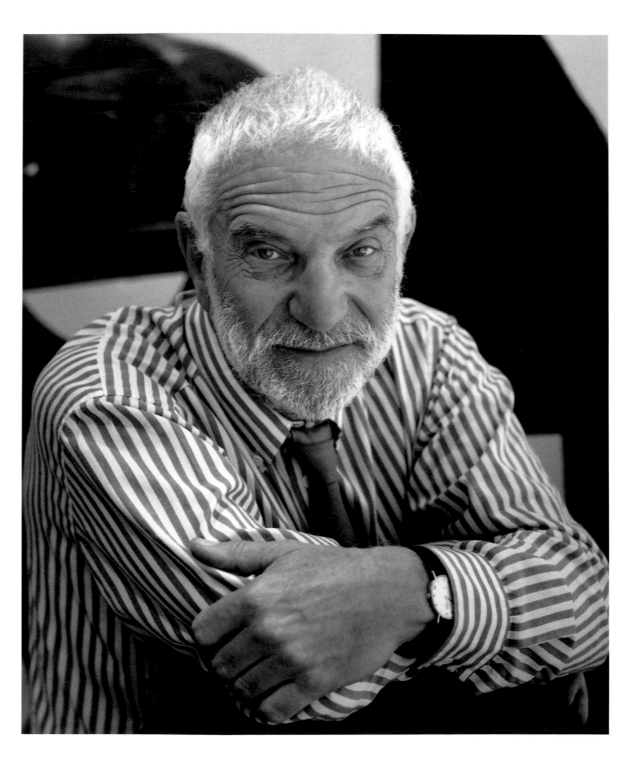

Anthony Caro  British sculptor

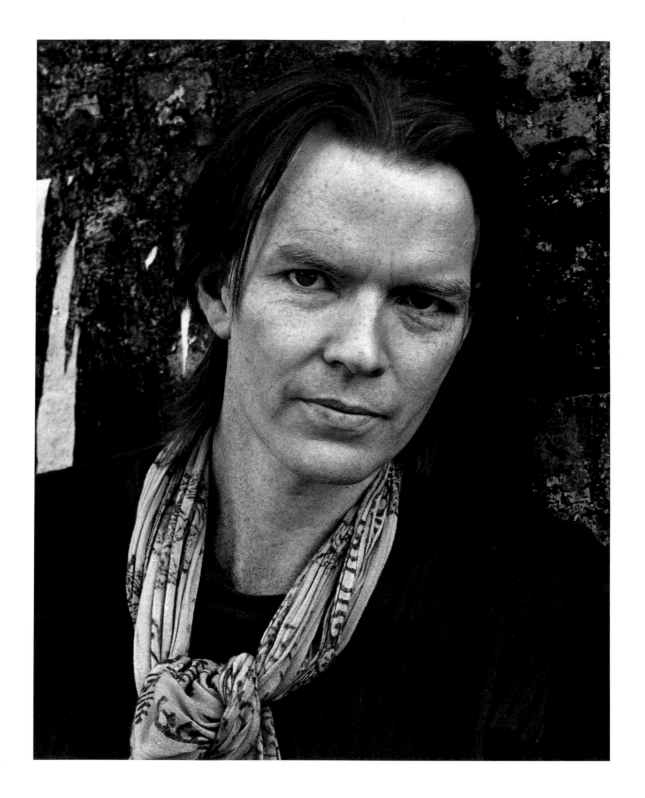

Jim Carroll  New York poet, rock singer

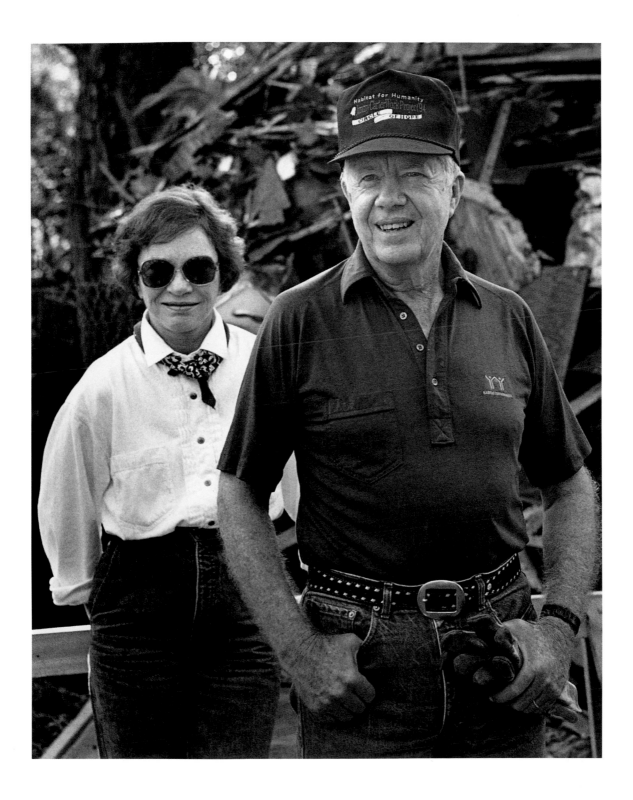

Jimmy & Rosalyn Carter  Author, former president & first lady

Rosanne Cash  Singer/songwriter, author

César  *Nouveau Réaliste* sculptor, assemblagist

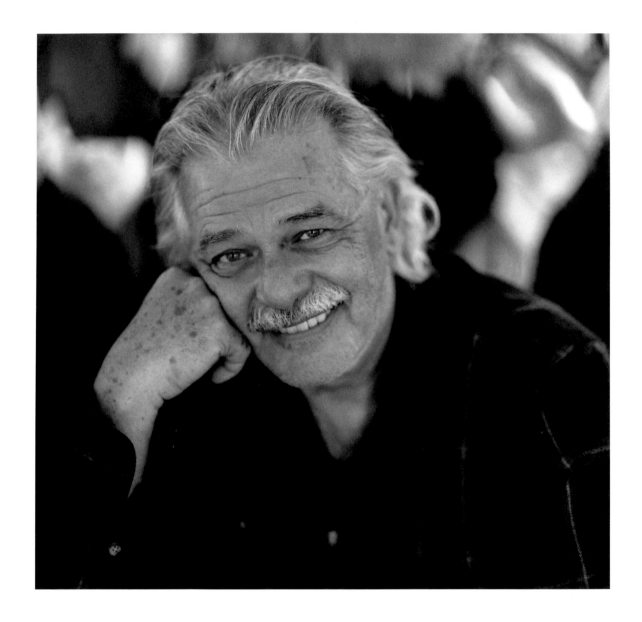

John Chamberlain  Sculptor

Sam & Ann Charters  Musicologist & Beat scholar

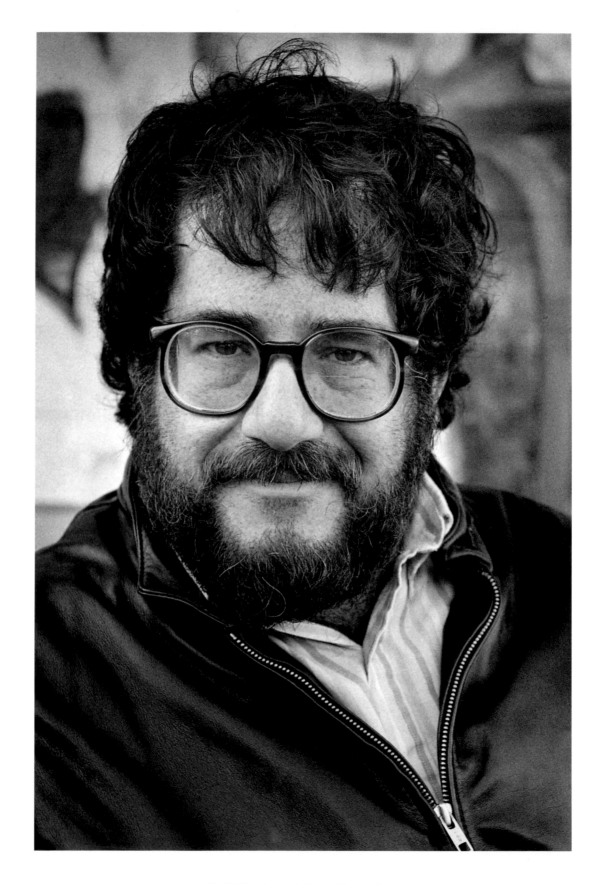

Neeli Cherkovski  Poet, biographer

Sandro Chia  Italian painter

Noam Chomsky  Linguist, political theorist

Dan Christensen  Abstract painter

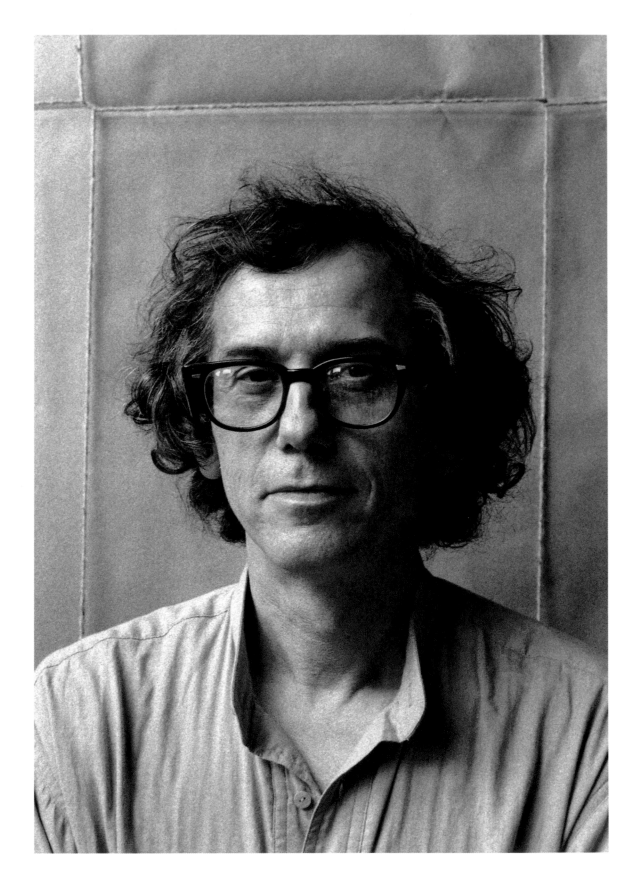

Christo  Environmental sculptor

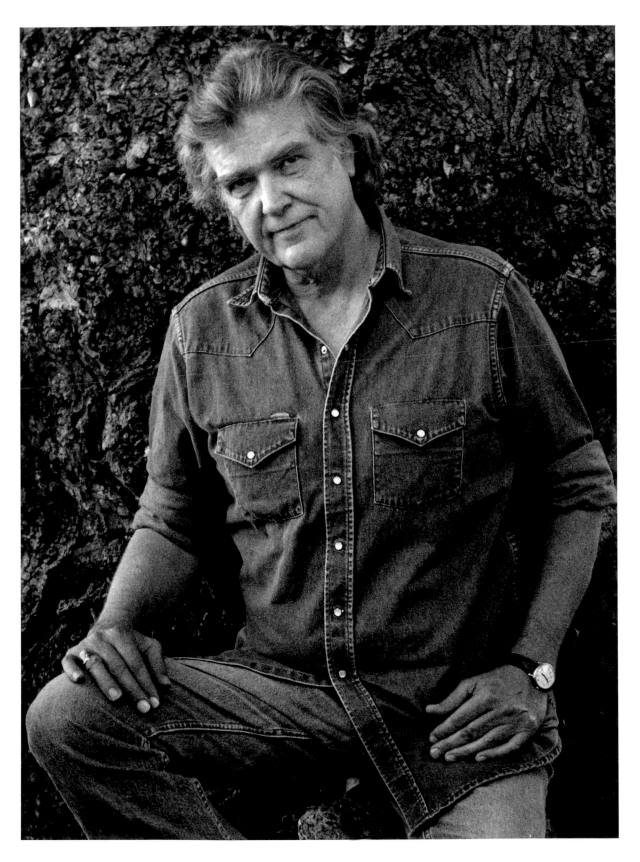

Guy Clark  Lyric singer/songwriter

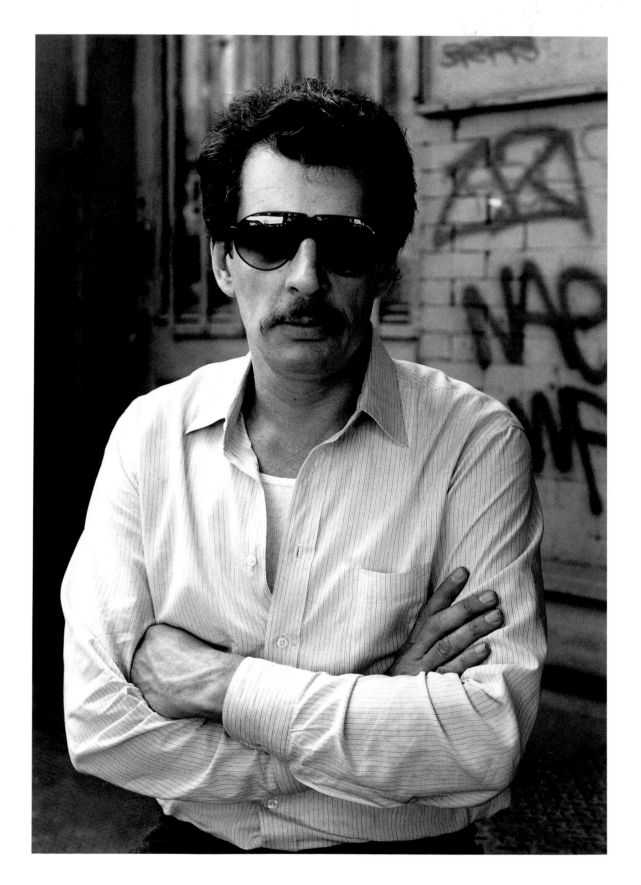

Larry Clark  Artist, director

Tom Clark  Poet, critic, biographer

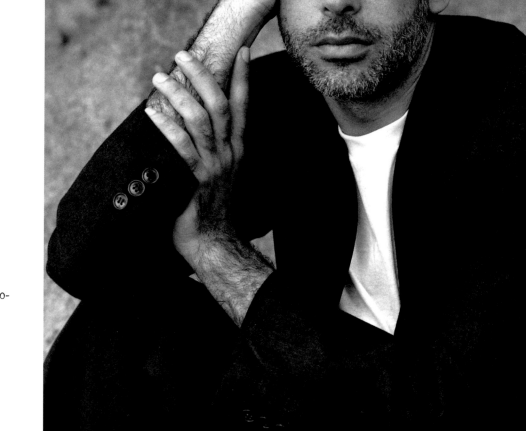

Francesco Clemente  Artist

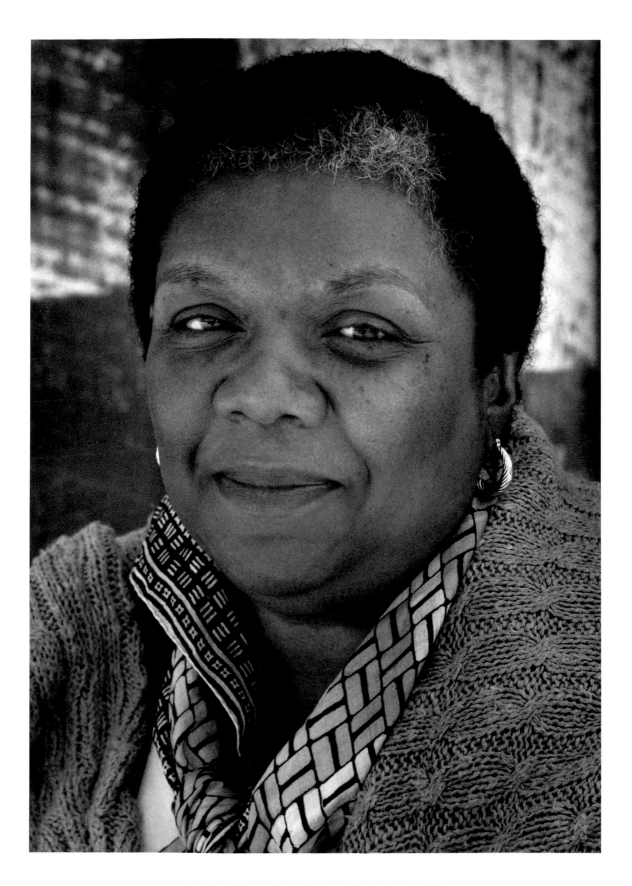

Lucille Clifton  Poet, National Book Award 2000

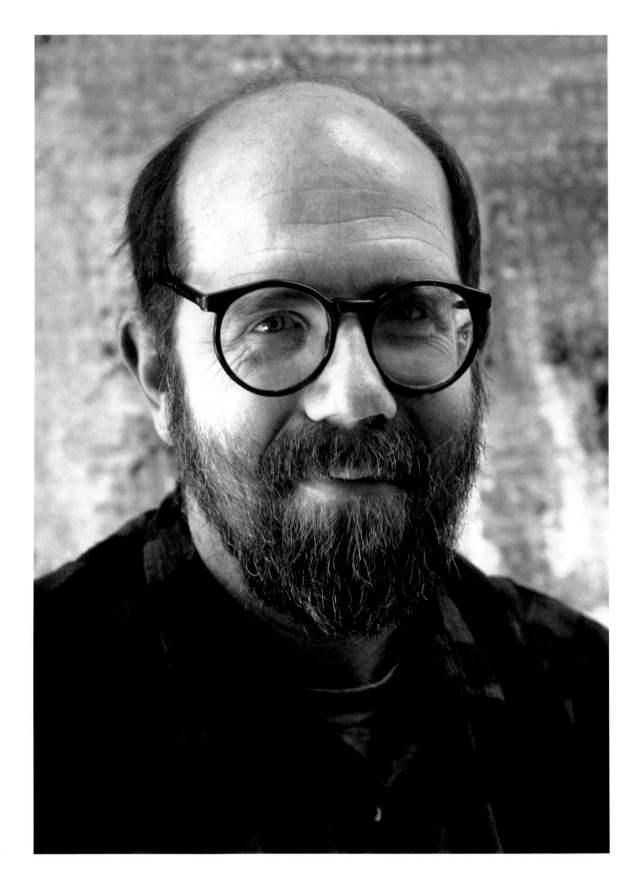

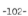-102-

Chuck Close  Artist

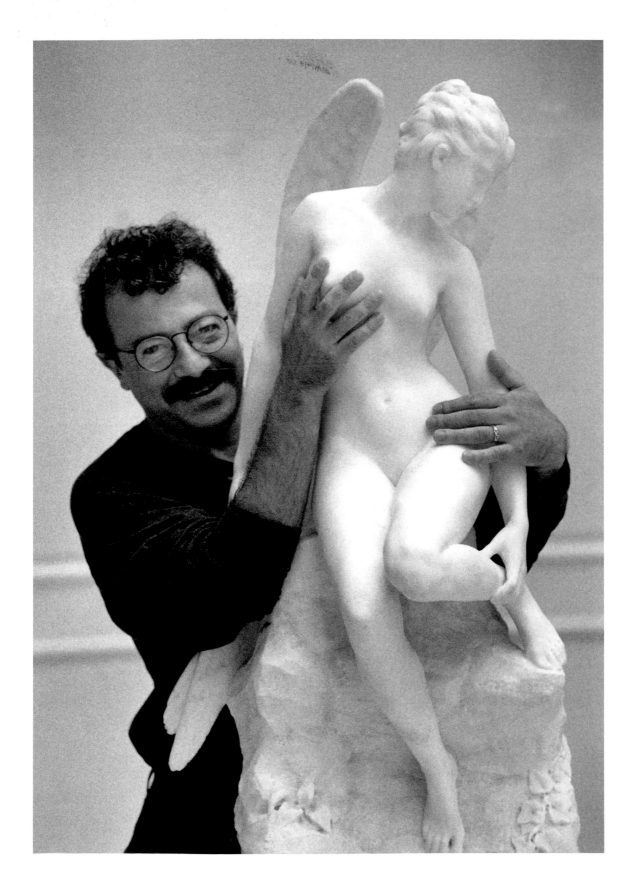

Andrei Codrescu  Romanian emigré poet, commentator

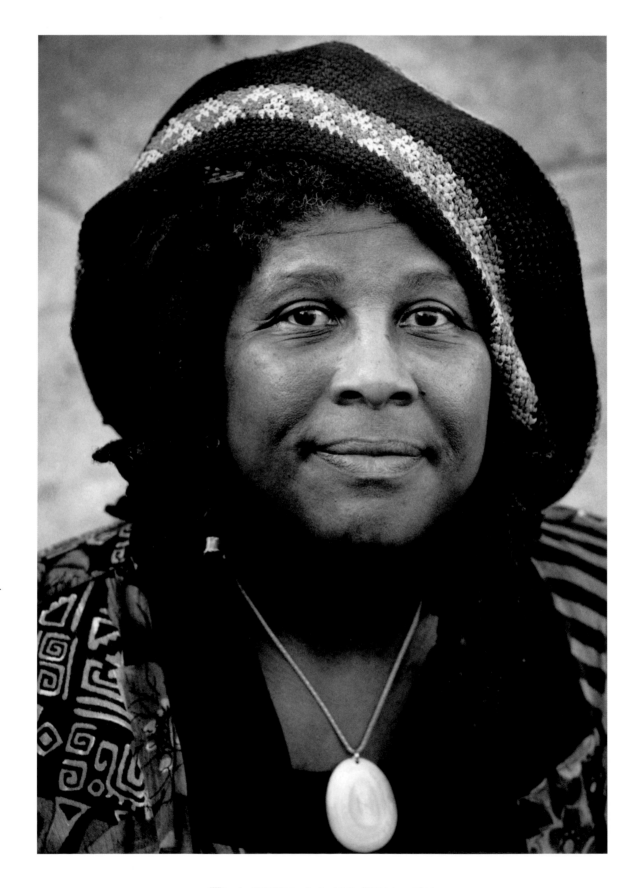

Wanda Coleman  L.A. poet, fiction writer

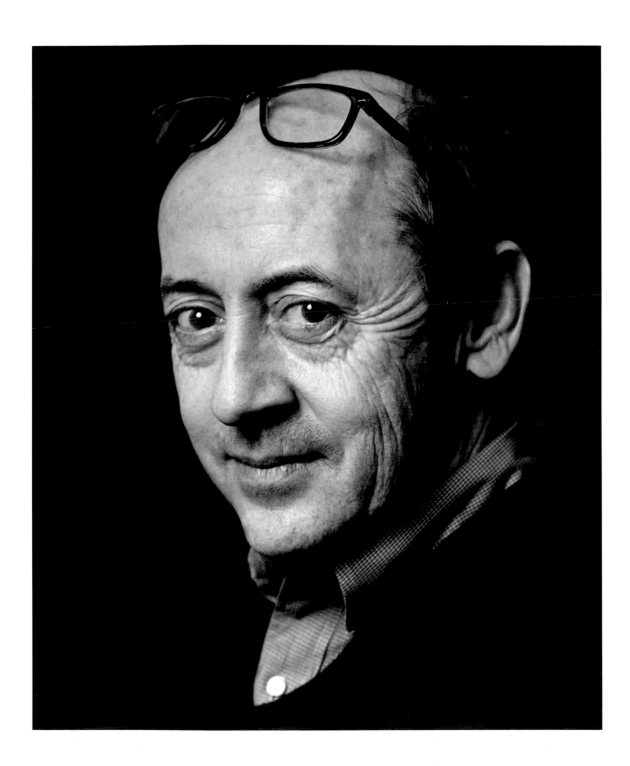

Billy Collins  Poet

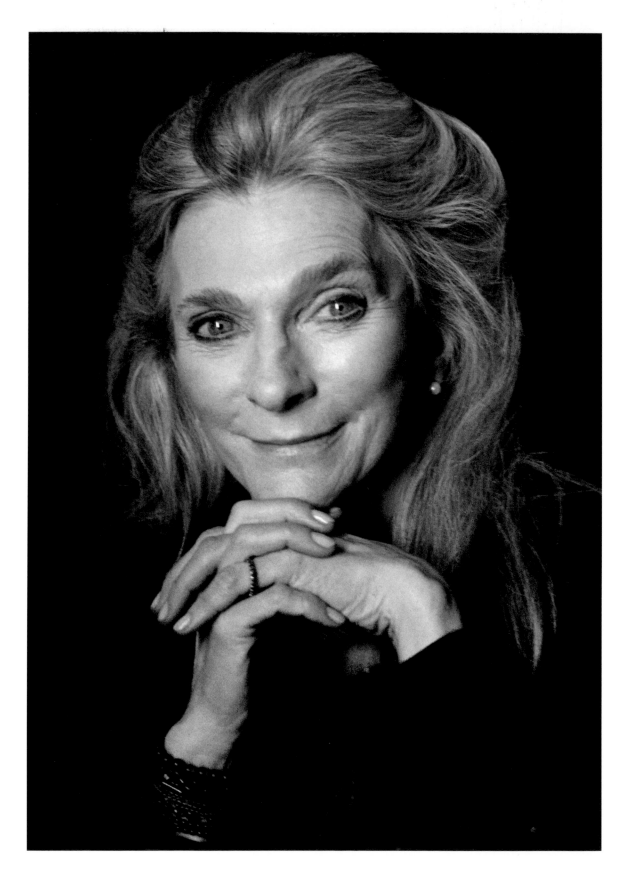

Judy Collins  Folk/pop singer/songwriter

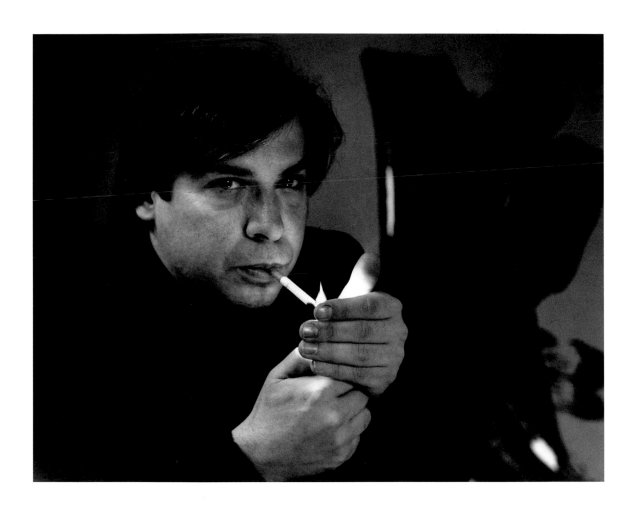

-107-

George Condo  Collage painter

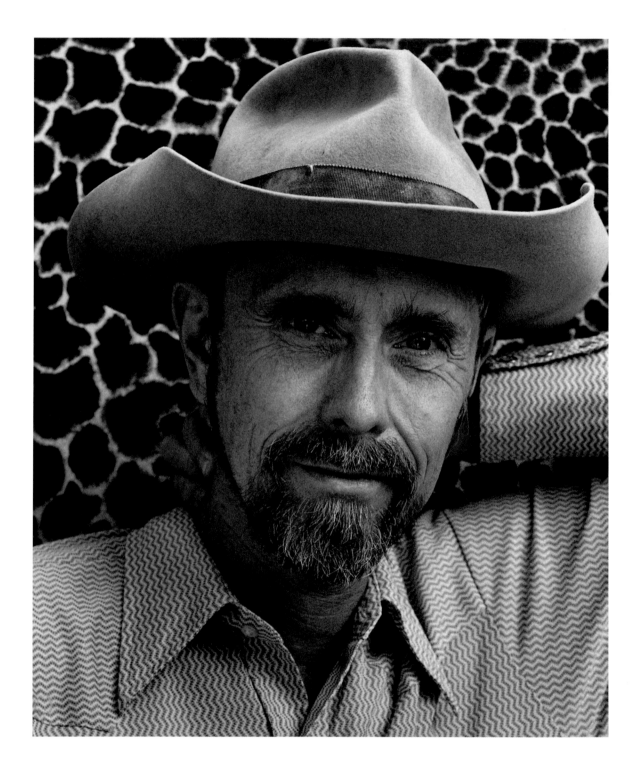

Bruce Conner  Beat artist, assemblagist, filmmaker

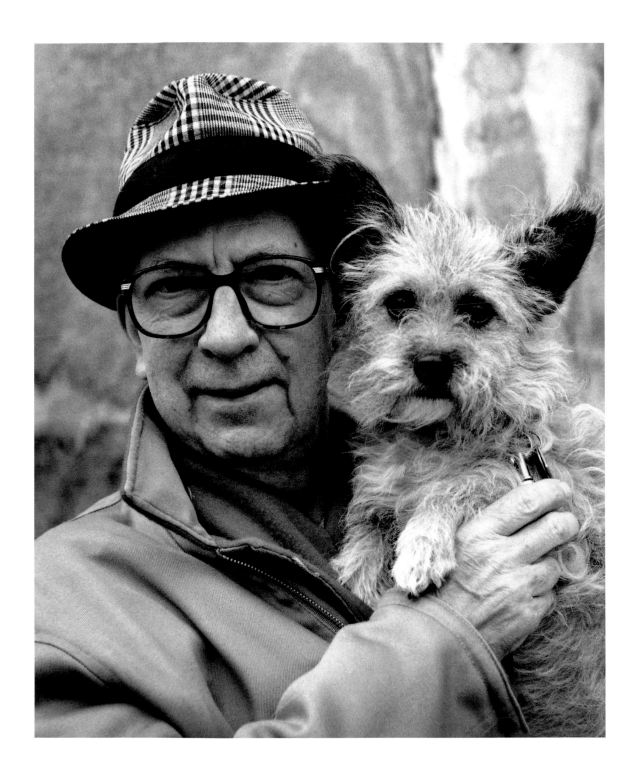

Constant "Cobra group" artist

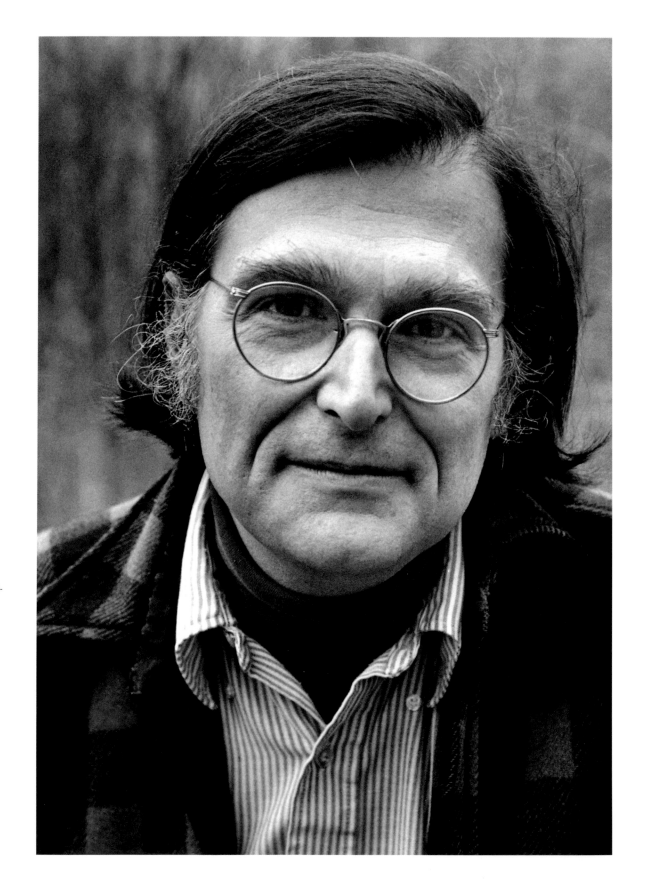

Clark Coolidge  Poet, jazz drummer

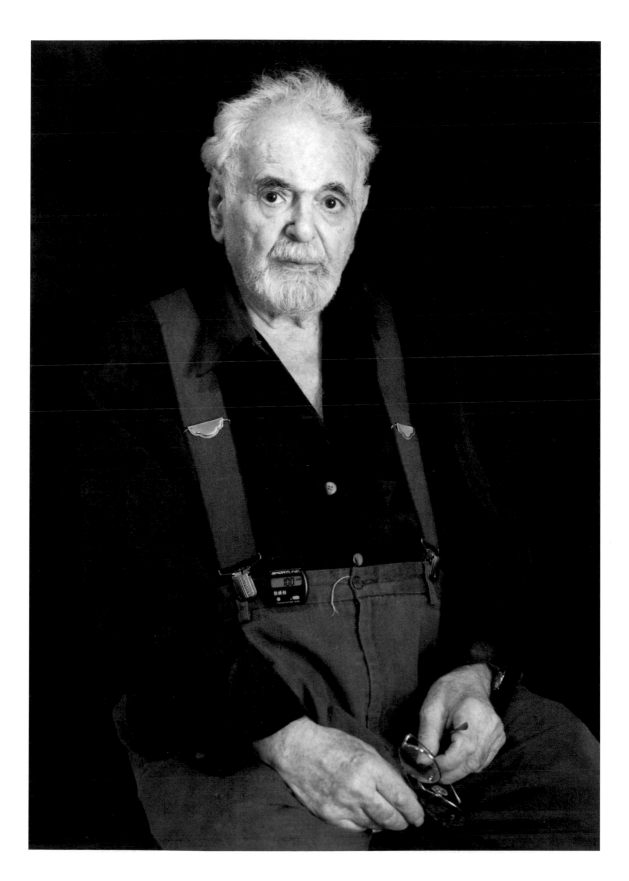

John Coplans  Photographer, editor

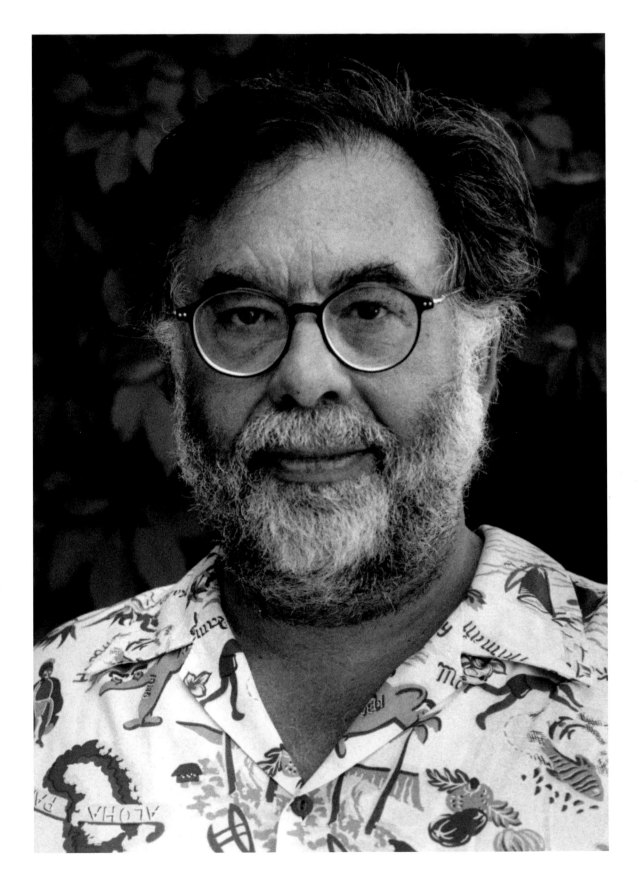

Francis Ford Coppola  Film director, producer, vintner

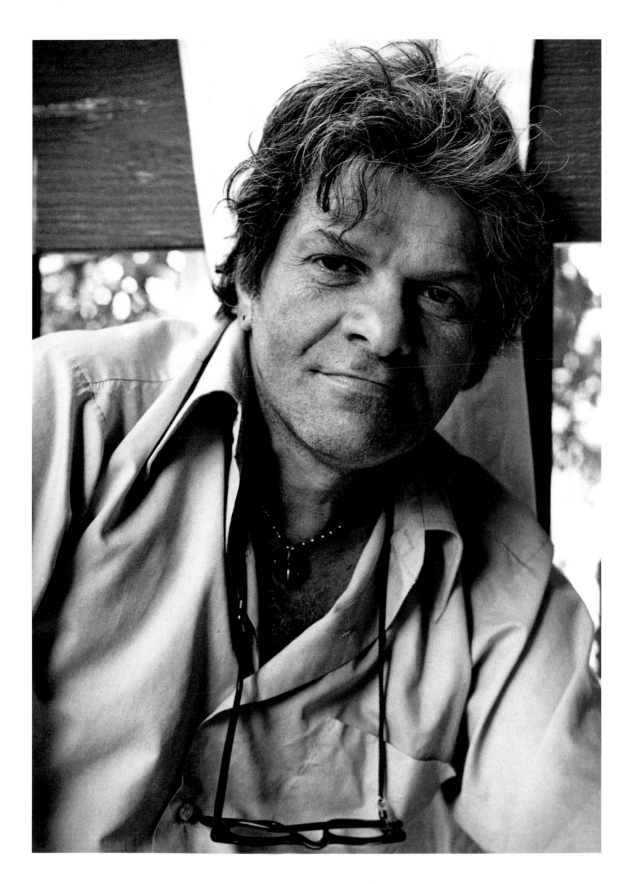

Gregory Corso  Beat poet

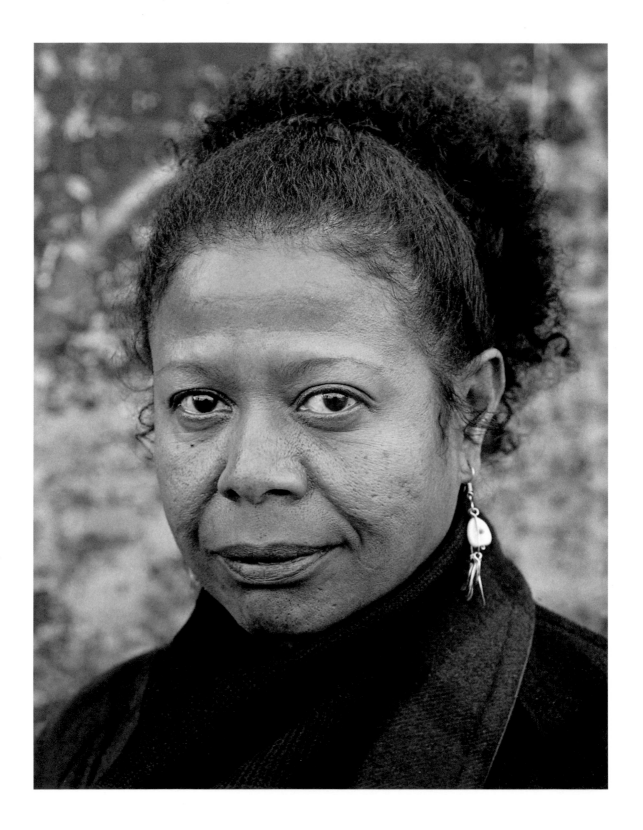

Jayne Cortez  Performance poet

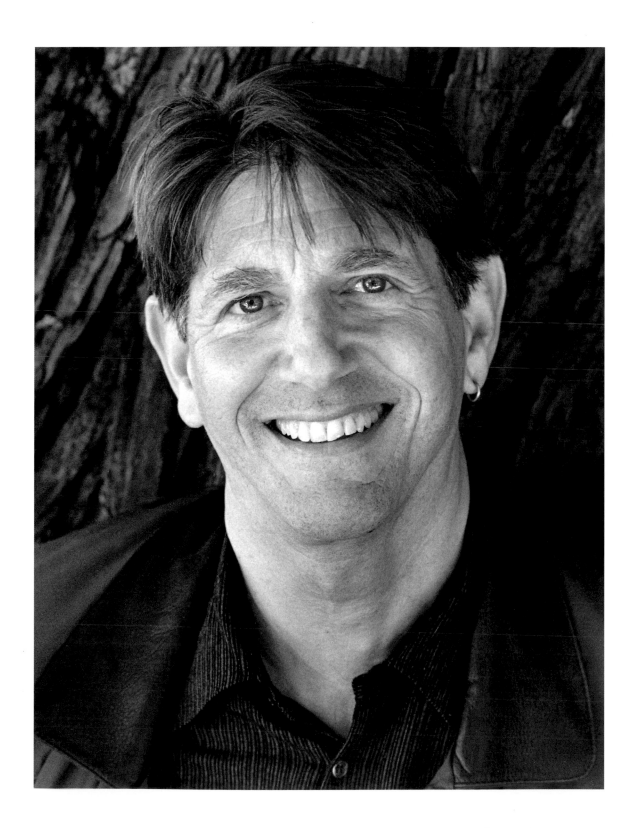

Peter Coyote  Actor, author

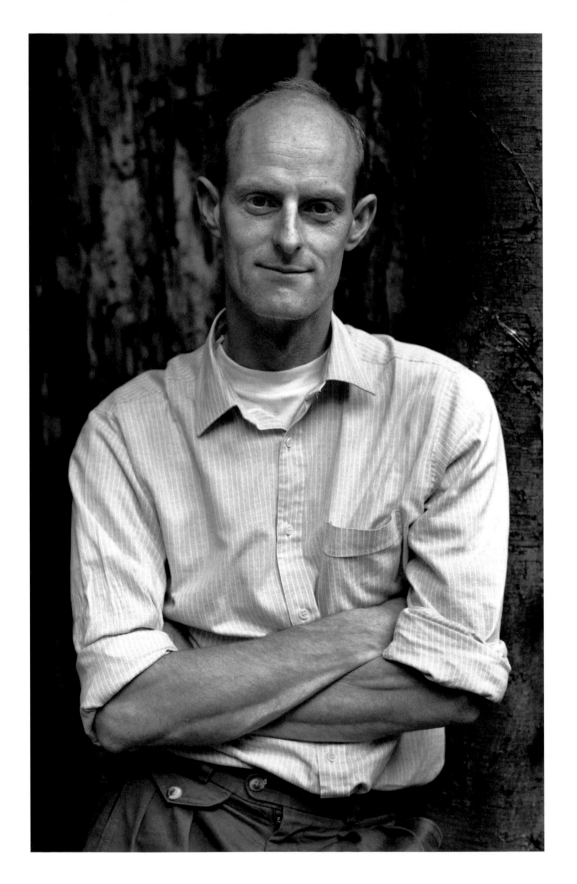

Tony Cragg  British sculptor

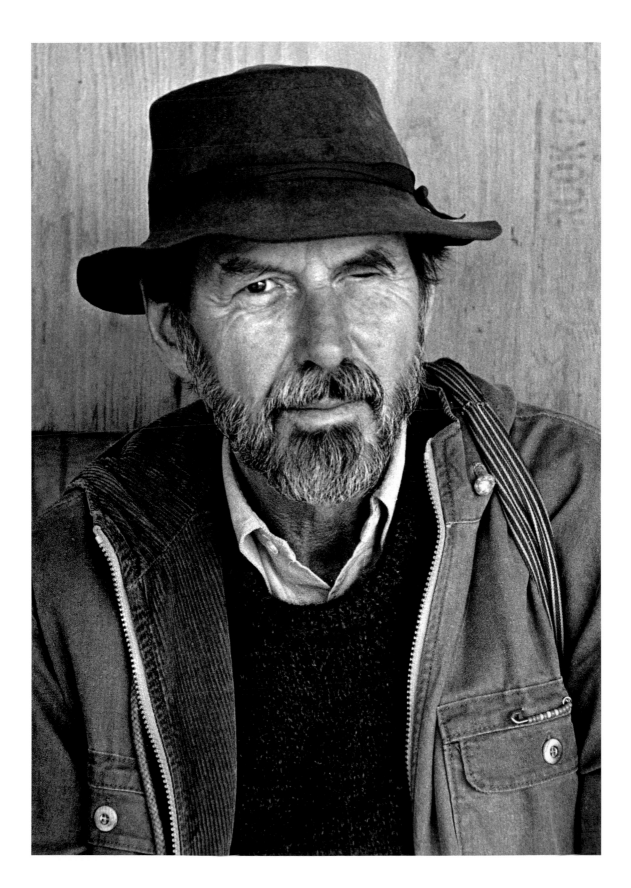

Robert Creeley  Black Mountain poet

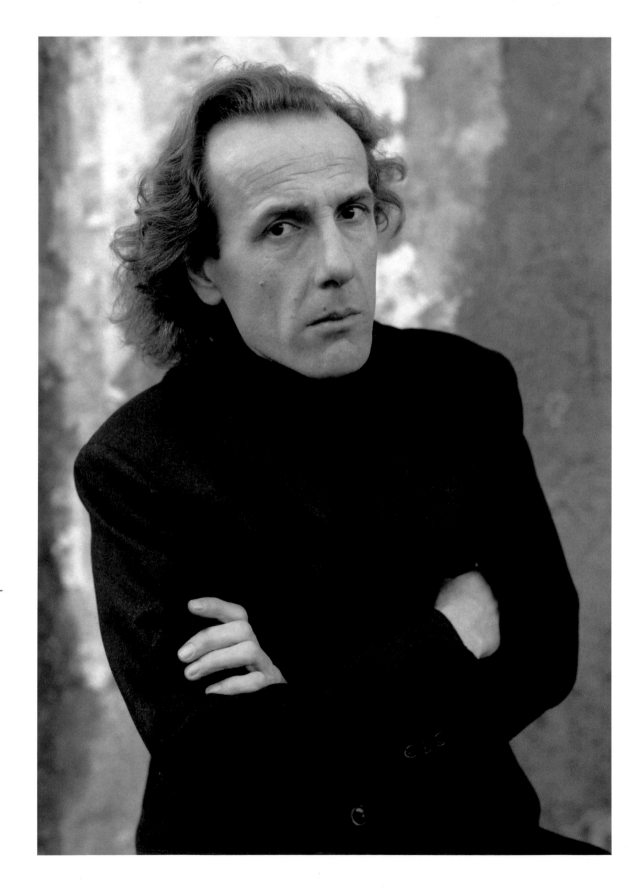

Enzo Cucchi  Trans-avantgarde painter/sculptor

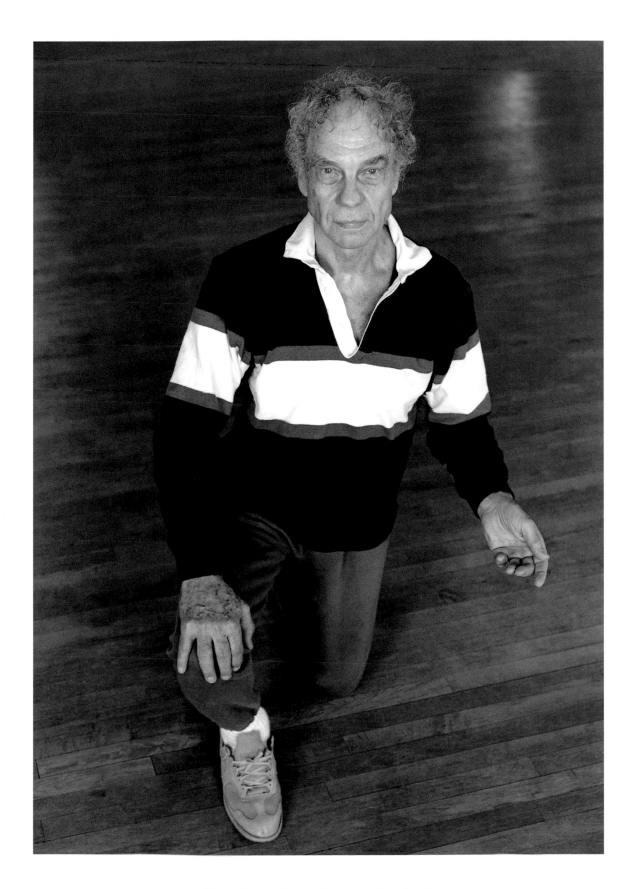

Merce Cunningham  Choreographer, dancer

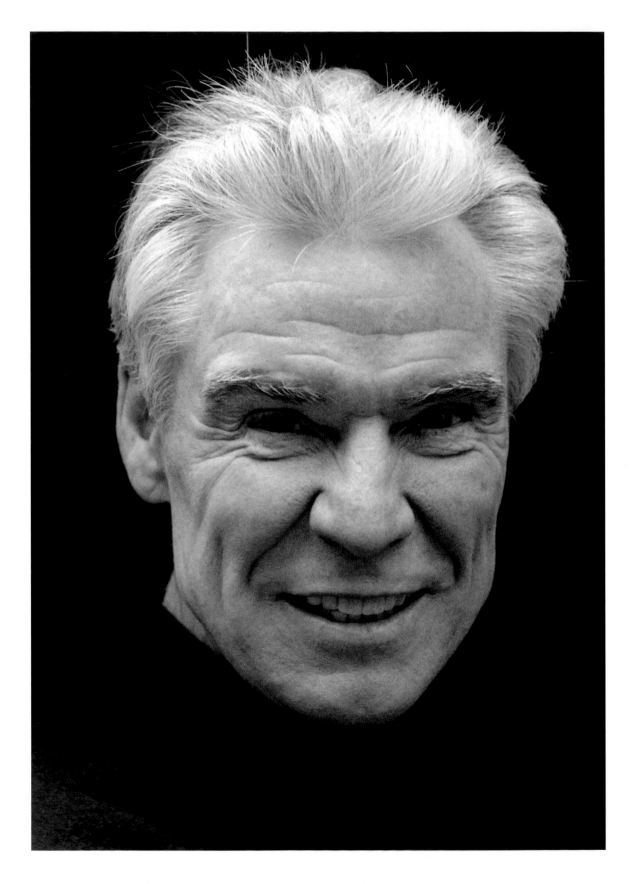

Jacques d'Amboise  Dancer, choreographer

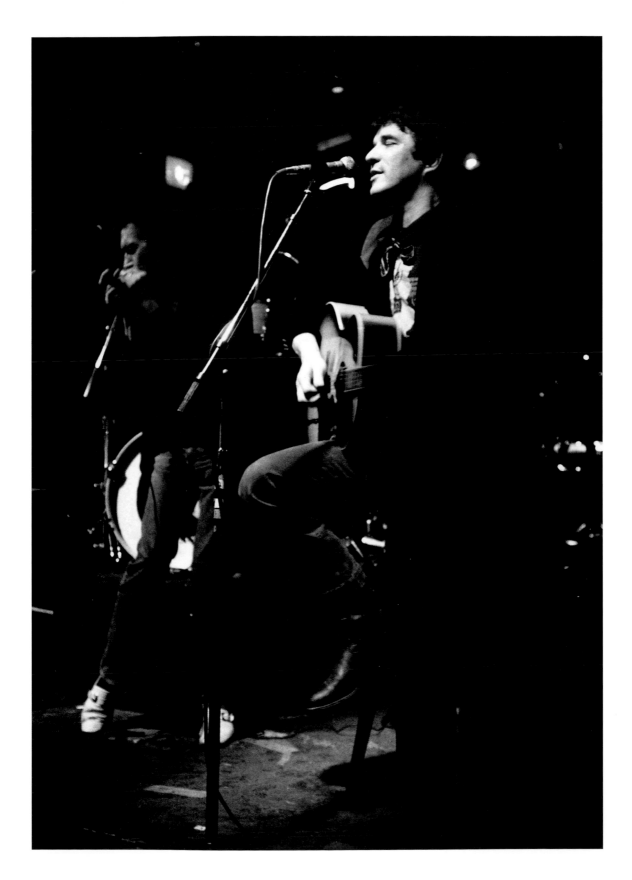

Rick Danko  Singer/bassist, The Band

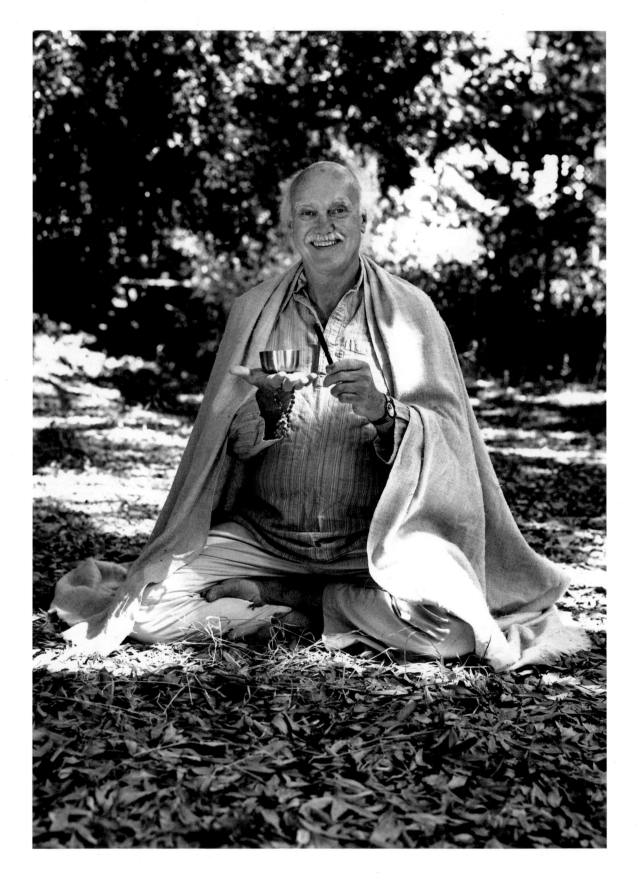

Baba Ram Dass  Spiritual guru, author

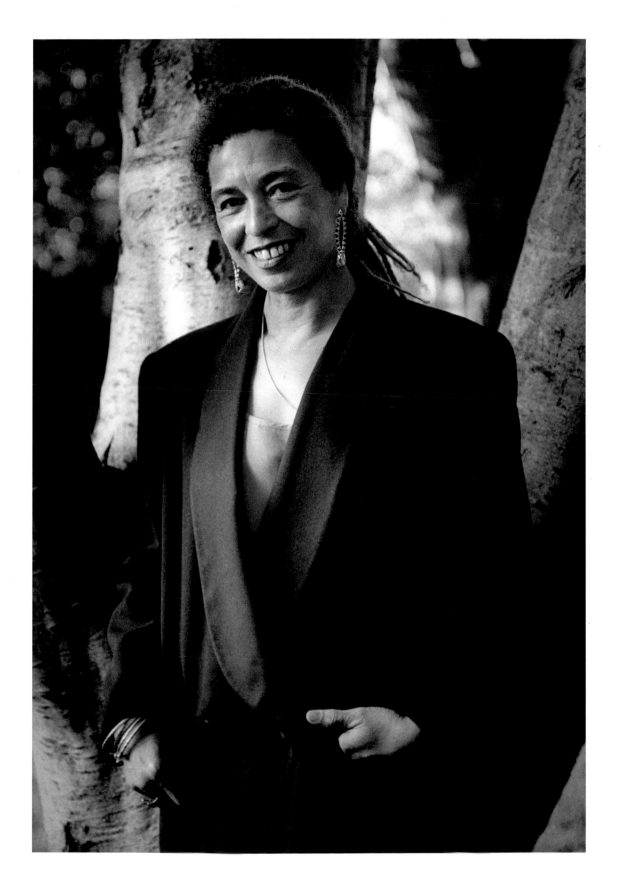

Angela Davis  Author, activist

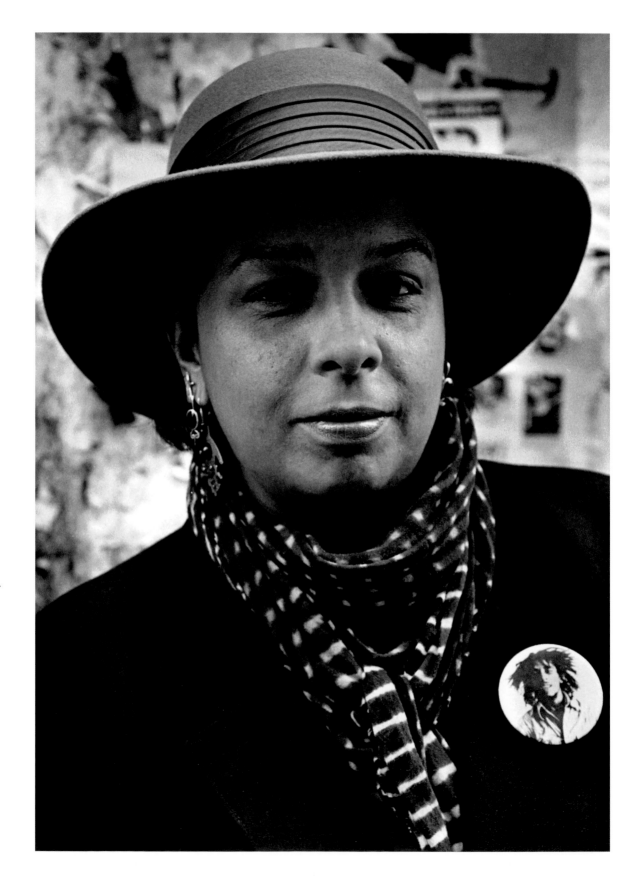

Thulani Davis  Novelist, poet, Grammy-winning lyricist

Willem de Kooning  Abstract expressionist painter

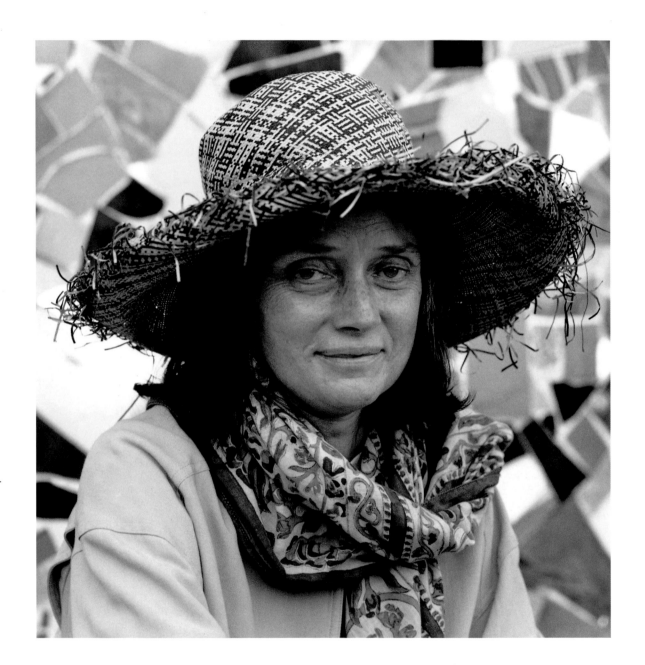

Niki De Saint Phalle  *Nouveax Réalistes* assemblagist, sculptor

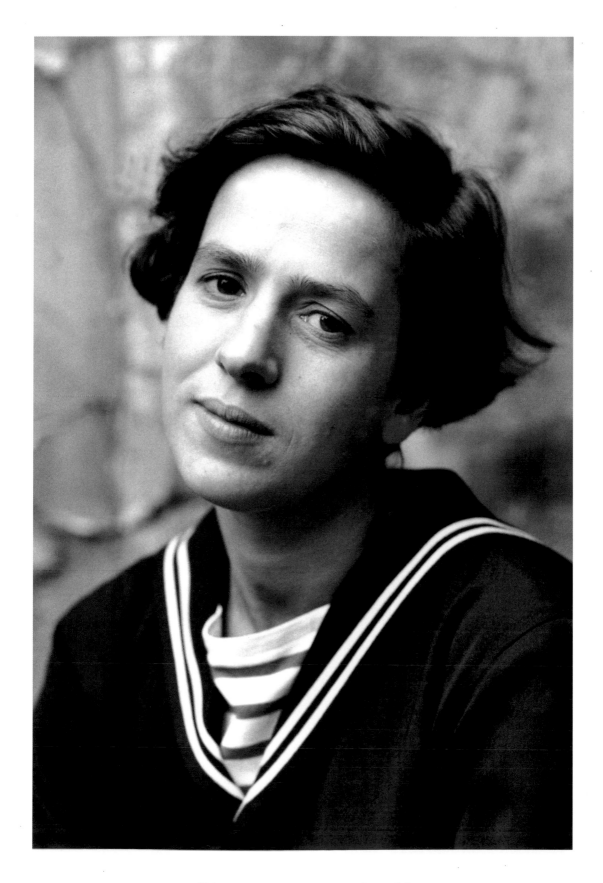

Helene Delprat  French surrealist artist

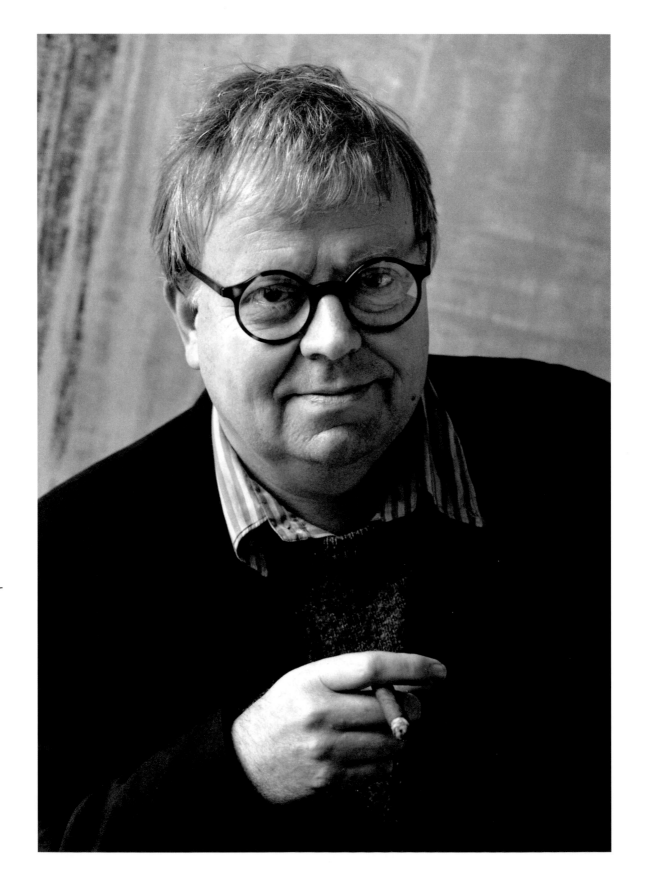

Jan Dibbets  Earth/conceptual photographer

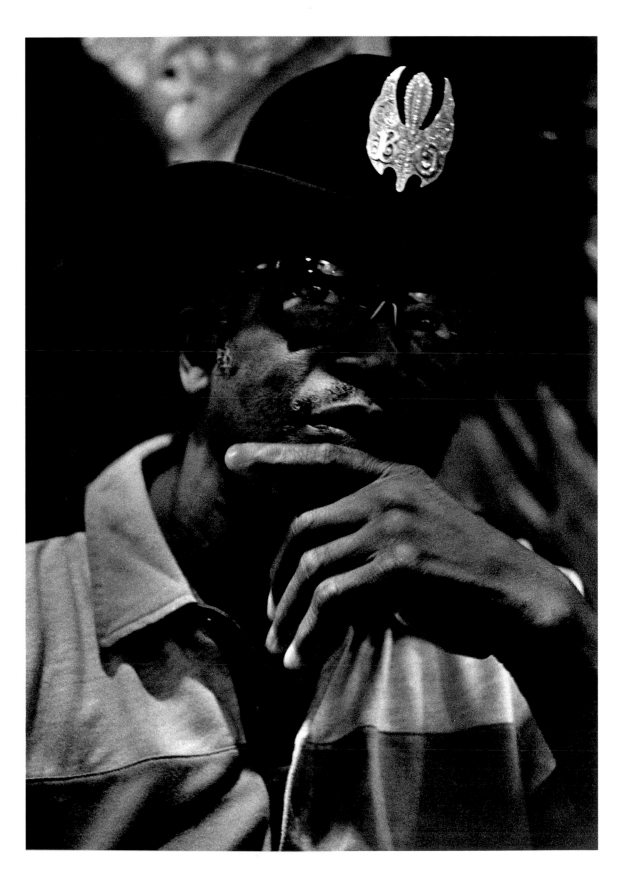

Bo Diddley  R&B guitar legend

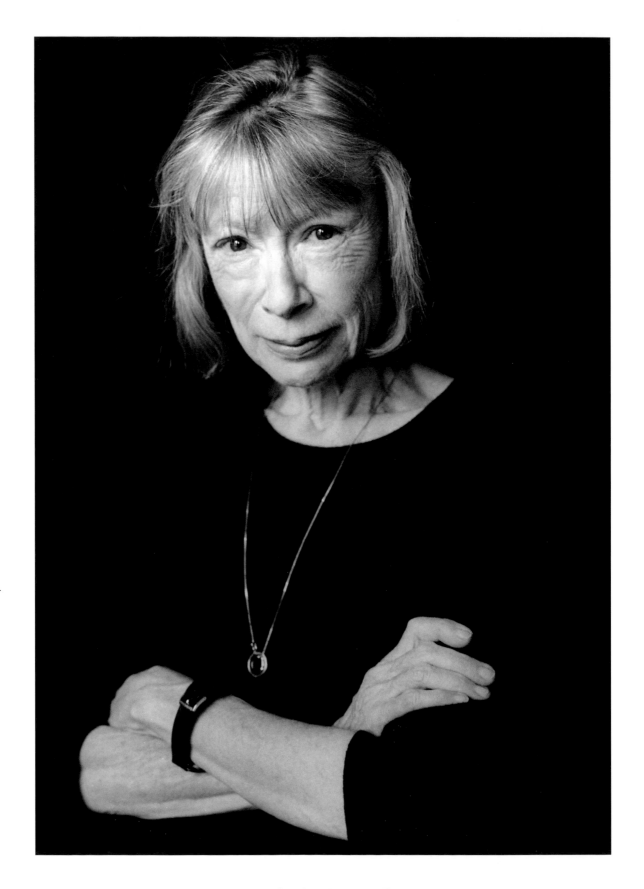

Joan Didion  Novelist, lost American Dream essayist

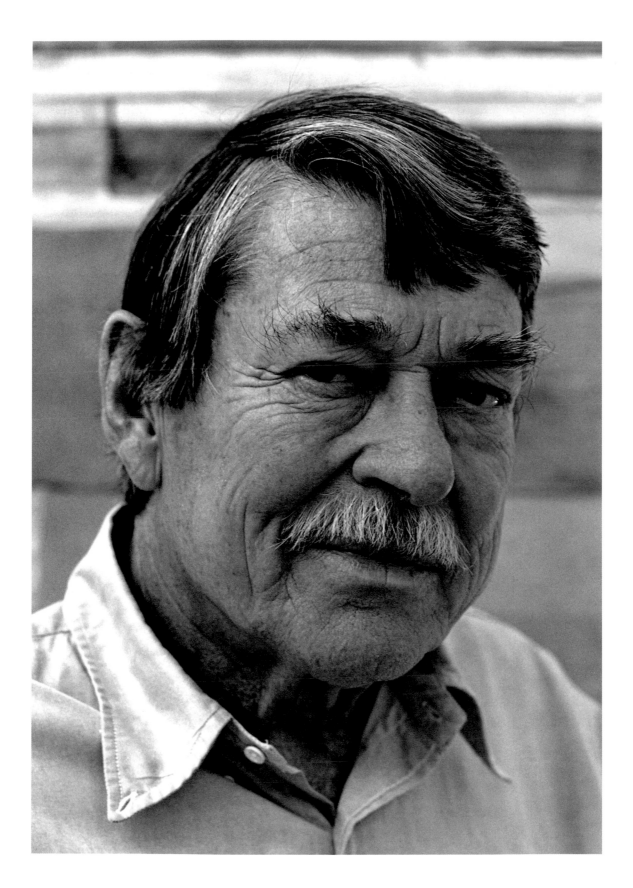

Richard Diebenkorn  West Coast painter

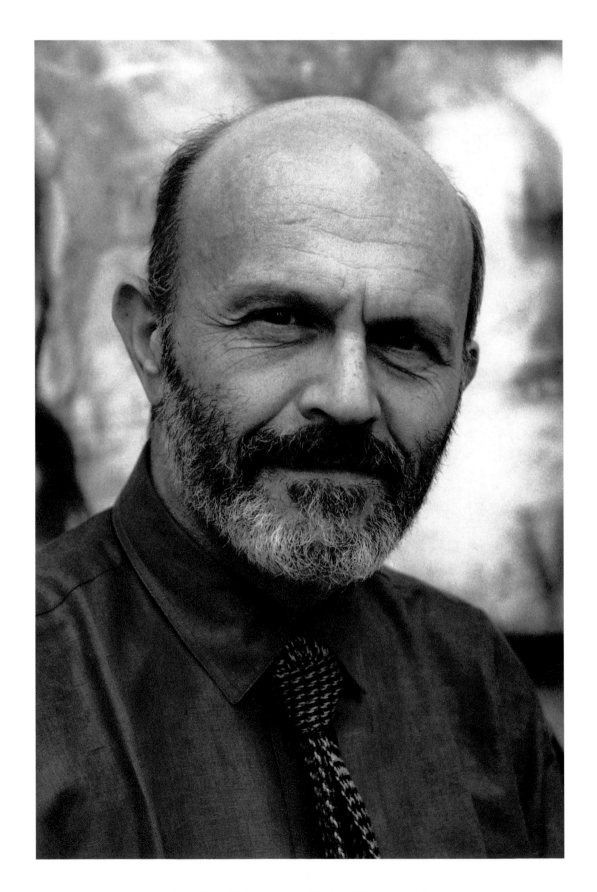

Jim Dine  Painter, assemblagist, "Happenings"

Diane di Prima  Beat poet, memoirist

Mark di Suvero  Sculptor

E. L. Doctorow  Novelist

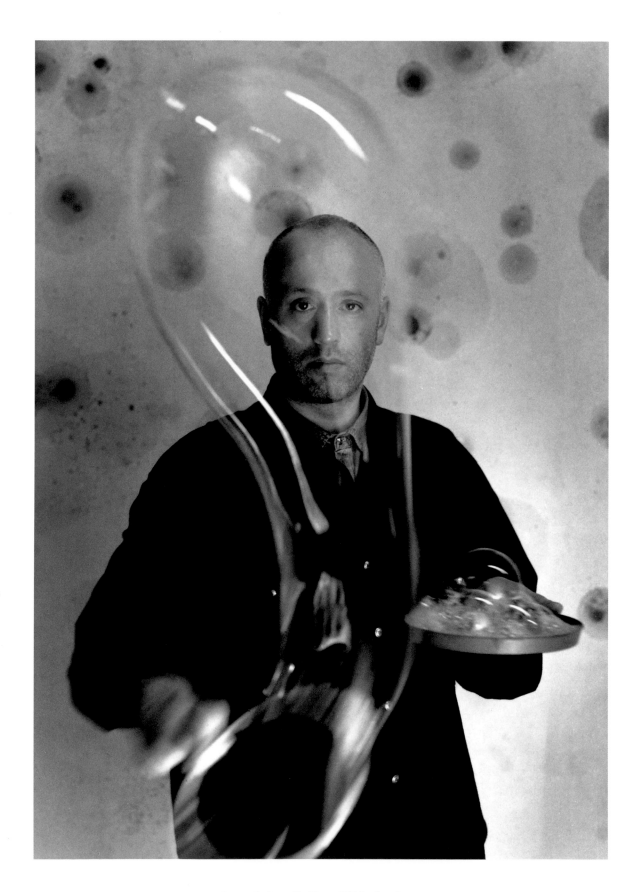

Jiri Georg Dokoupil  *Neue Wilde* Czech painter

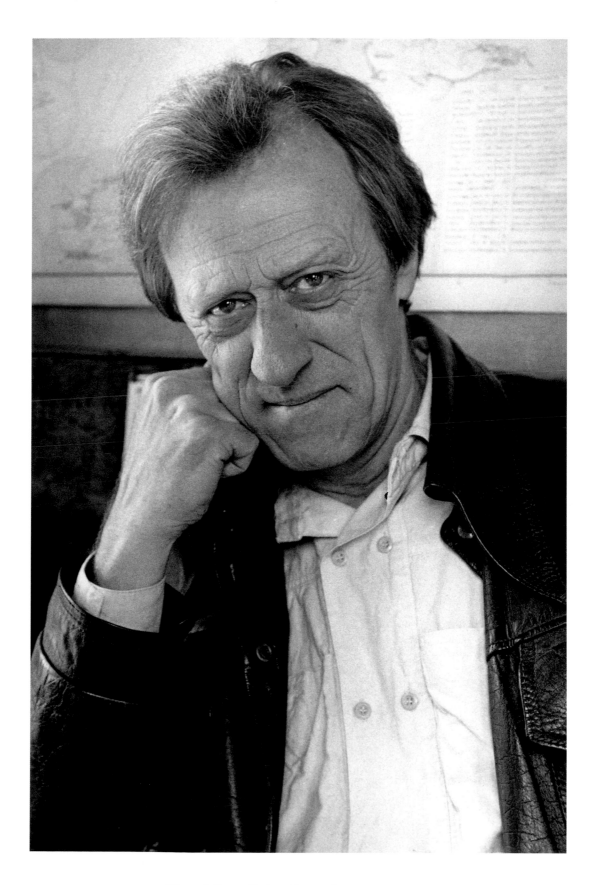

Edward Dorn  Poet, satirist, ethnopoetics scholar

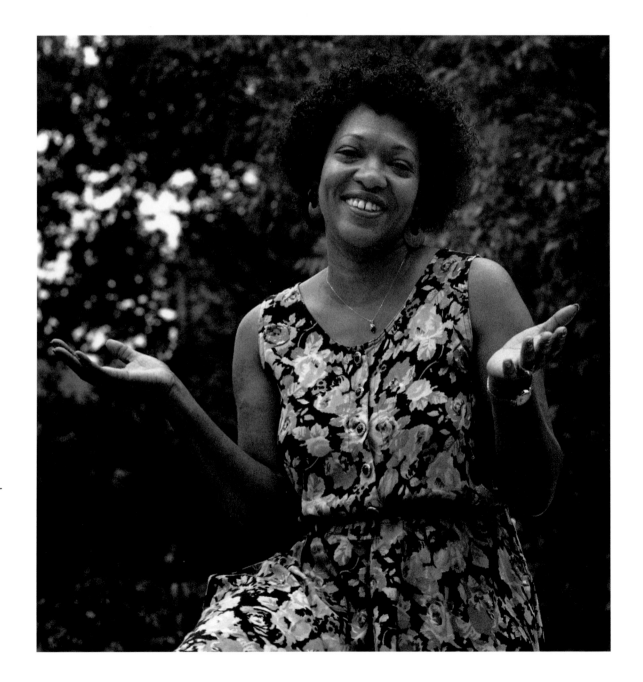

Rita Dove  U.S. Poet Laureate, 1993–95

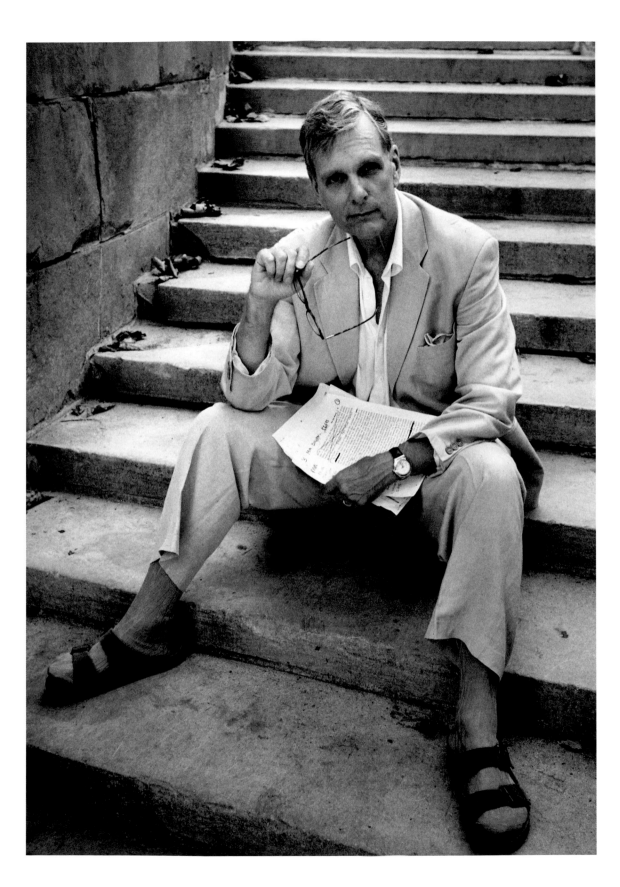

Keir Dullea  Actor

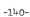

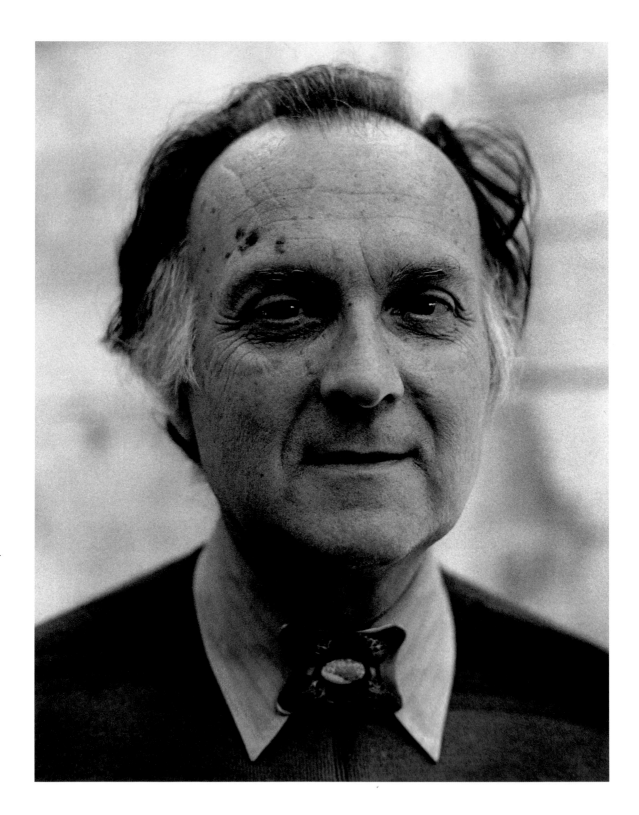

Robert Duncan  San Francisco Renaissance poet

Dominick Dunne  Novelist, celebrity-trial journalist

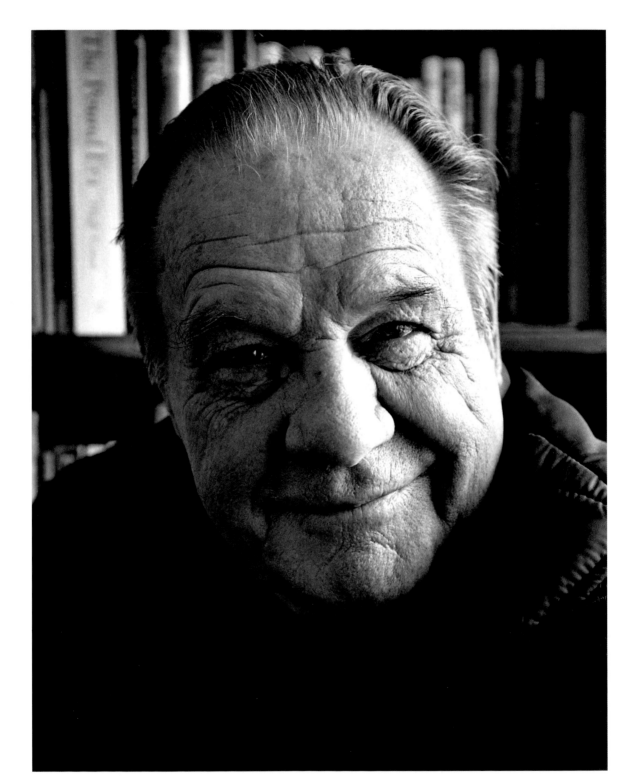

Lawrence Durrell  Novelist, poet

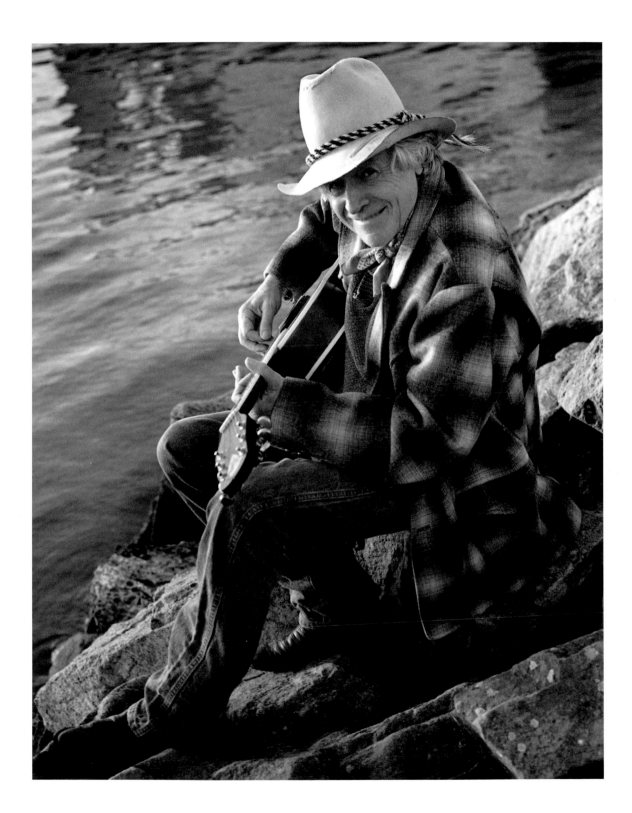

Ramblin' Jack Elliott  Cowboy folksinger

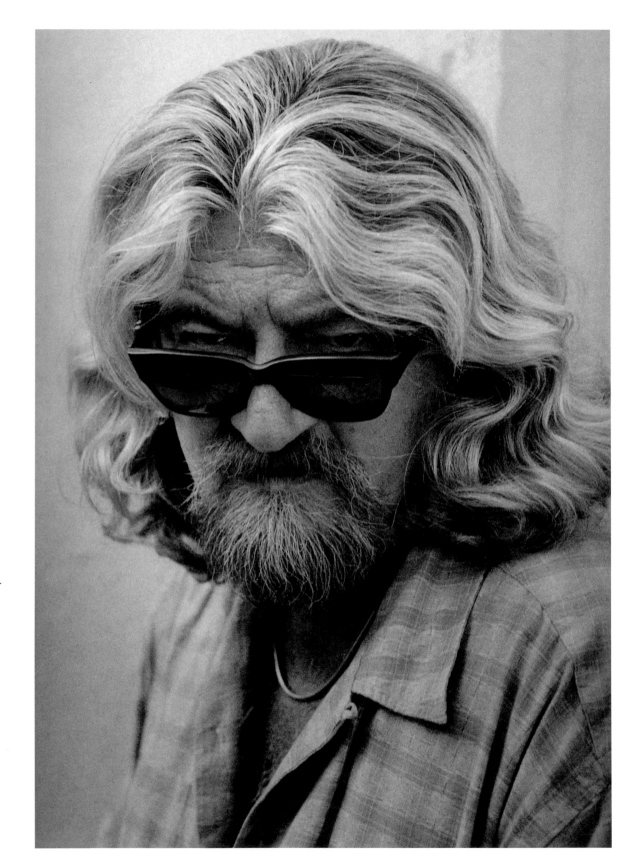

-144-

Joe Esterhaus  Hollywood screenwriter

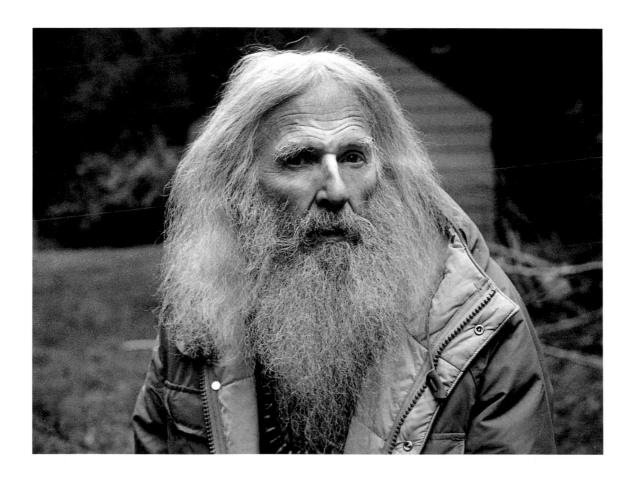

William Everson/Brother Antoninus Poet, letterpress printer

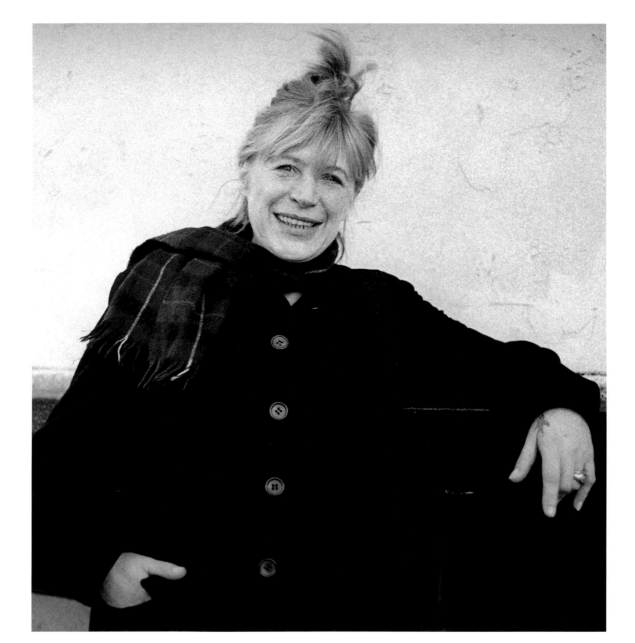

Marianne Faithfull  Lyric rock balladeer

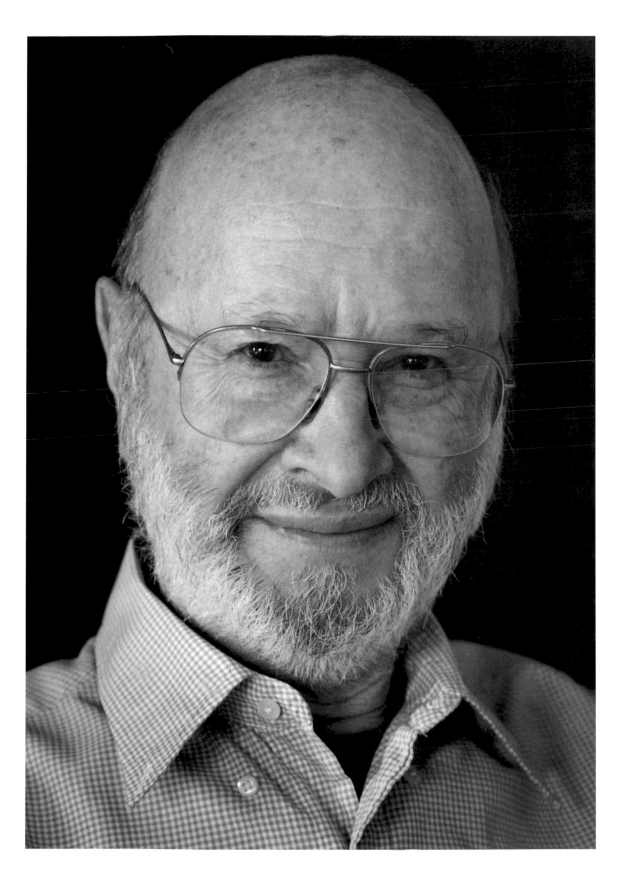

Jules Feiffer  Cartoonist, playwright

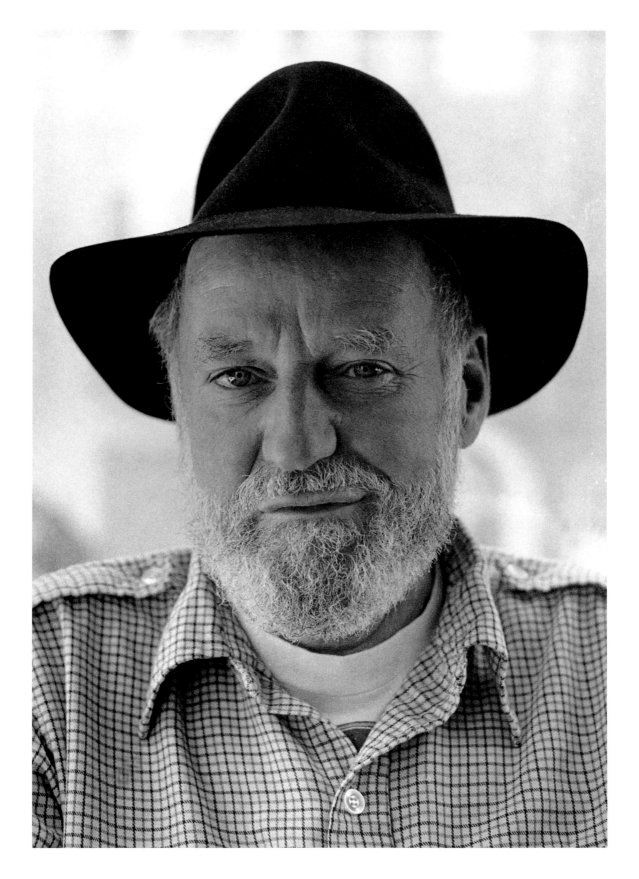

-148-

Lawrence Ferlinghetti  Poet, painter, publisher

Karen Finley  Performance artist

Carolyn Forché  Poet, political witness

Charles Henri Ford  Poet, photographer, publisher

Raymond Foye  Coeditor Hanuman Books, writer

Sam Francis  California abstract painter

-154-

Helen Frankenthaler  Abstract painter

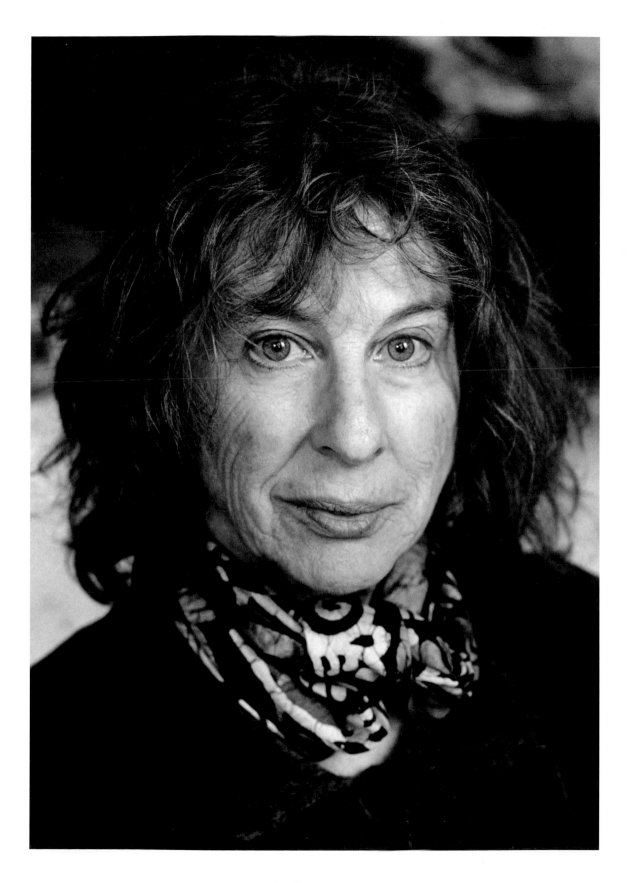

Mary Frank  Painter, sculptor

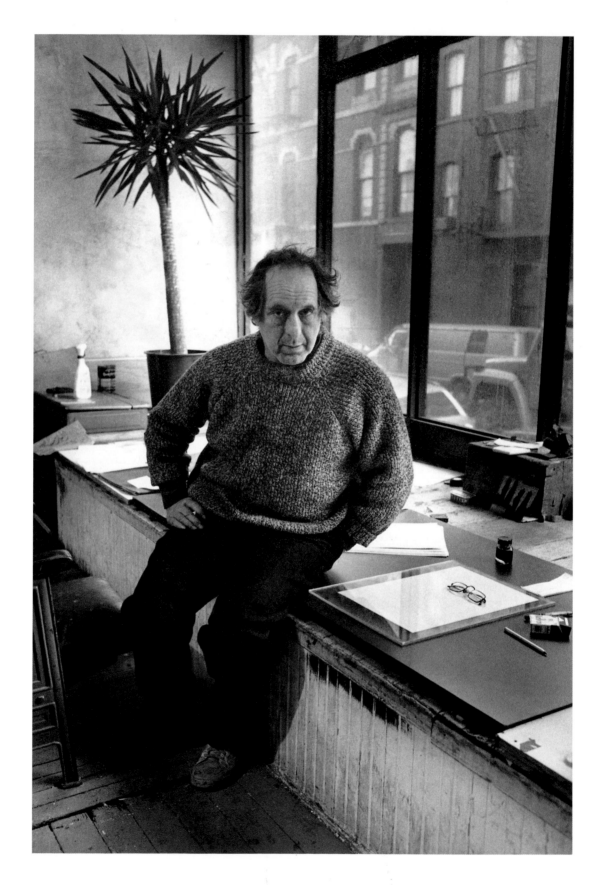

Robert Frank  Photographer, filmmaker

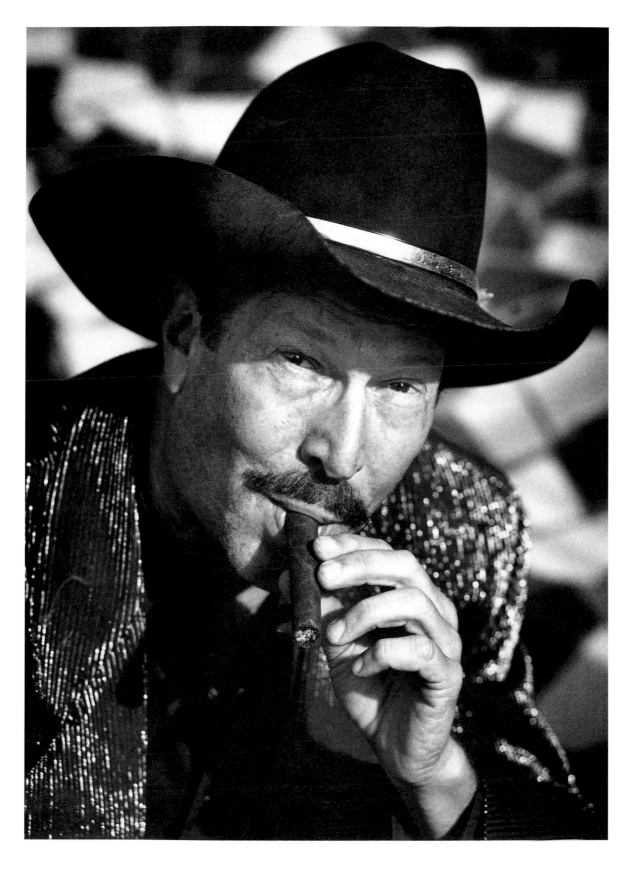

Kinky Friedman  Country rocker, mystery writer

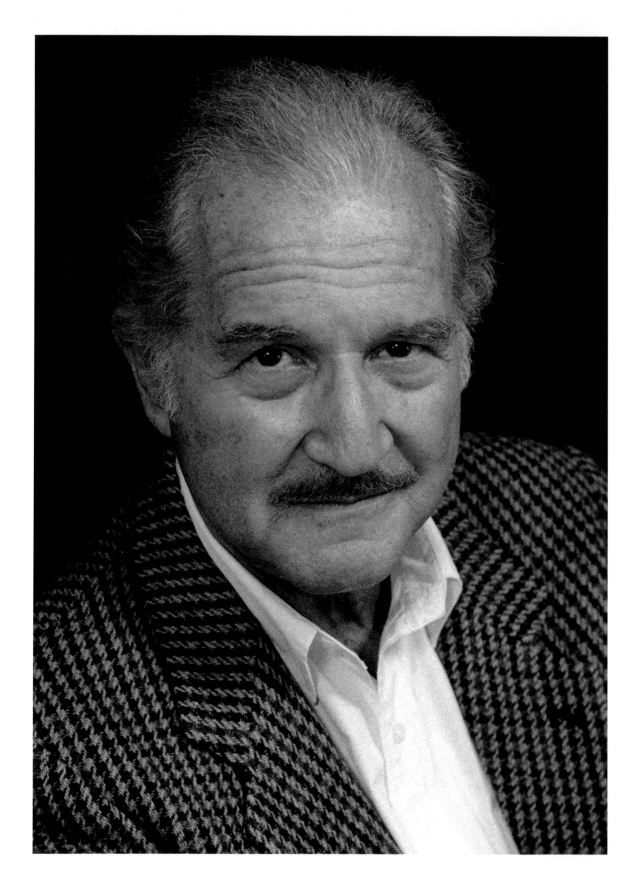

Carlos Fuentes  Mexican novelist, diplomat

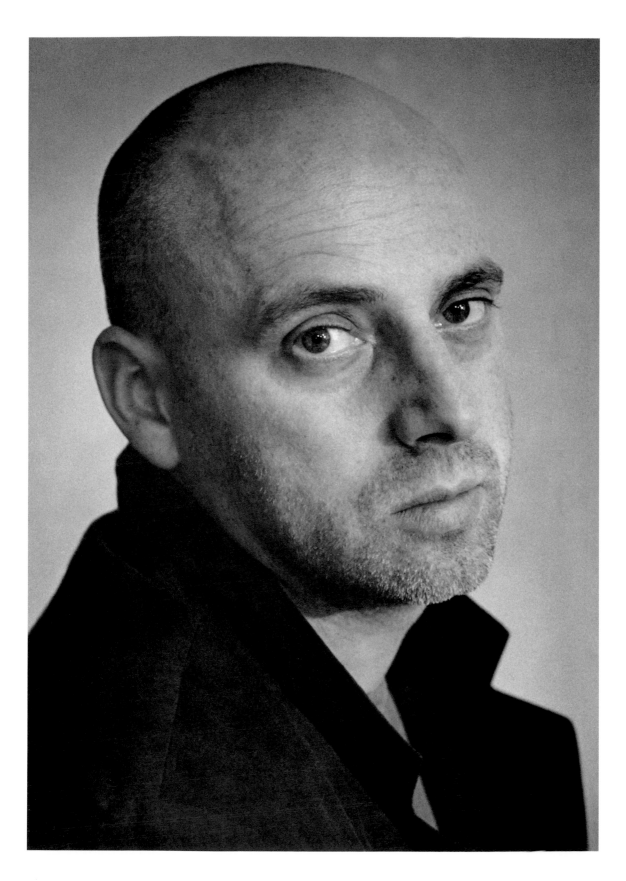

Adam Fuss  Photogram artist

John Kenneth Galbraith  Economist, author, ambassador

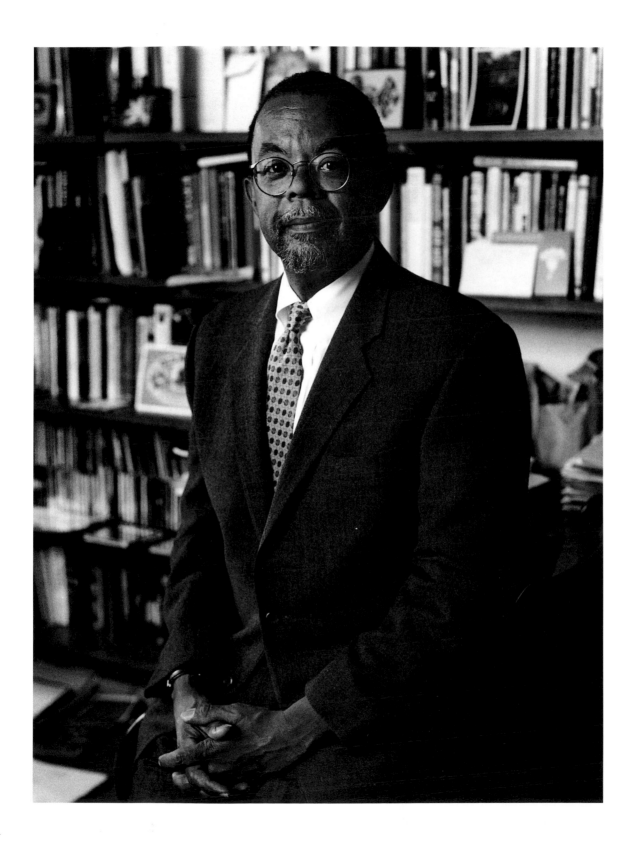

Henry Louis Gates Jr.  Cultural critic, Afro-American Studies, Harvard

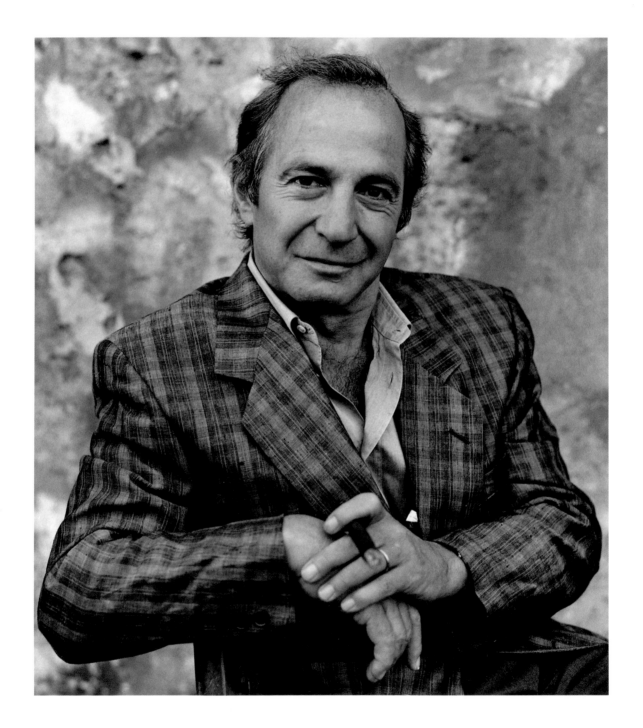

Ben Gazzara  New York film, stage actor

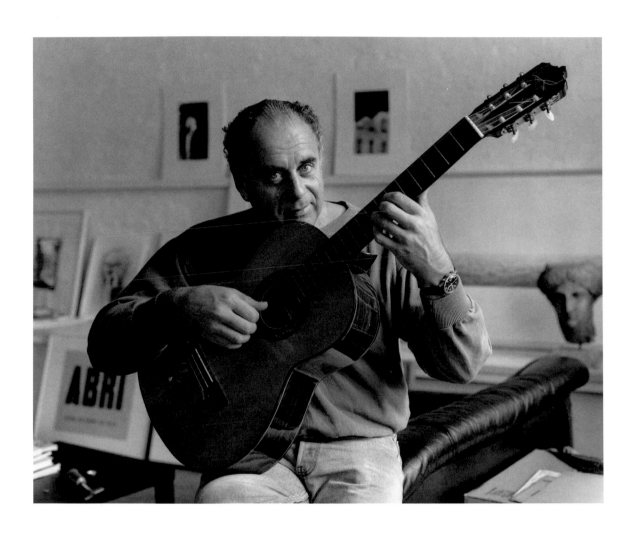

Ralph Gibson  Photographer, publisher

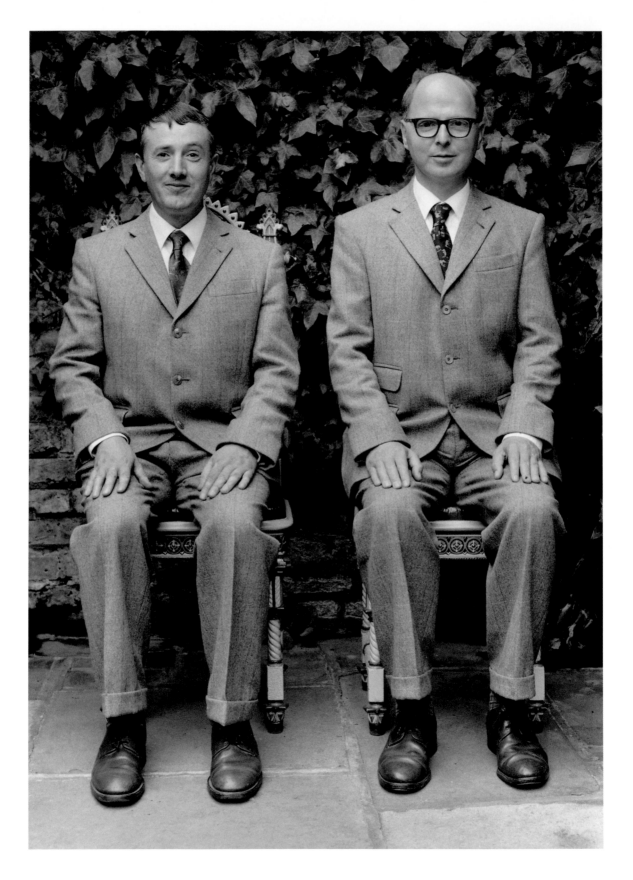

Gilbert & George  Performance, photographic artists

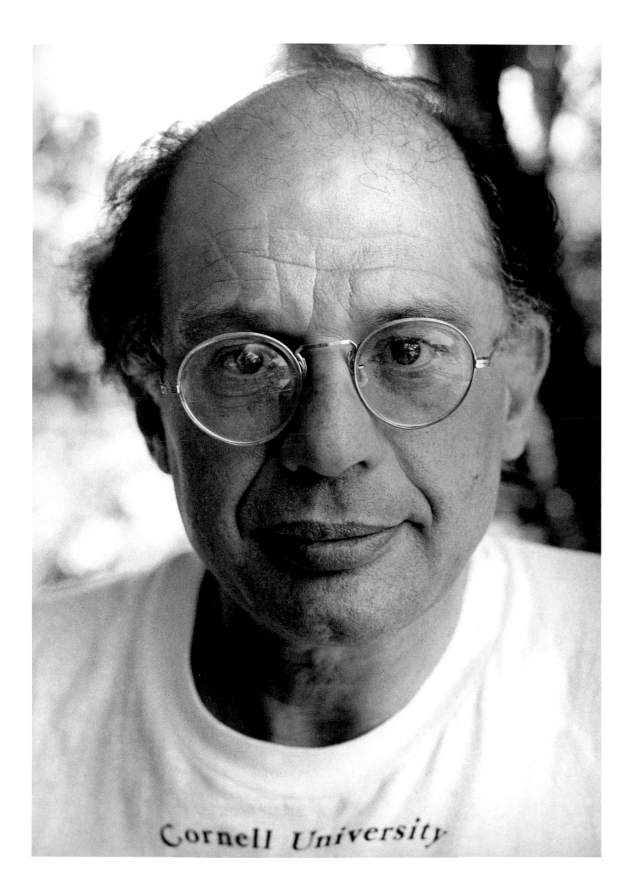

Allen Ginsberg  Beat Buddhist bard

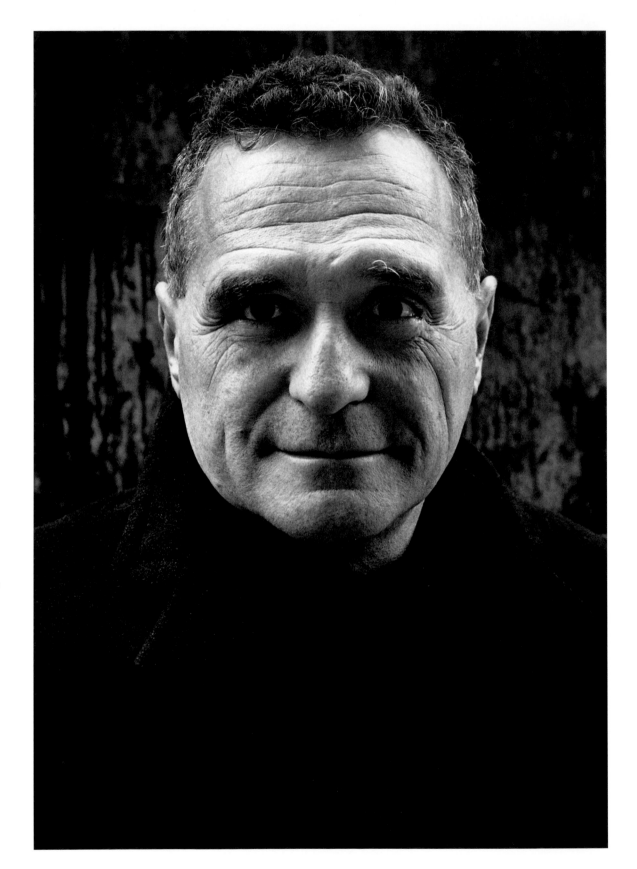

John Giorno  Performance/sound poet

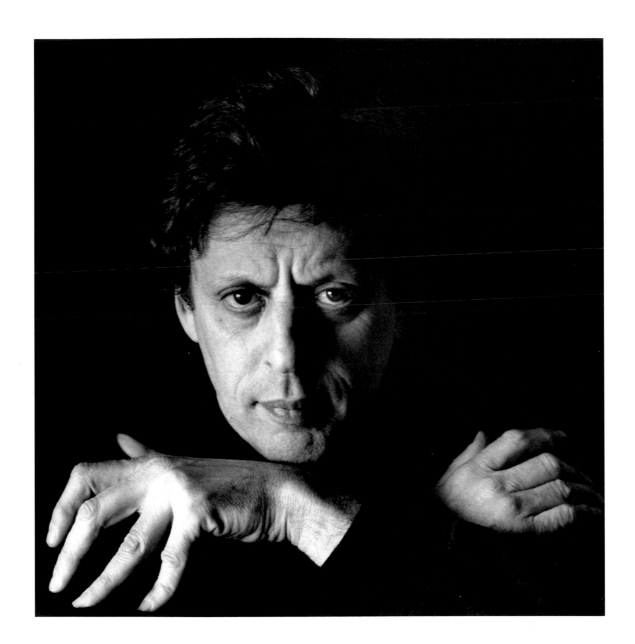

Philip Glass  New classical composer, pianist

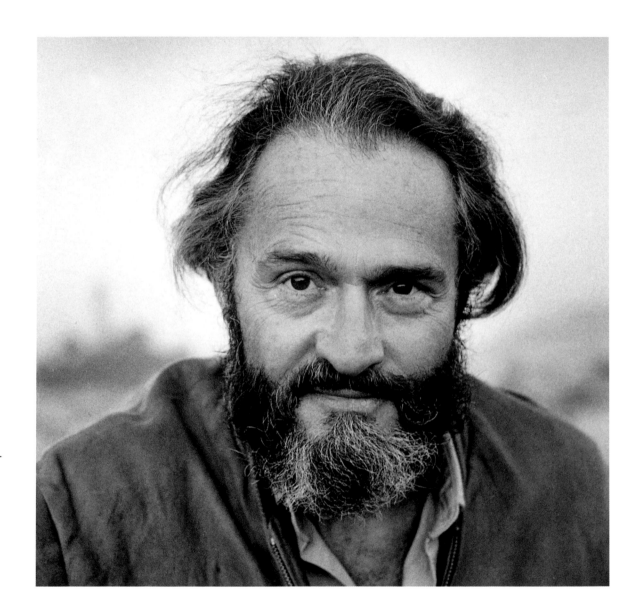

Herbert Gold  San Francisco fiction writer

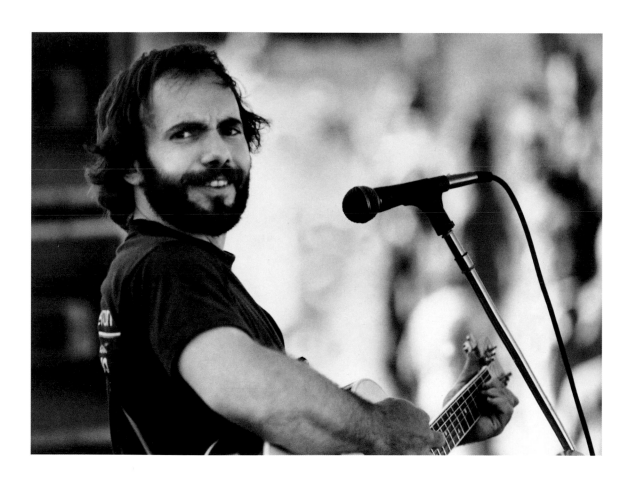

Steve Goodman  Country folk singer/songwriter

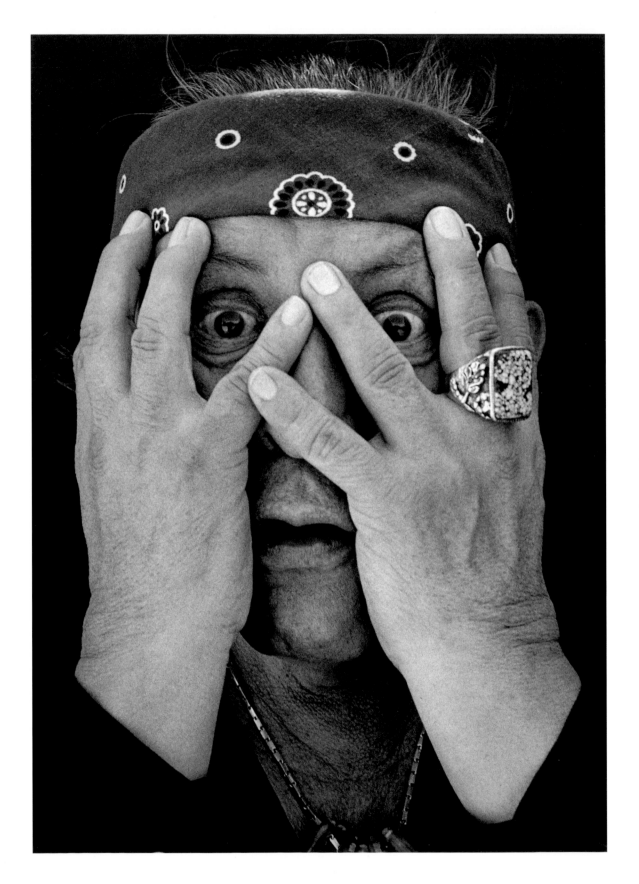

R. C. Gorman  Navajo artist

Dan Graham  Conceptual artist, culture critic

-172-

Robert Graham  Figurative sculptor/painter

Michael Graves  Architect, designer

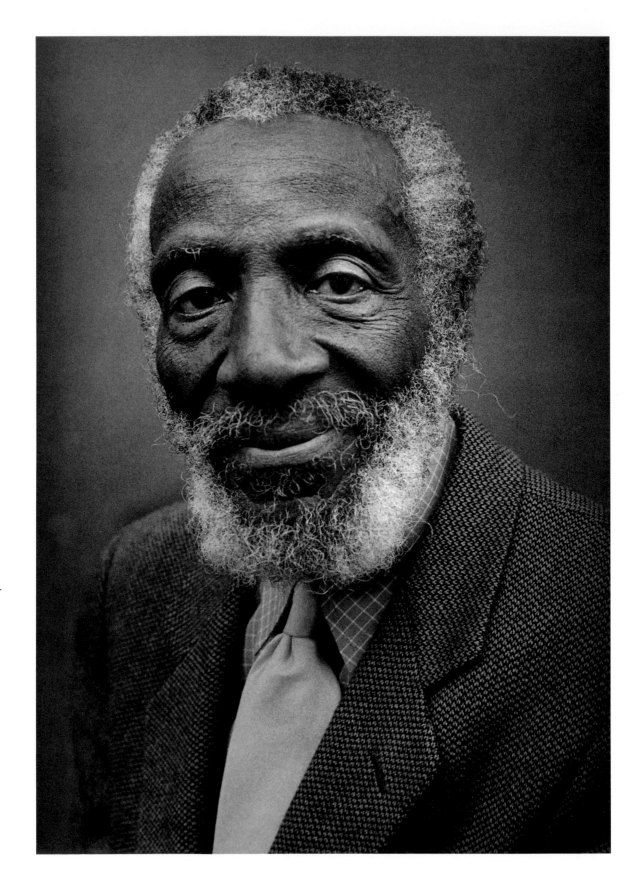

Dick Gregory  Activist, comedian, nutritionist

Barbara Guest  New York School poet

Thom Gunn Poet, critic

Arlo Guthrie  Singer/songwriter

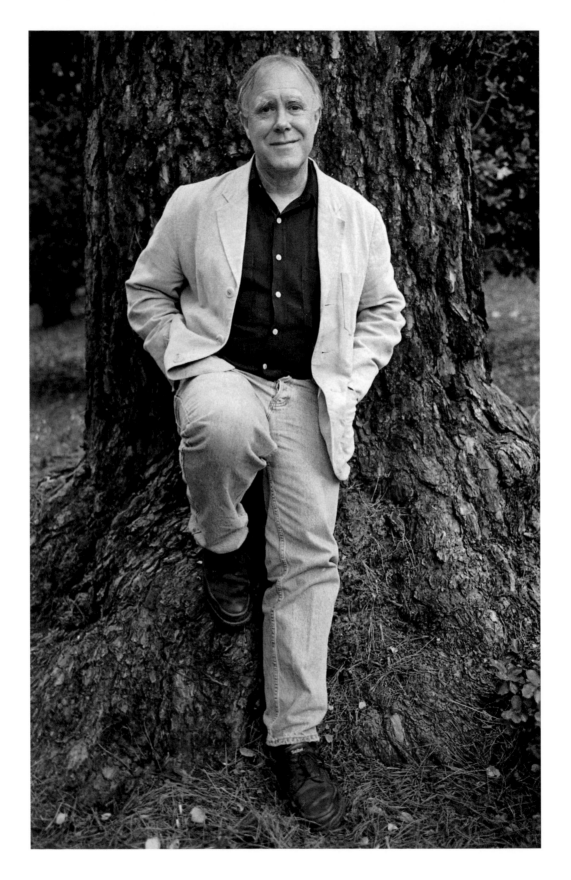

Robert Haas  U.S. Poet Laureate 1995–97

Jessica Hagedorn  *Filipina poet, novelist*

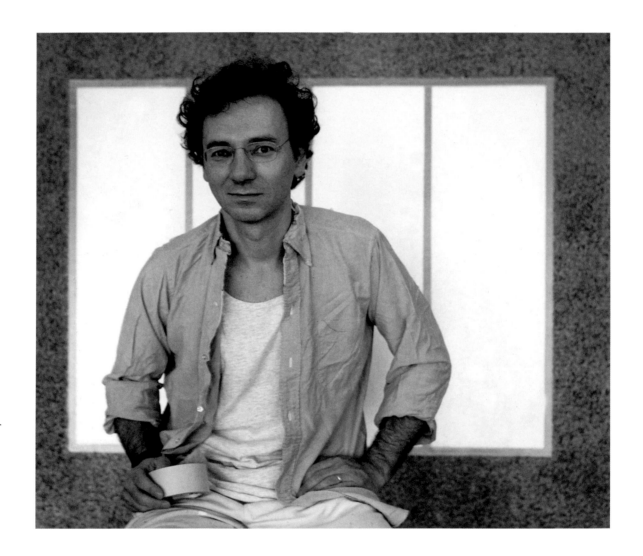

Peter Halley  Simulationist painter

Richard Hamilton  British Pop artist, educator

Ian Hamilton-Finlay  Concrete poet, sculptor

David Hammons  African American installation artist

Roy Hargrove Jazz trumpeter

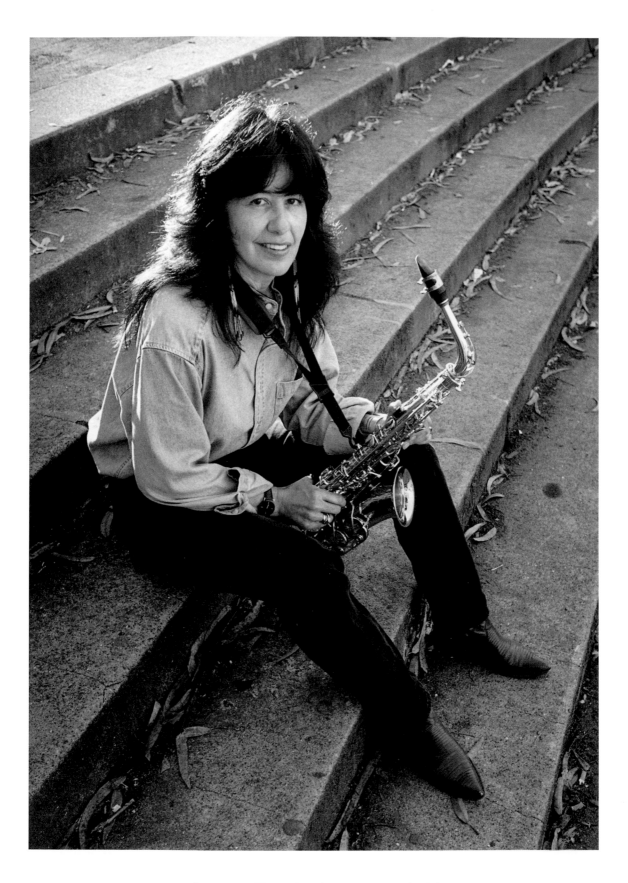

Joy Harjo  Native American poet, saxophonist

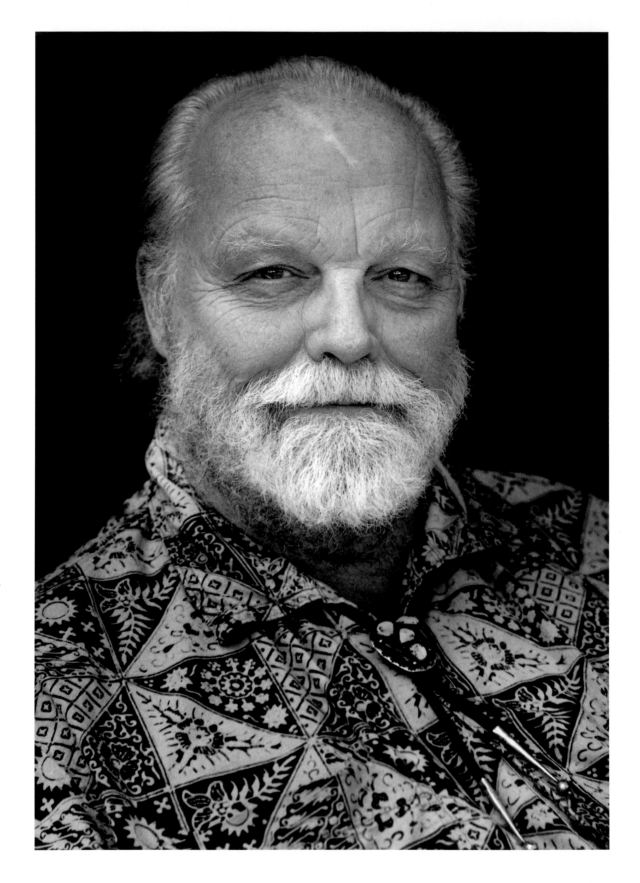

Lou Harrison  New Music composer, poet

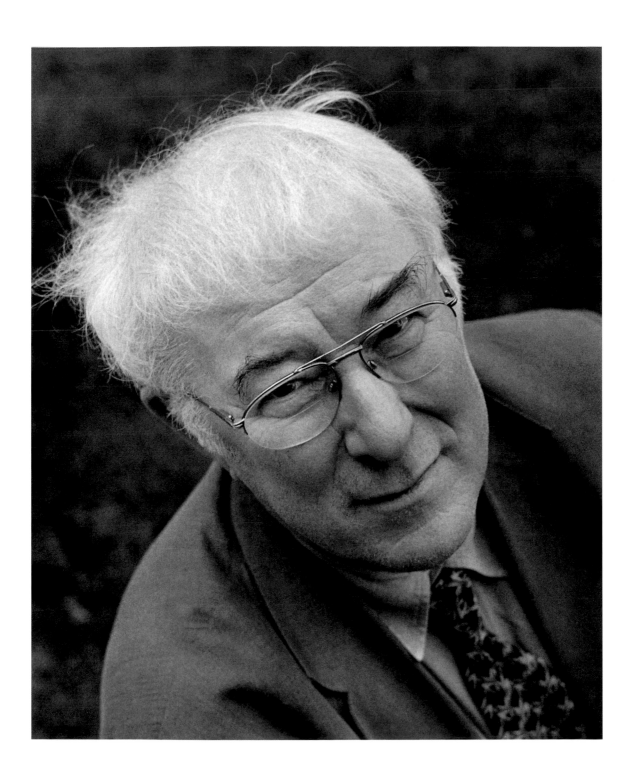

Seamus Heaney  Poet, translator, Nobel laureate 1995

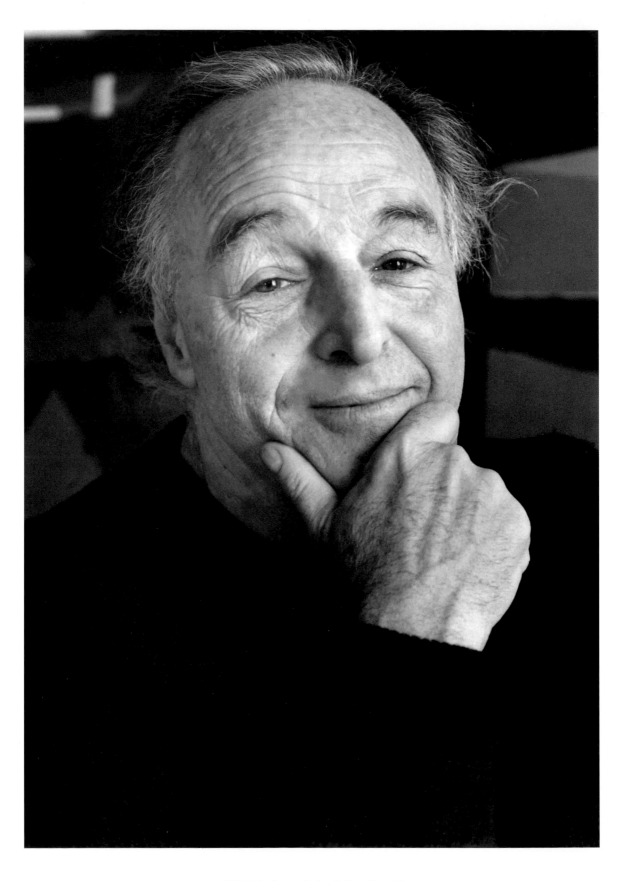

Al Held  Geometric abstractionist

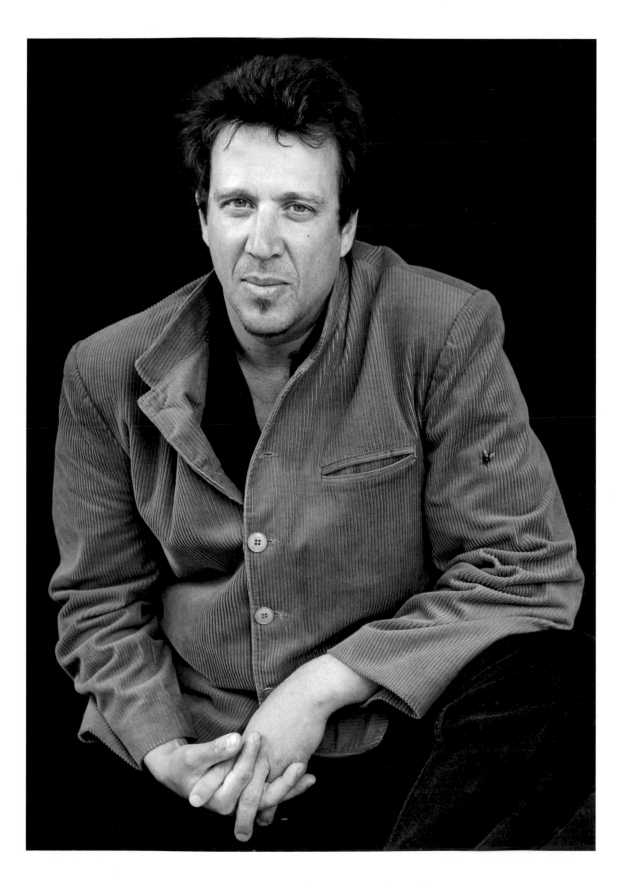

-189-

Richard Hell "Blank Generation" rocker, writer

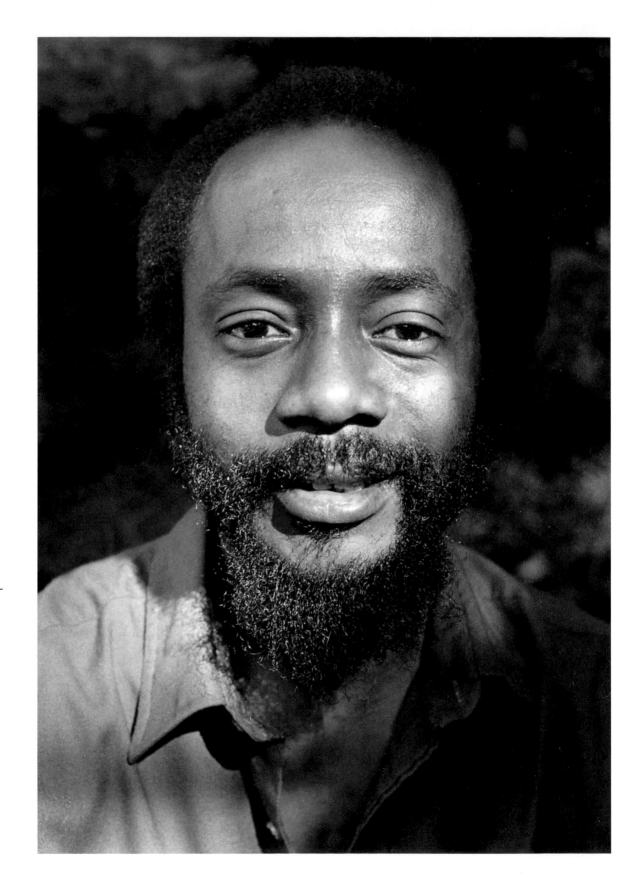

David Henderson  Poet, Jimi Hendrix biographer

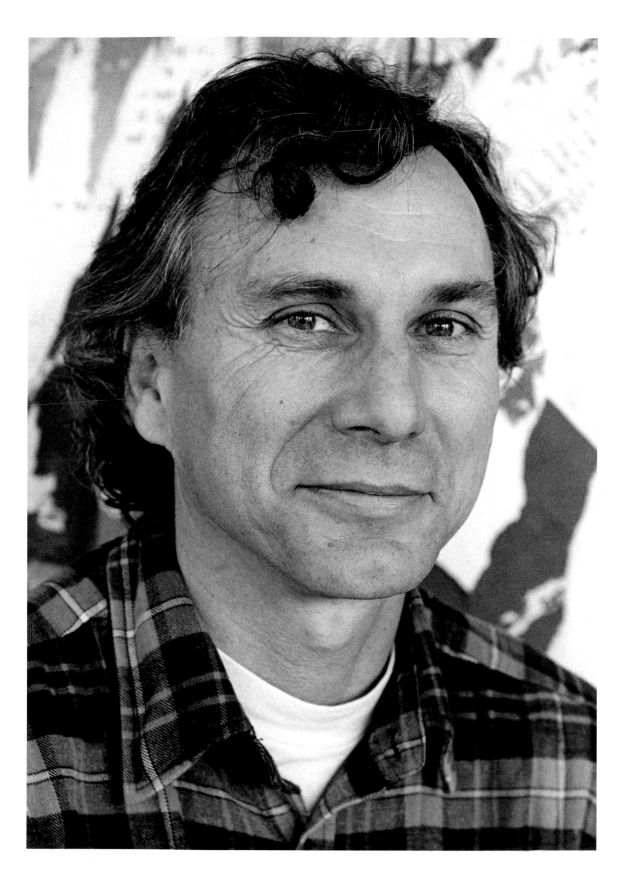

George Herms  West Coast assemblagist

-192-

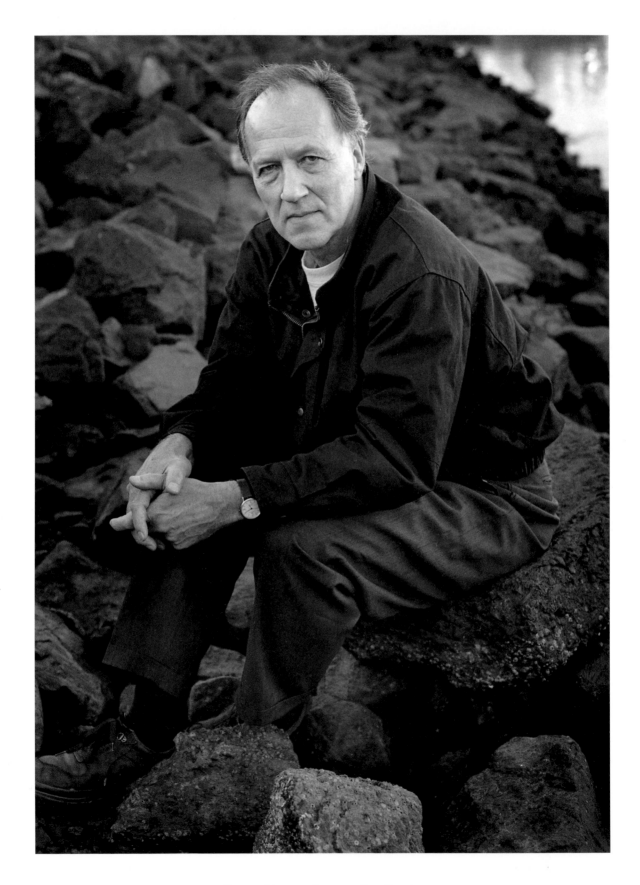

Werner Herzog  German film director

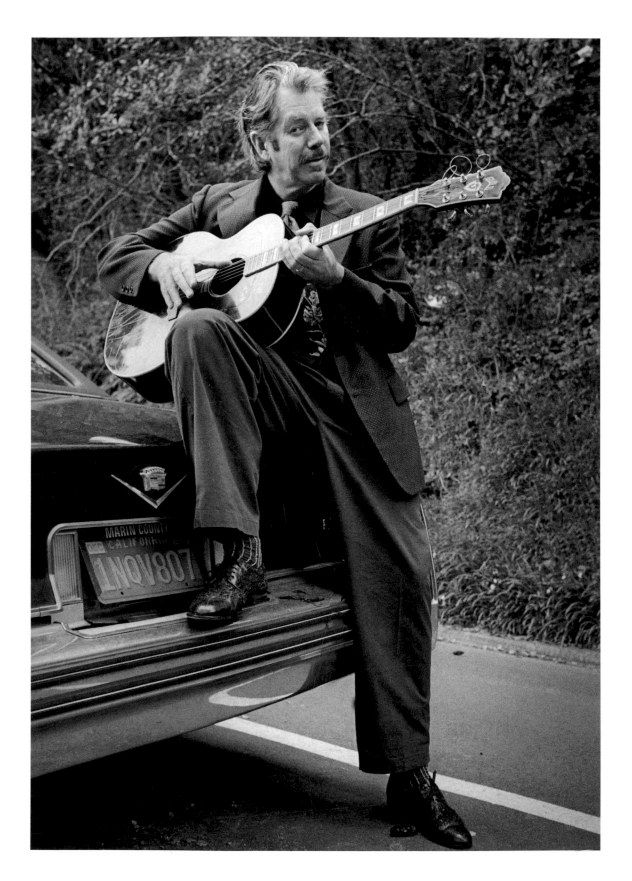

Dan Hicks  Hot folk/jazz/swing musician

Julia Butterfly Hill  Environmental activist

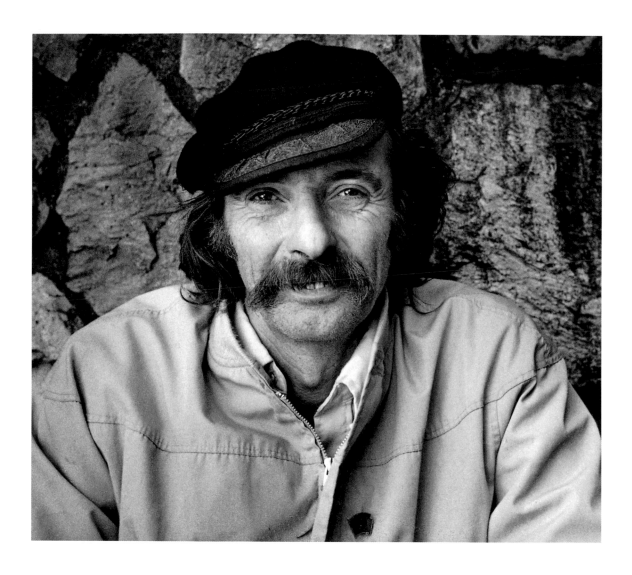

Jack Hirschman  Poet, translator

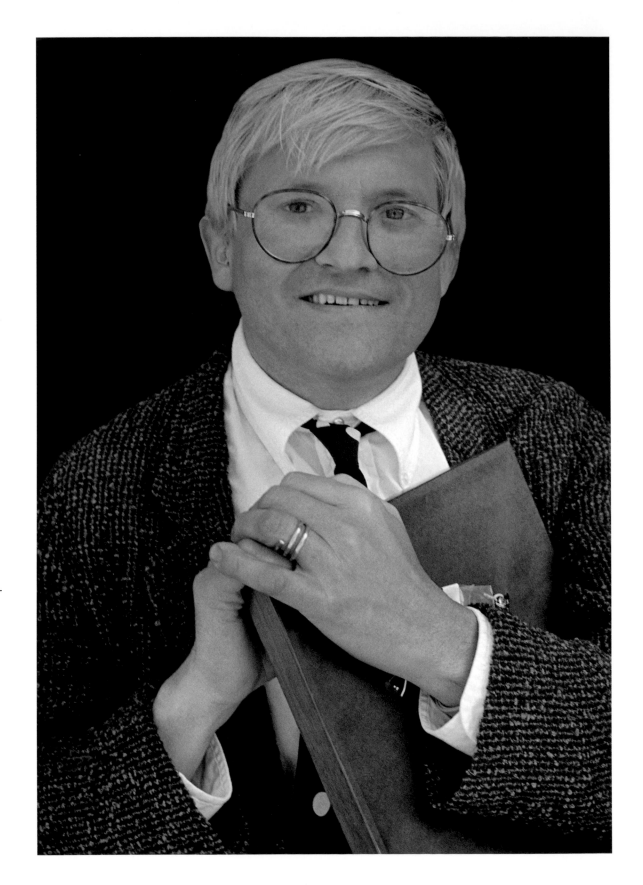

David Hockney  Artist

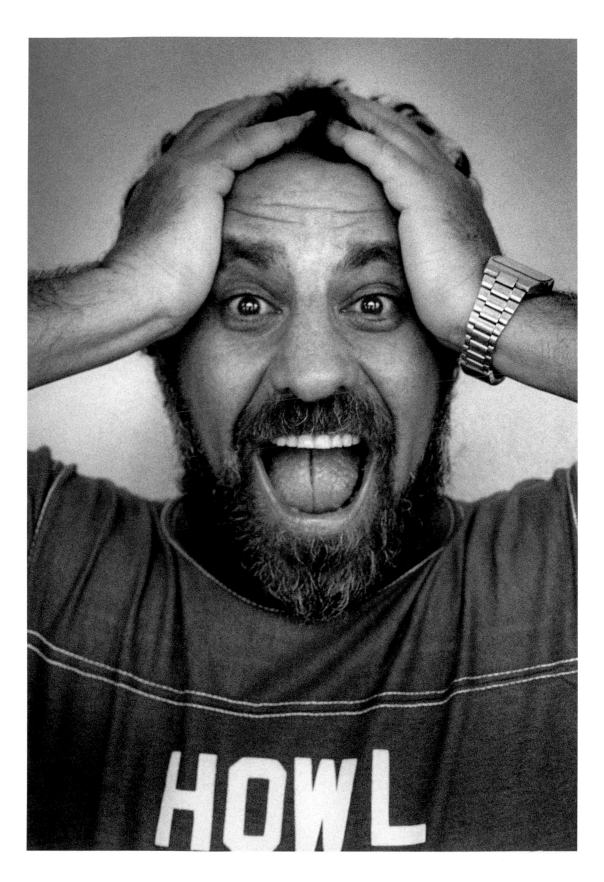

Abbie Hoffman  Yippie activist

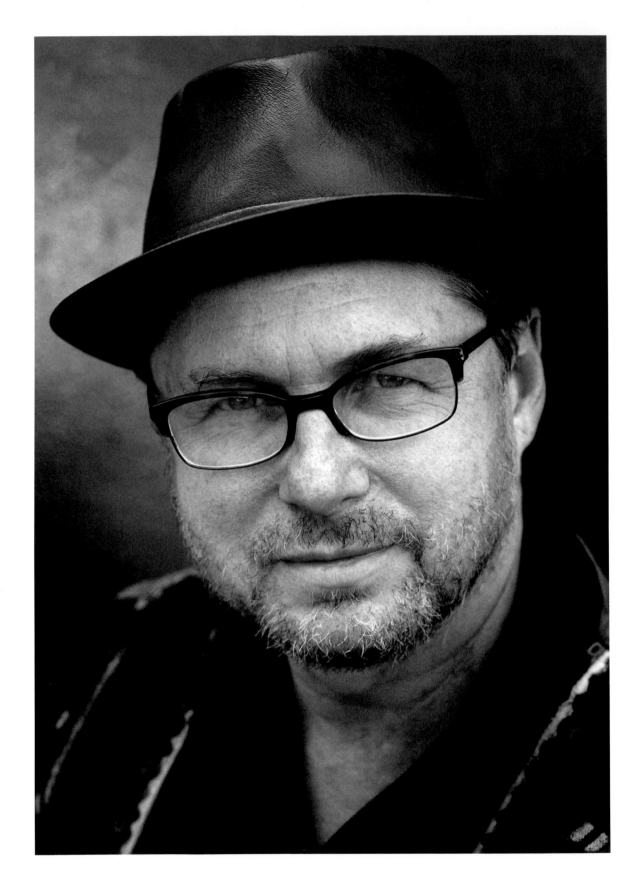

Bob Holman  Performance poet, impresario

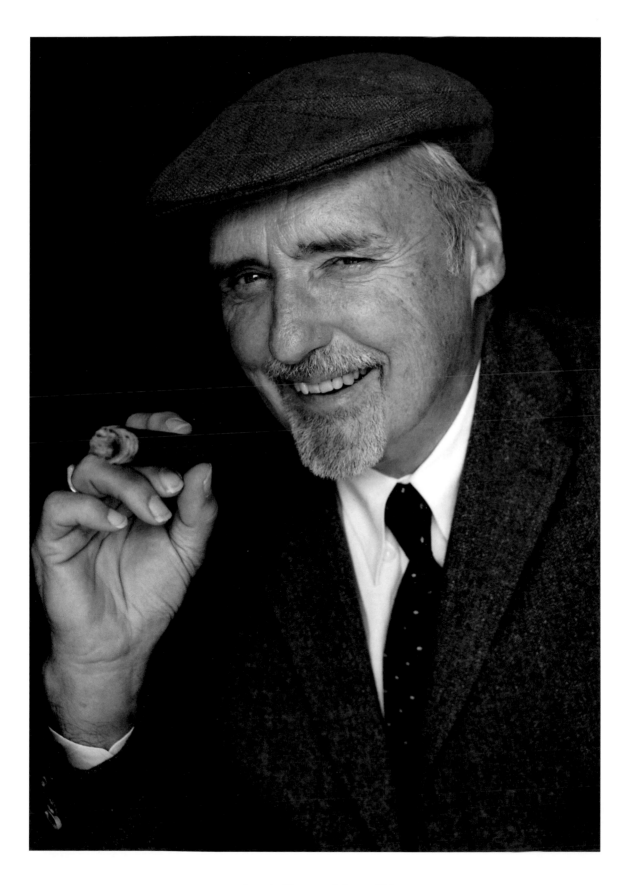

Dennis Hopper  Actor, artist

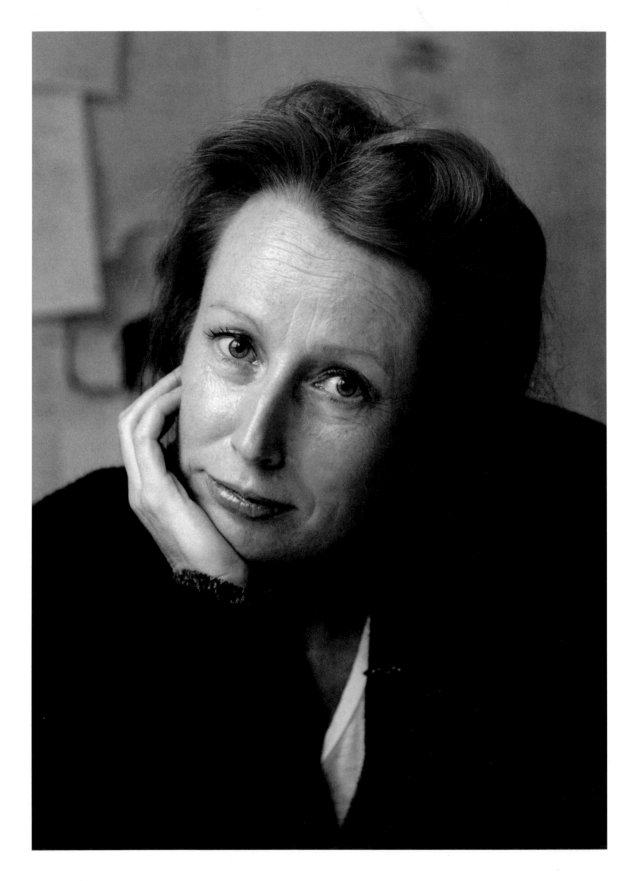

Rebecca Horn  German sculptor

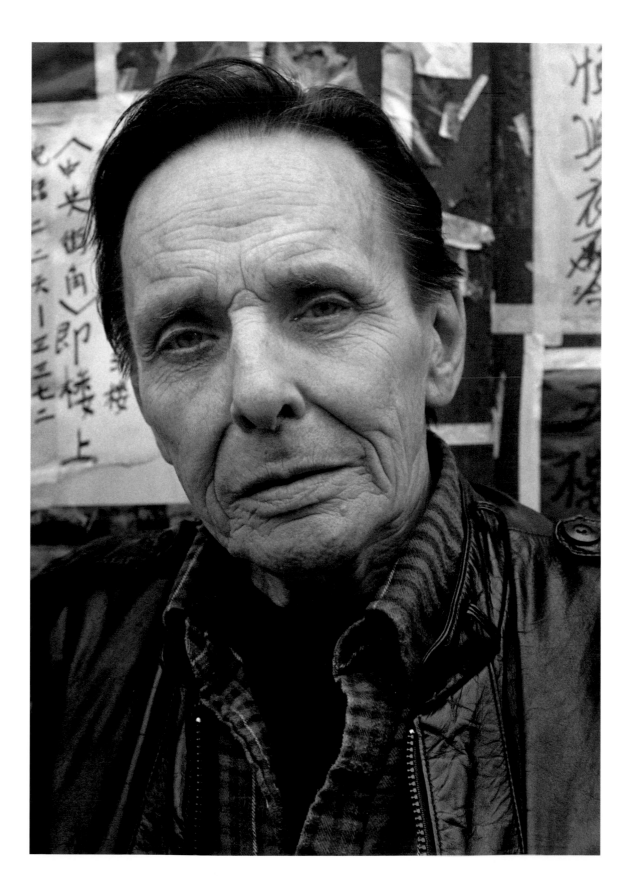

Herbert Hunke  Beat writer

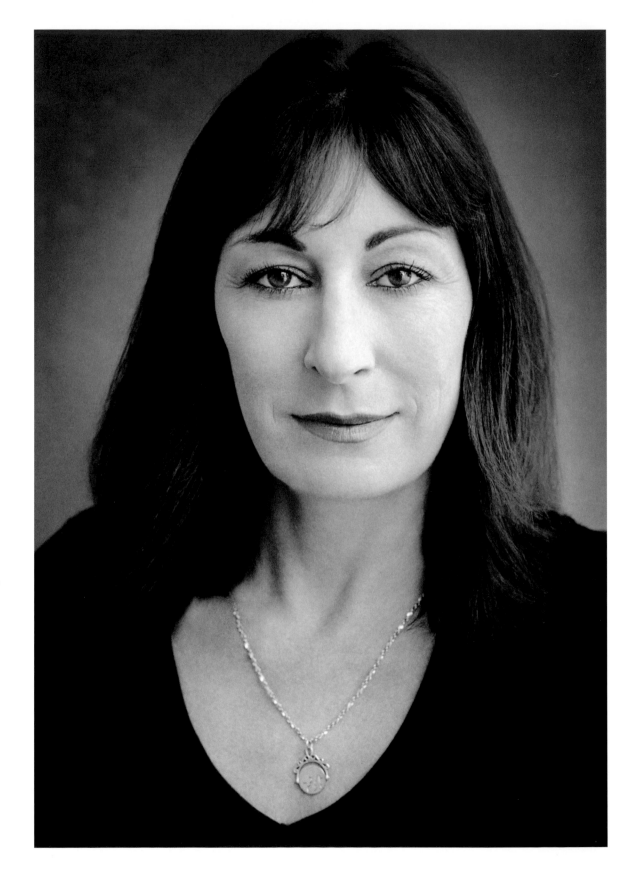

Anjelica Huston  Film actress, director

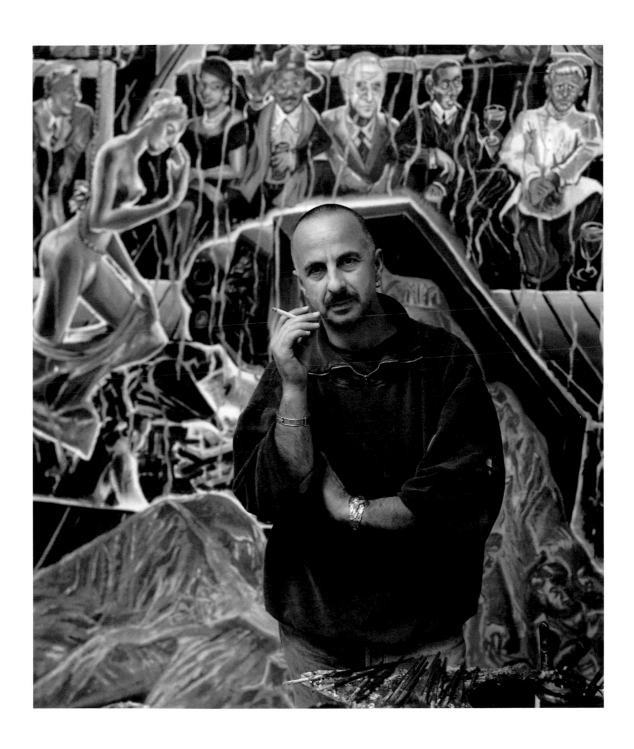

Jörg Immendorff  Figurative Neo-Expressionist painter

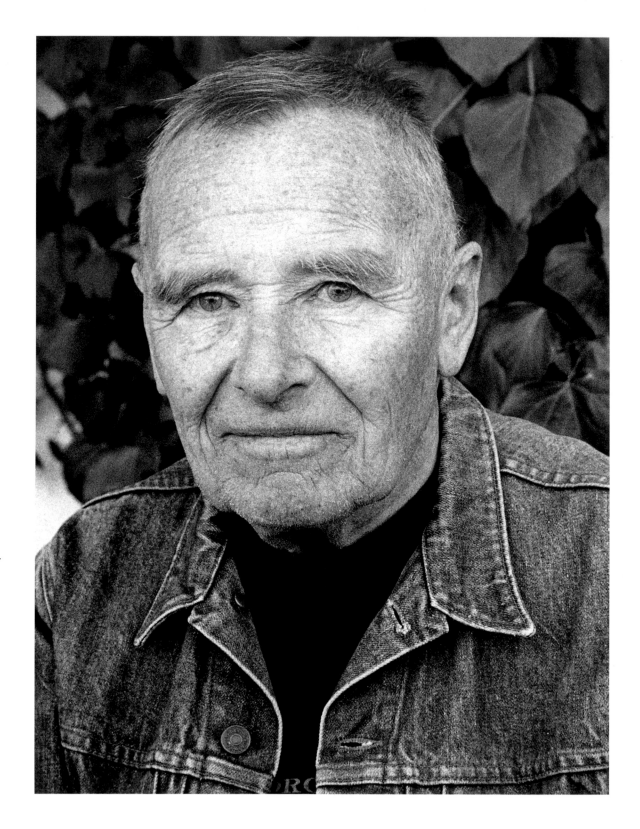

Christopher Isherwood  British novelist

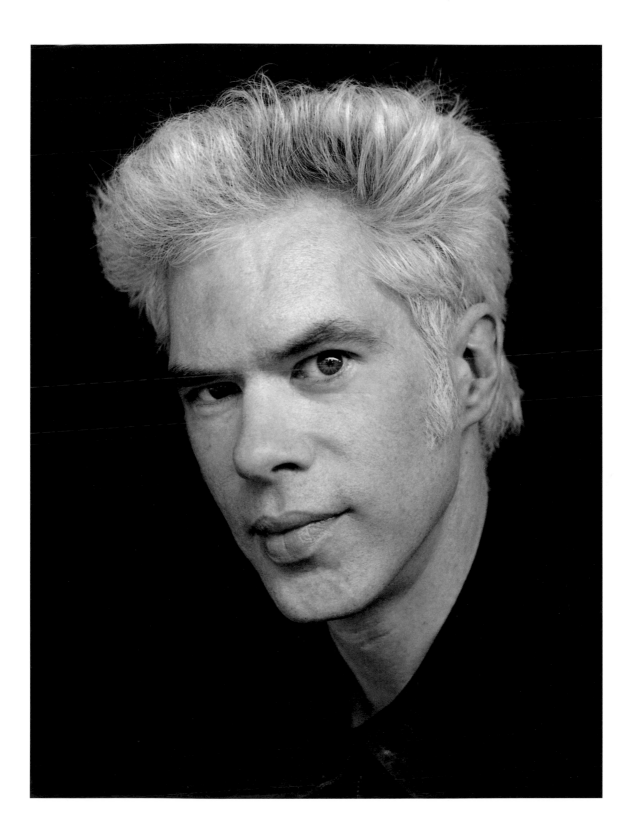

Jim Jarmusch  Independent film director

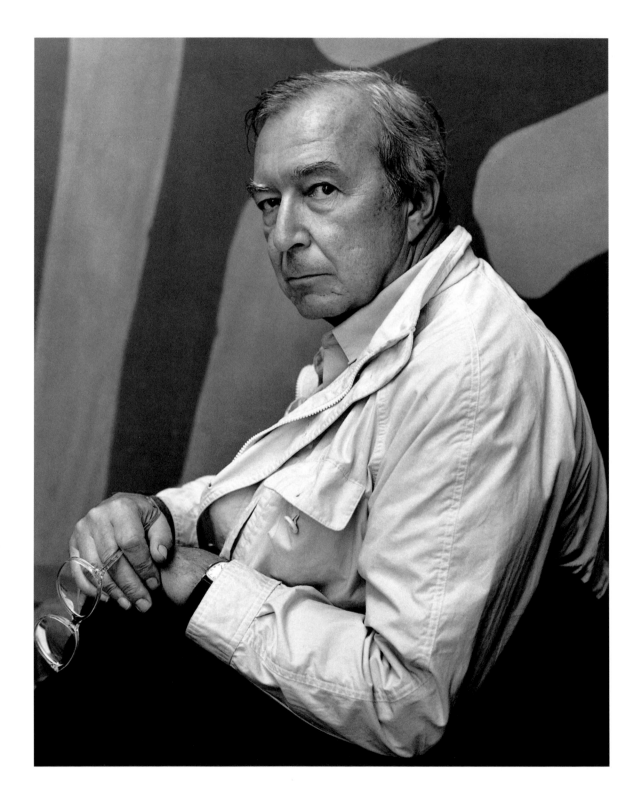

Jasper Johns  Artist

Erica Jong  Novelist, poet

-208-

Donald Judd  Minimalist sculptor

Ilya Kabakov  Russian conceptual artist

Anish Kapoor  Indian-born British sculptor

Allan Kaprow  Artist/inventor of Happenings

Alex Katz  New York School figurative painter

Bob Kaufman  San Francisco Beat poet

Jorma Kaukonen  Acoustic guitarist

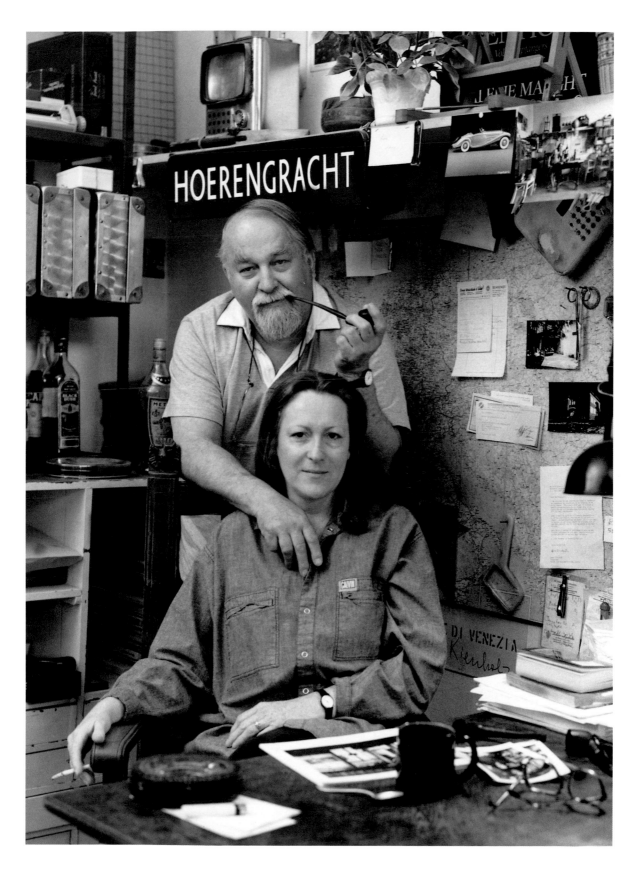

Ed & Nancy Keinholz  Assemblage artists/sculptors

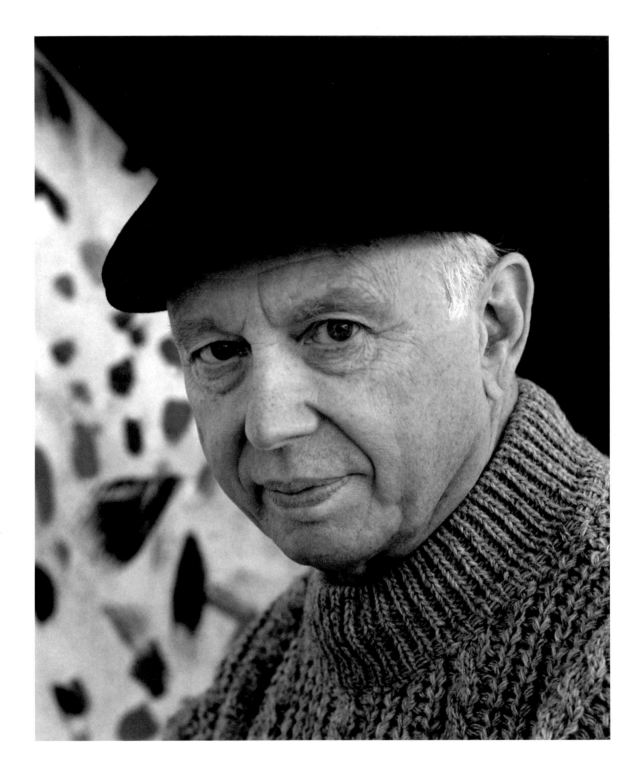

Ellsworth Kelly  Painter, sculptor

KATHRYN
McILHENNY

HIS WIFE

1860 ✠ 1934

MICHAEL T.
PHELAN

1850 ✠ 1895

-217-

William Kennedy  Novelist

Jan Kerouac  Novelist

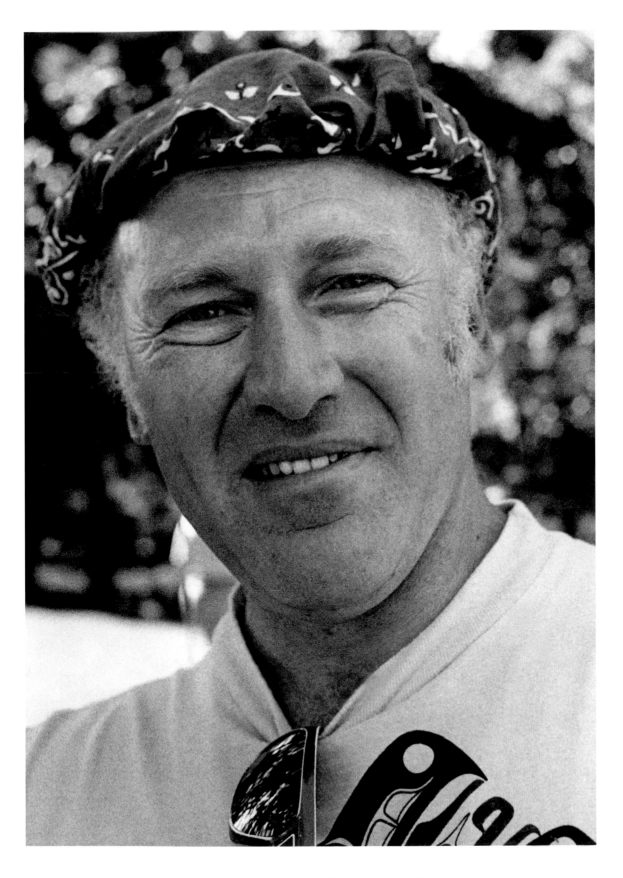

Ken Kesey  Novelist, "Merry Prankster"

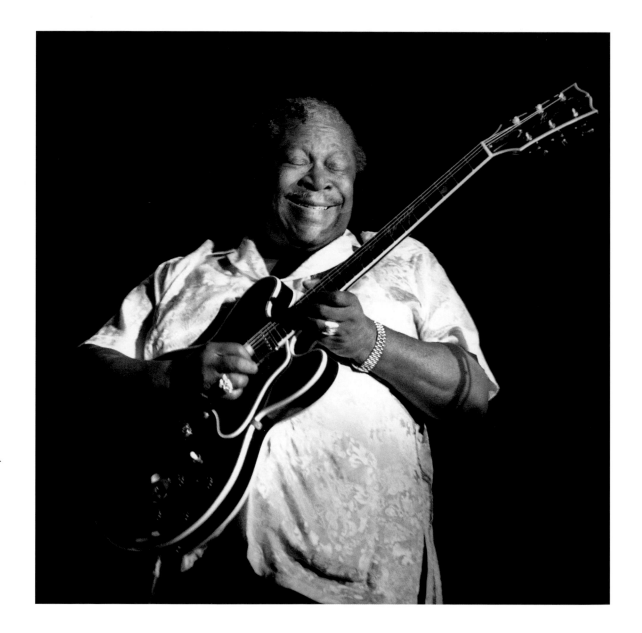

B. B. King  "King of the Blues"

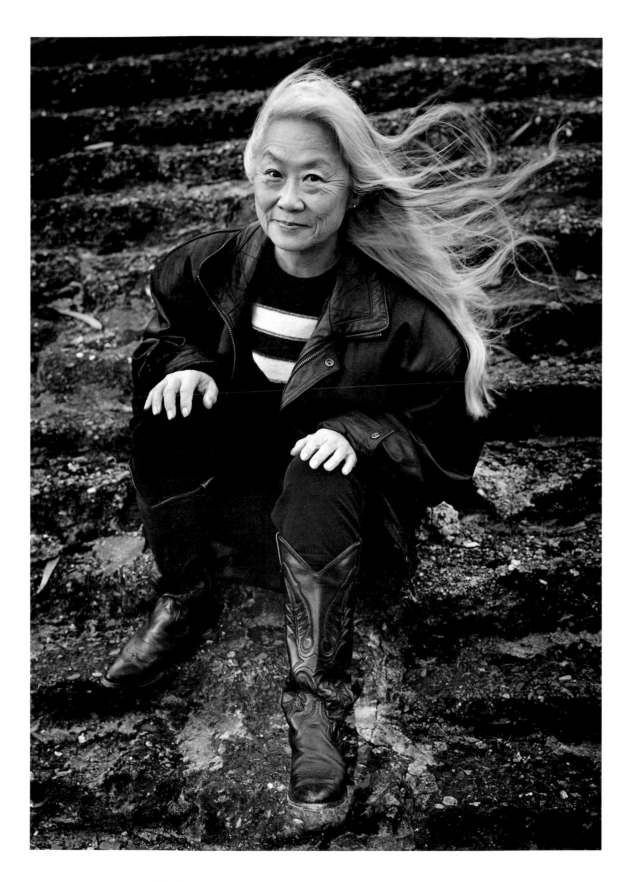

Maxine Hong Kingston  Novelist, National Book Award 1980

Galway Kinnell  Pulitzer Prize—winning poet, 1983

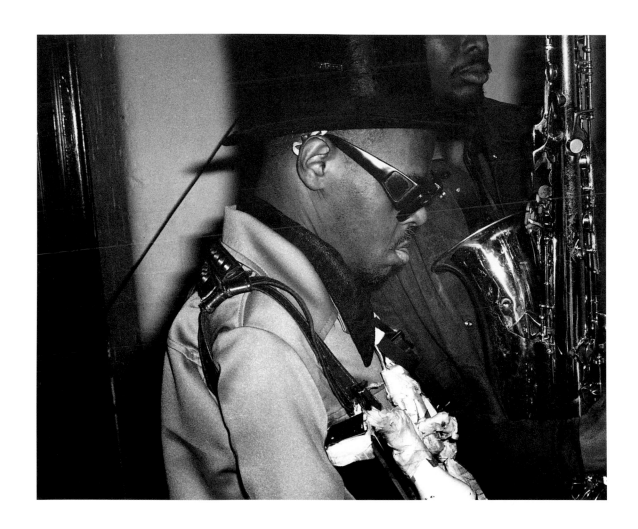

Rahsaan Roland Kirk  Improvisational composer, instrumentalist

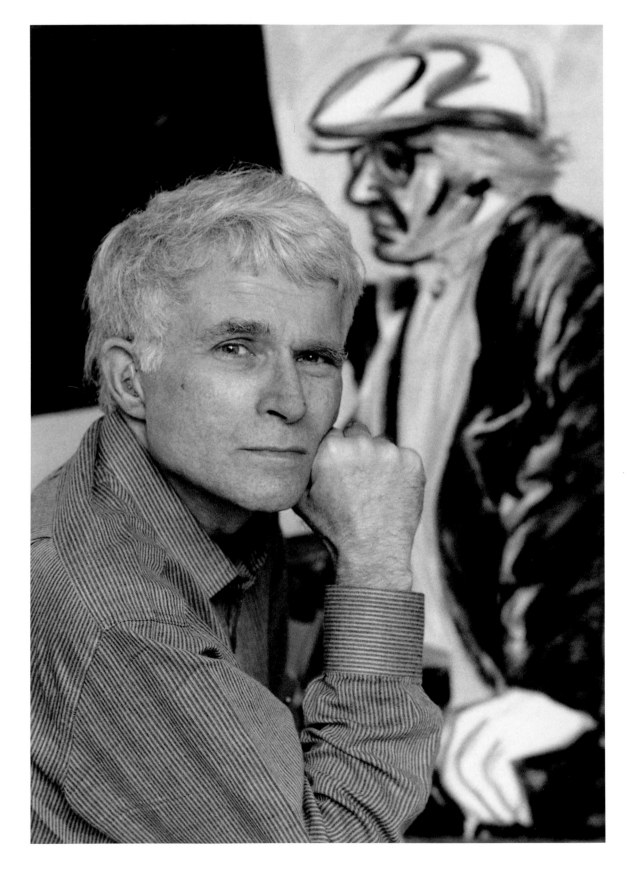

R. B. Kitaj  Diasporist artist

Carolyn Kizer  Poet, translator, Pulitzer Prize 1985

Kenneth Koch  New York School poet, playwright, educator

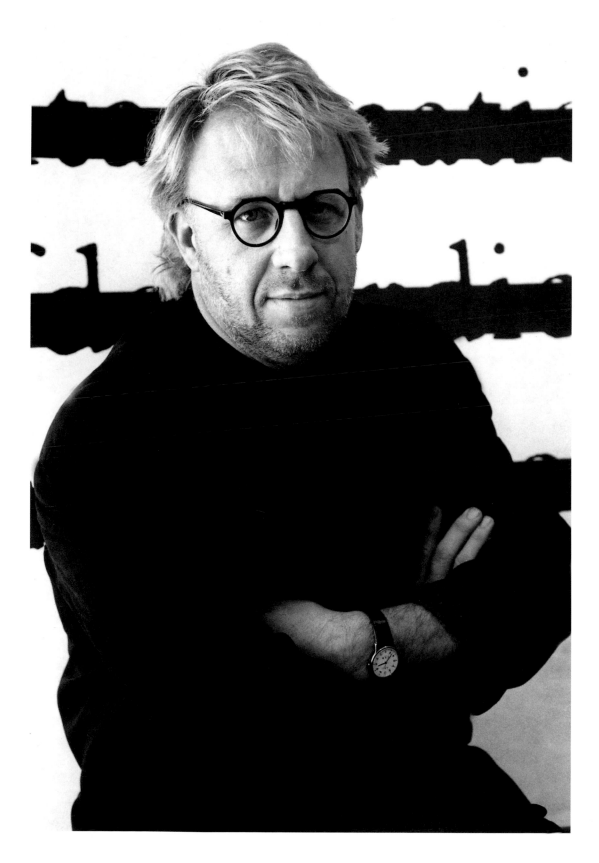

Joseph Kosuth  Conceptual artist

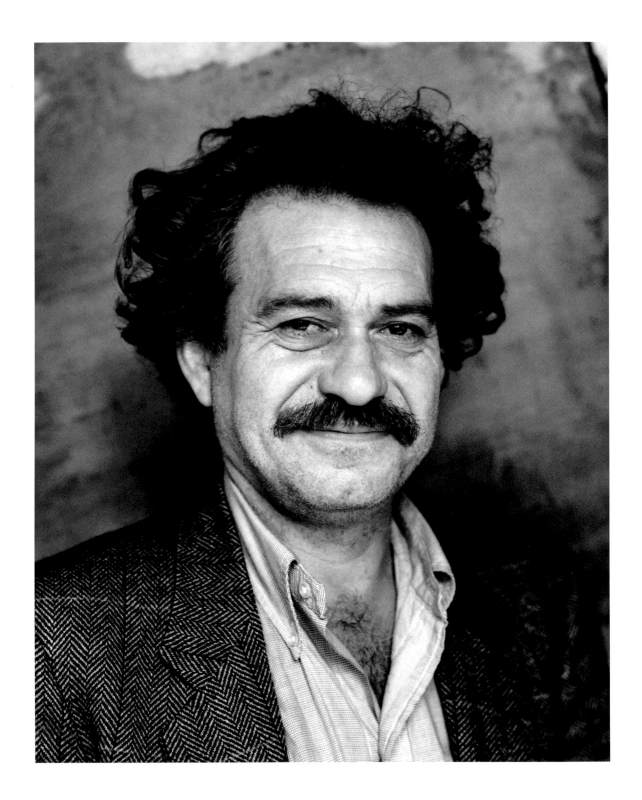

Jannis Kounellis  Greek *Arte Povera* artist

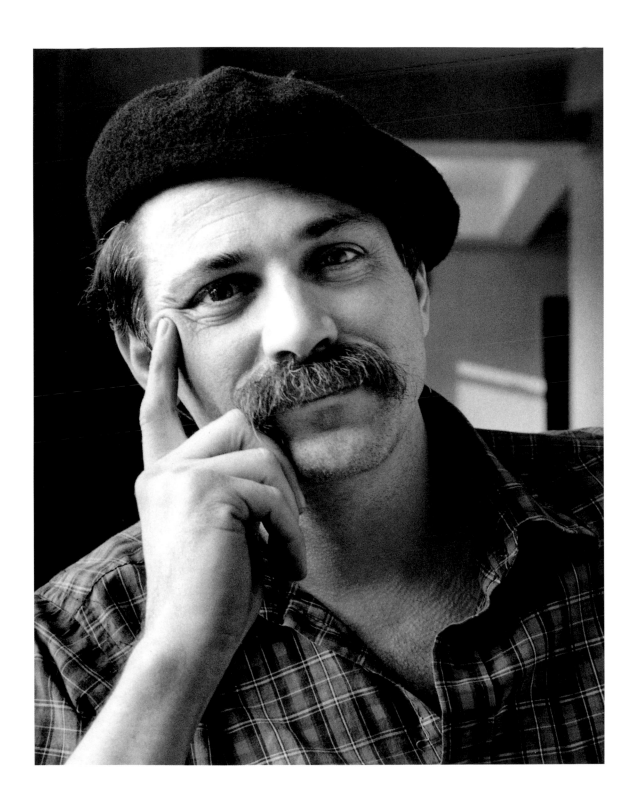

Ron Kovic  Novelist, antiwar activist

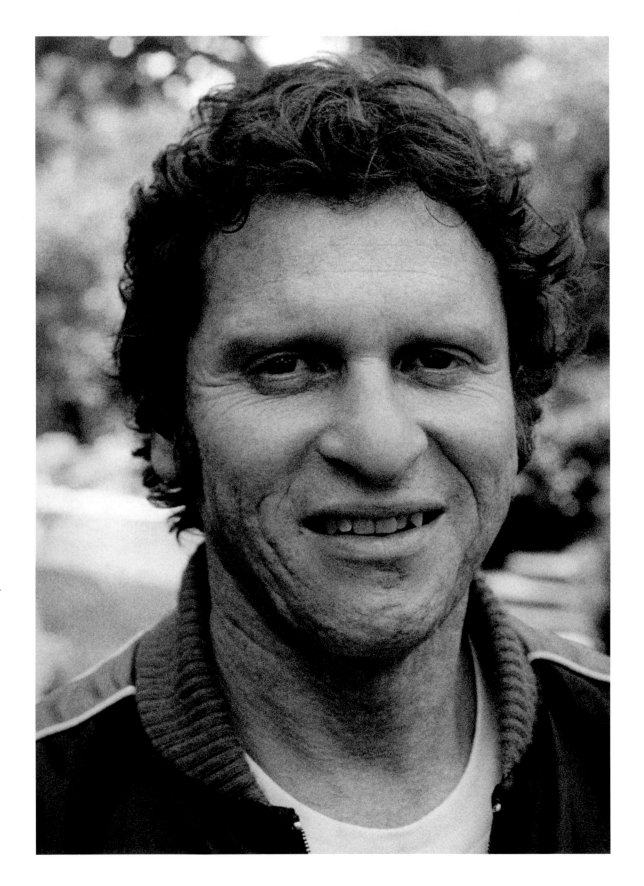

Paul Krassner  Political, social satirist, comedian

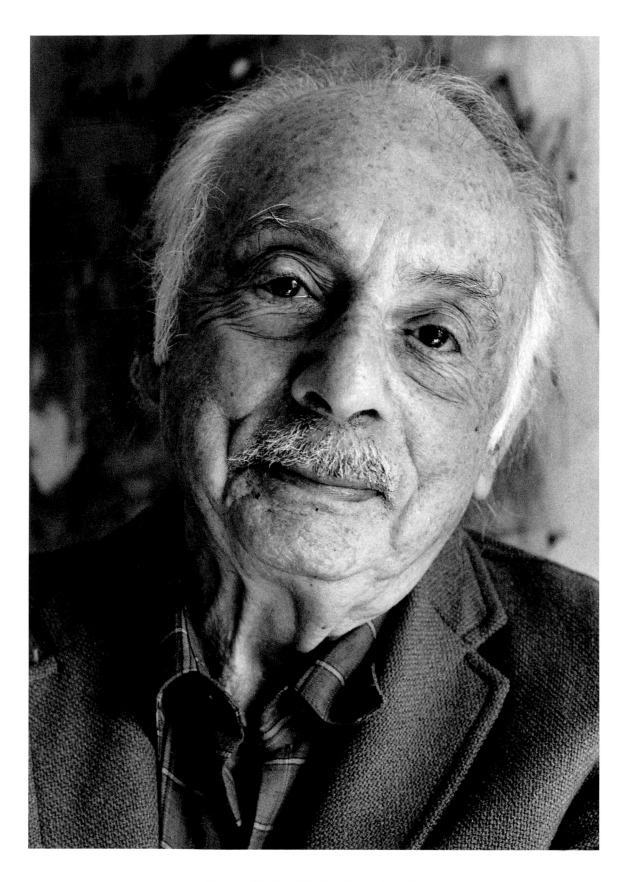

-231-

Stanley Kunitz U.S. Poet Laureate, 2000

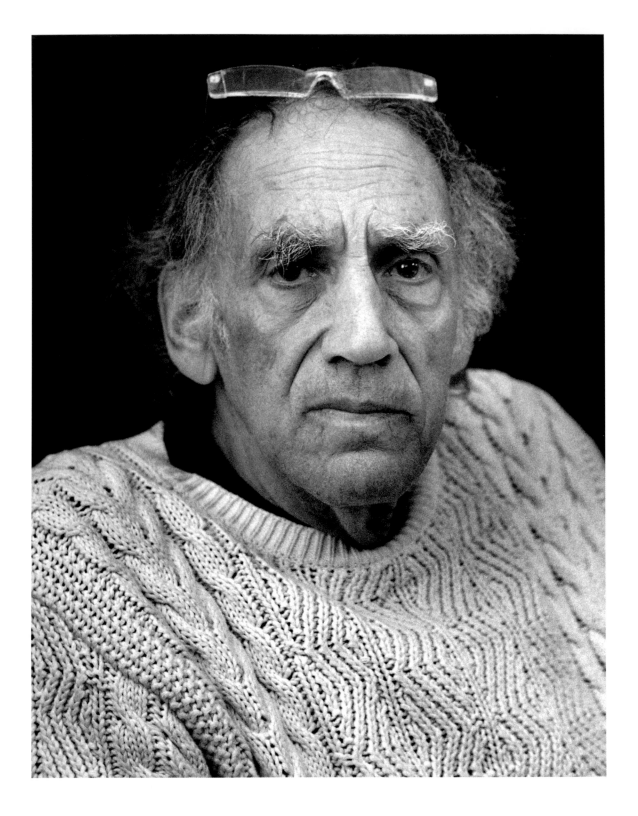

William Kunstler  Lawyer

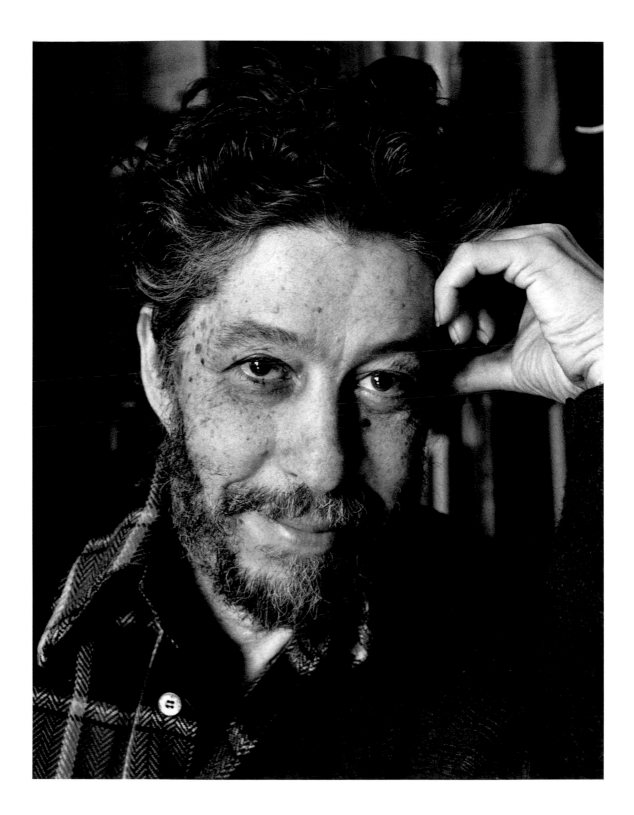

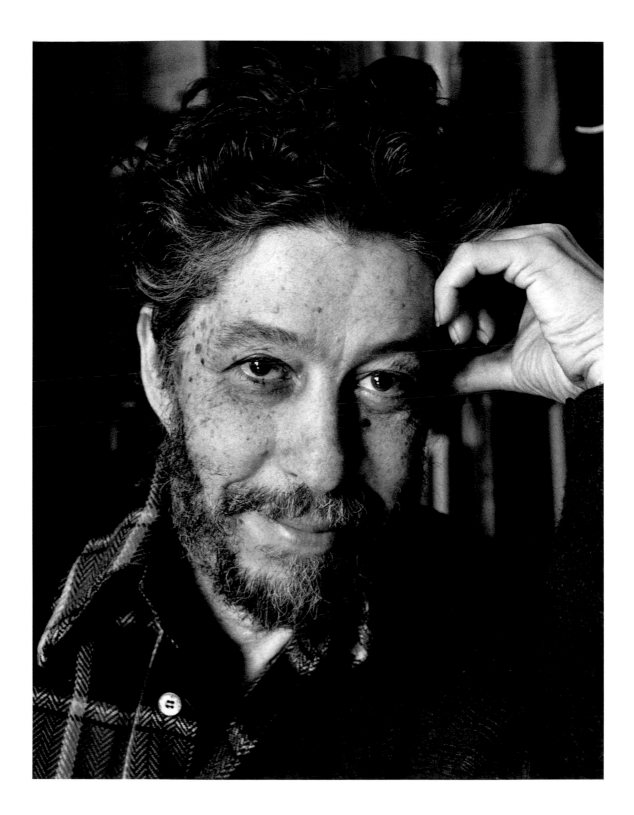

-233-

Tuli Kupferberg  Poet, peace activist

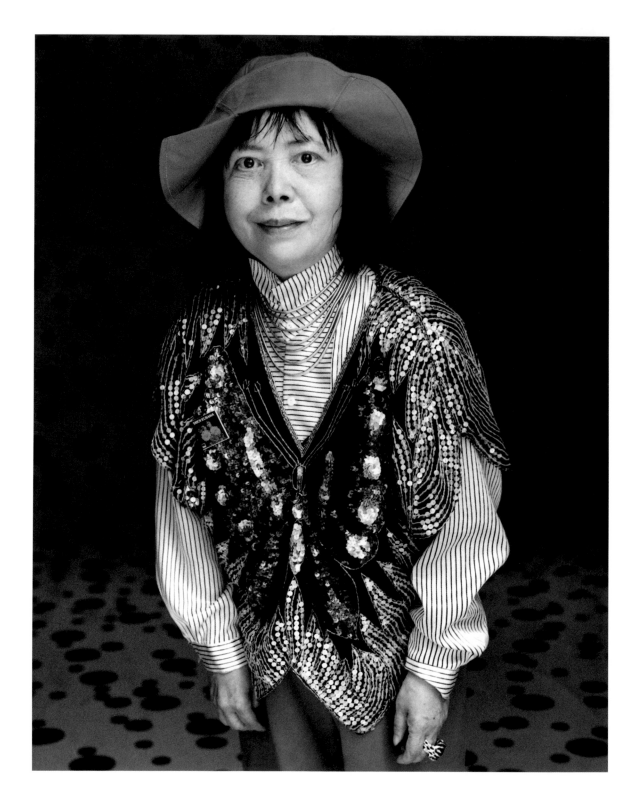

Yayoi Kusama  Painter, writer, performance artist

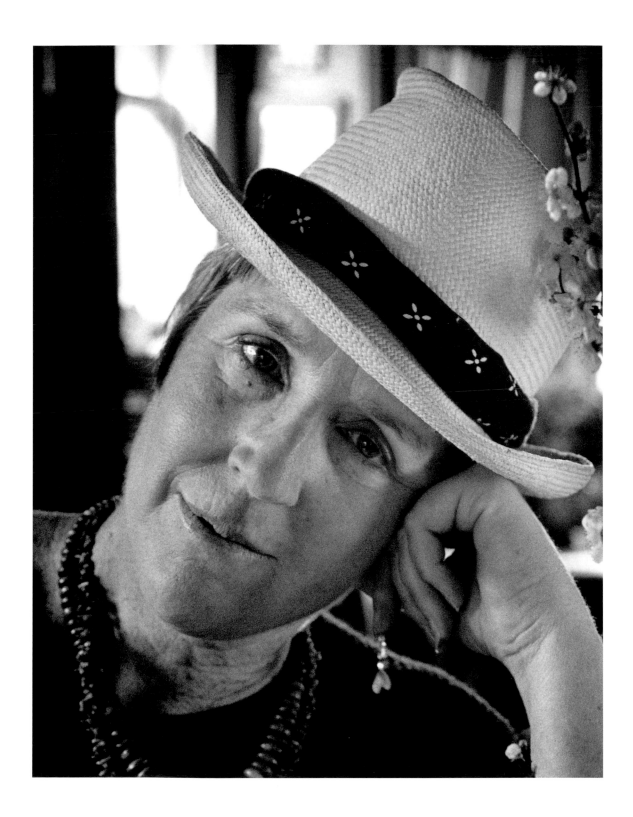

Joanne Kyger  Buddhist Beat poet

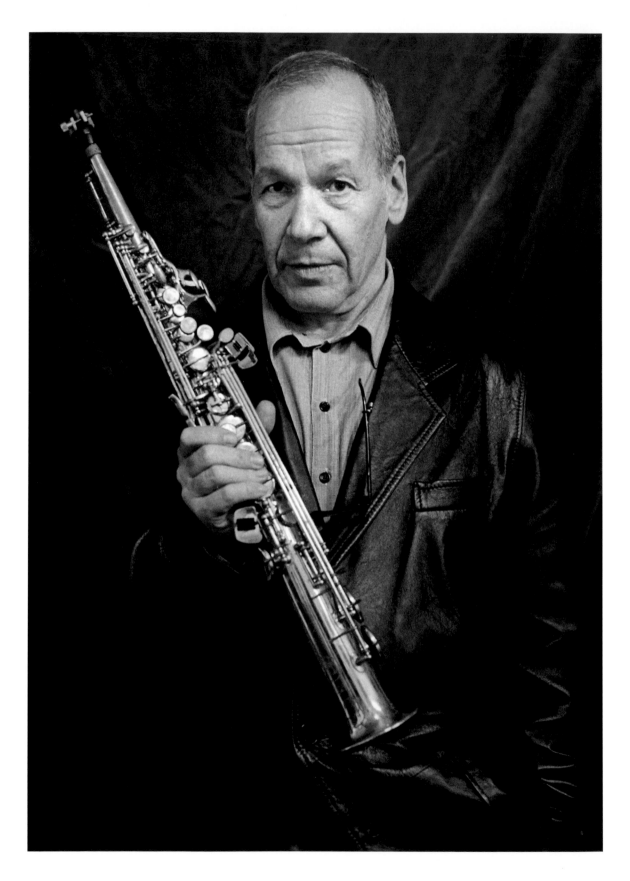

Steve Lacy  Jazz saxophonist, composer

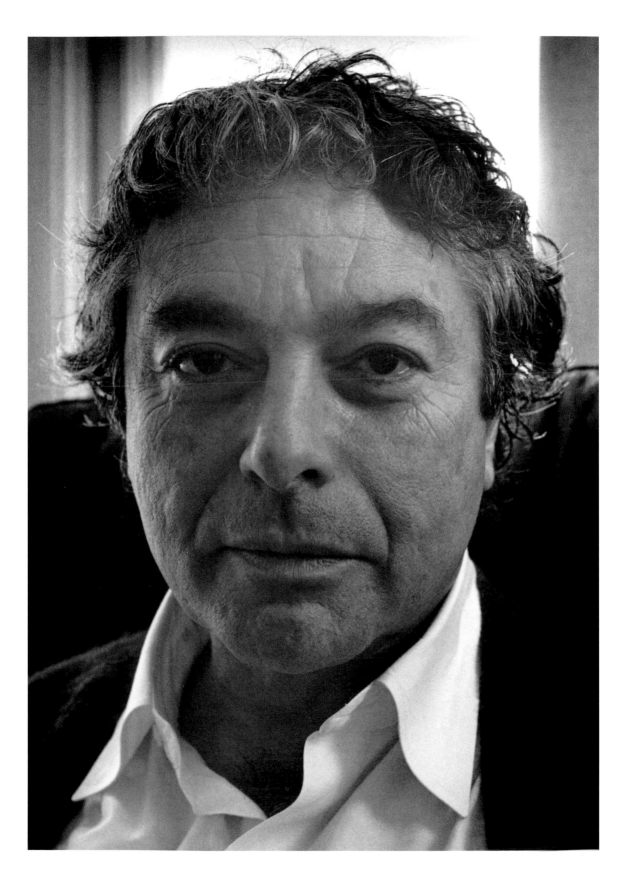

Philip Lamantia  American surrealist poet

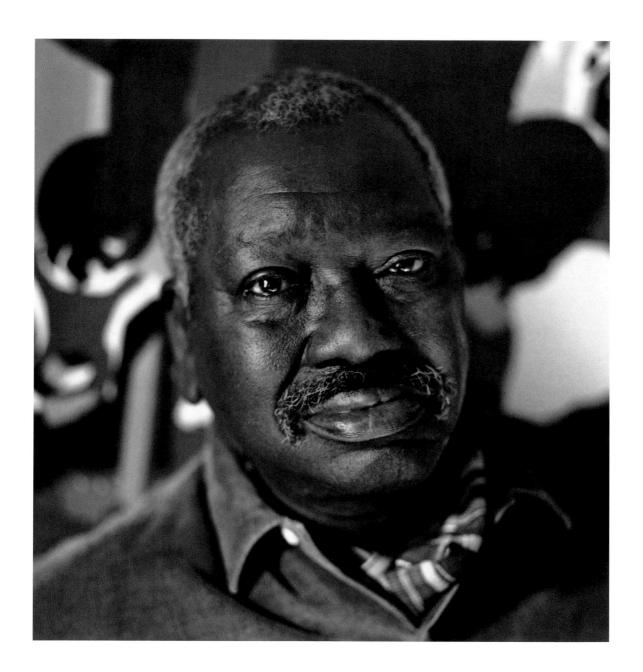

Jacob Lawrence  African American modernist painter

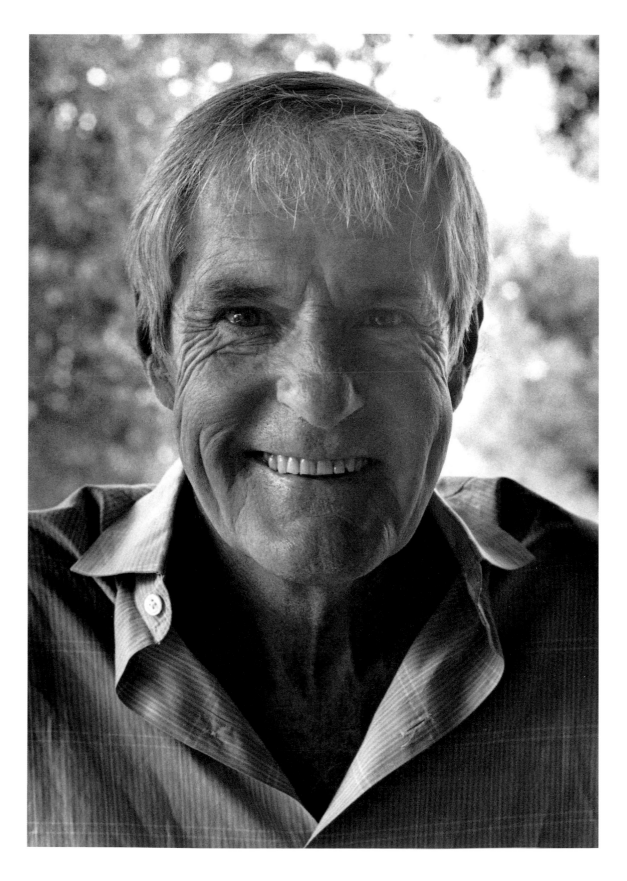

Timothy Leary  Psychologist, psychedelic explorer

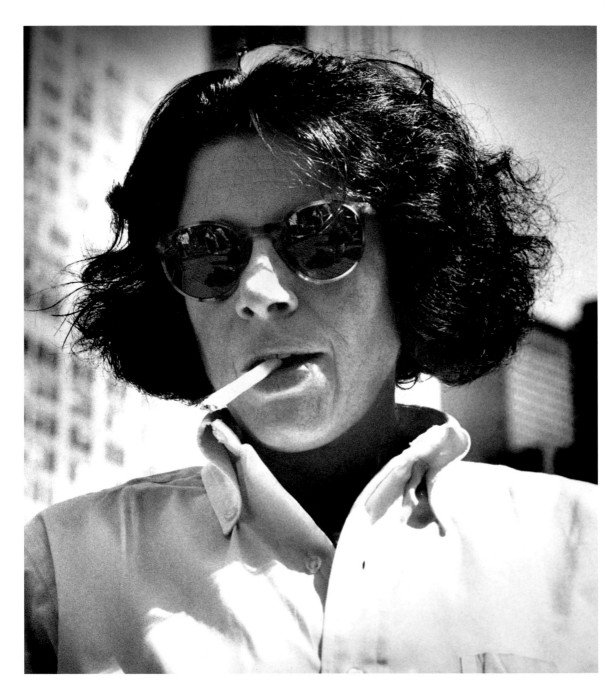

Fran Lebowitz  Writer, humorist

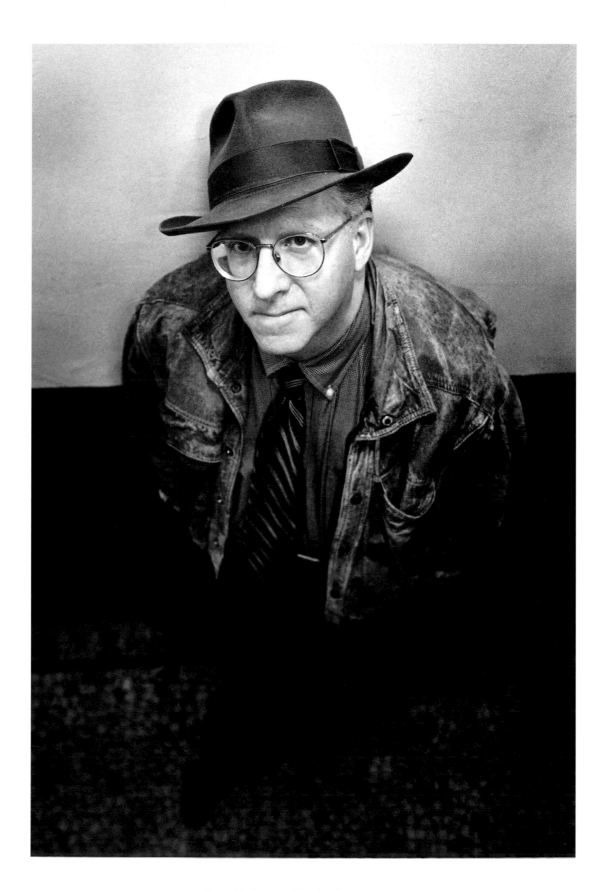

David Lehman  New York poet, critic

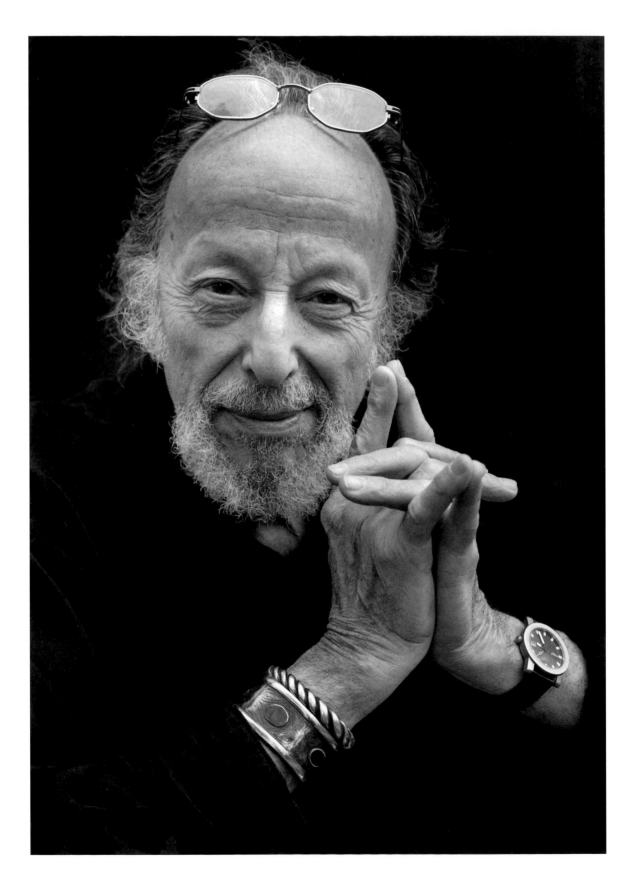

**Herman Leonard**  Jazz photographer

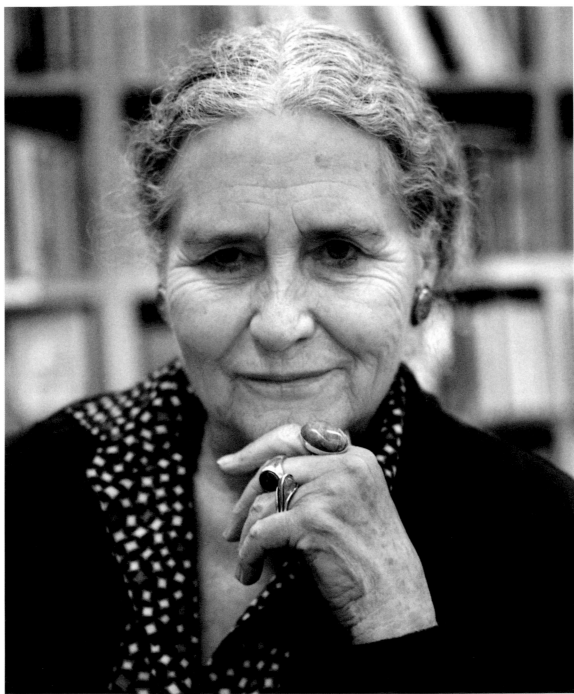

Doris Lessing  English fiction writer

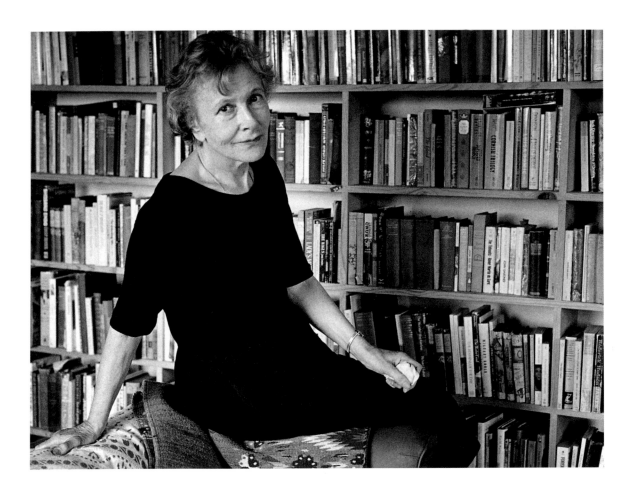

Denise Levertov  Poet

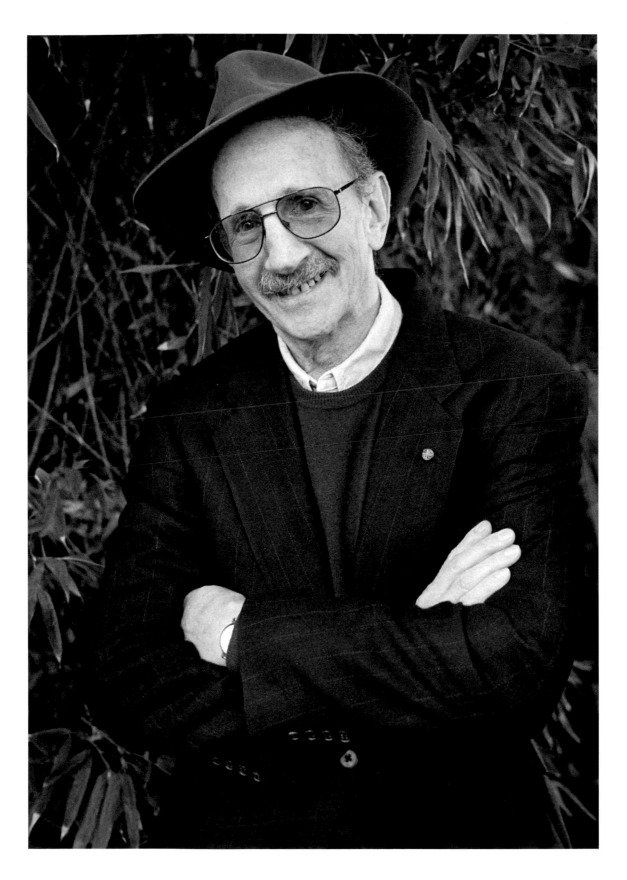

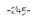
-245-

Philip Levine  Poet, Pulitzer Prize 1995

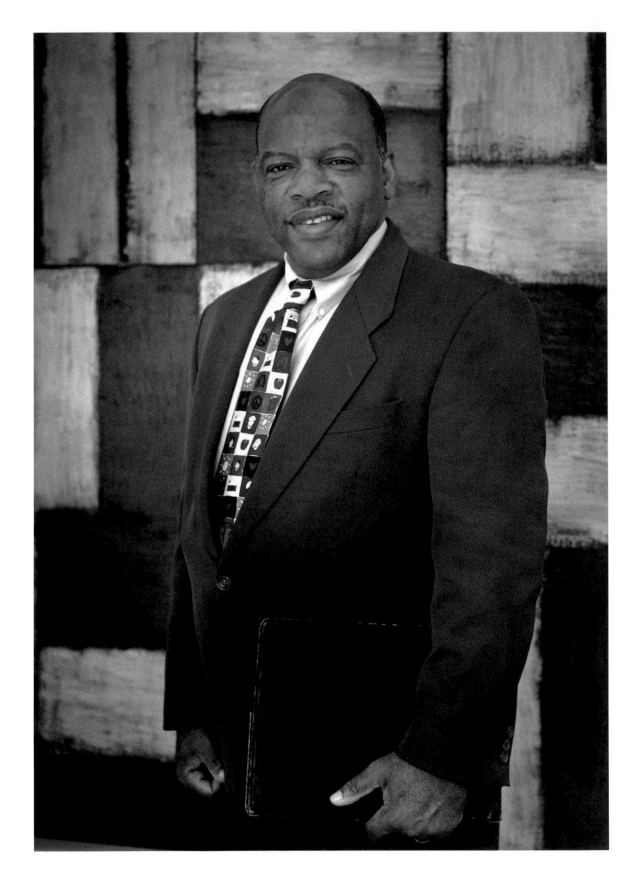

John Lewis  Congressman, civil rights activist

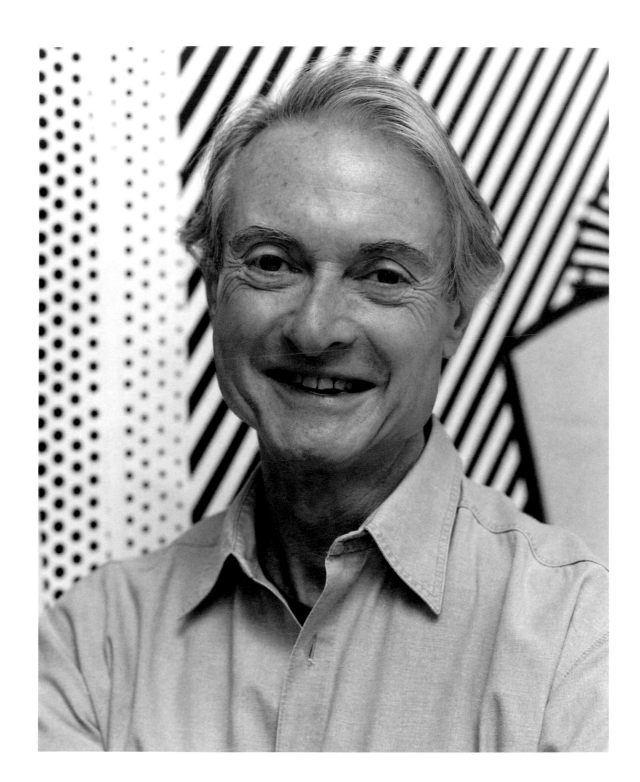

Roy Lichtenstein  New York Pop artist

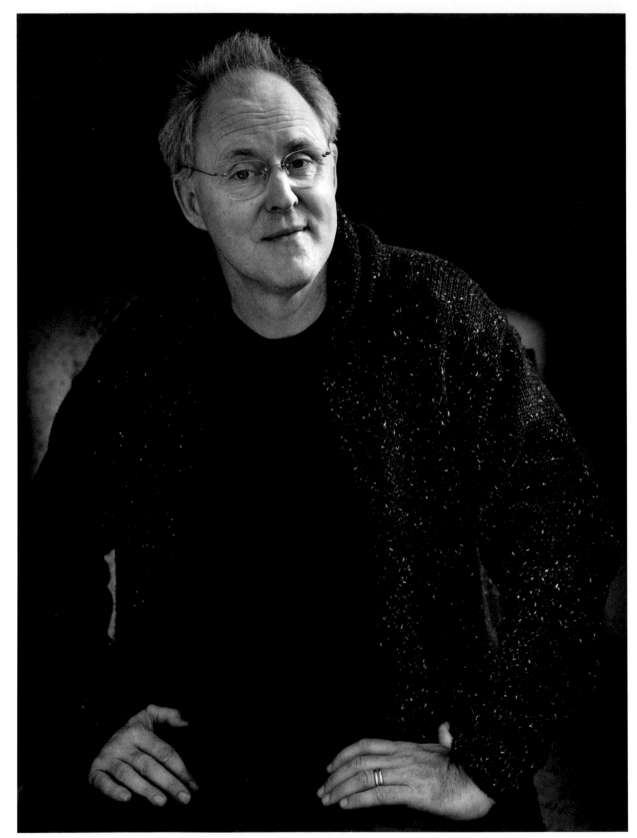

John Lithgow  TV, film, stage actor

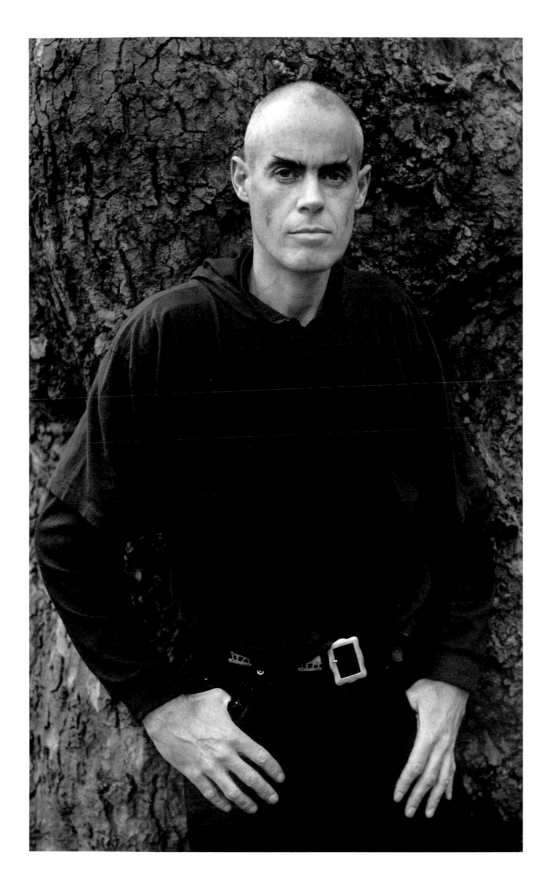

Richard Long  British conceptual artist

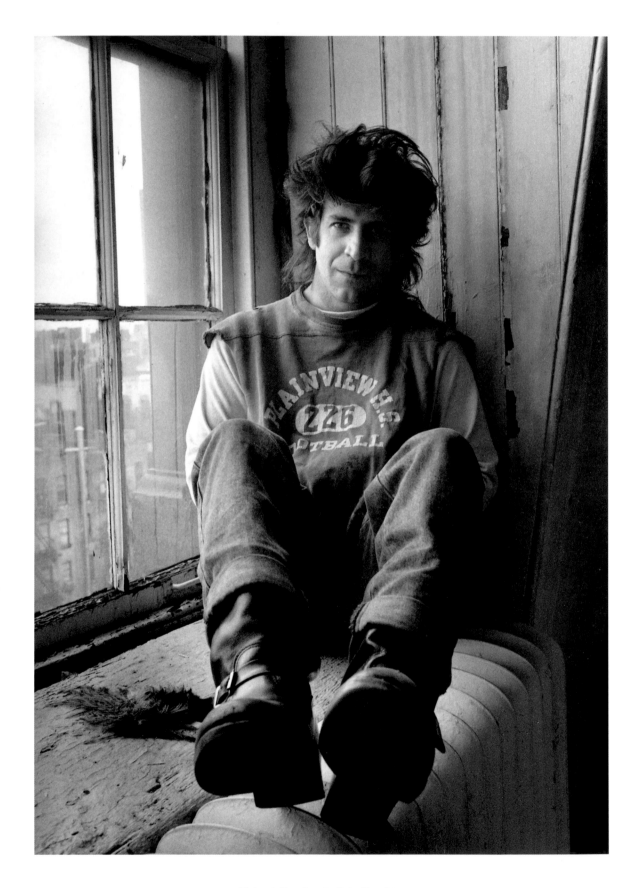

Robert Longo  Artist, director

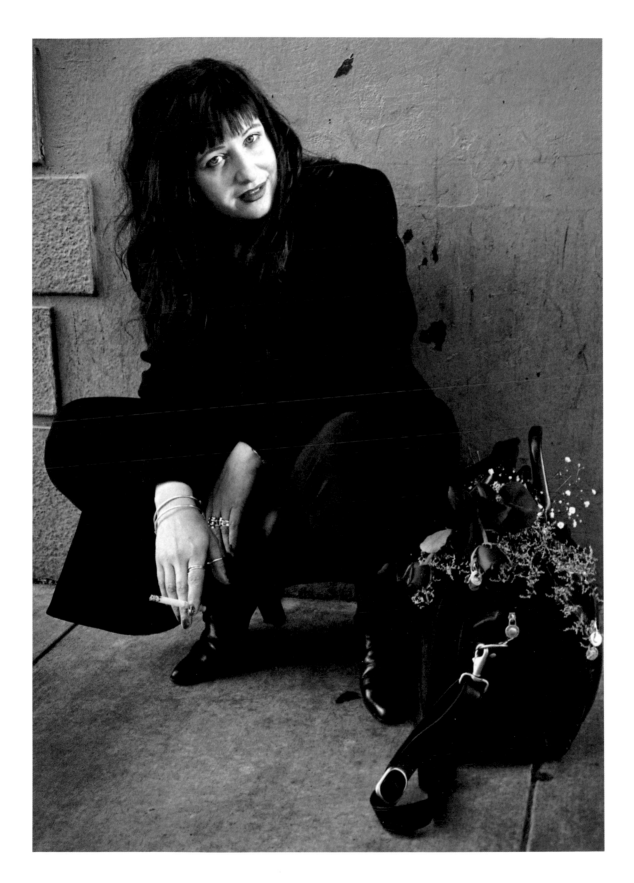

Lydia Lunch  Punk rocker, spoken word artist

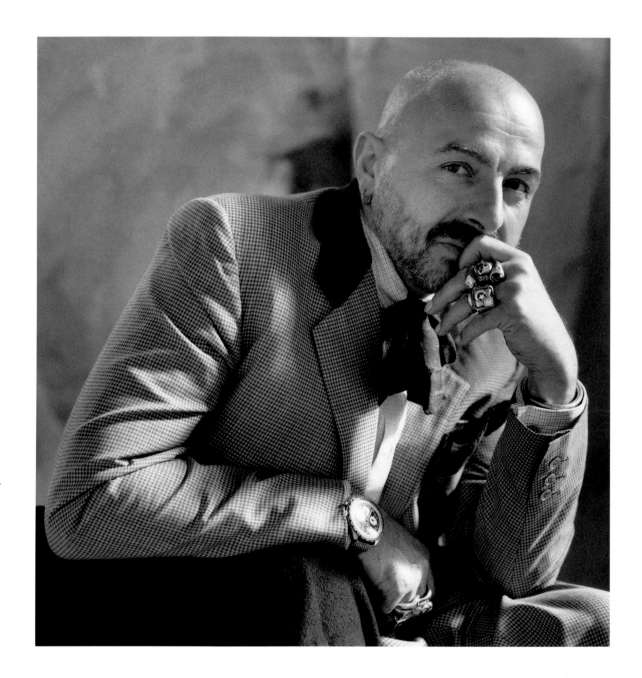

Markus Lüpertz  Neo-Expressionist painter

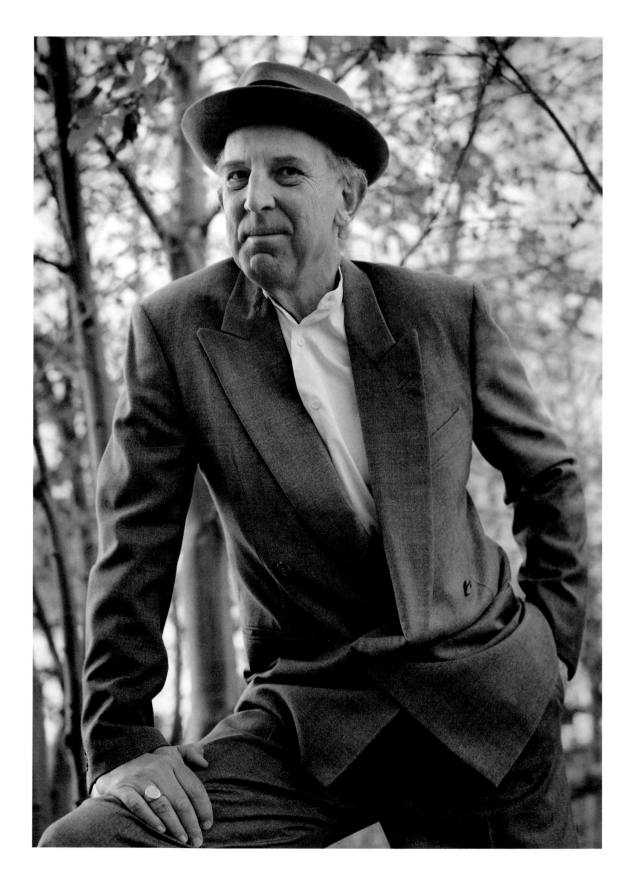

Lewis MacAdams  Poet, journalist

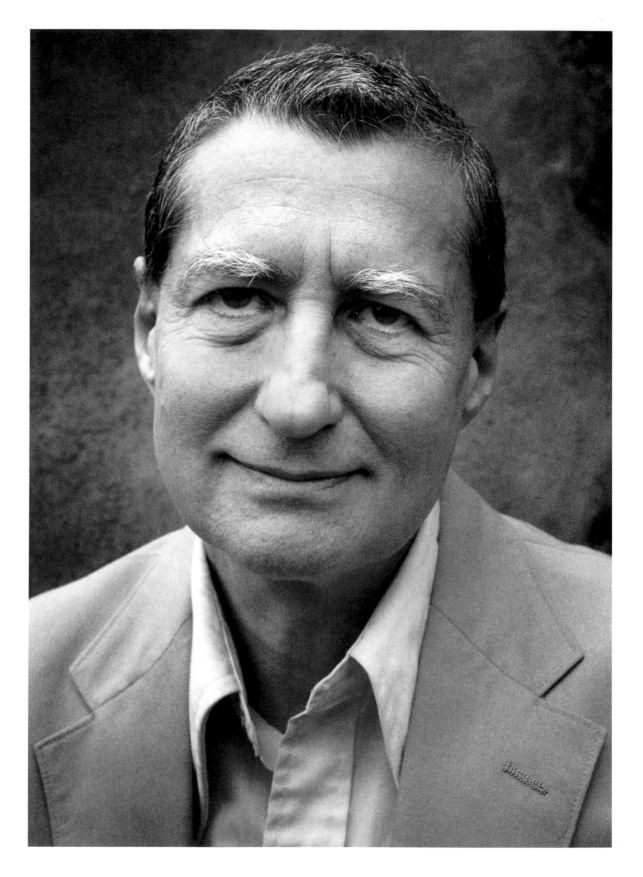

Jackson Mac Low  Poet, composer

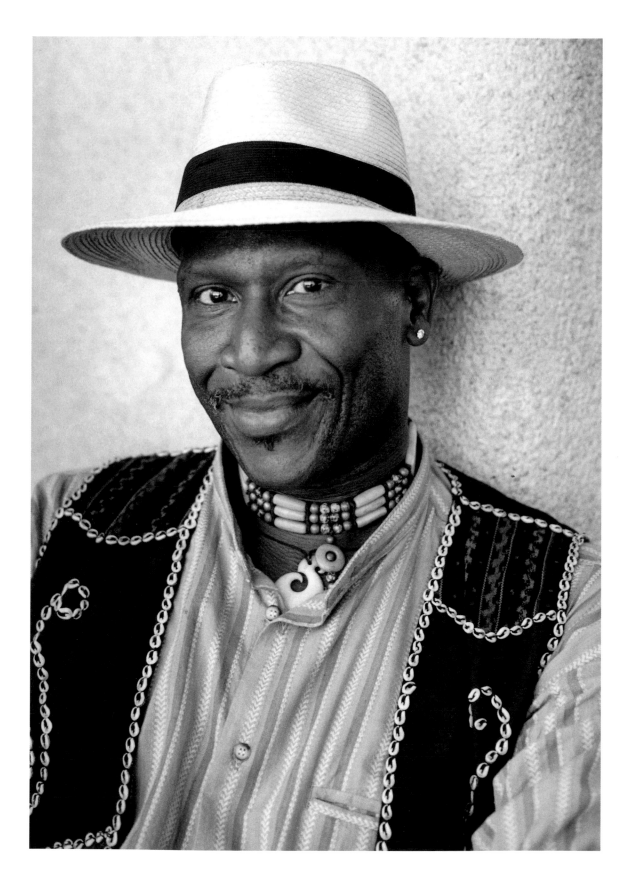

Taj Mahal  Legendary bluesman

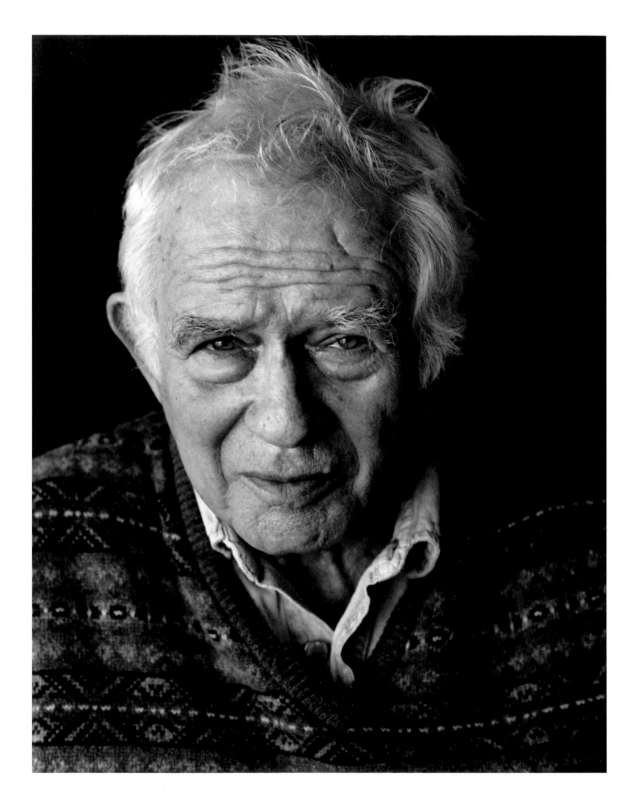

Norman Mailer  Novelist, essayist, New Journalist

Gerard Malanga  Actor, poet, photographer

Judith Malina  Living Theatre cofounder, director, actress

Chuck Mangione  Jazz trumpeter

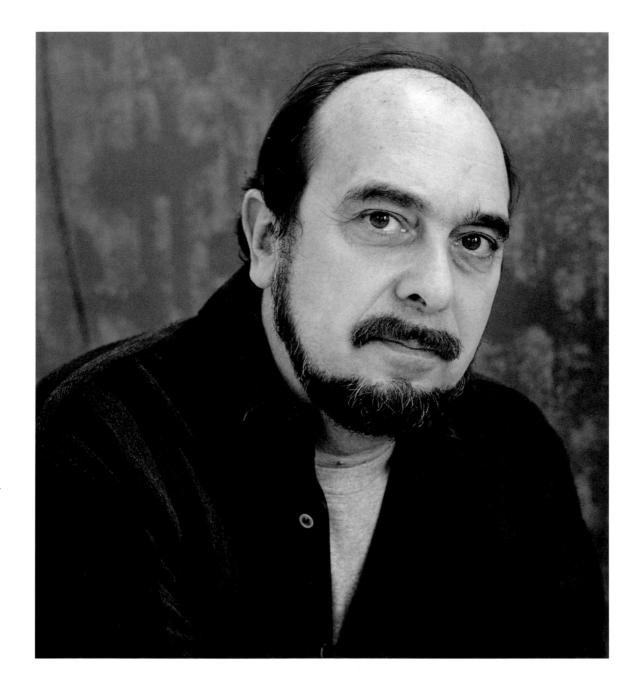

Robert Mangold  Minimalist

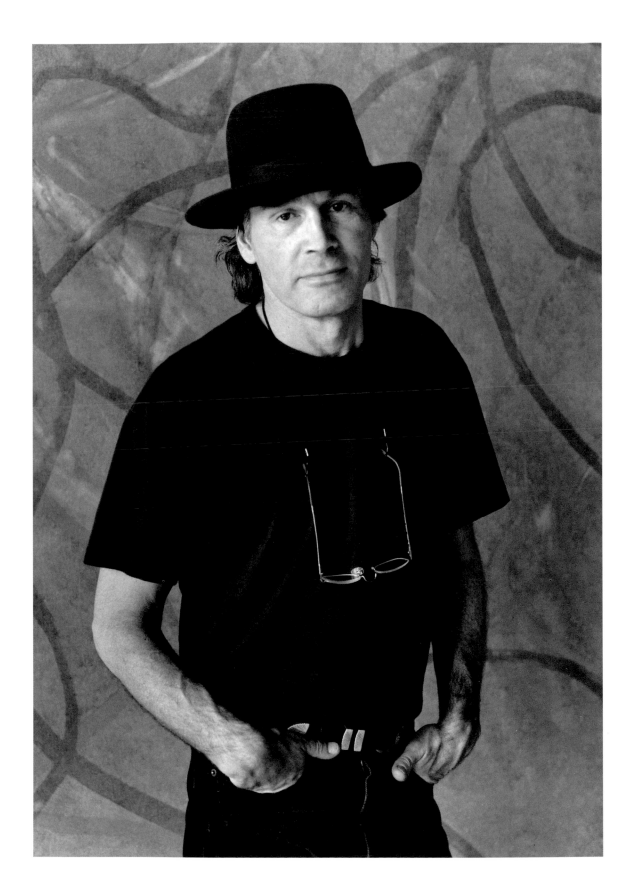

Brice Marden  Painter

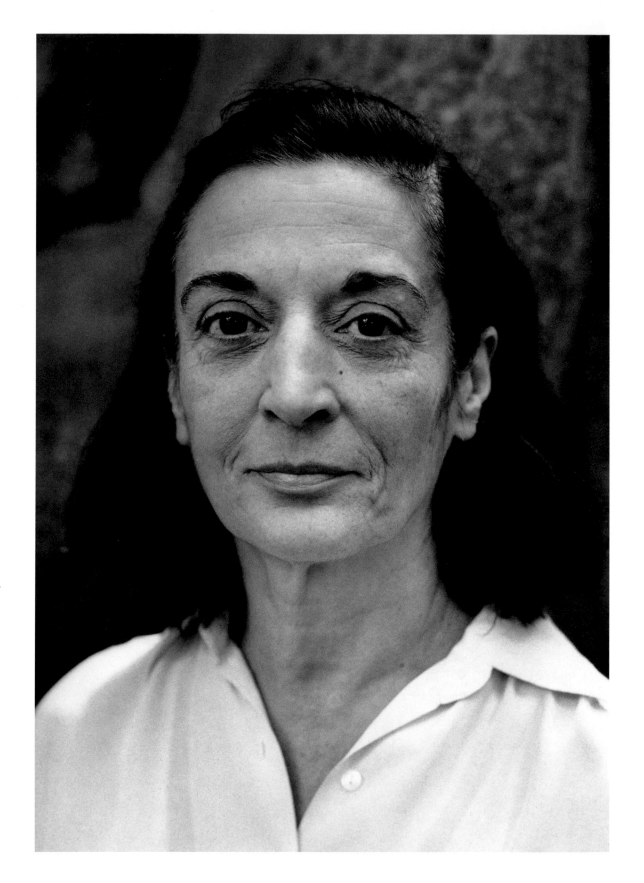

Marisol Sculptor

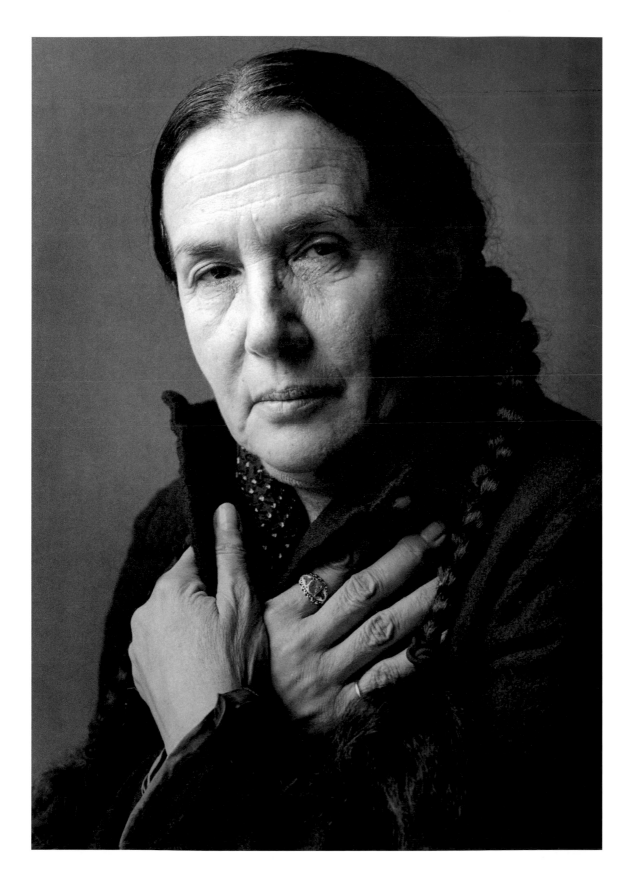

Mary Ellen Mark  American photographer

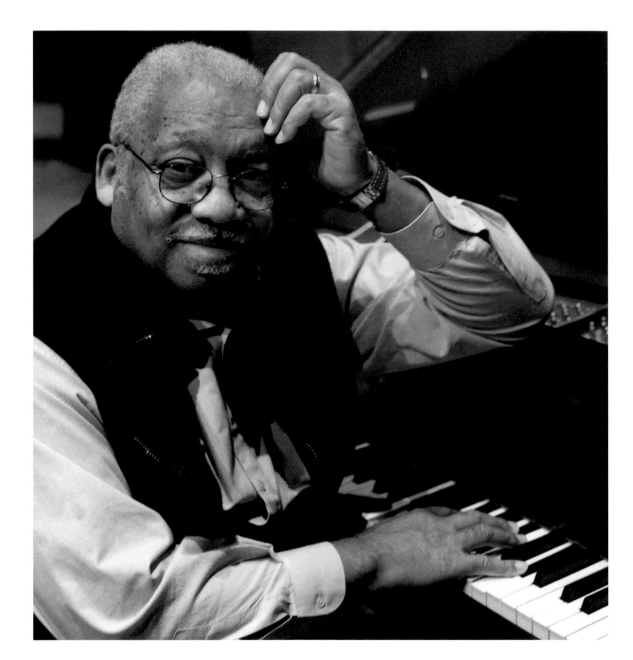

Ellis Marsalis  New Orleans jazz pianist, educator

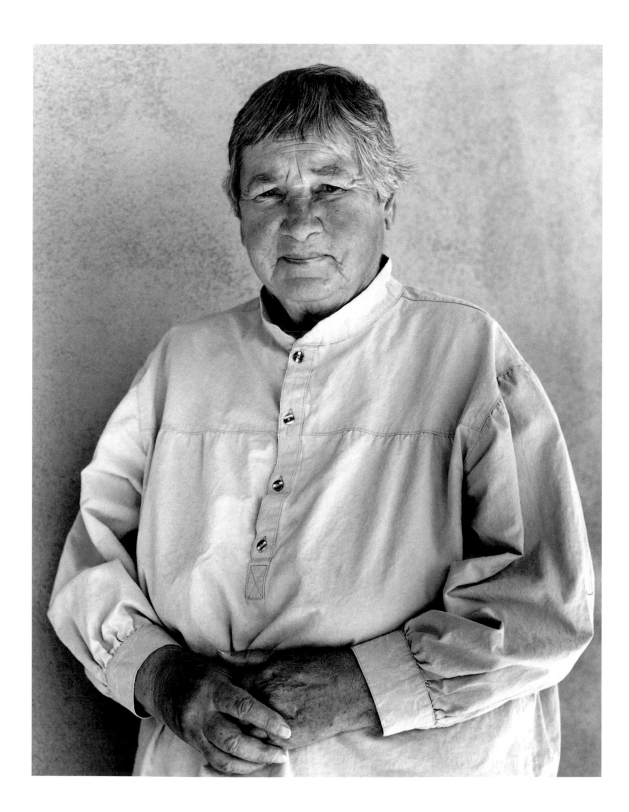

Agnes Martin  Painter

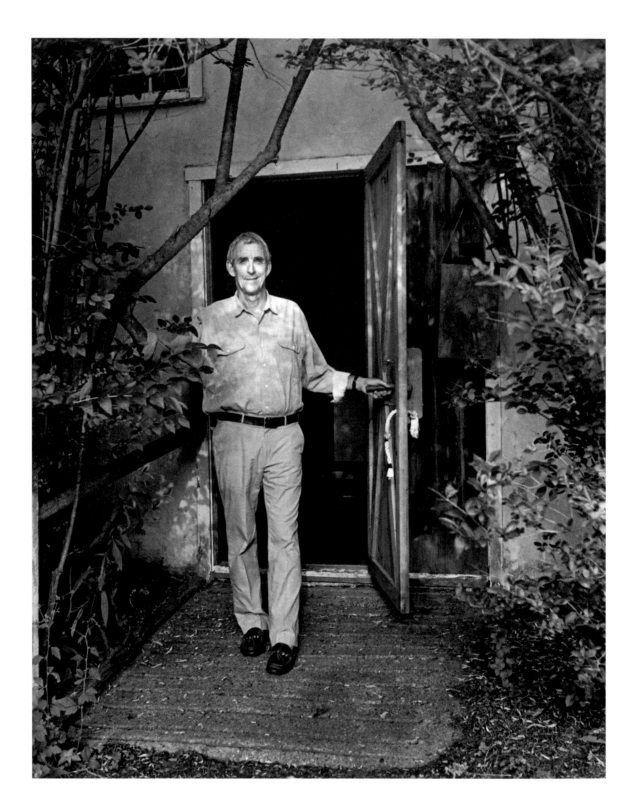

Peter Matthiessen  Novelist, essayist

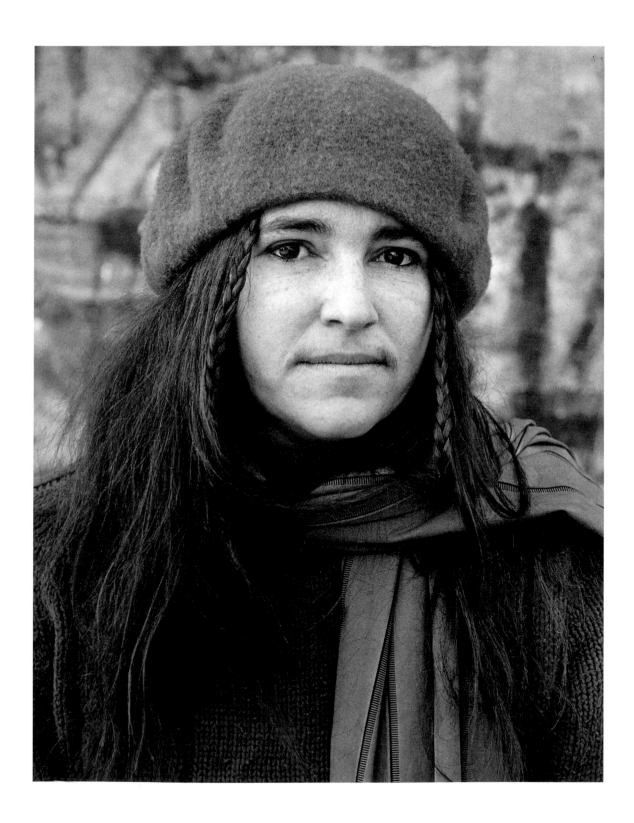

Bernadette Mayer  New York School poet

Paul Mazursky   Film director, actor, screenwriter

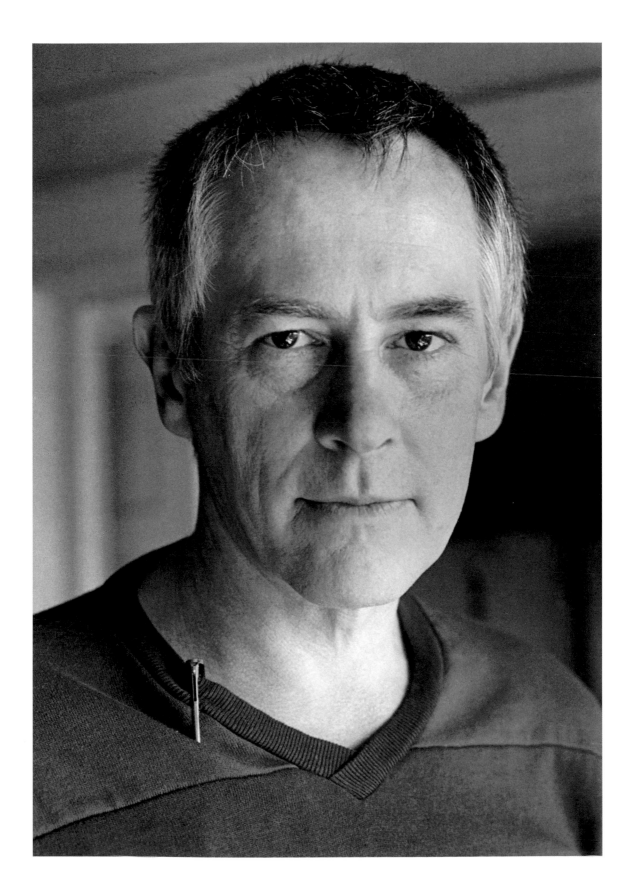

Michael McClure  Beat poet, playwright, essayist

Frank McCourt  Memoirist, Pulitzer Prize 1997

Ann McCoy  Alchemic painter

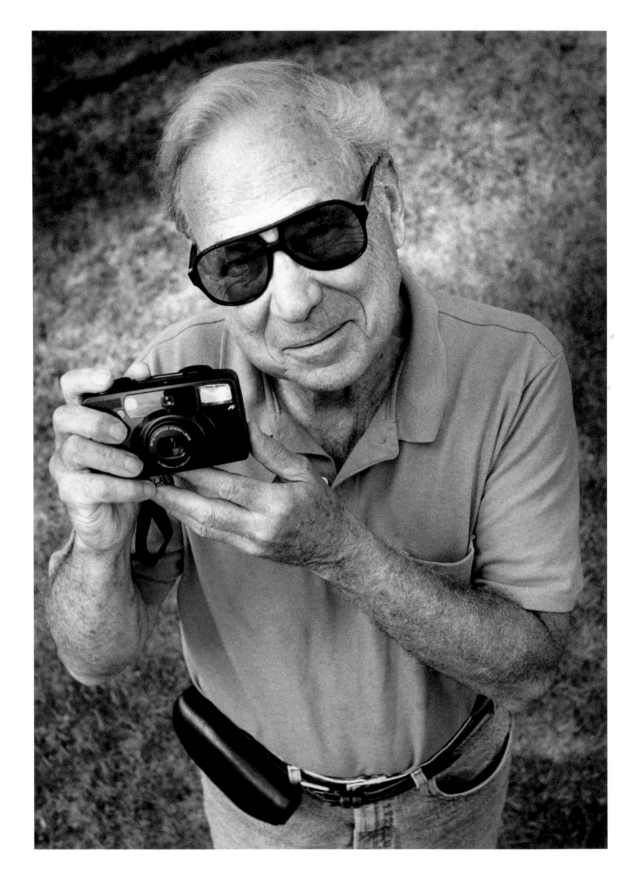

Fred W. McDarrah New York portrait photographer

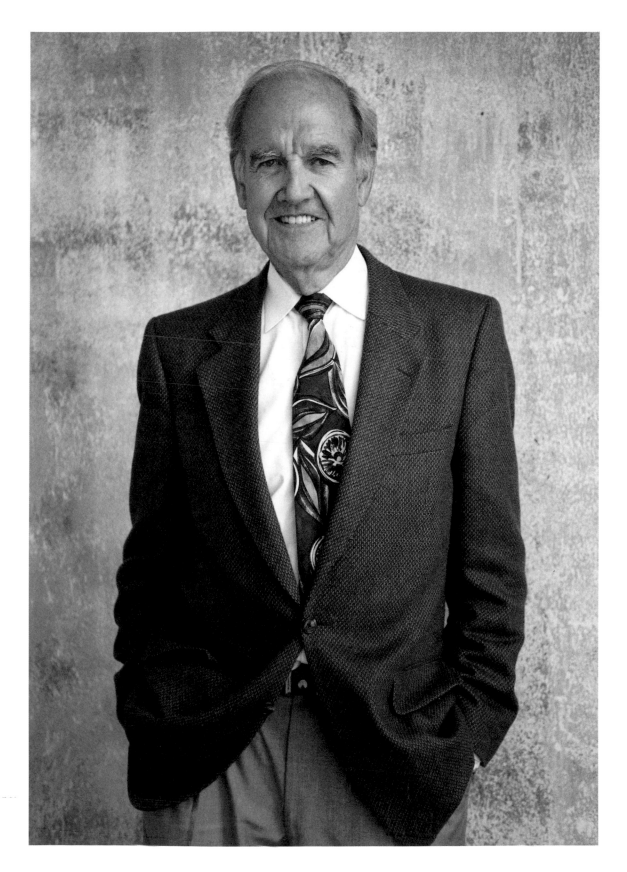

George McGovern  Presidential candidate, 1972

Jay McInerney  Comic novelist

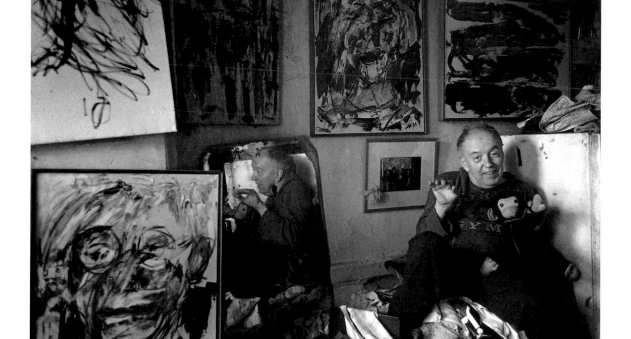

Taylor Mead  Actor, writer

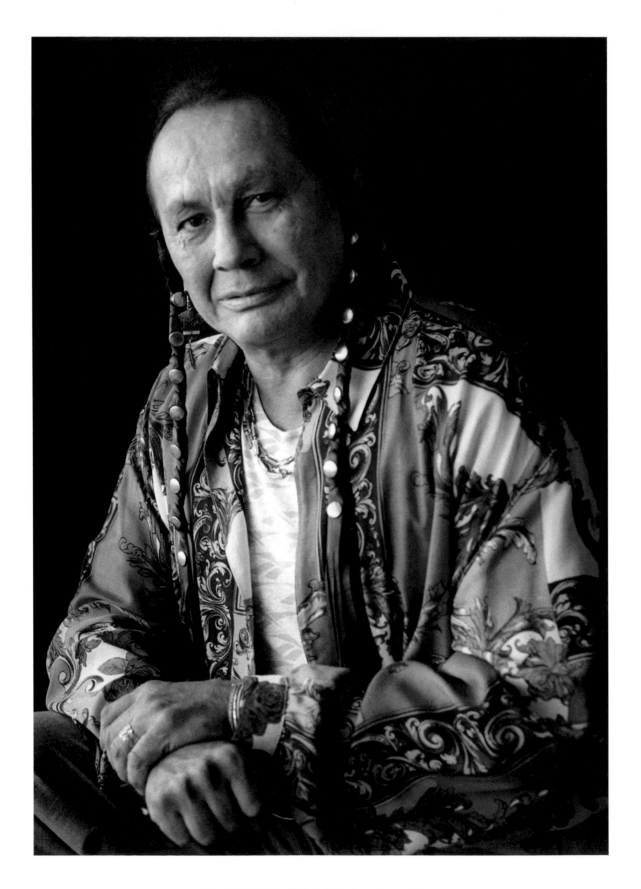

Russell Means  Oglala Lakota actor, author

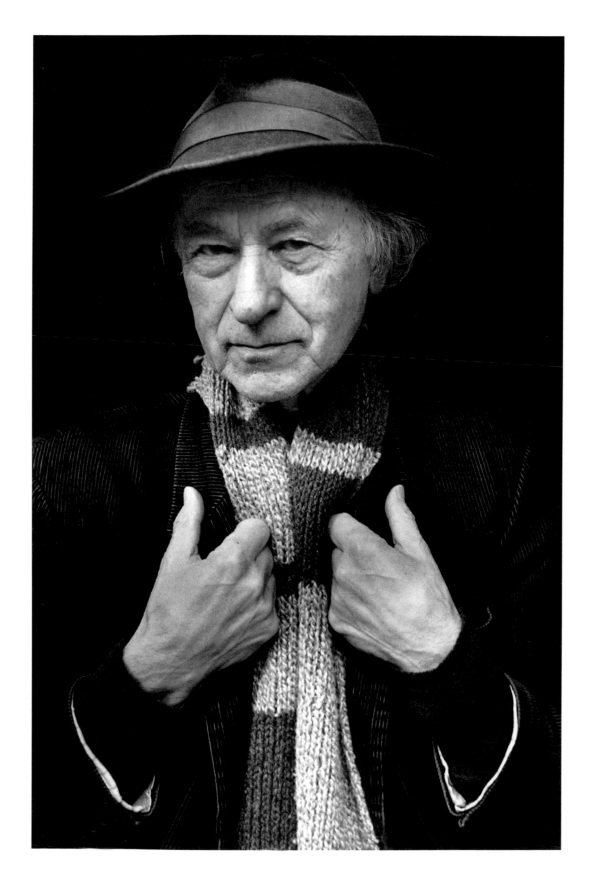

Jonas Mekas  Filmmaker, critic

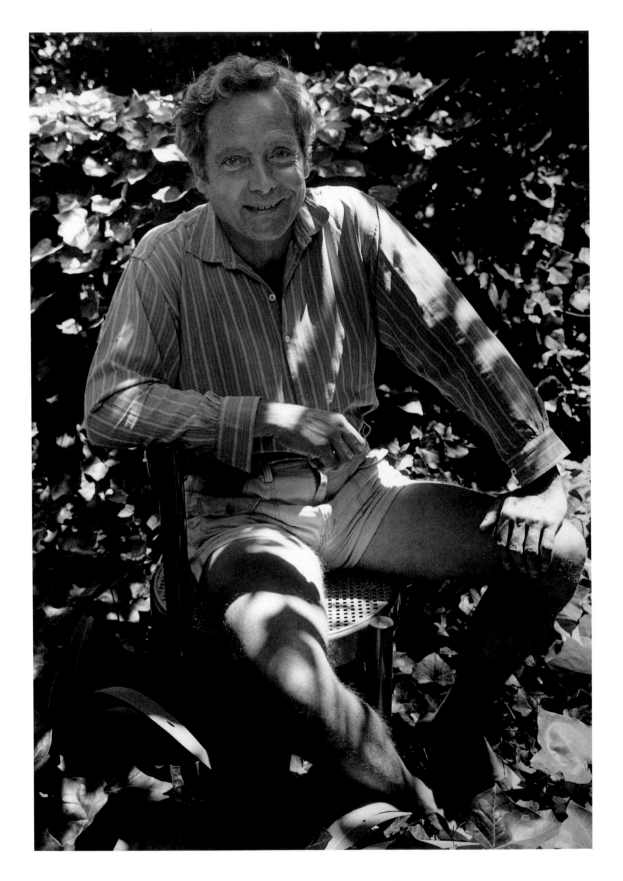

W. S. Merwin  Poet, translator, conservationist

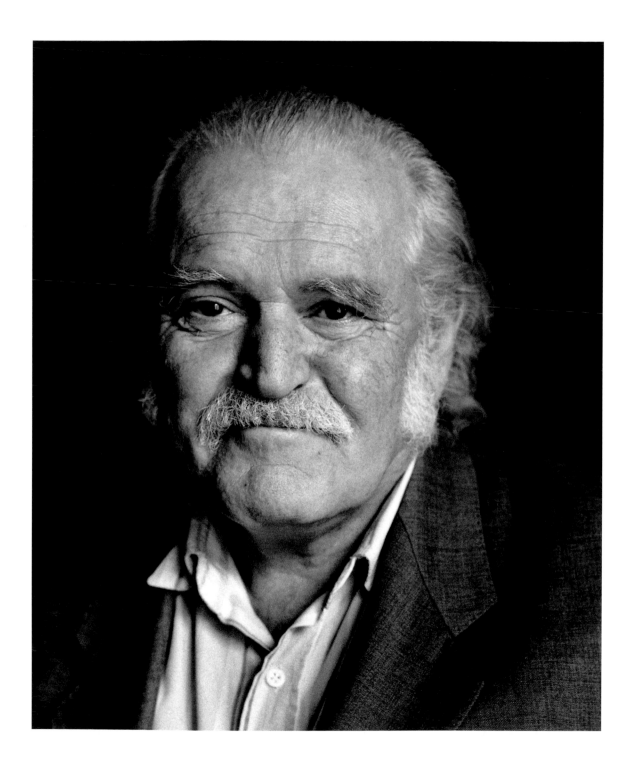

Mario Merz  *Arte Povera* artist

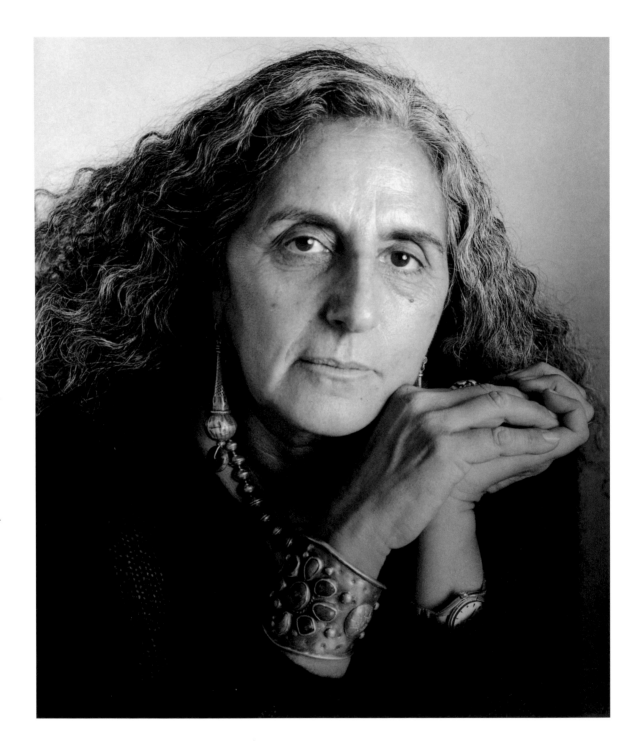

Sheila Metzner Photographer

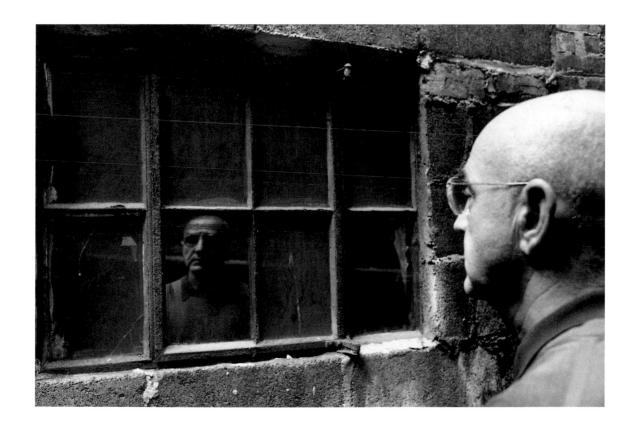

Duane Michals  Photographer, writer

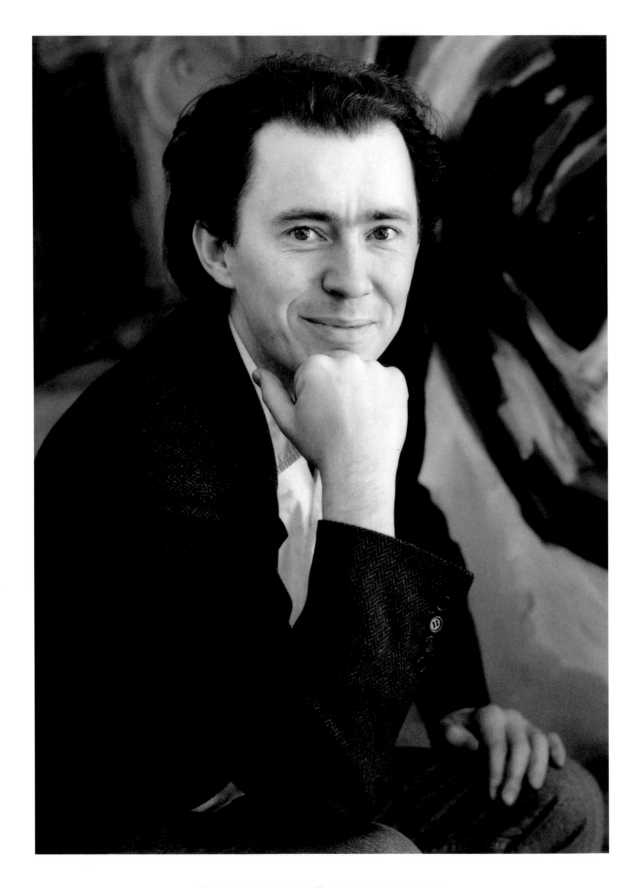

-282-

Helmut Middendorf  Neo-Expressionist artist

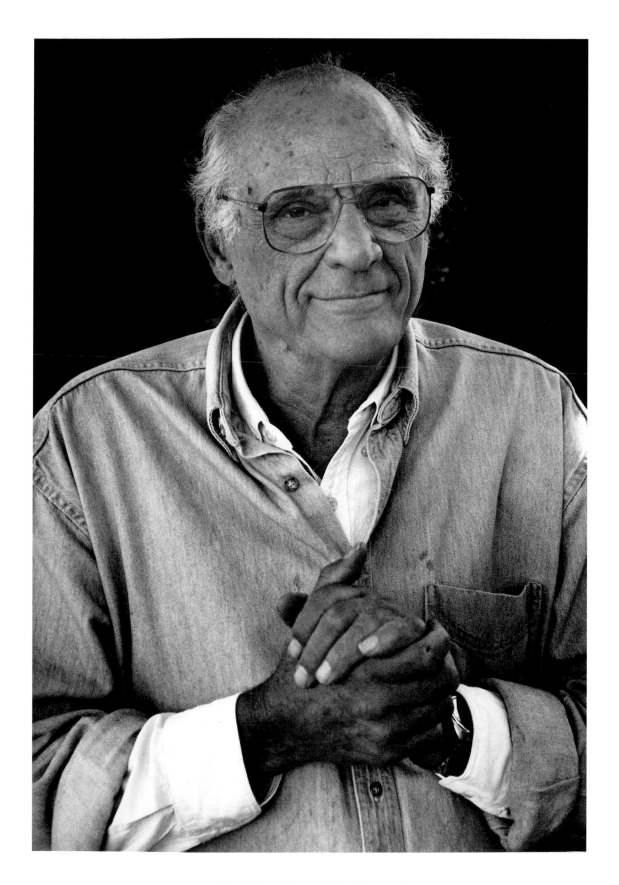

Arthur Miller  Playwright, fiction writer

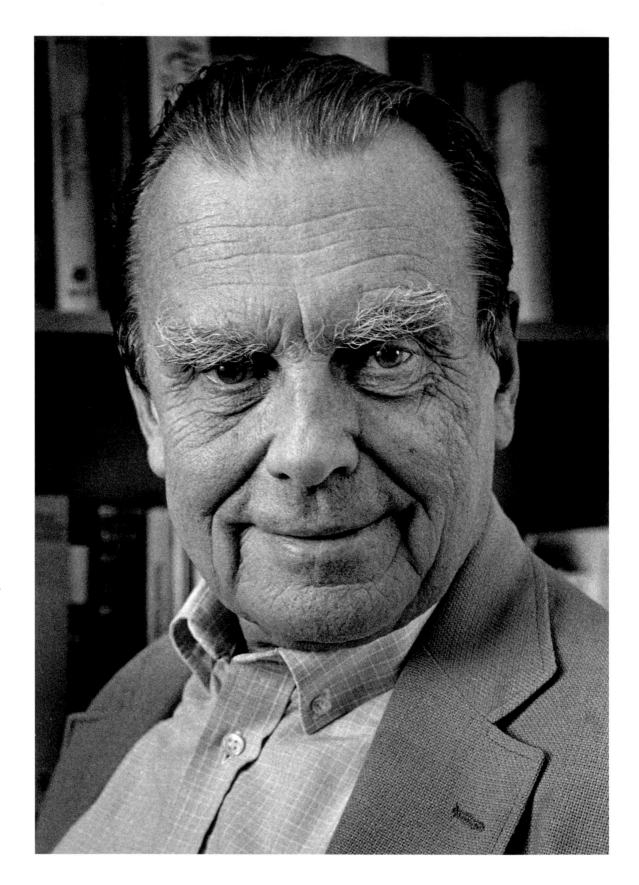

Czeslaw Milosz  Poet, Nobel laureate 1980

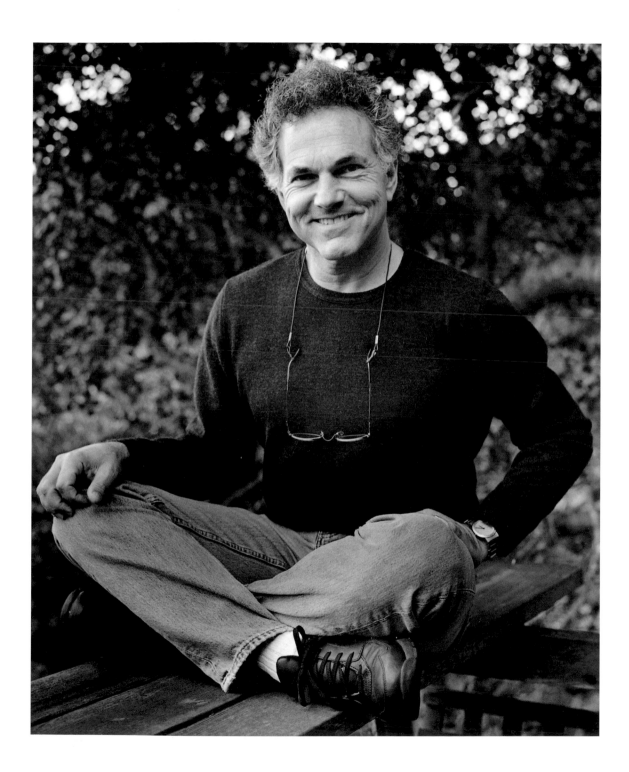

Richard Misrach  Photographer

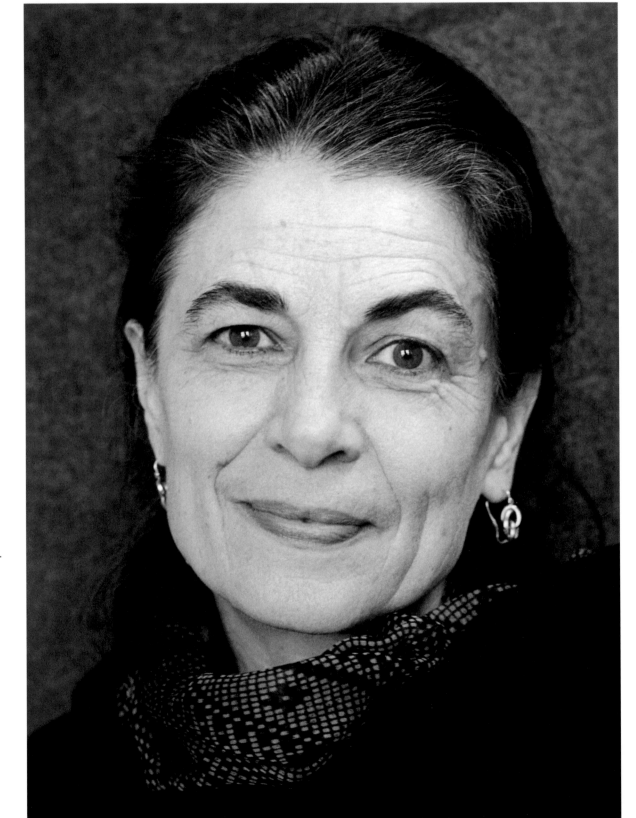

Mary Miss  Site specific sculptor

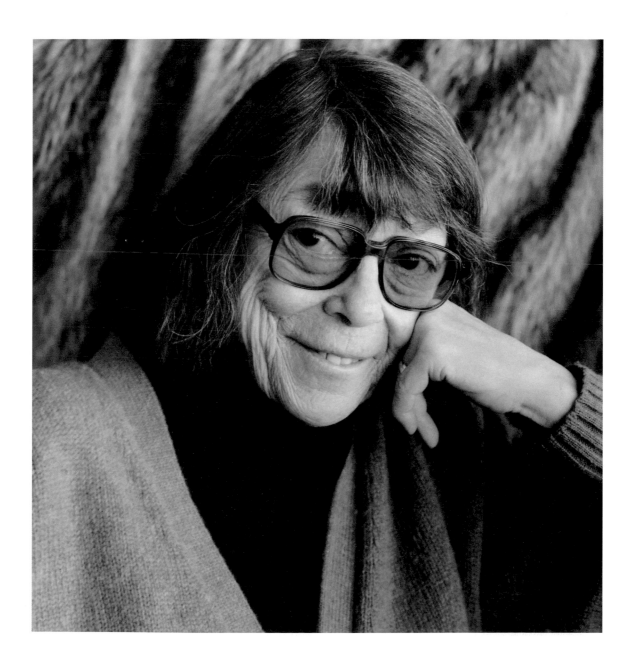

Joan Mitchell  Abstract painter

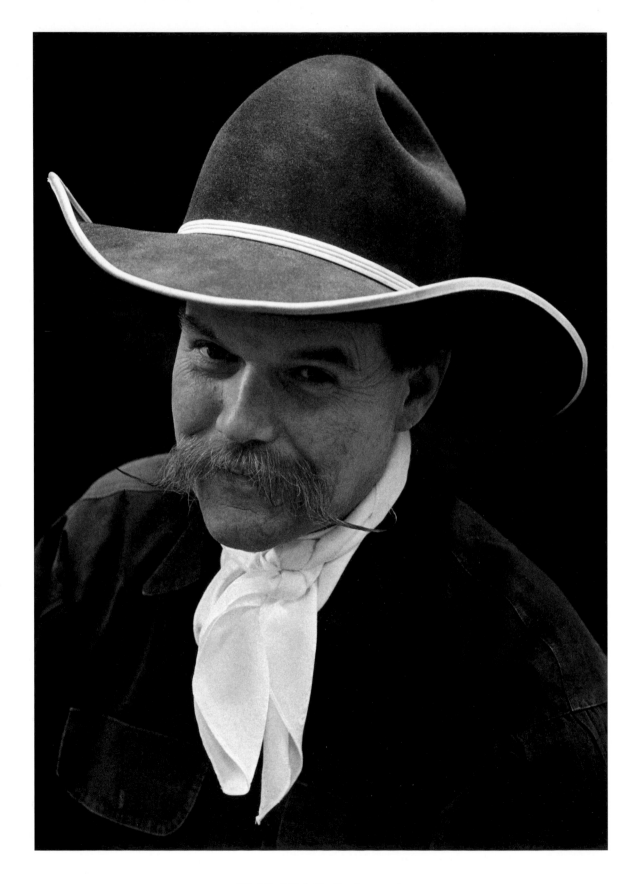

Waddie Mitchell  Cowboy poet

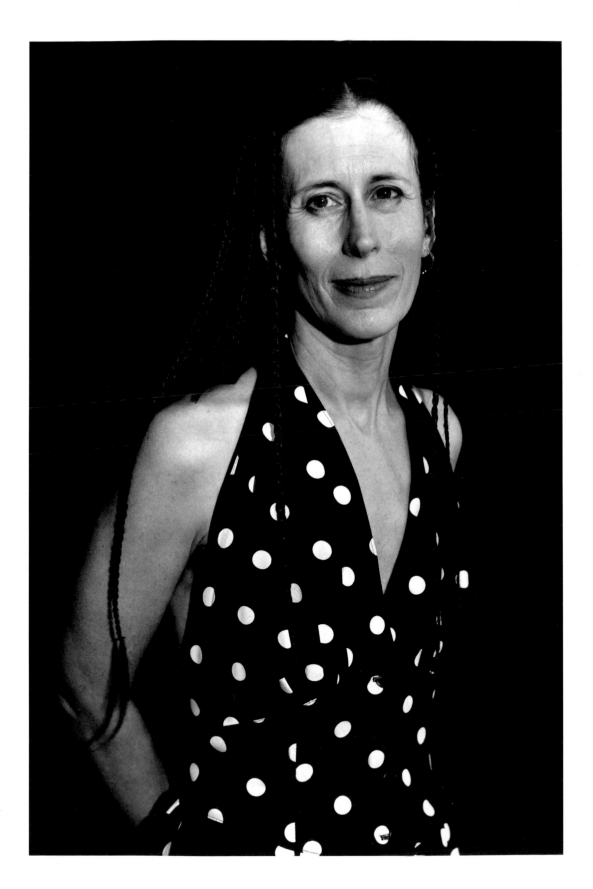

Meredith Monk  Singer, composer

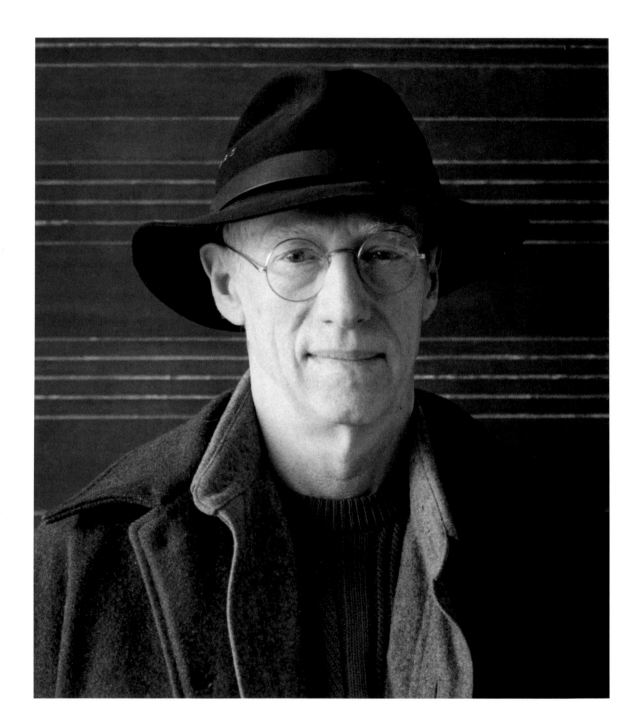

Robert Morris  Sculptor, performance artist

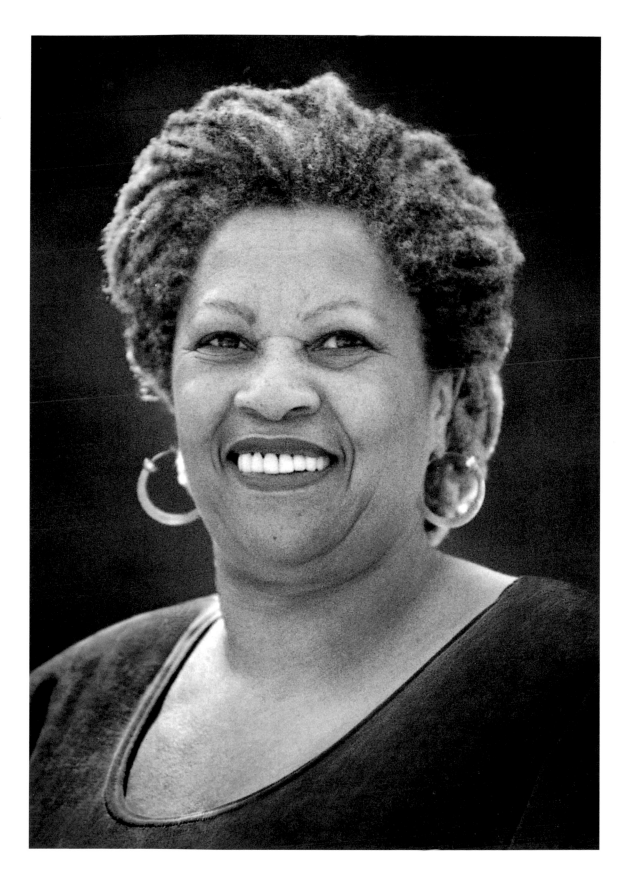

Toni Morrison  Novelist, Nobel laureate 1993

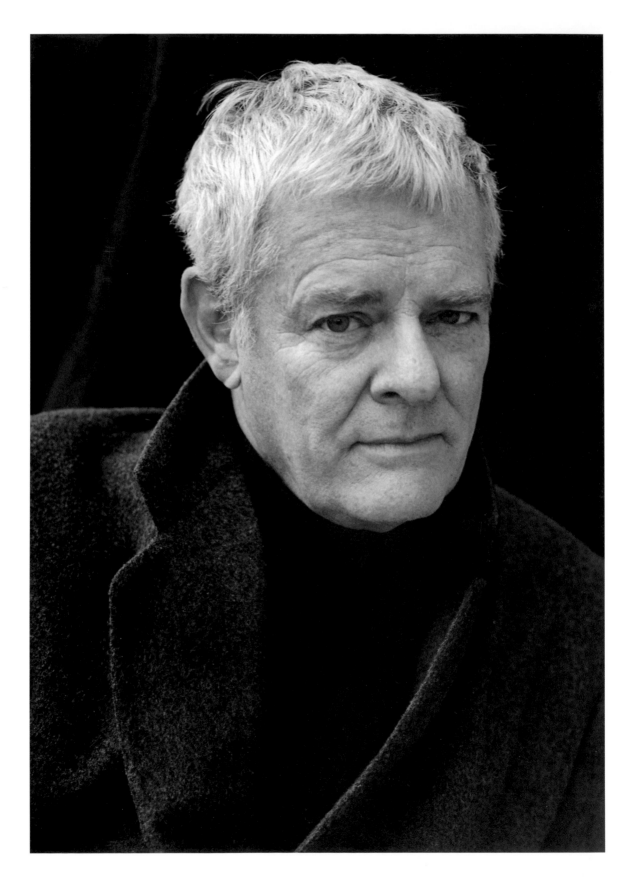

Paul Morrissey  Art film director

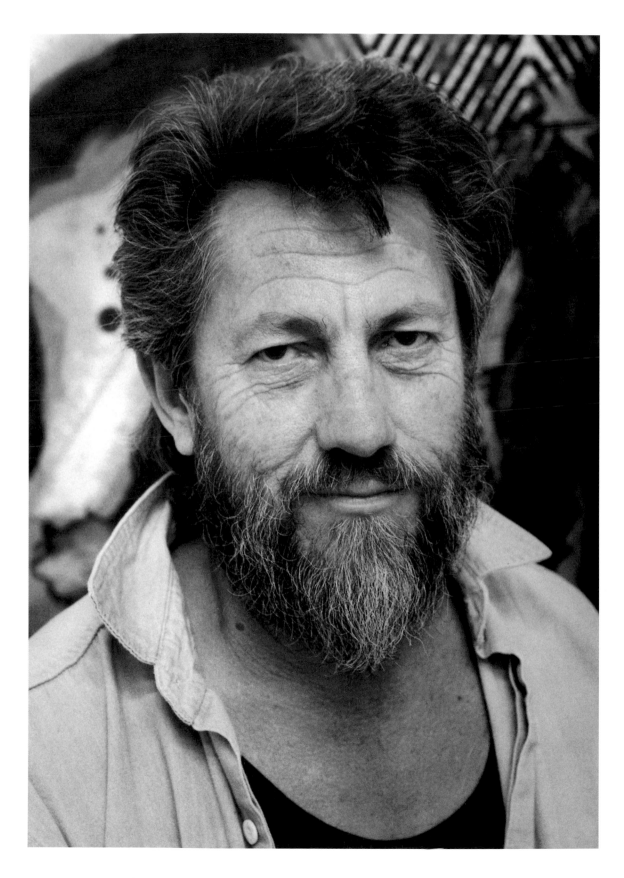

Ed Moses  West Coast artist

Robert Motherwell  Abstract expressionist painter, collagist

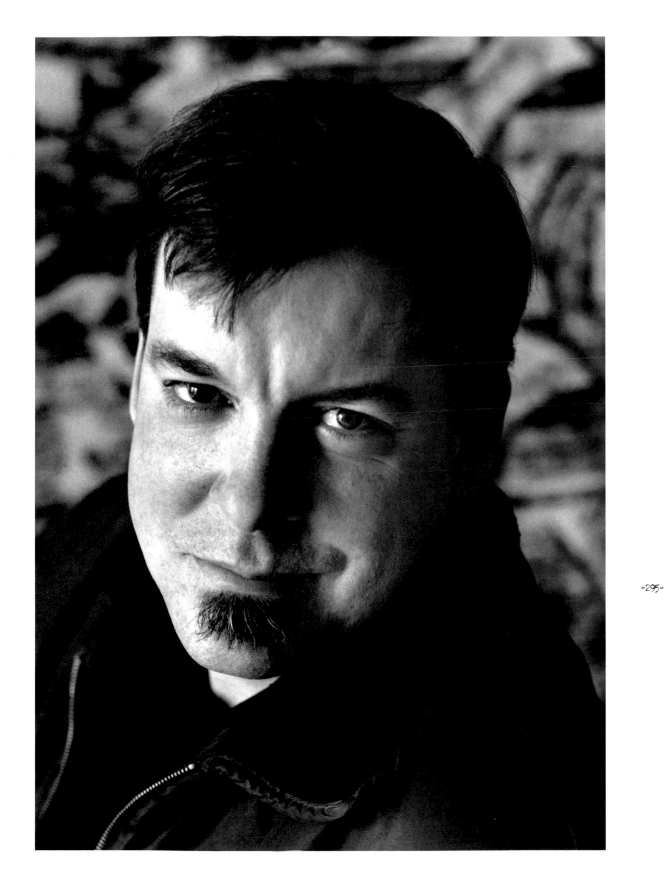

Matt Mullican  L.A. computer/video artist

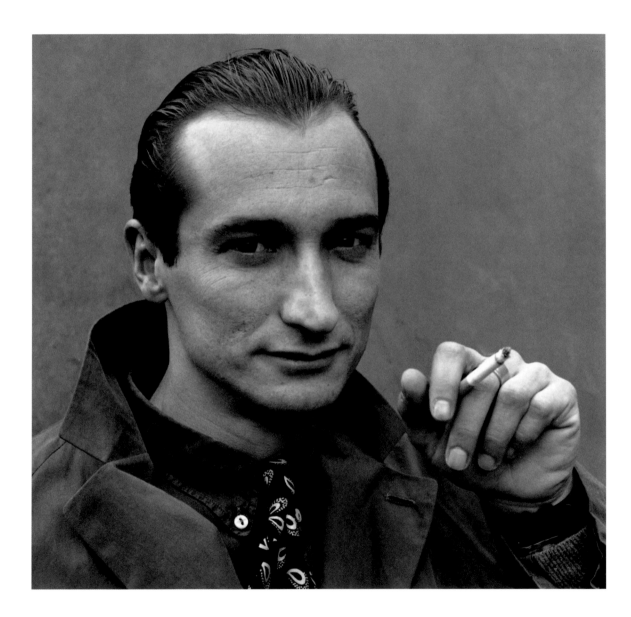

Juan Muñoz  Spanish conceptual artist

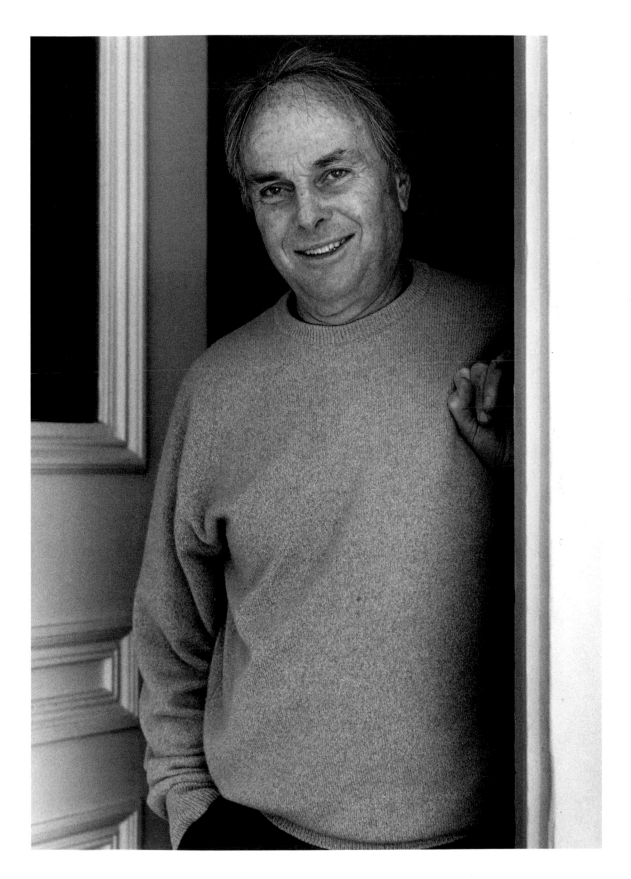

Michael Murphy  Esalen cofounder, author

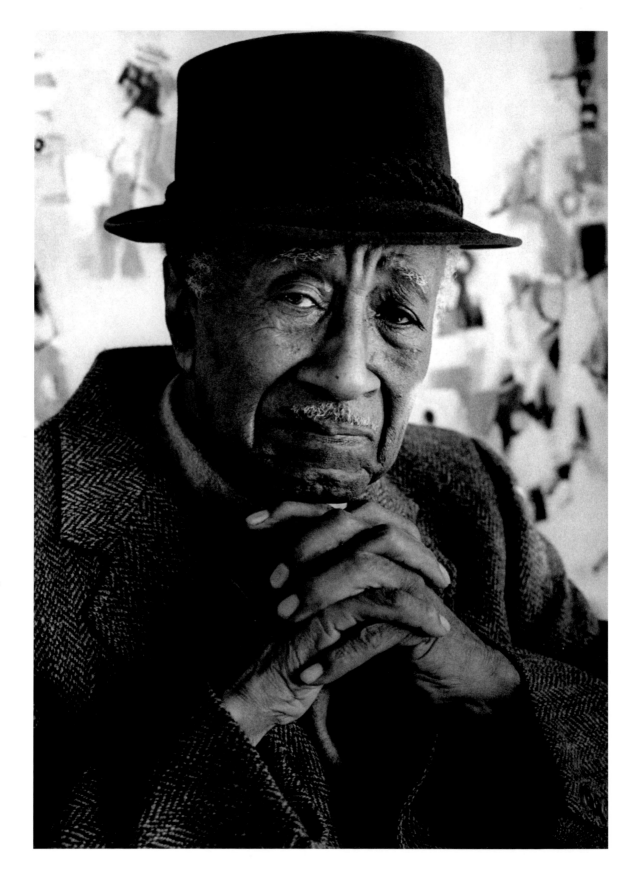

Albert Murray  Critic, biographer, novelist

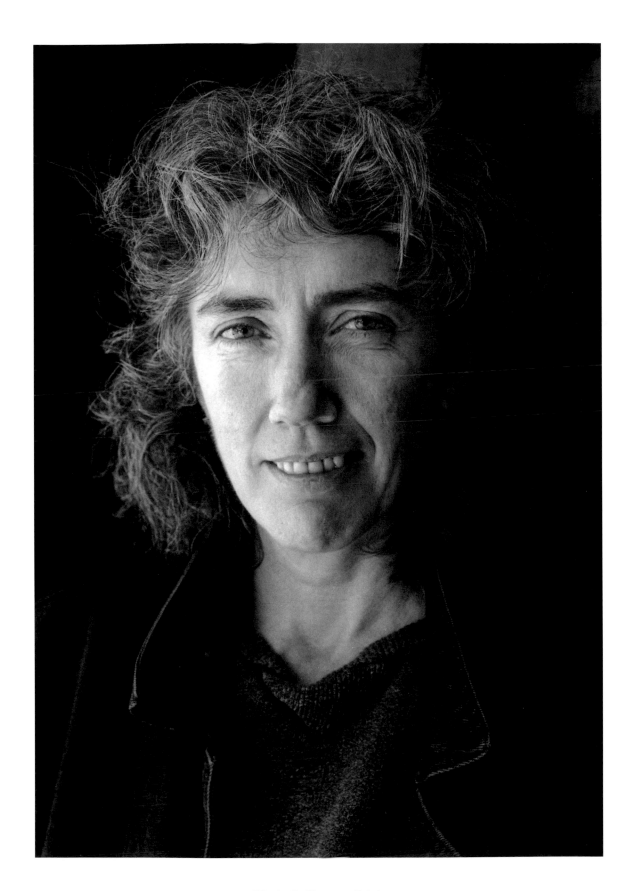

Elizabeth Murray  Painter

Eileen Myles  Poet, prose writer

Graham Nash  Musician, photographer

Willie Nelson  Country western singer/songwriter

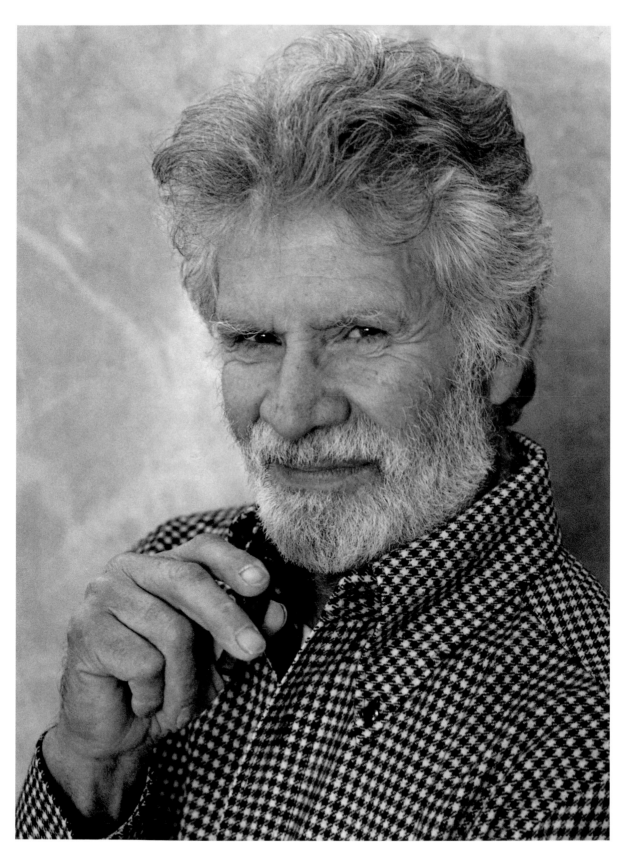

**Manuel Neri** Bay Area figurative sculptor

-304-

Louise Nevelson  Abstract assemblagist/sculptor

Arnold Newman  Portrait photographer

Isamu Noguchi  Artist

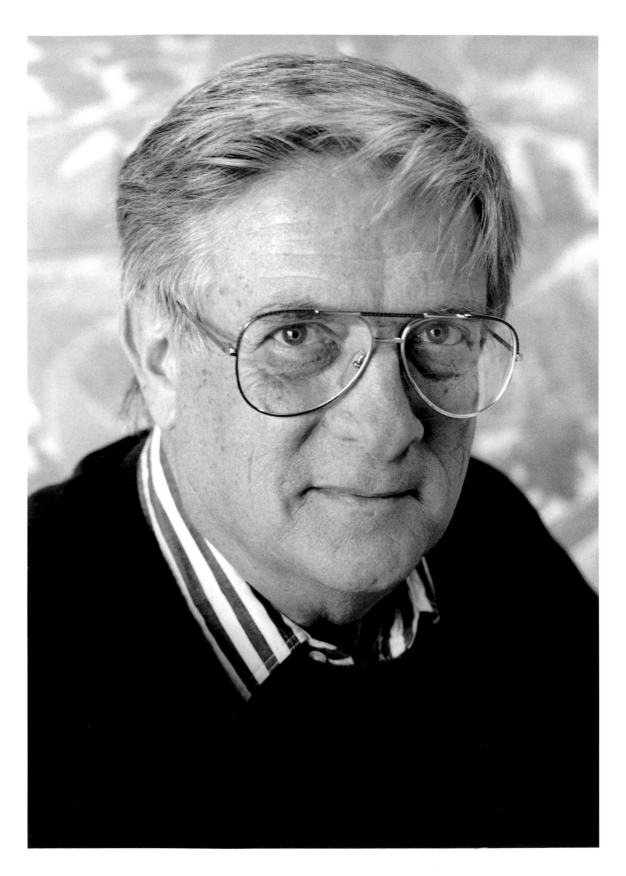

Kenneth Noland  Painter

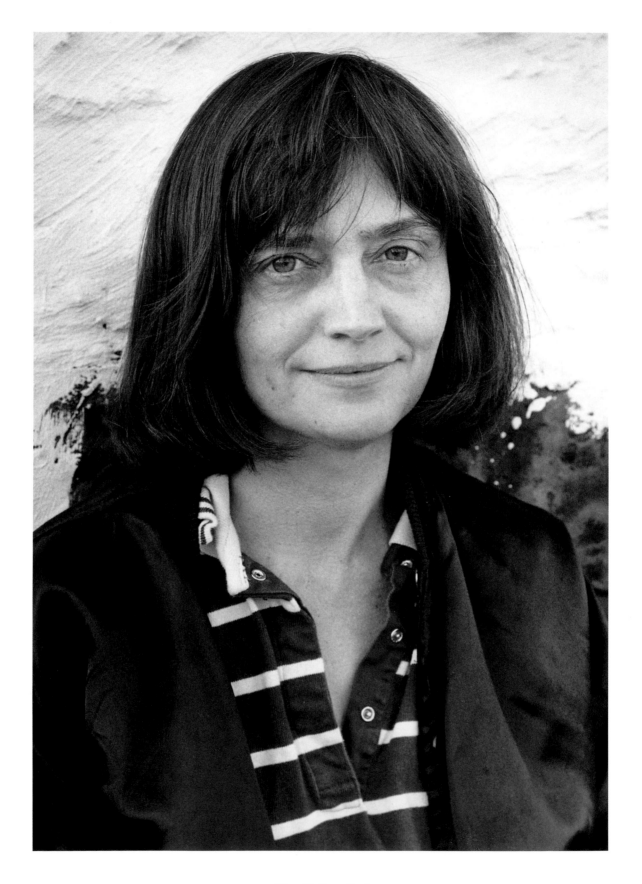

Alice Notley  Poet

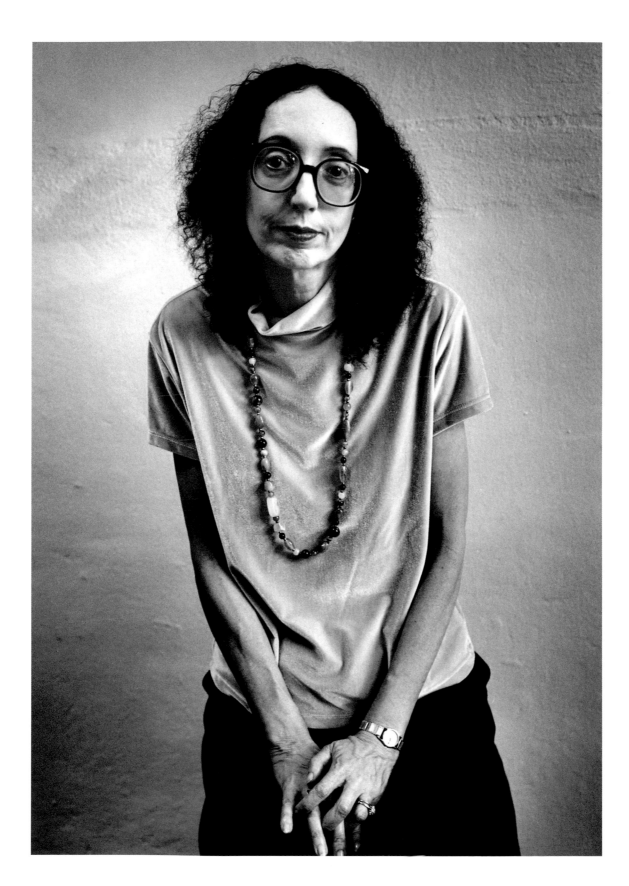

Joyce Carol Oates  Fiction writer, poet, critic

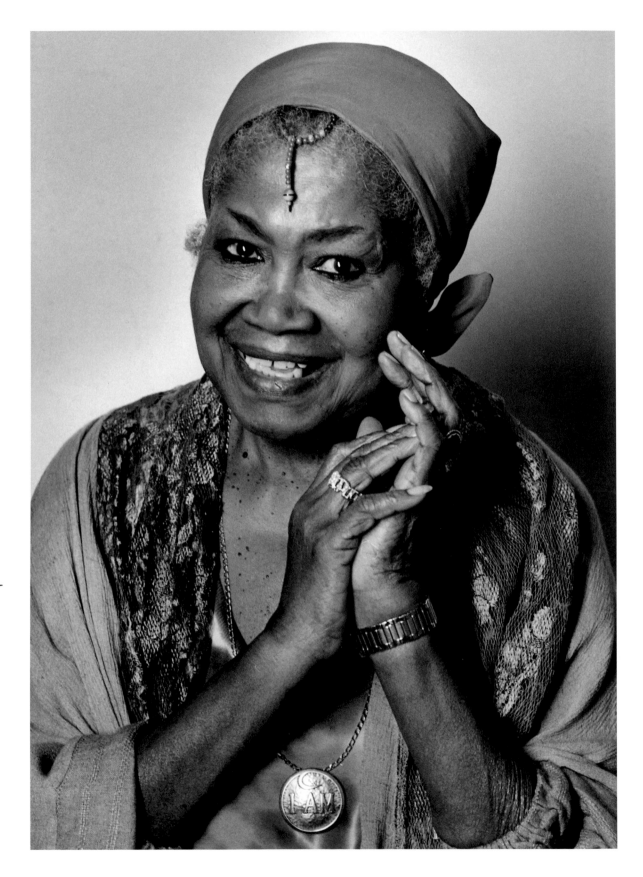

Odetta  Folksinger/actress

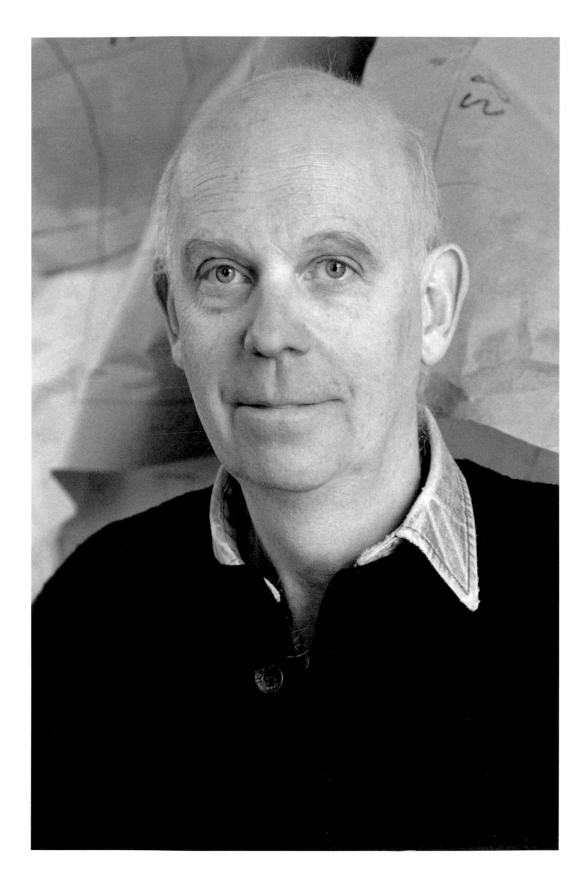

Claes Oldenburg  Pop art sculptor

Sharon Olds  Poet

Tillie Olsen  Fiction writer, activist

Michael Ondaatje  Canadian poet, novelist

Dennis Oppenheim  Performance artist, sculptor

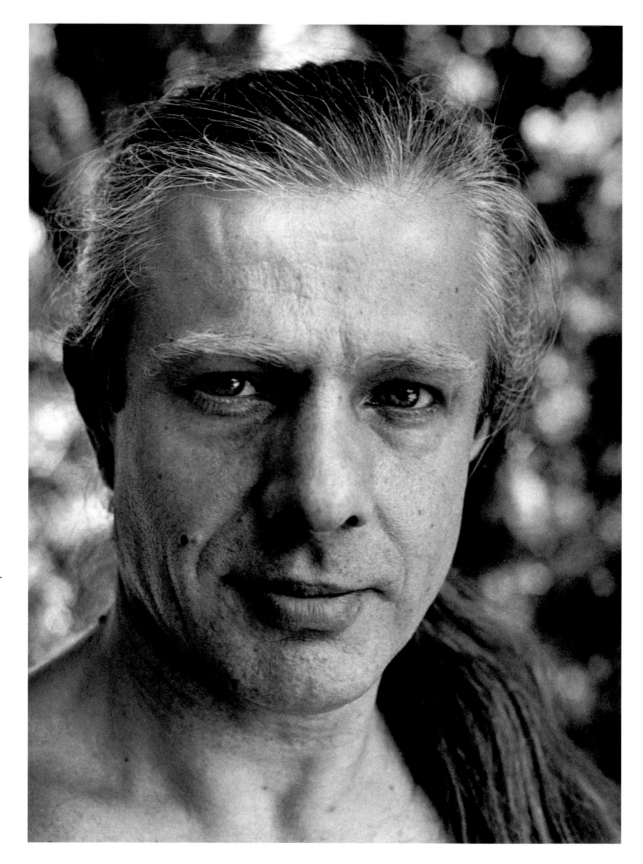

Peter Orlovsky  Beat poet

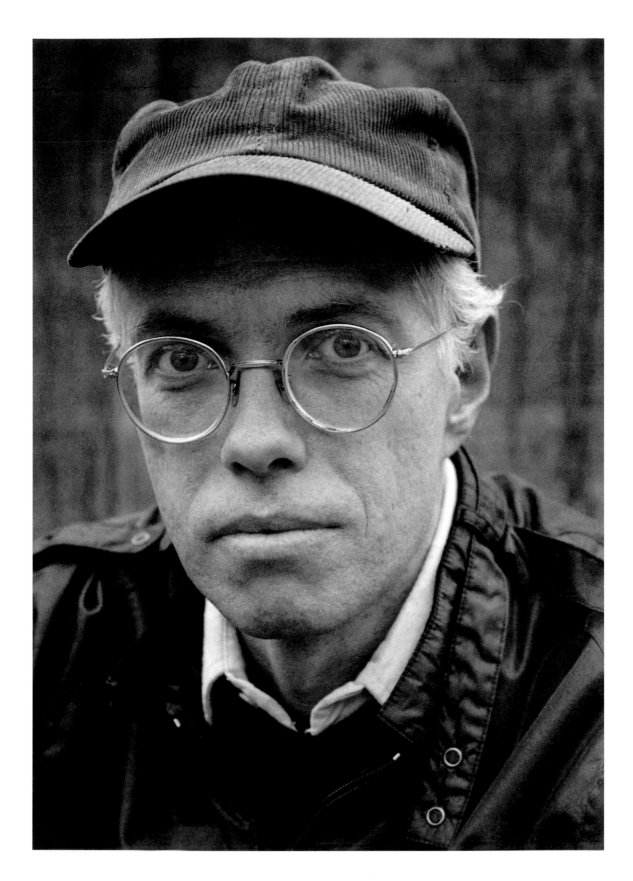

Ron Padgett  Poet, educator

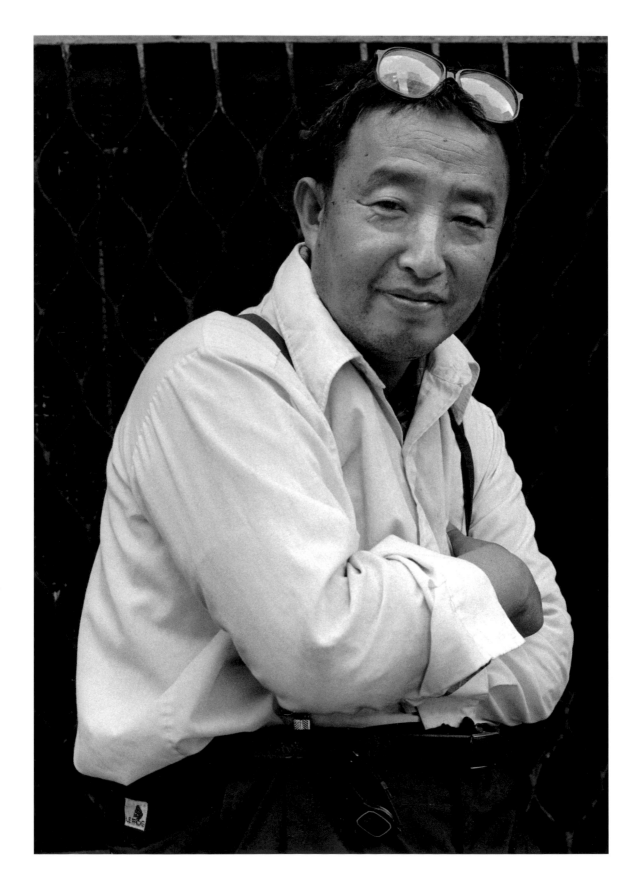

Nam June Paik  Video artist

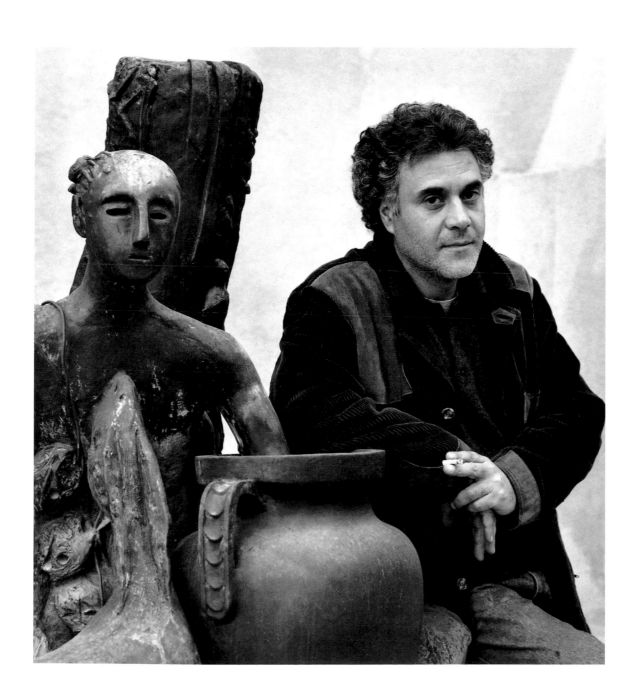

**Mimmo Paladino** Trans-avantgarde artist

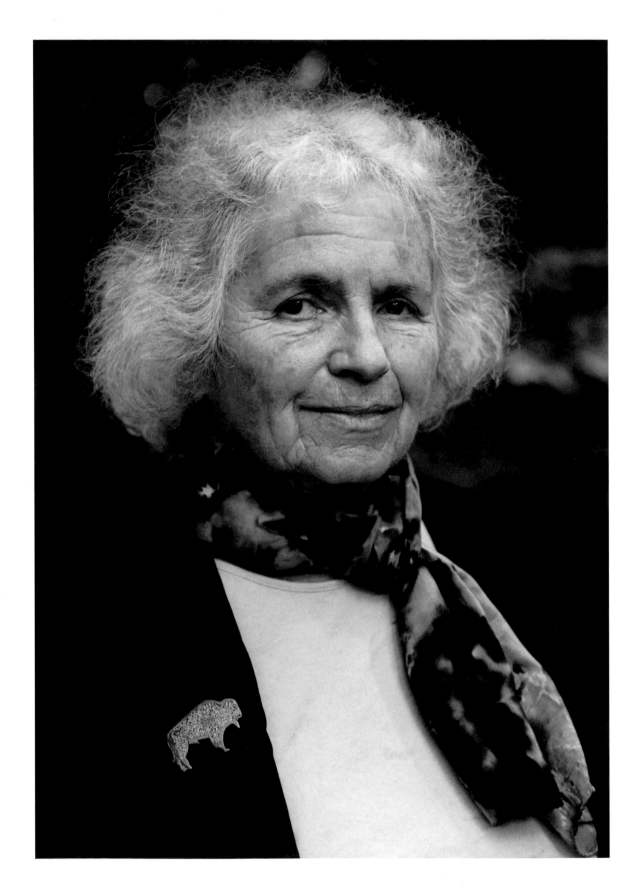

Grace Paley  Fiction writer, poet

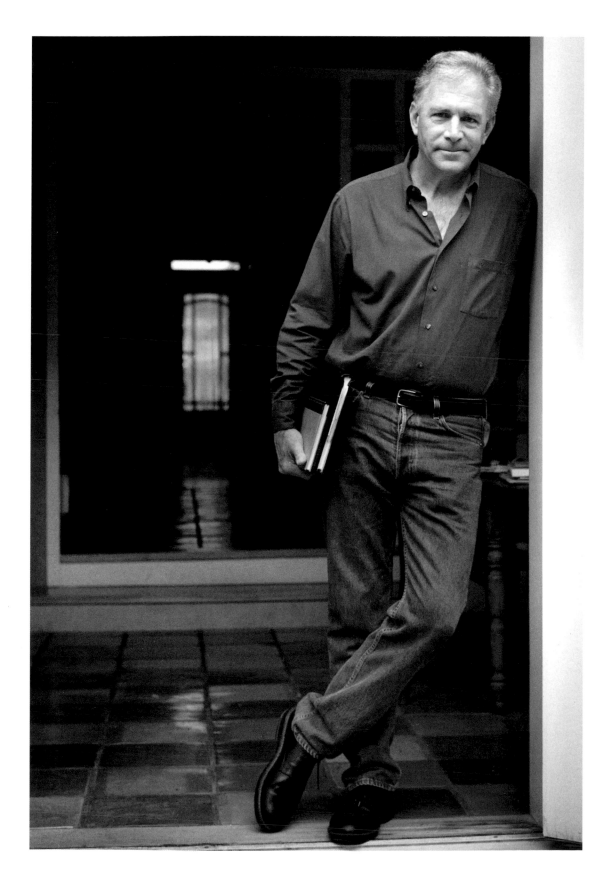

Michael Palmer  San Francisco poet

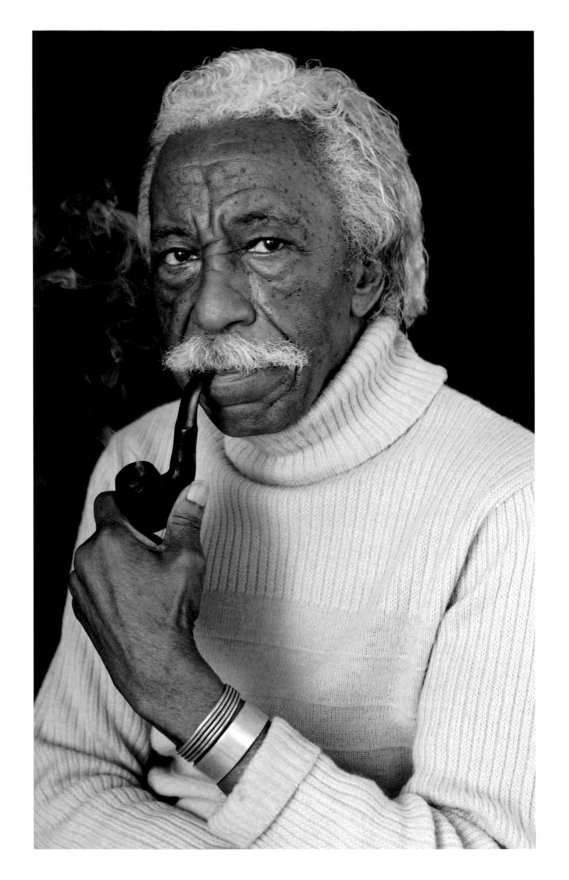

Gordon Parks  Photographer, film director, composer

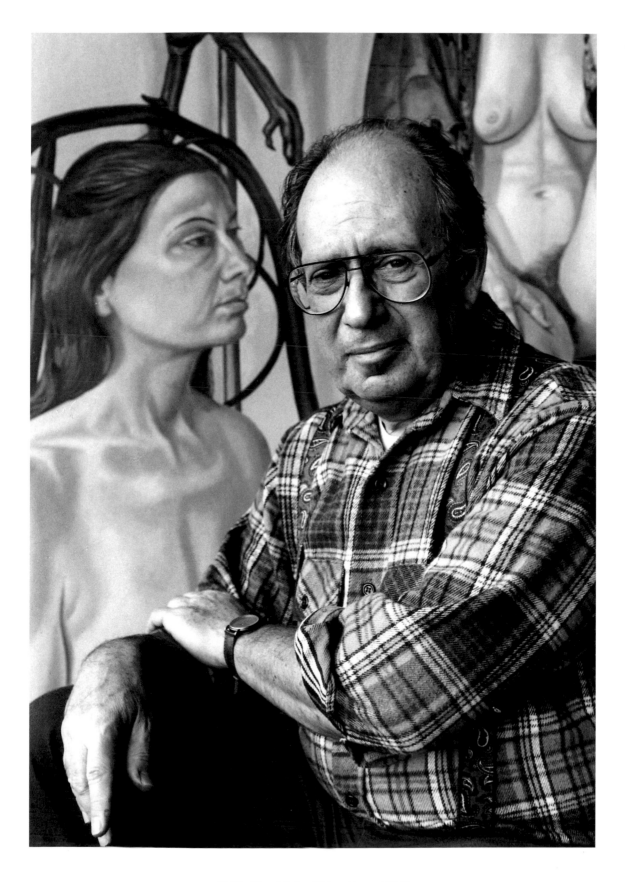

Philip Pearlstein  Figurative painter

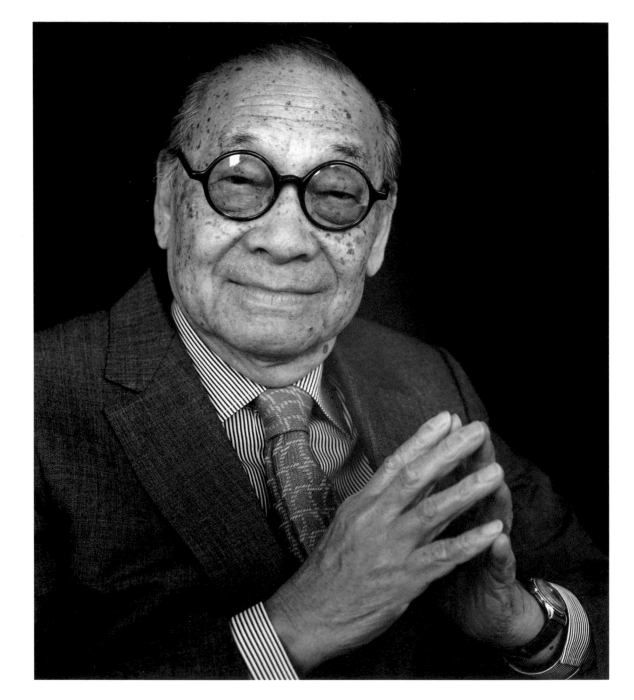

I. M. Pei  Architect

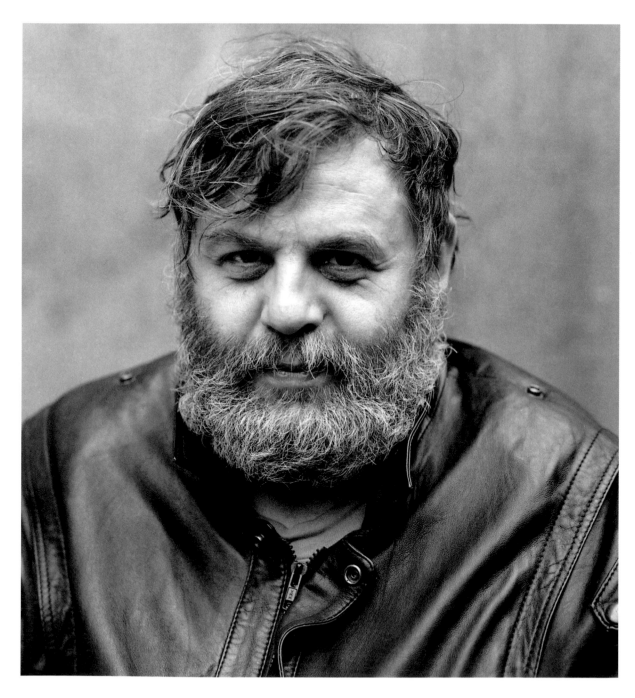

A. R. Penck  German painter

Judy Pfaff  Sculptor, installation artist

Robert Pinsky  U.S. Poet Laureate 1997–2000, critic, translator

George Plimpton  Author, journalist, humorist, editor *The Paris Review*

Anne & Patrick Poirier  French sculptors

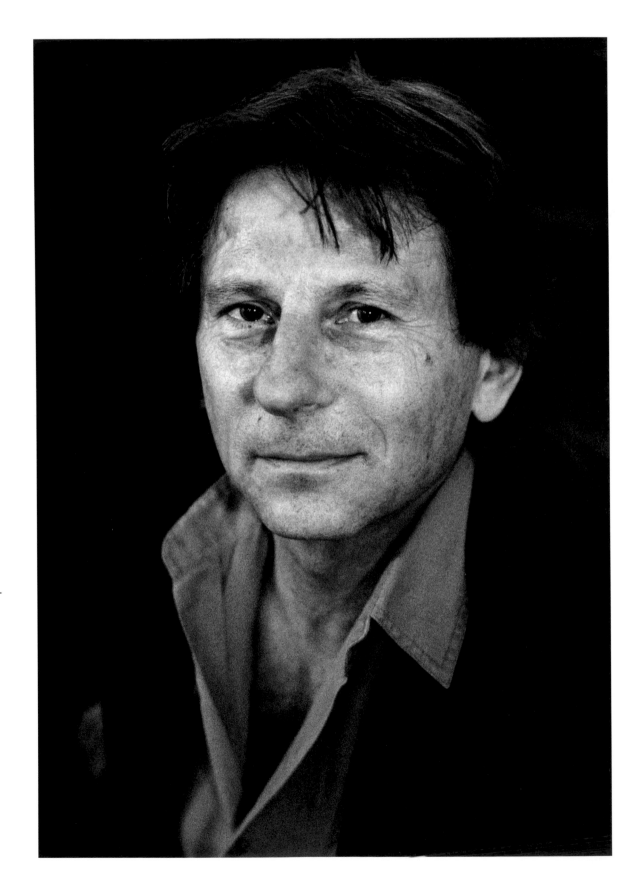

Roman Polanski  Director

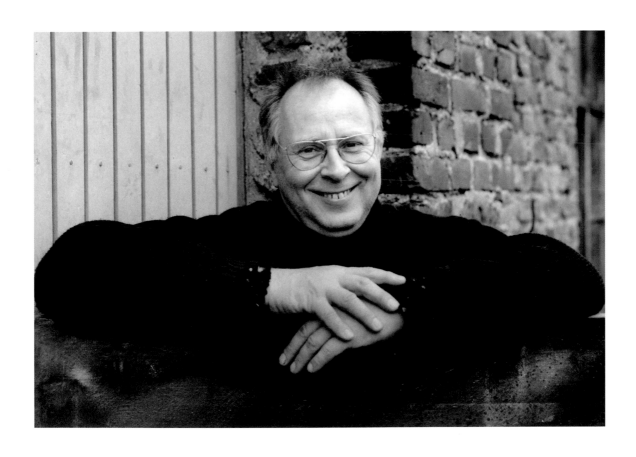

-331-

Sigmar Polke  German experimental painter

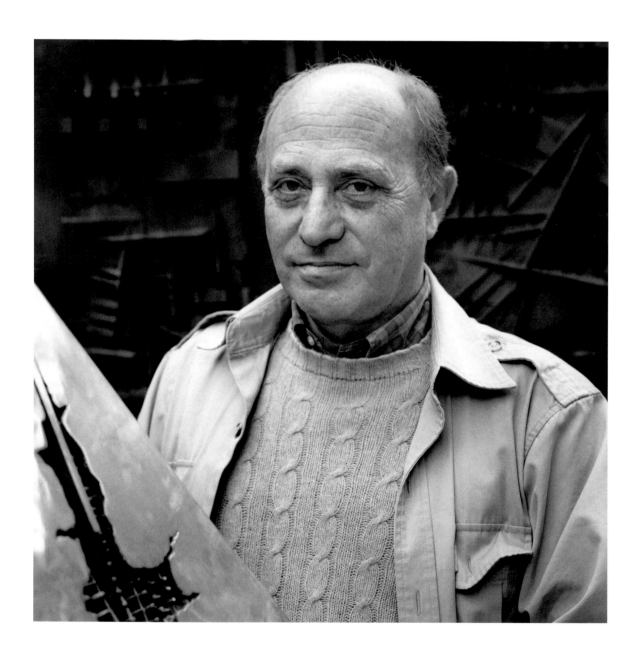

Arnaldo Pomodoro  Milan sculptor

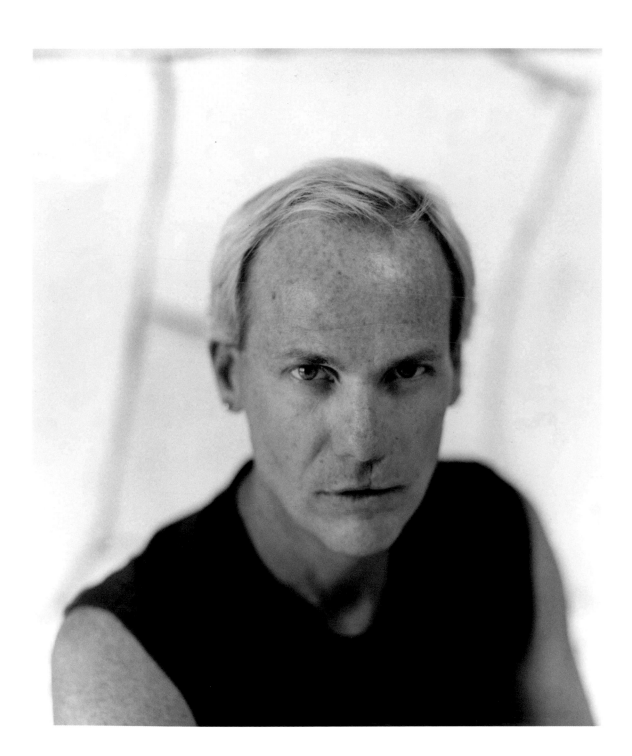

Richard Prince  Postmodernist painter/photographer

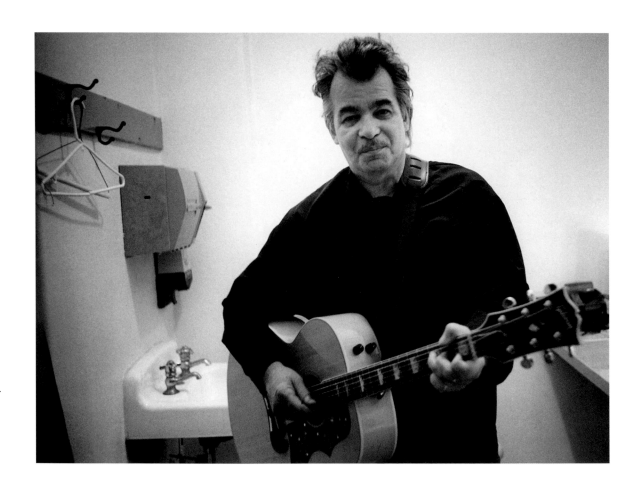

John Prine  Roadhouse blues singer

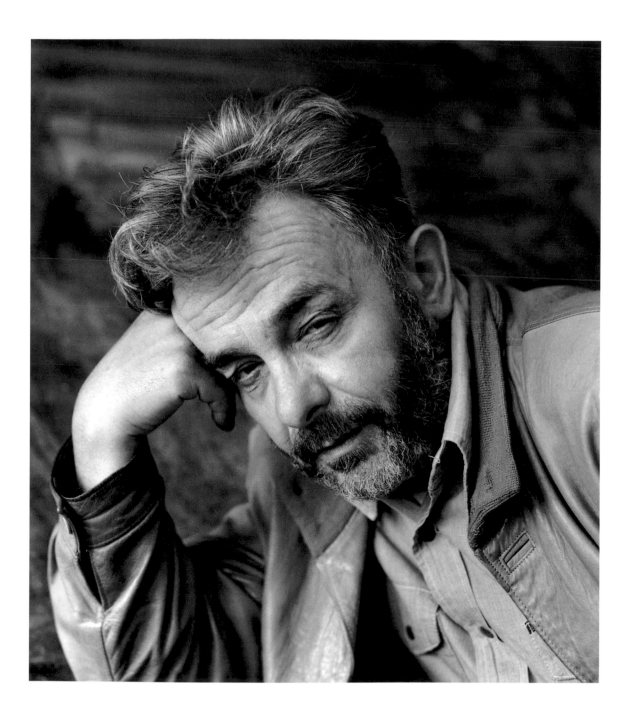

Arnulf Rainer  "Actionist" photographer

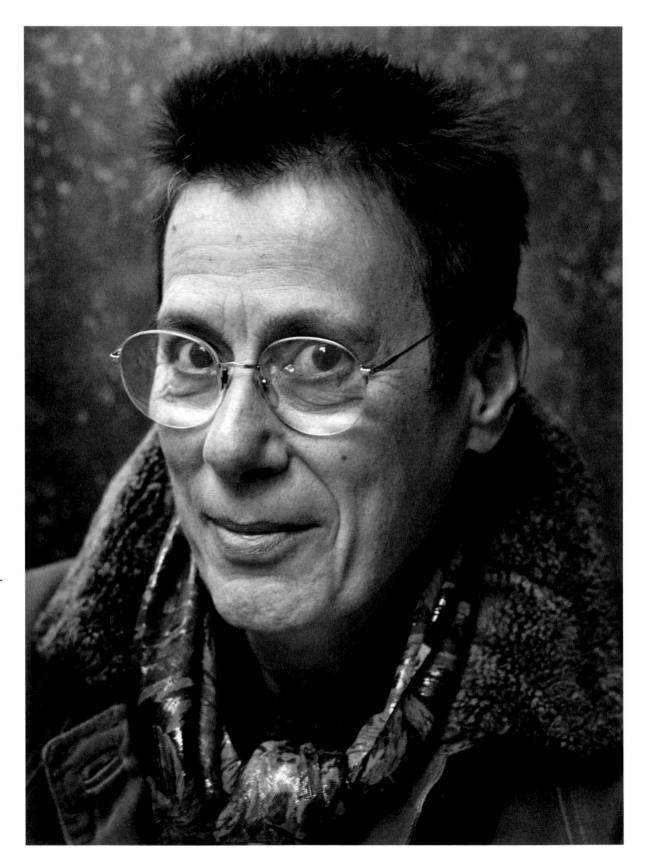

Yvonne Rainer  Avant-garde filmmaker, choreographer

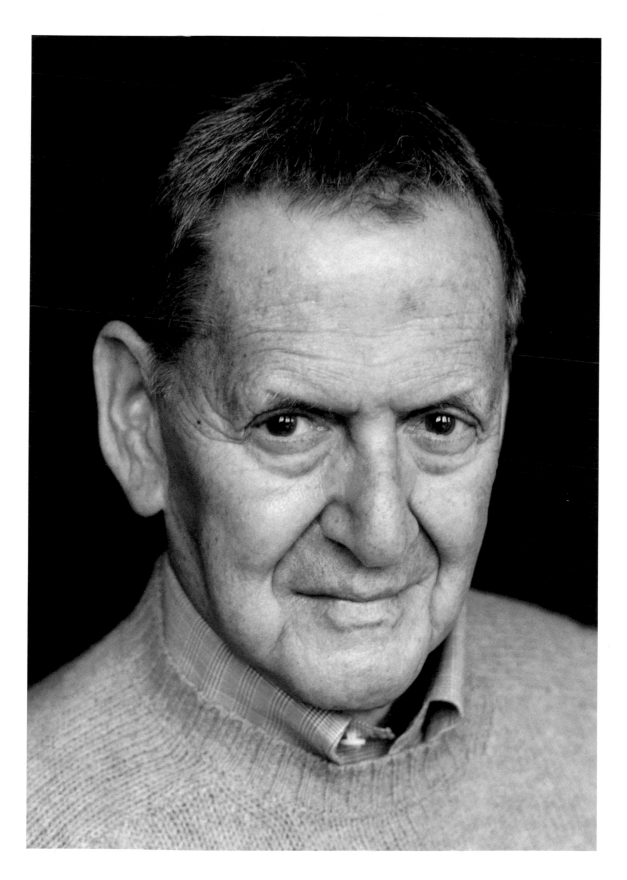

Tony Randall  Actor, film, stage

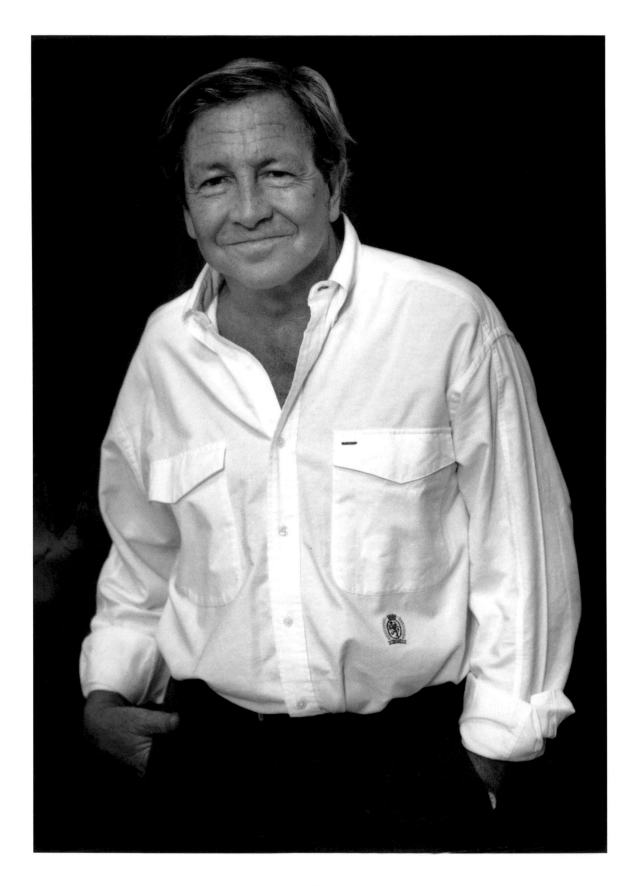

Robert Rauschenberg  Artist

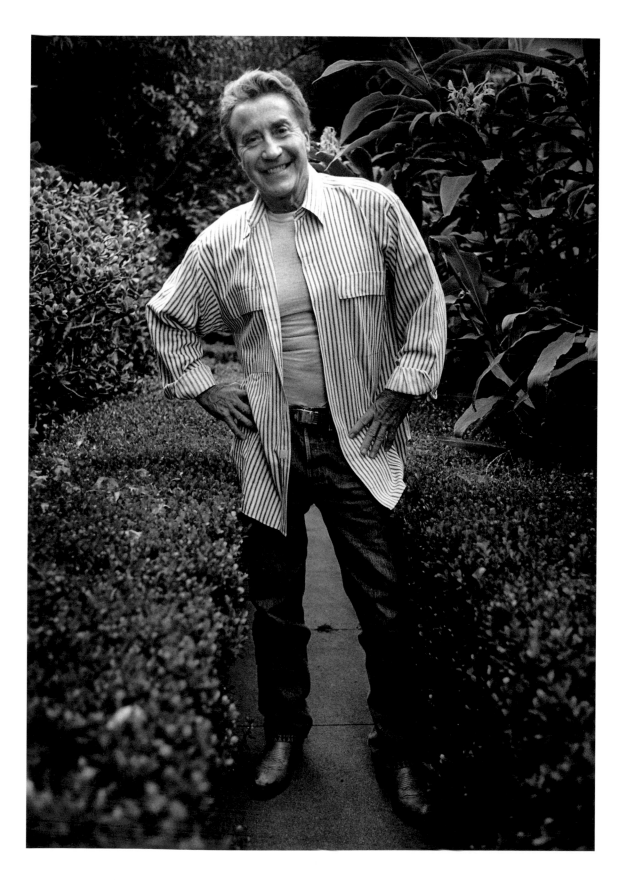

John Rechy  L.A. novelist

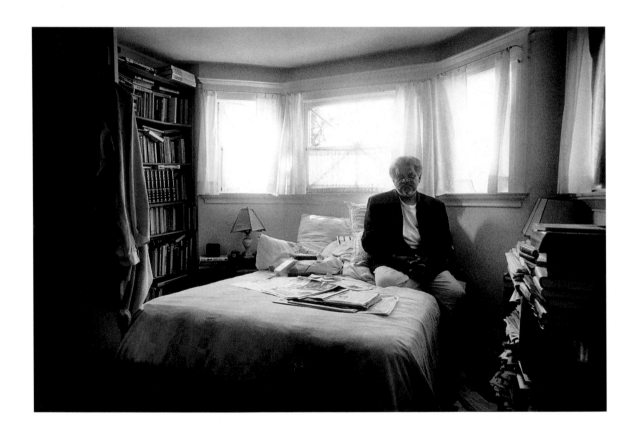

Ishmael Reed   Novelist, poet, media watcher

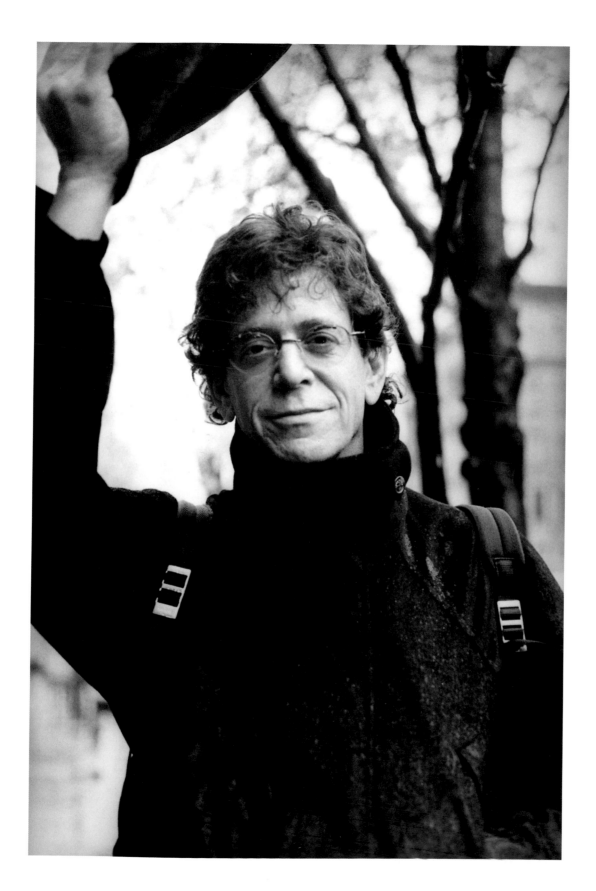

Lou Reed  Songwriter, avant-garde rocker

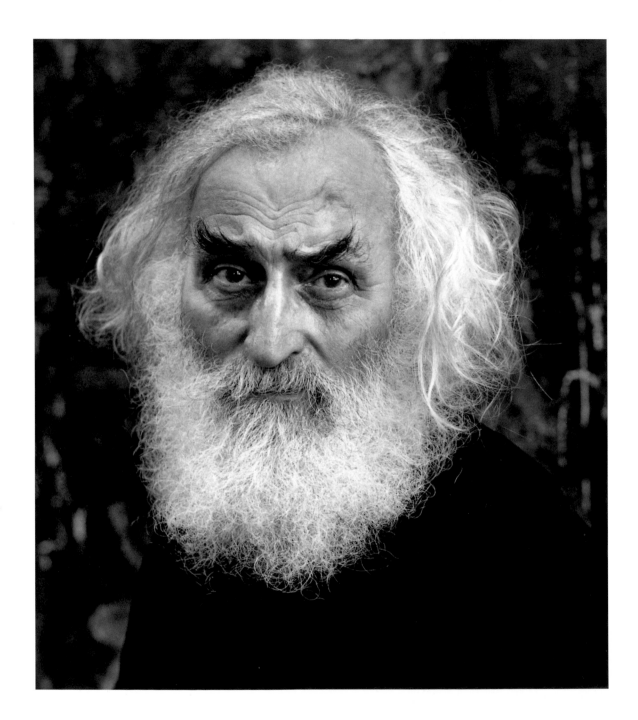

Milton Resnick  Abstract painter

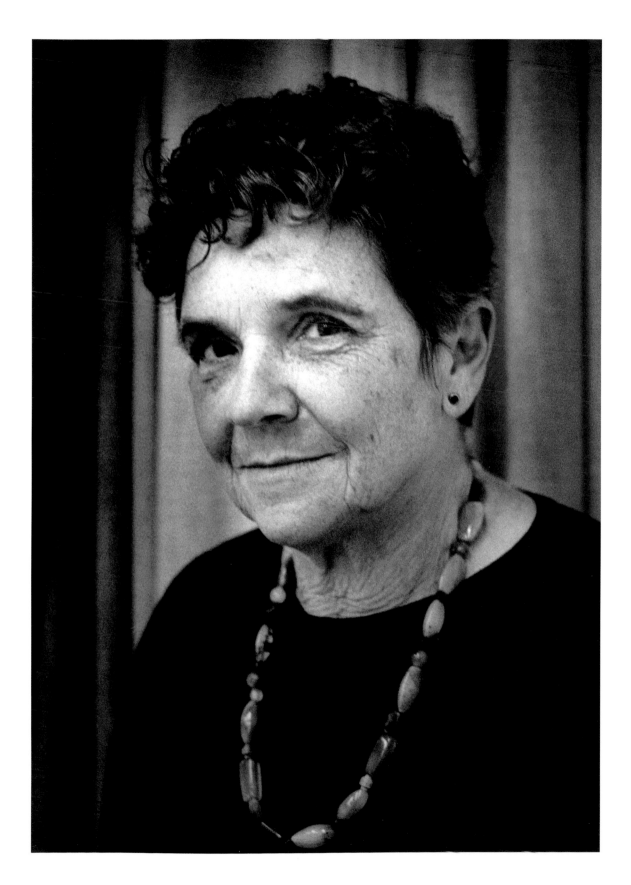

Adrienne Rich  Preeminent poet, feminist

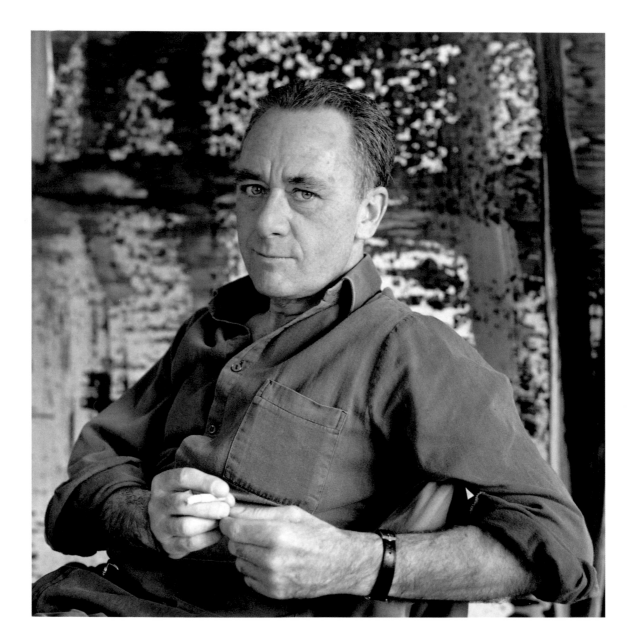

Gerhard Richter  German artist

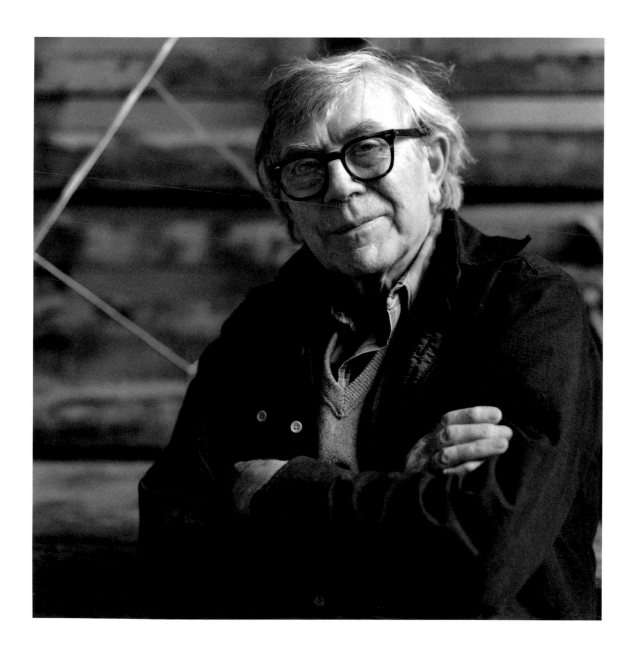

George Rickey  Kinetic sculptor

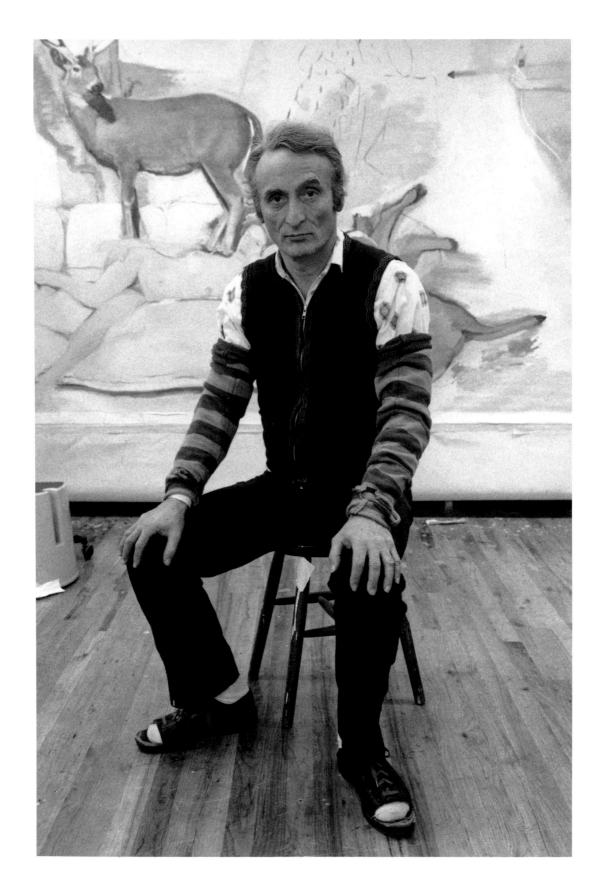

-346-

Larry Rivers  New York School artist

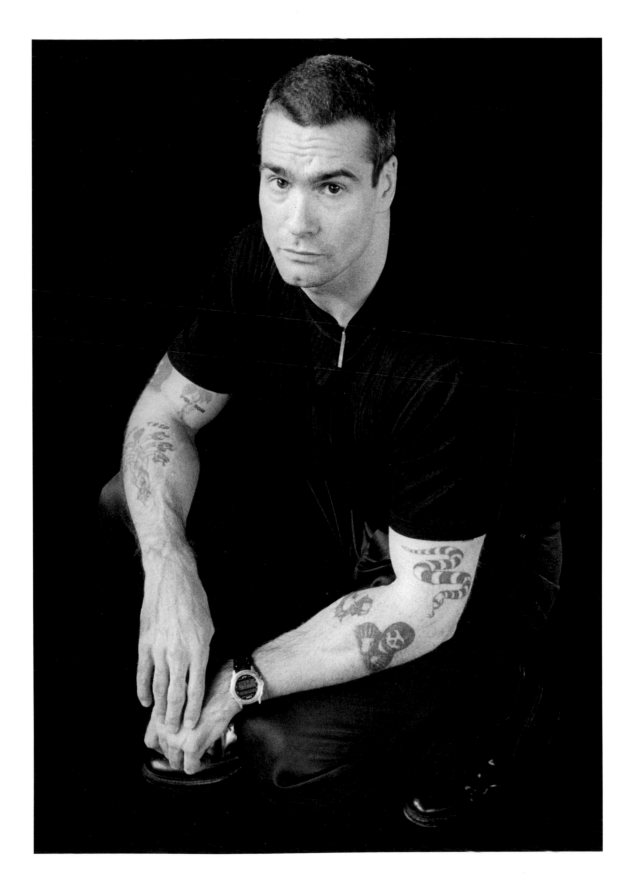

Henry Rollins  Spoken word artist, author

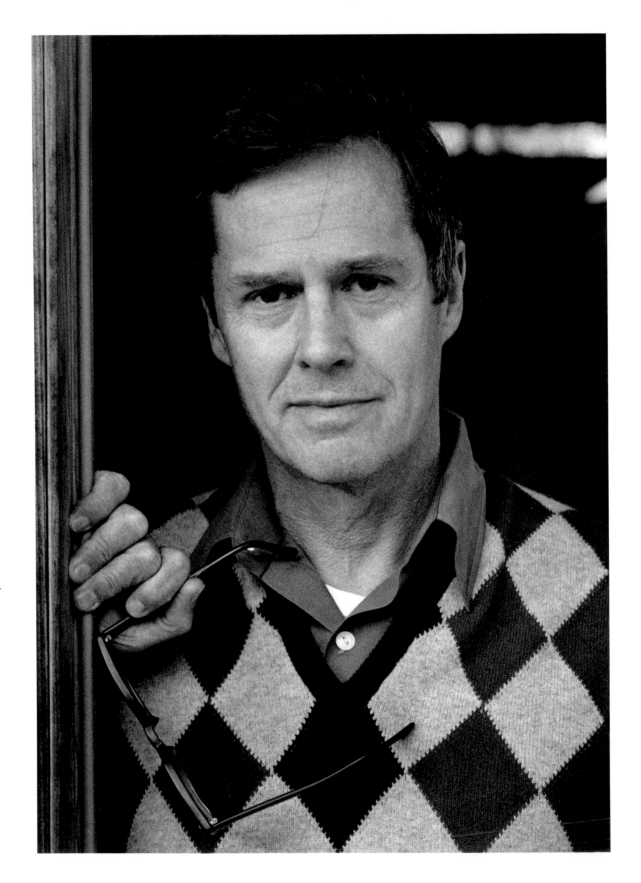

Ned Rorem  Composer, author

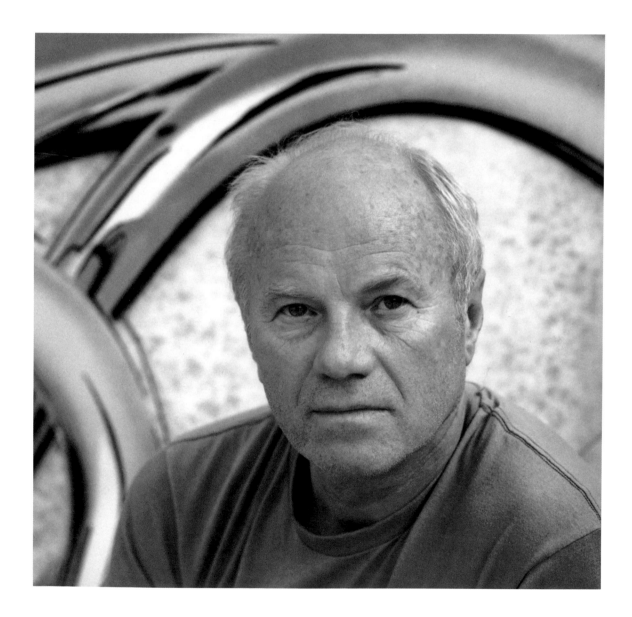

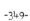
-349-

James Rosenquist  Pop artist

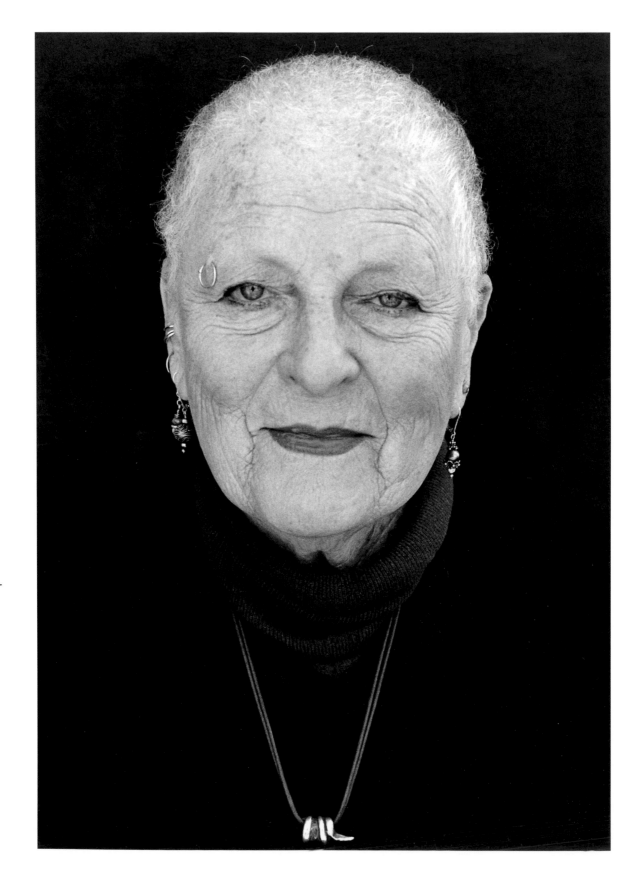

Rachel Rosenthal  "Inter" theater director, performer

Barney Rossett  Grove Press publisher

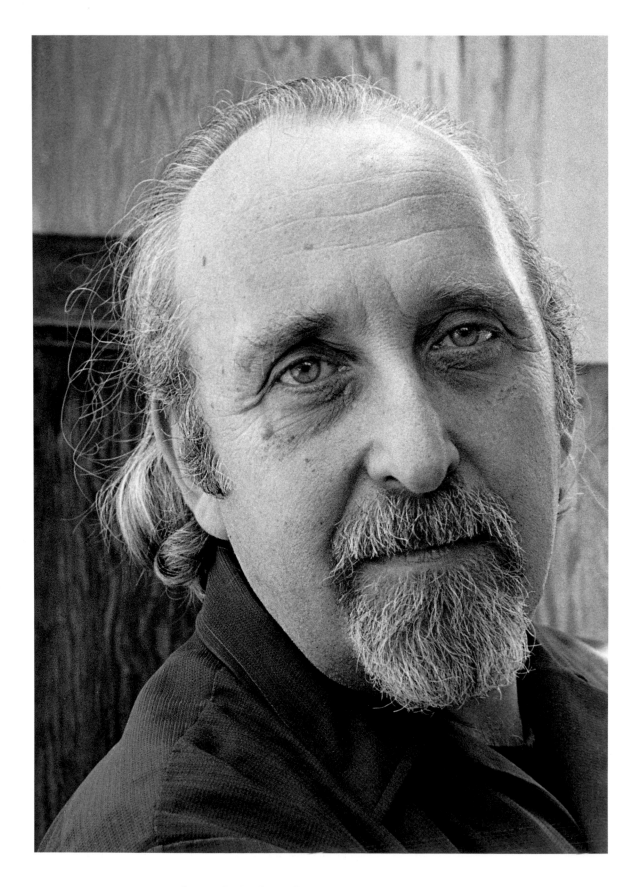

Jerome Rothenberg  Poet, translator, ethnopoeticist

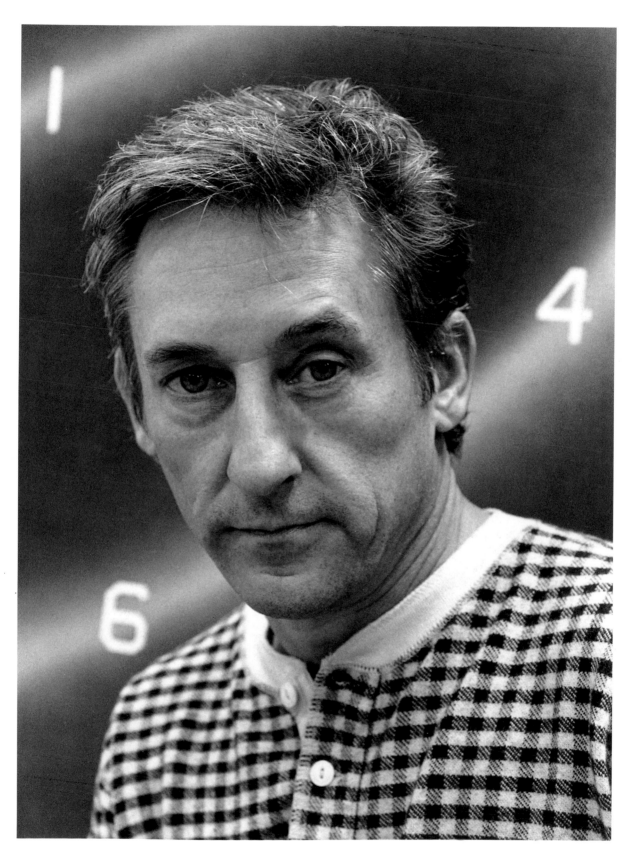

-353-

Ed Ruscha  California Pop painter

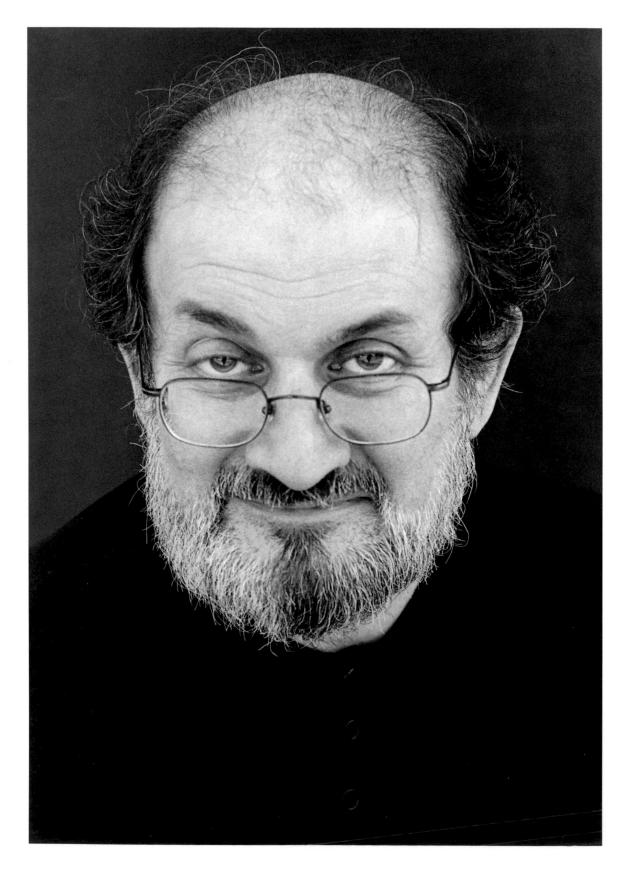

Salman Rushdie  Novelist

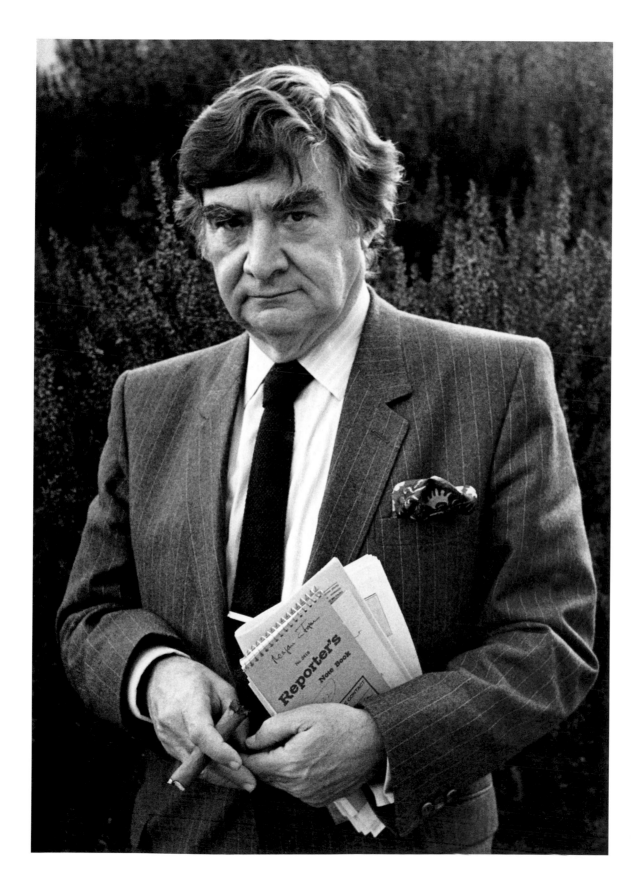

Pierre Salinger  Author, journalist

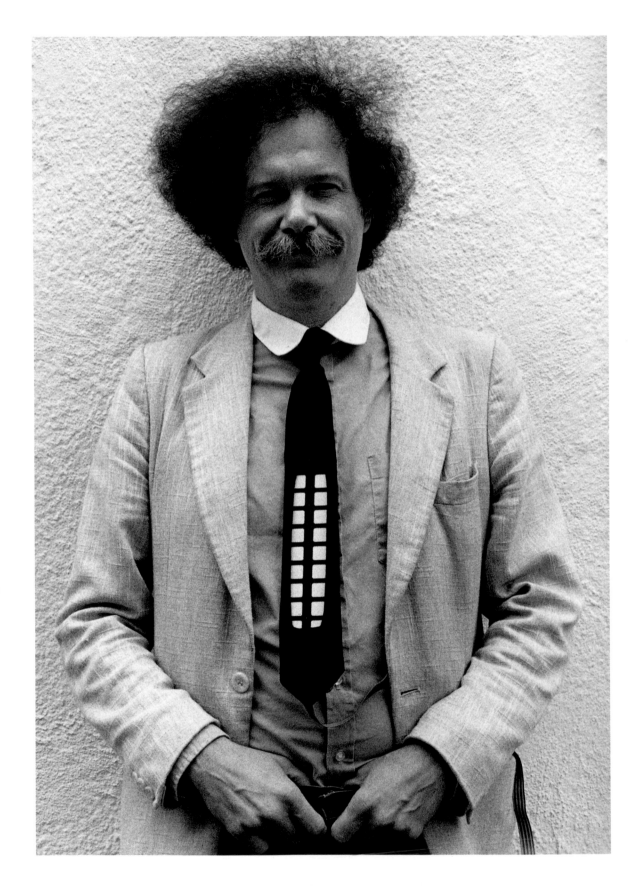

Ed Sanders Investigative poet

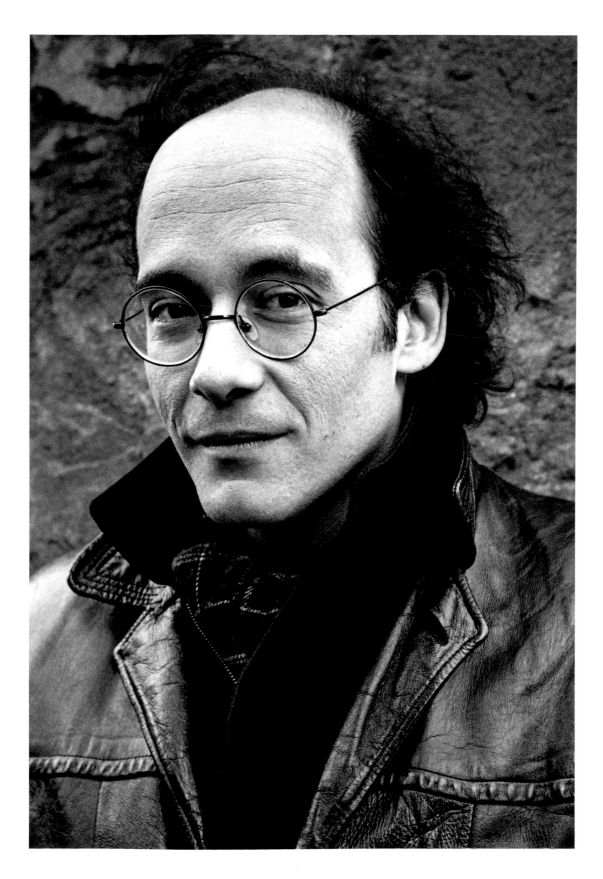

Luc Sante  New York writer, critic

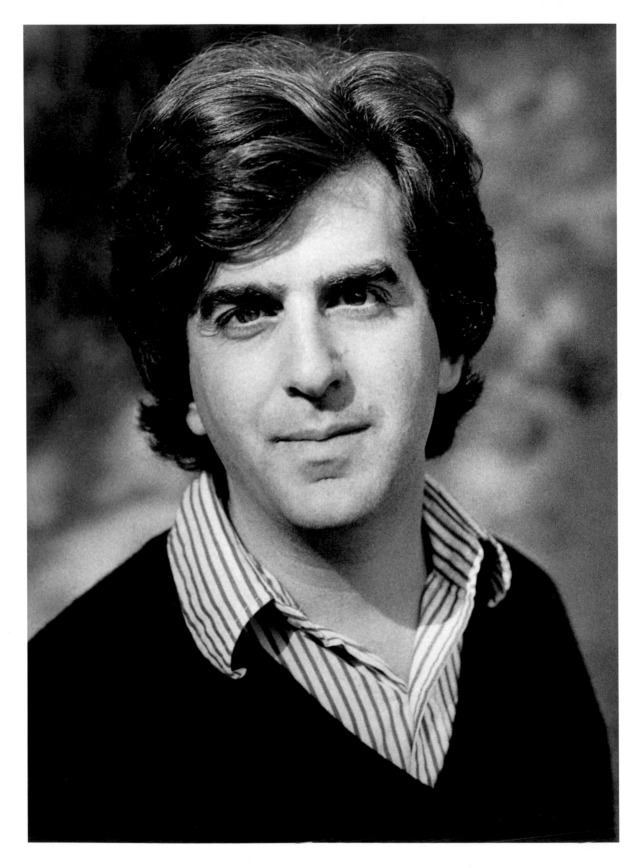

Aram Saroyan  Poet, prose writer

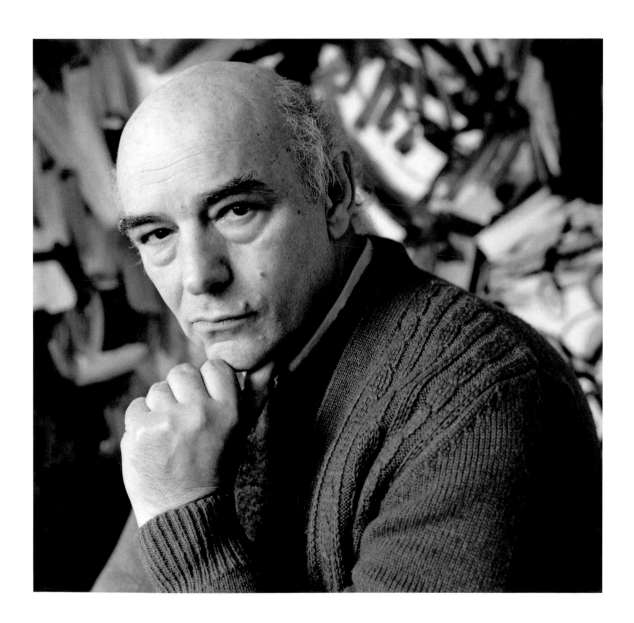

Antonio Saura  Spanish painter, printmaker

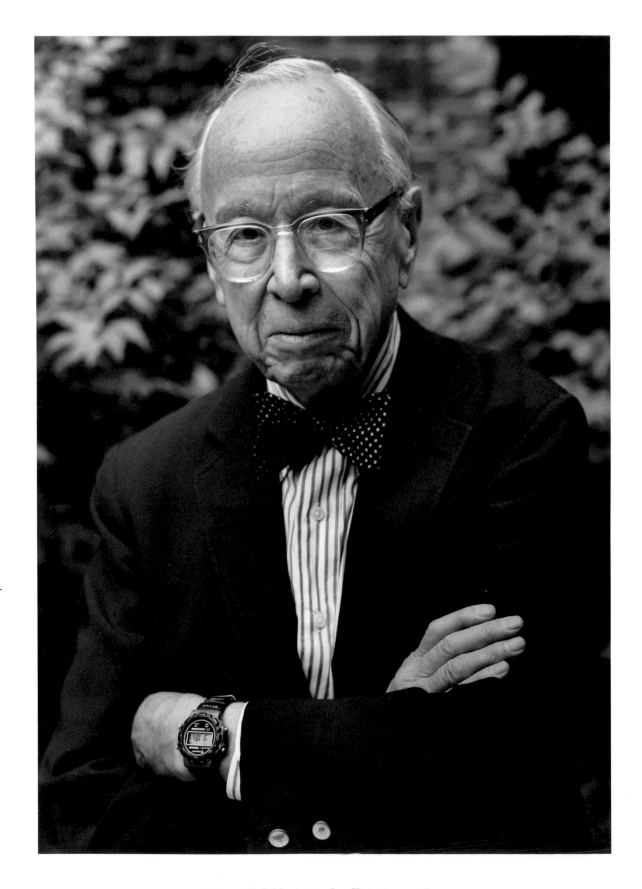

Arthur M. Schlesinger Jr.  Historian, author

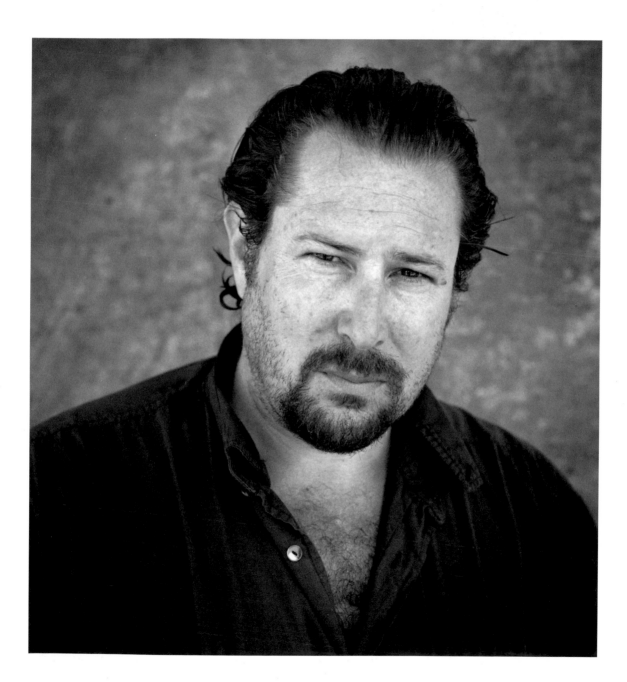

Julian Schnabel  Painter, director

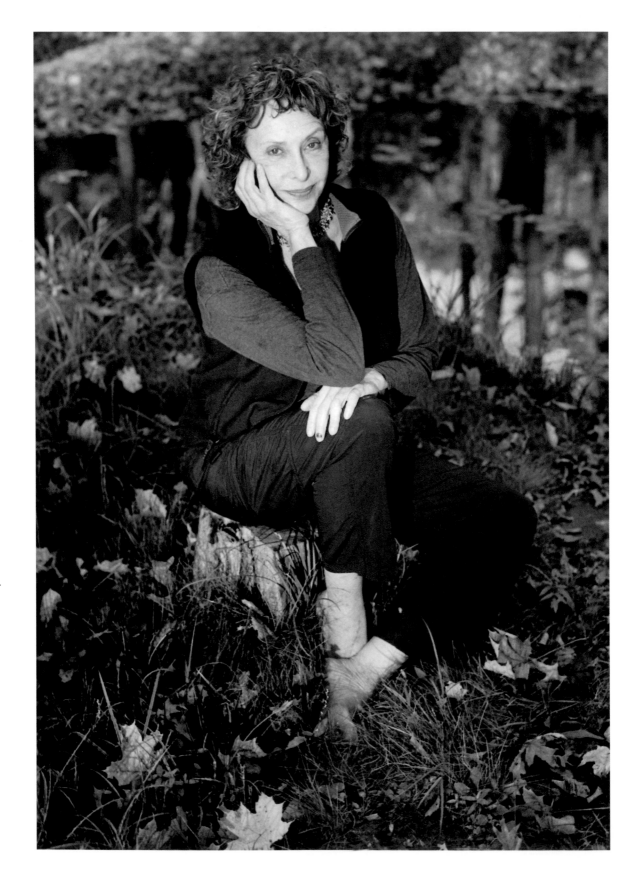

Carolee Schneeman  Feminist performance artist, essayist

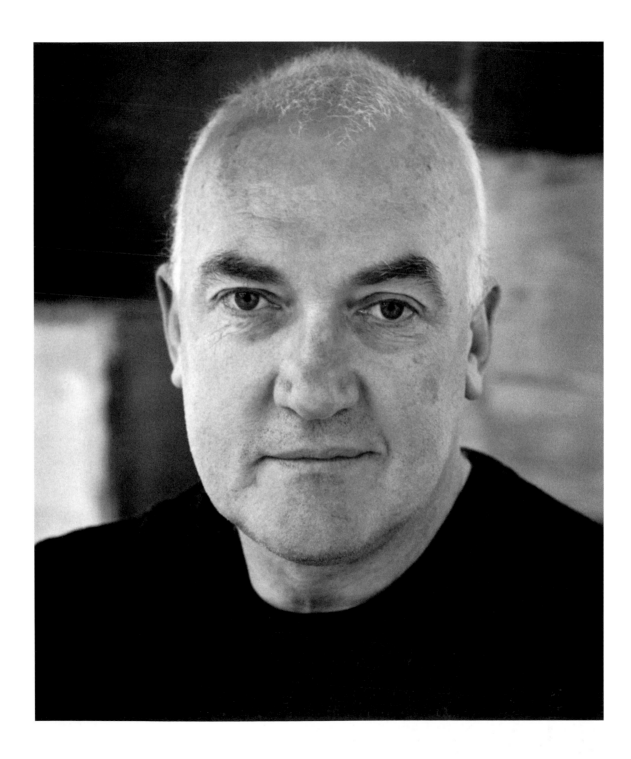

Sean Scully  Irish painter

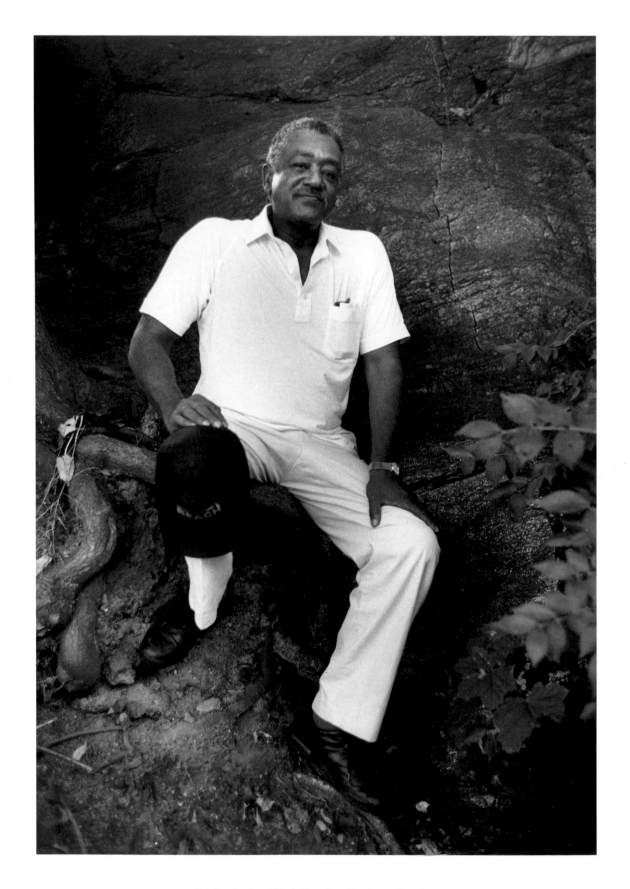

Bobby Seale  Black Panther Party cofounder

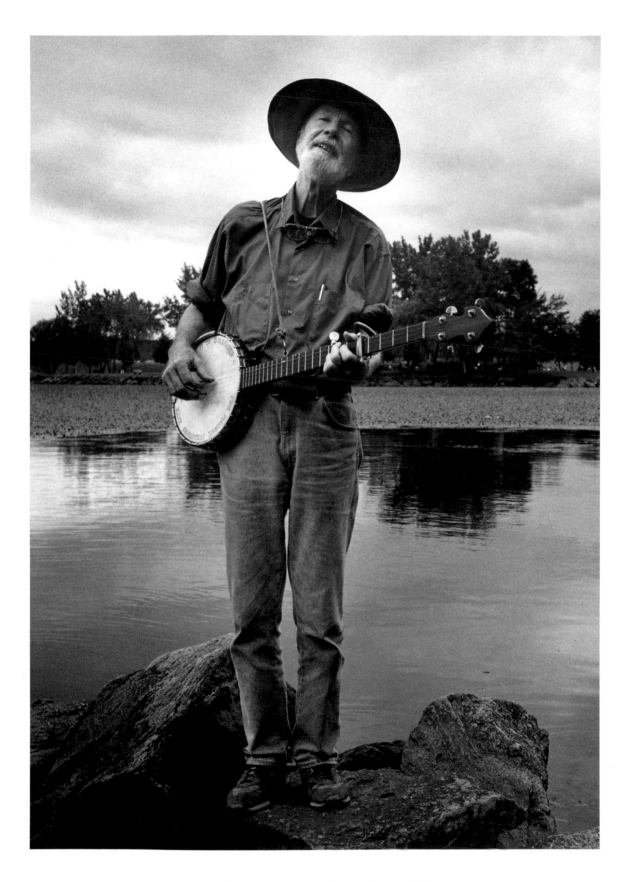

Pete Seeger  Folksinger/songwriter, activist

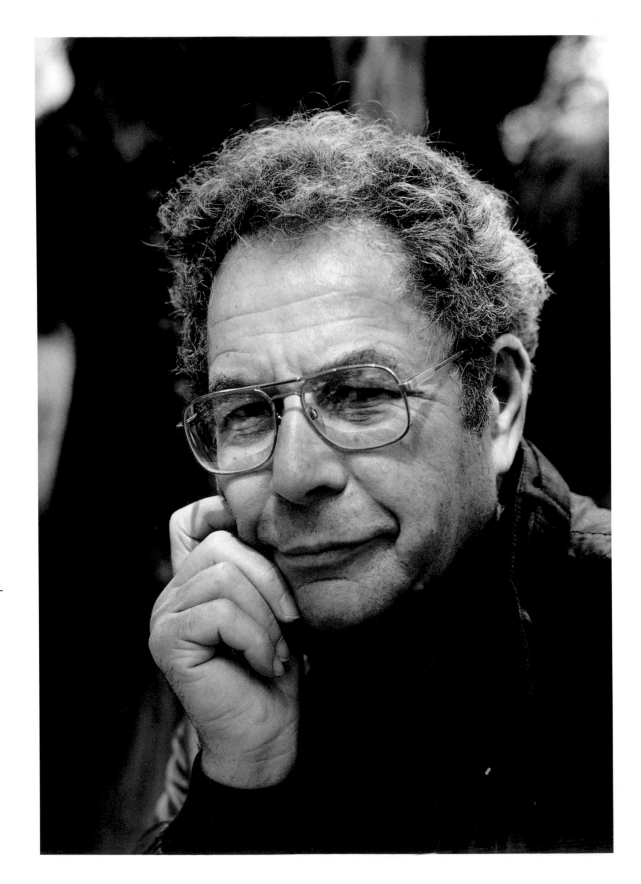

George Segal  Figurative sculptor

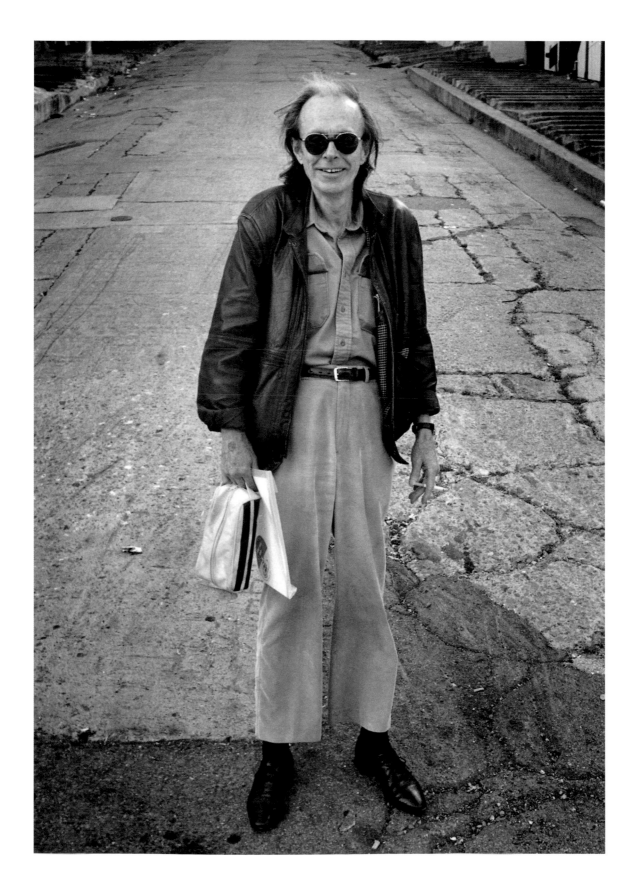

Hubert Selby Jr.  Novelist

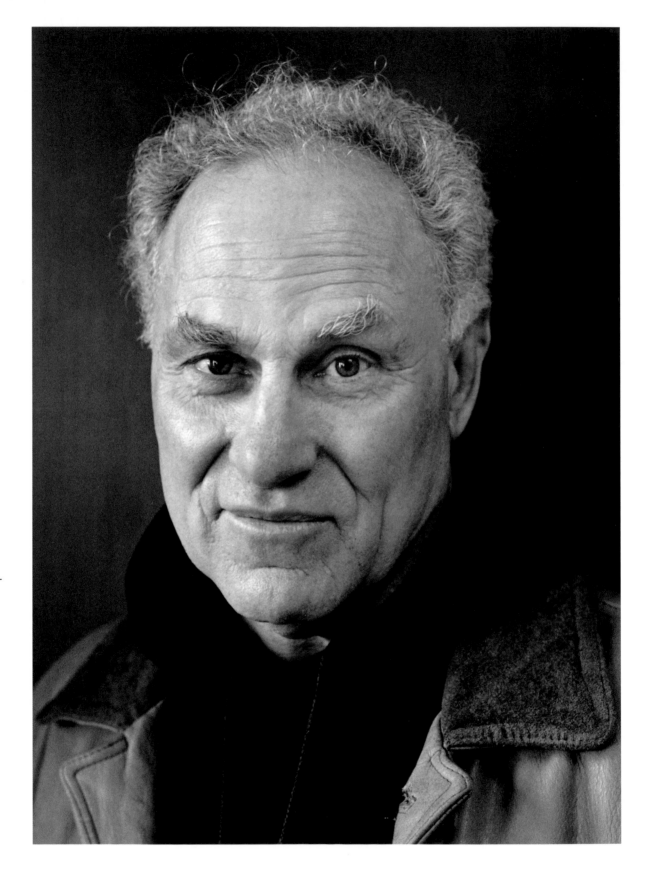

Richard Serra  Minimalist sculptor, filmmaker

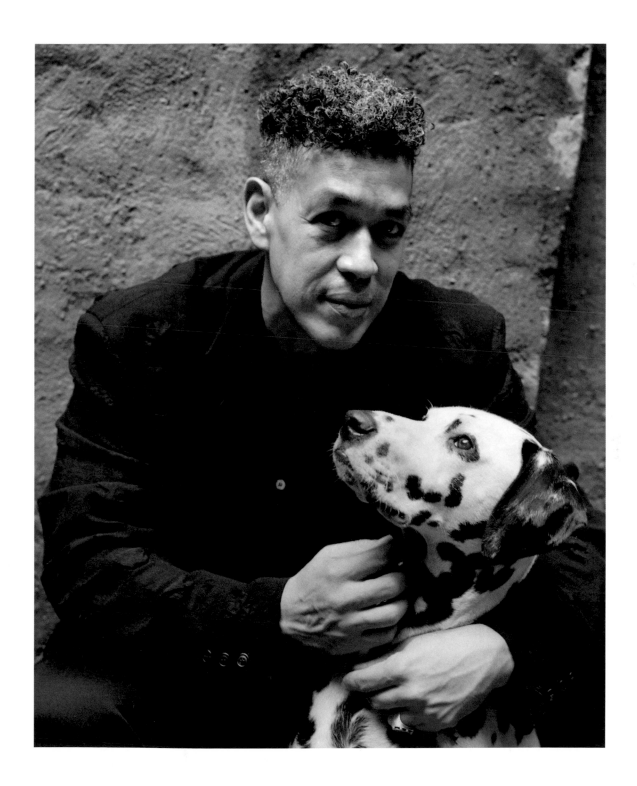

Andres Serrano  Transgressive photographic artist

David Shapiro   Poet, art critic

Joel Shapiro  Minimalist sculptor

-372-

Bobby Short  Cabaret singer, pianist

Charles Simic  Poet, Pulitzer Prize 1990

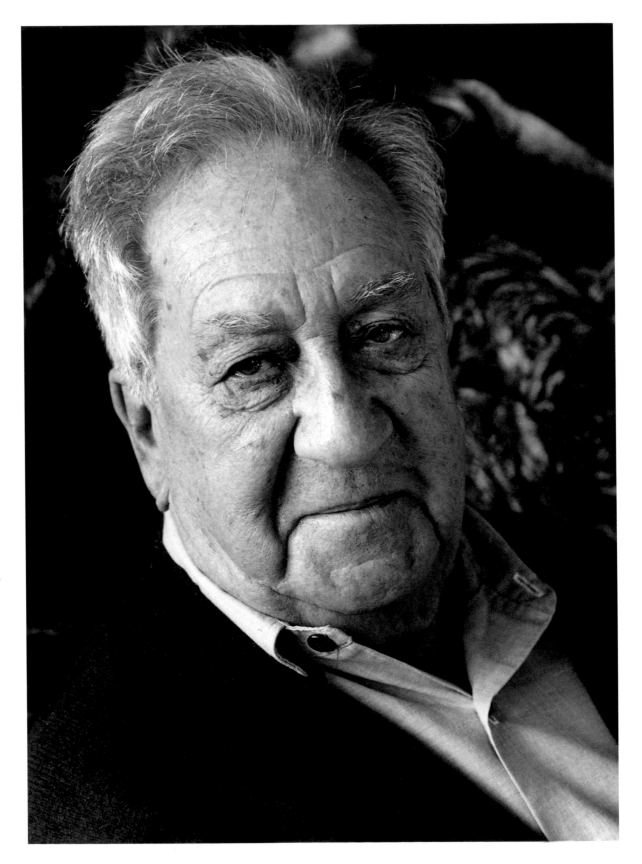

Aaron Siskind  Photographer

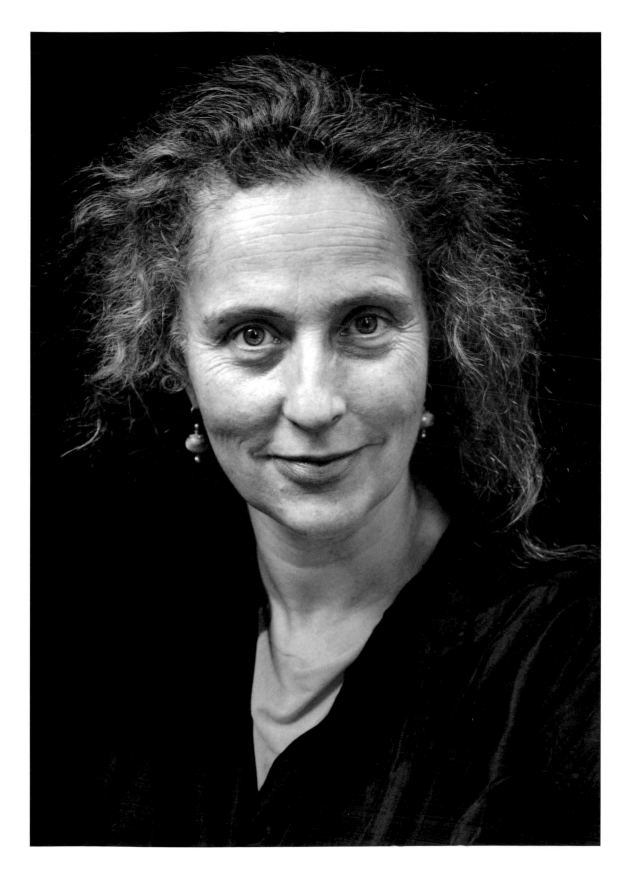

Kiki Smith  Feminist figurative sculptor

Patti Smith  Poet, punk rock pioneer

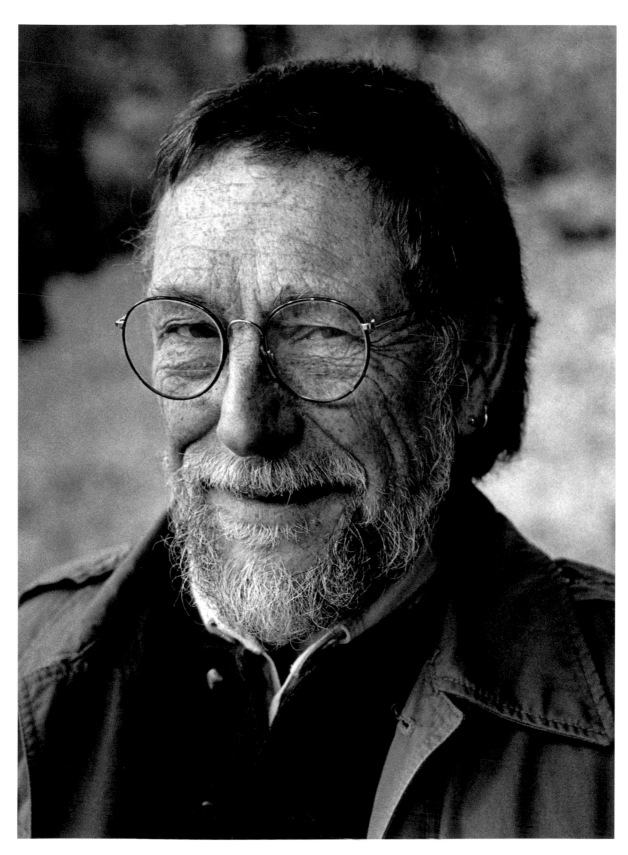

Gary Snyder  Poet, eco-activist, Pulitzer Prize 1975

Keith Sonnier  Postmodern tech sculptor

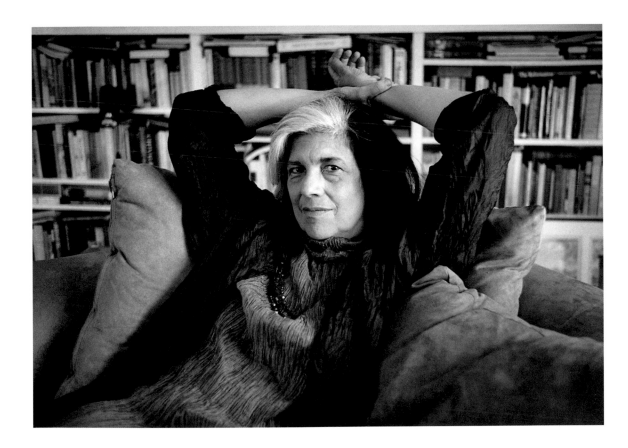

Susan Sontag  Novelist, essayist, critic

Terry Southern  Comic novelist, screenwriter

Steven Spielberg  Director, producer

Nancy Spero & Leon Golub   Feminist artist & figurative painter

Gloria Steinem   Writer, editor, feminist

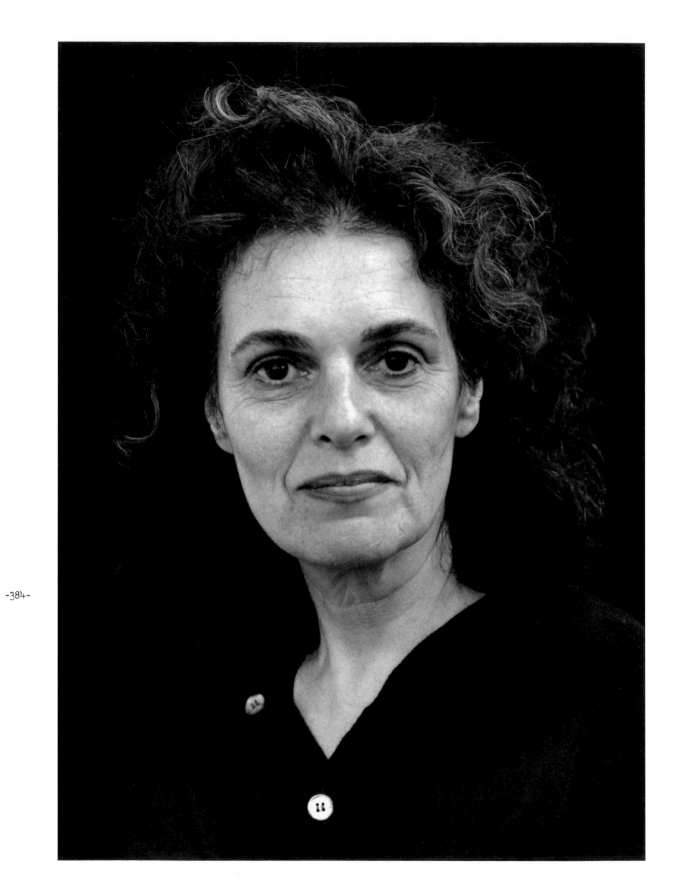

Pat Steir  Lyric painter

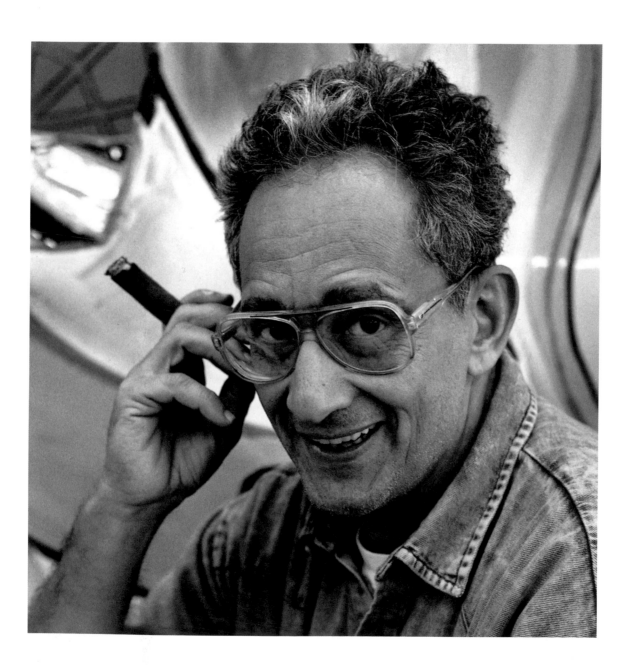

Frank Stella  Painter, sculptor

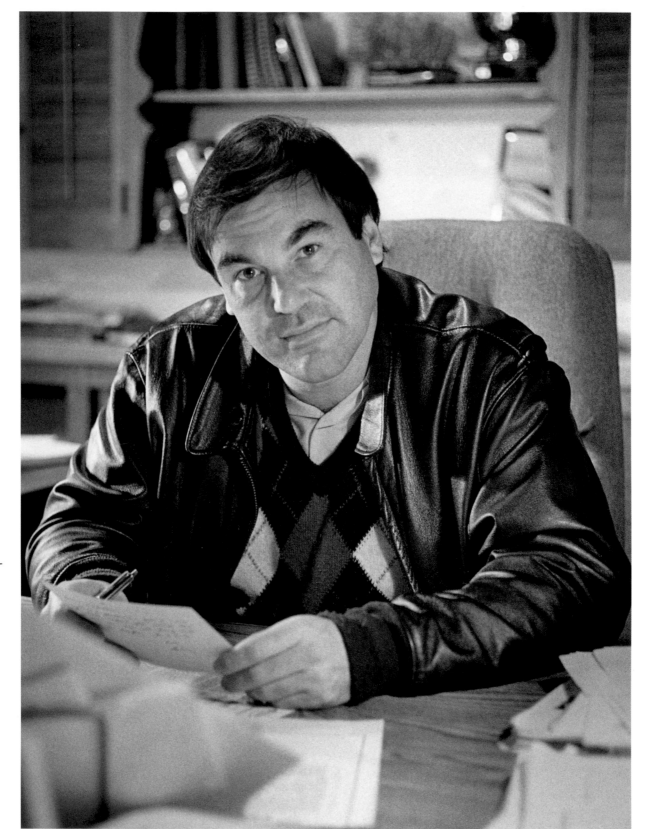

-386-

Oliver Stone  Director

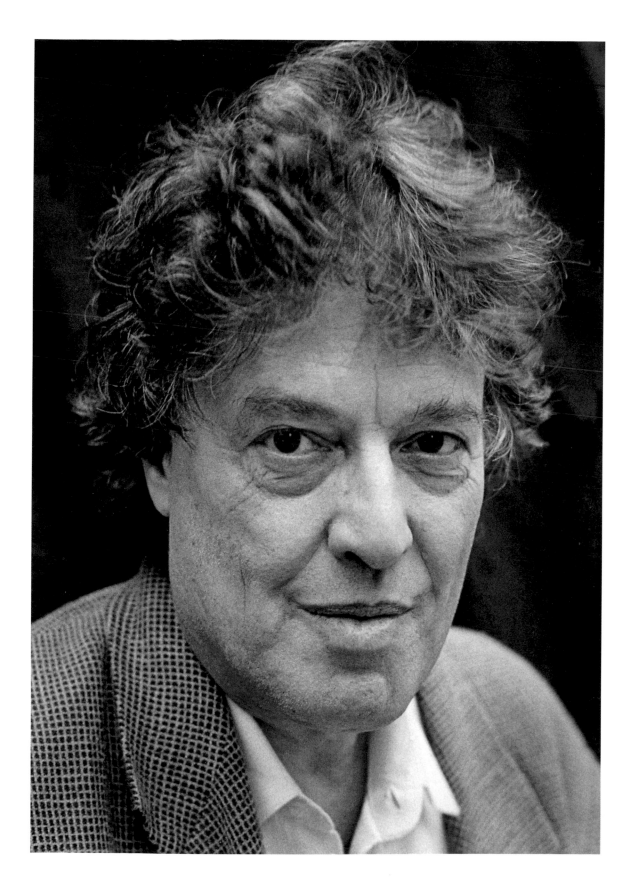

Tom Stoppard  Czech-born English playwright

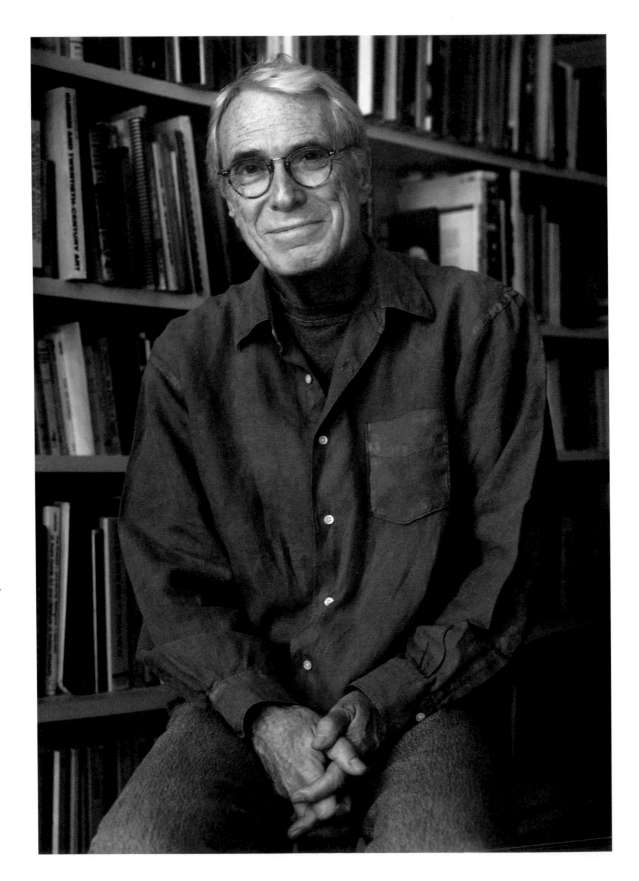

Mark Strand  U.S. Poet Laureate 1990–1991

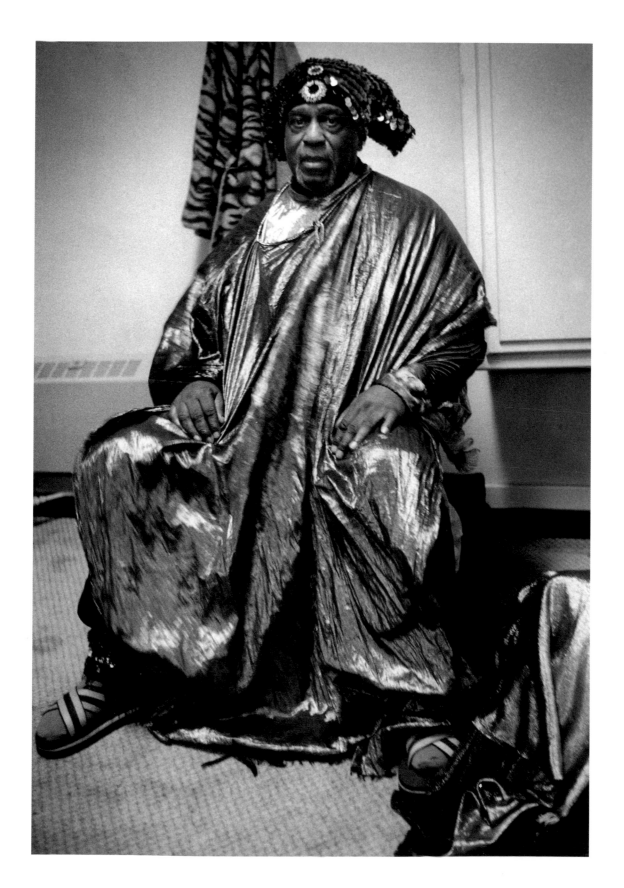

Sun Ra   "Free Jazz" musician

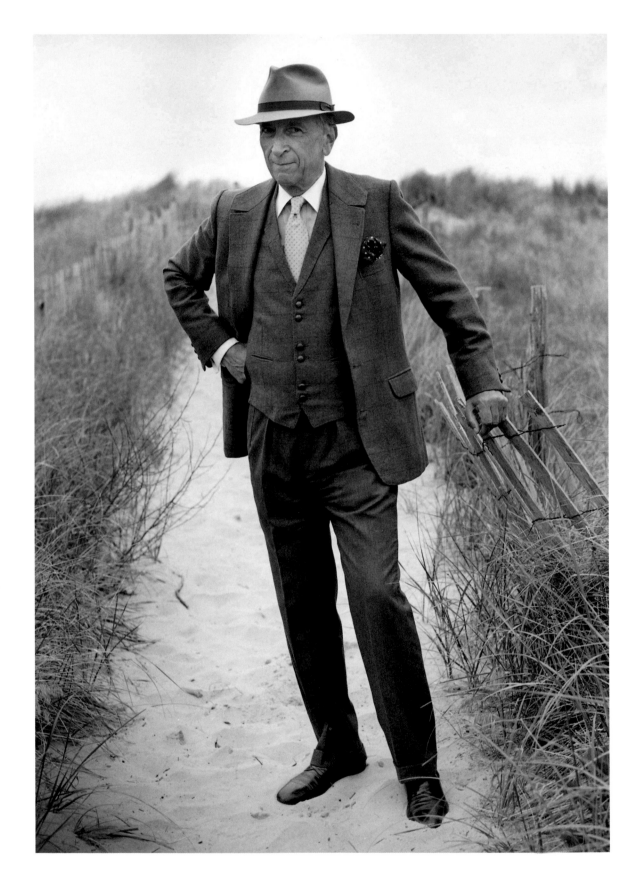

Gay Talese  Novelist, journalist

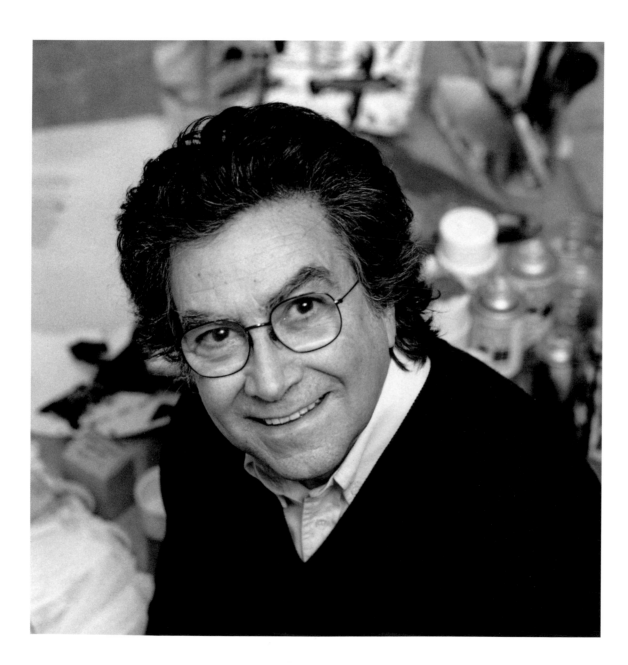

Antoni Tàpies  Painter, sculptor

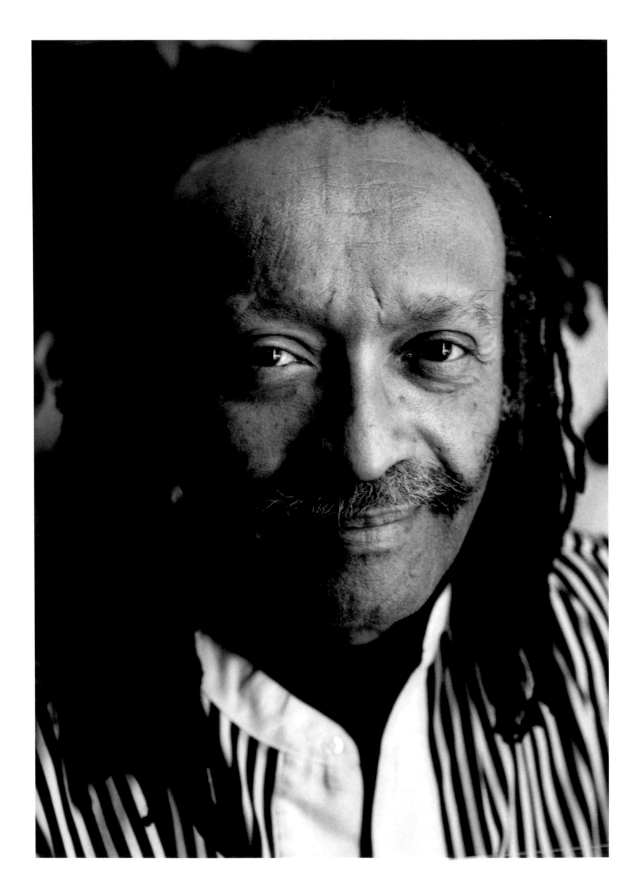

-392-

Cecil Taylor  Pianist, composer

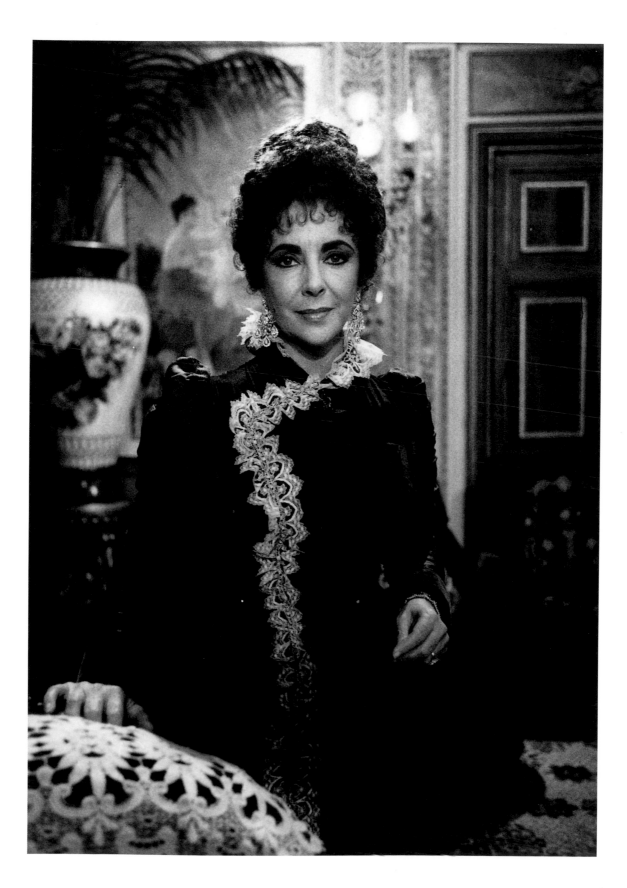

Elizabeth Taylor  Actress, activist

Studs Terkel  Chicago journalist, Pulitzer Prize 1985

Wayne Thiebaud  California realism painter

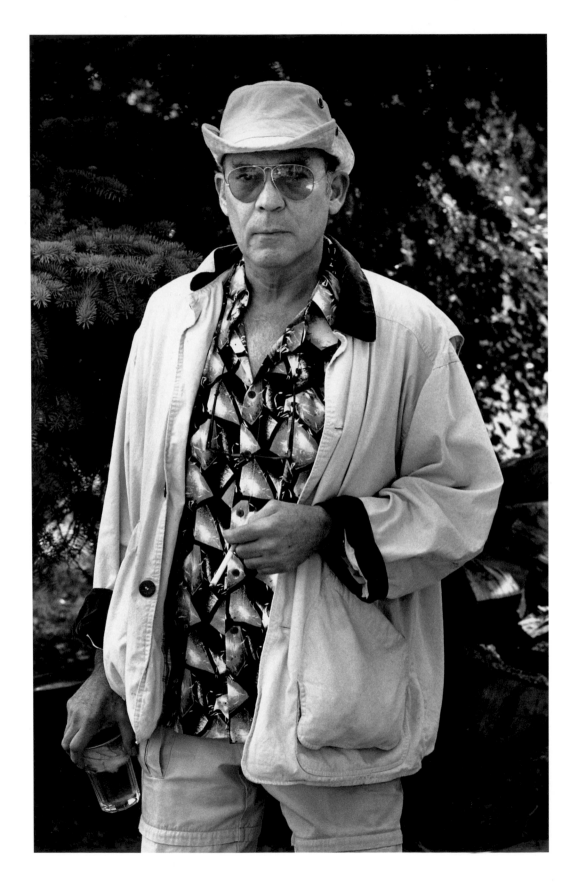

Hunter S. Thompson  Gonzo journalist

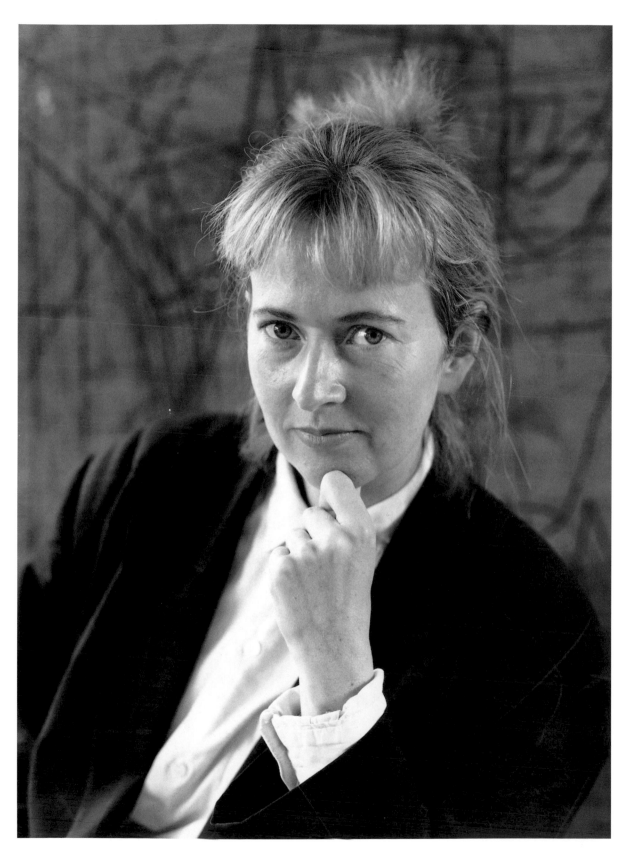

Rosemarie Trockel  Sculptor, painter, photographer

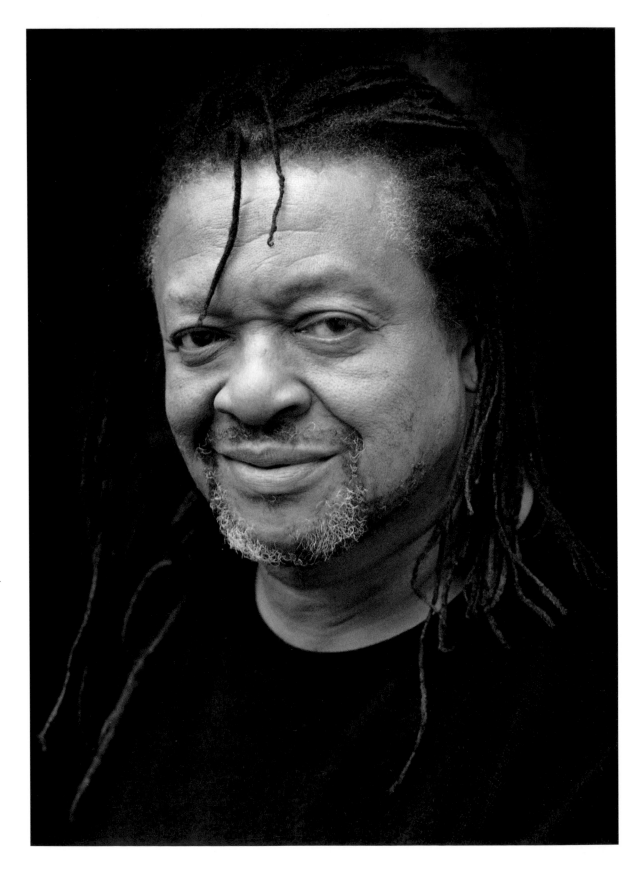

Quincy Troupe  Poet, jazz biographer

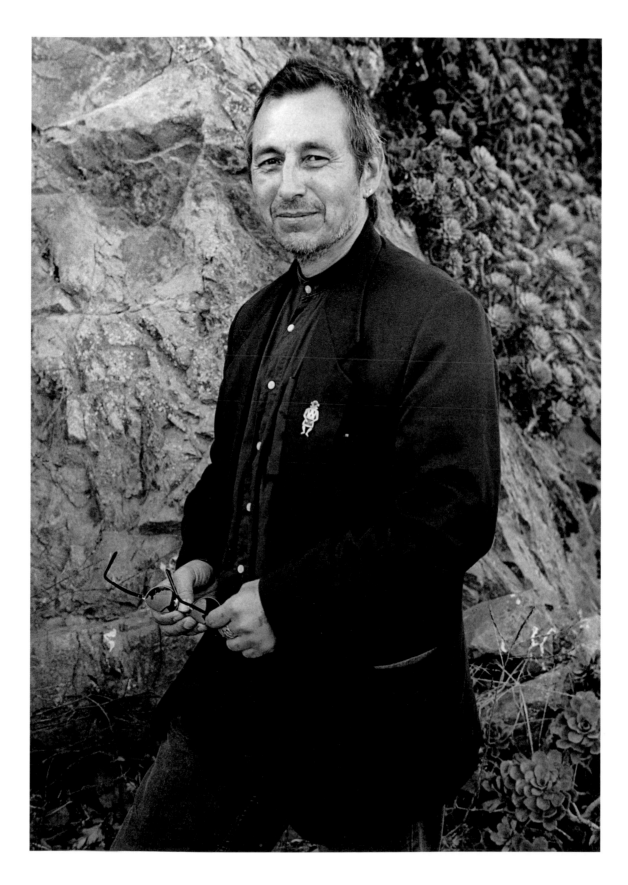

John Trudell  Native American poet, activist

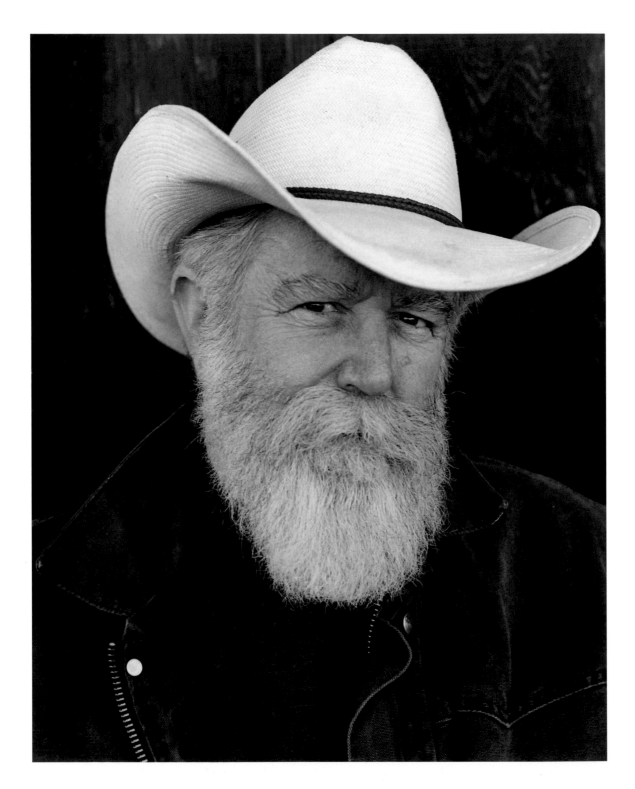

James Turrell  Light sculptor

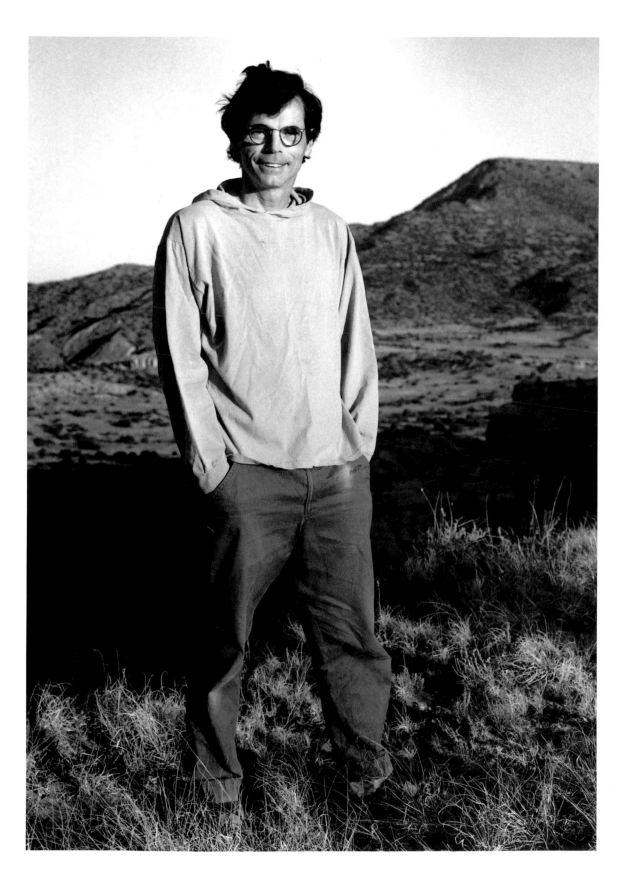

Richard Tuttle  Post-minimalist painter, sculptor

John Tytell  Beat biographer, critic

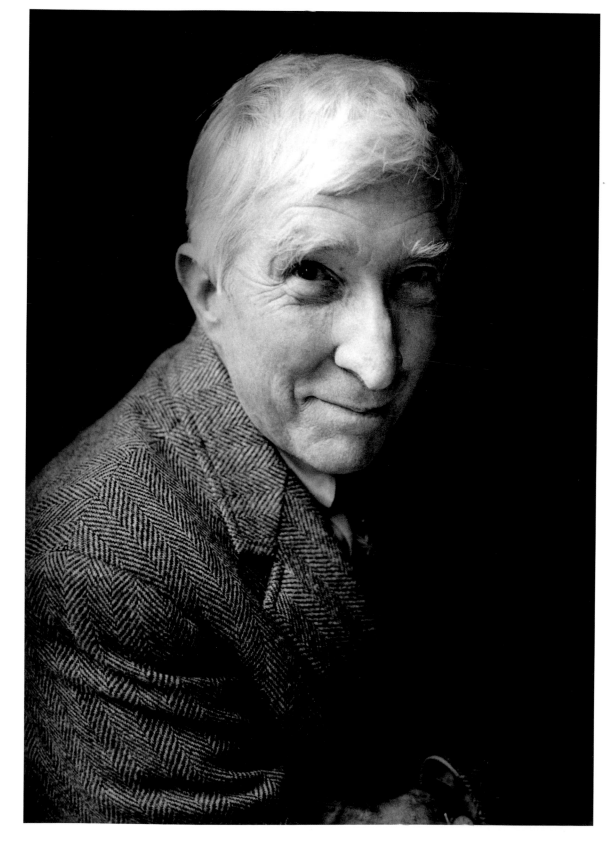

John Updike  Novelist, short story writer, essayist

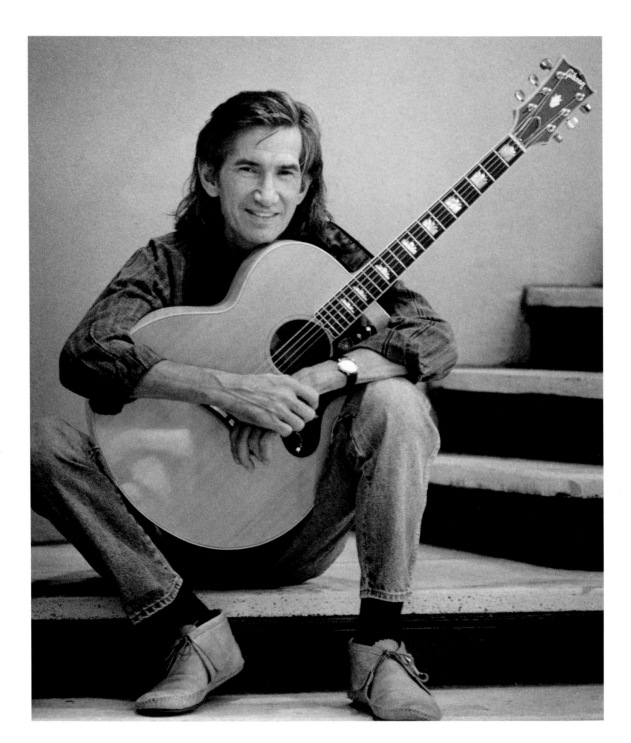

Townes Van Zandt  Legendary Texas songwriter

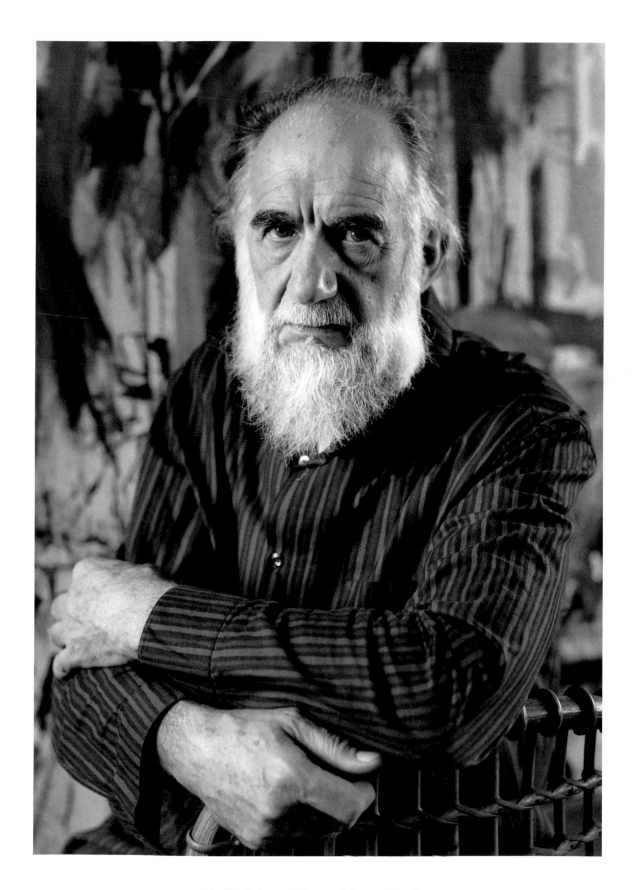

Emilio Vedova  Italian painter, printmaker

-406-

Jan Vercruysse  Conceptual artist

Gore Vidal  Novelist, pundit

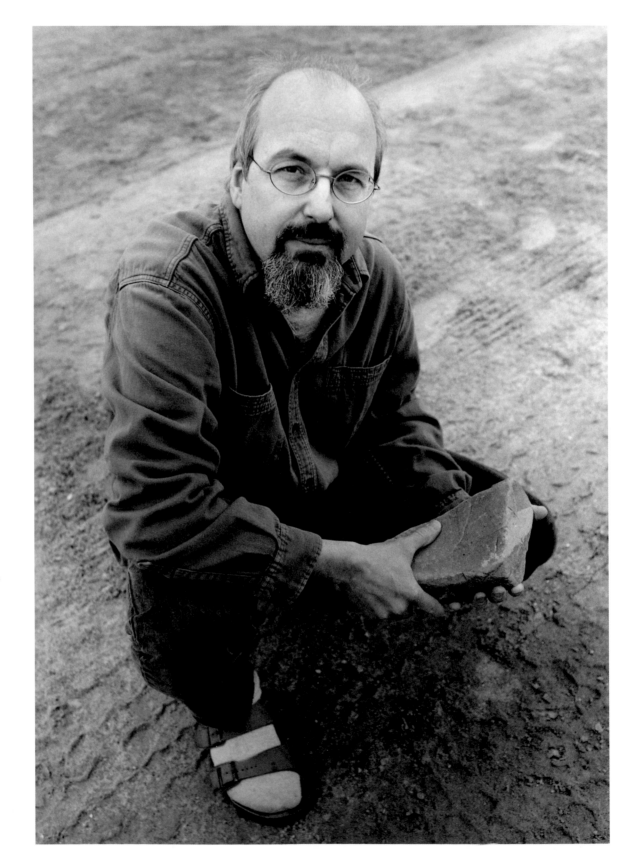

Bill Viola  Video artist

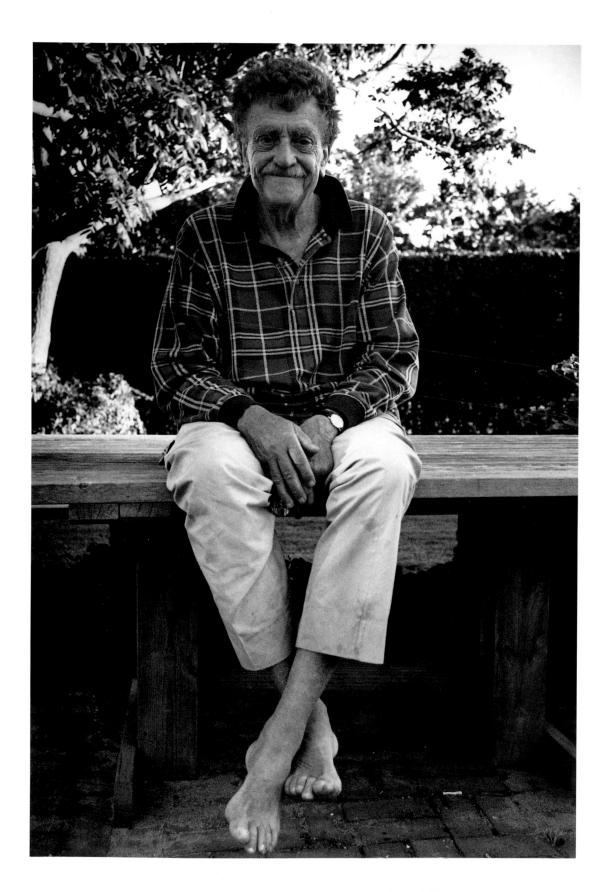

Kurt Vonnegut  Fiction writer, essayist, playwright

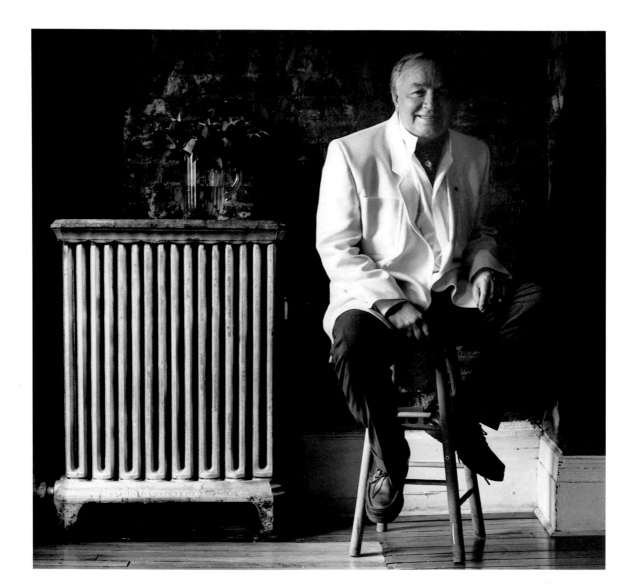

Andrei Vosnesenky  Russian poet

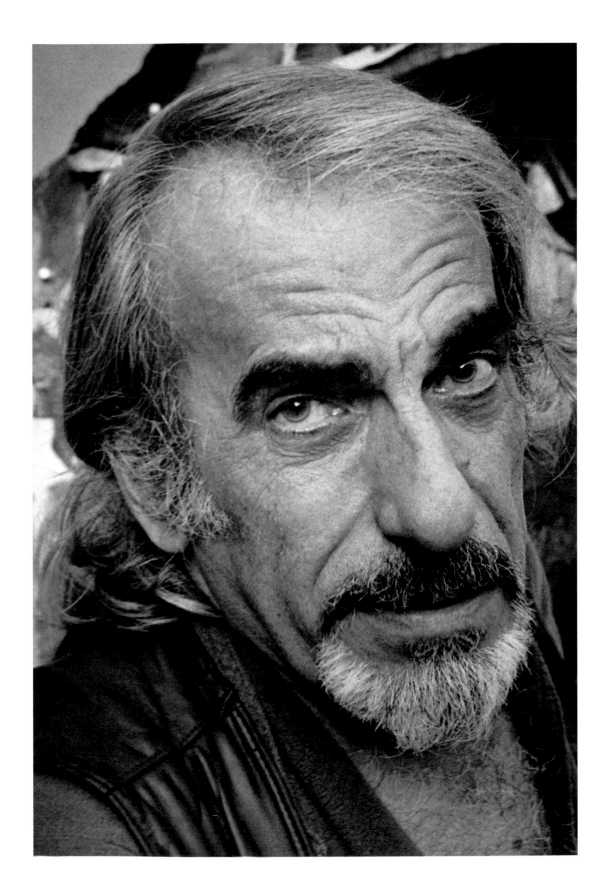

Peter Voulkos  California ceramic sculptor

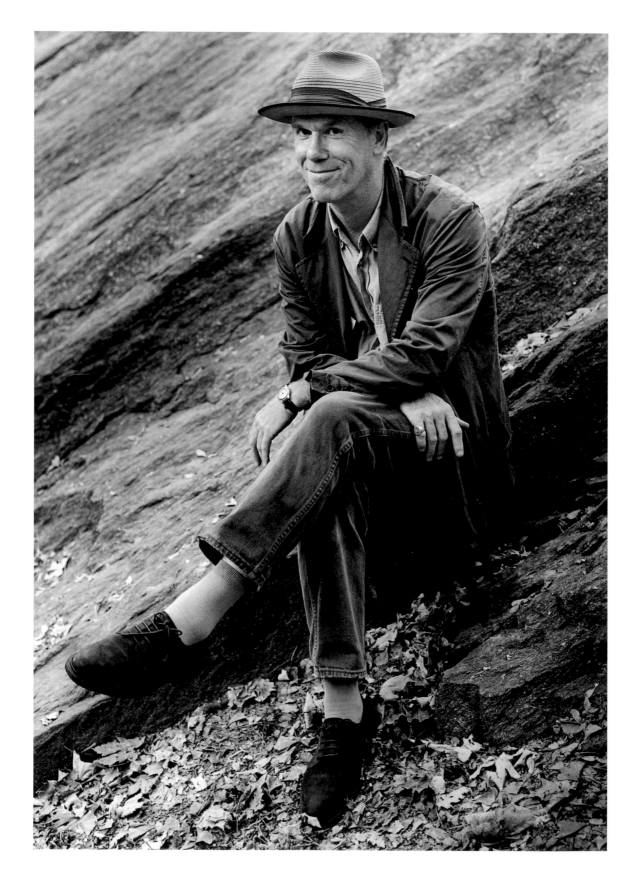

Loudon Wainwright III  Folk rock musician

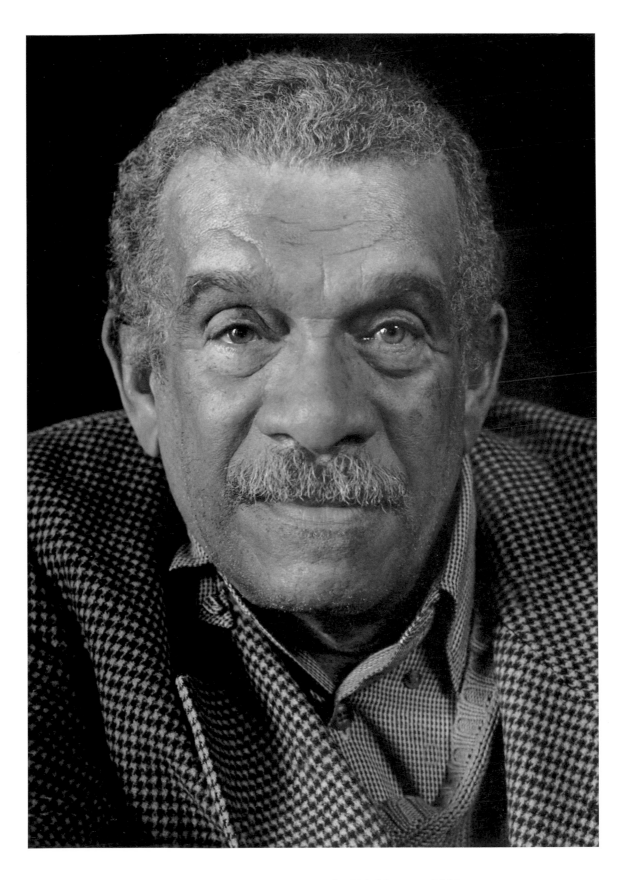

Derek Walcott  Poet, playwright, Nobel laureate 1992

Anne Waldman  Performance poet, translator

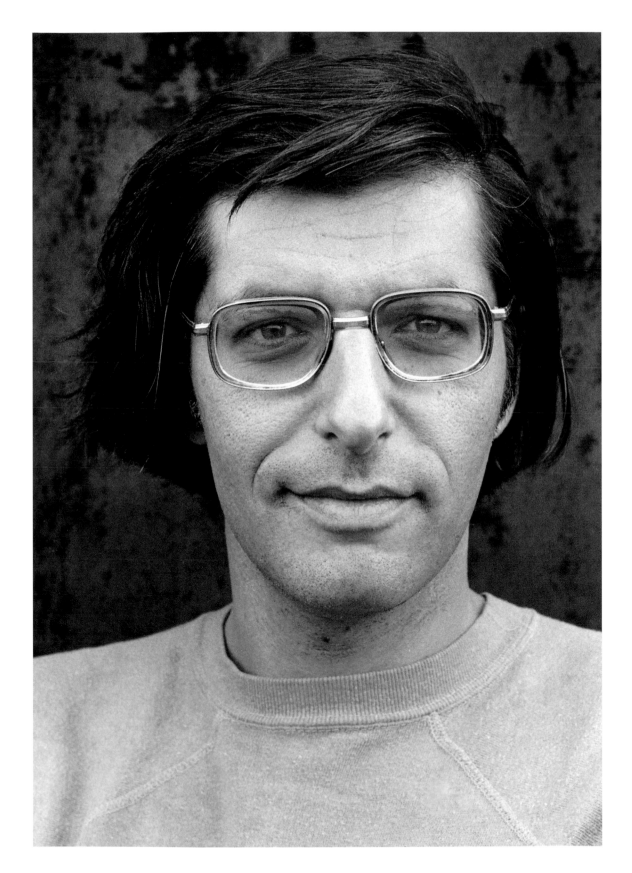

Lewis Warsh  New York School poet

Wavy Gravy a.k.a. Hugh Romney  Woodstock host, Camp Winnarainbow founder

**William Wegman**  Weimaraner dog photographer

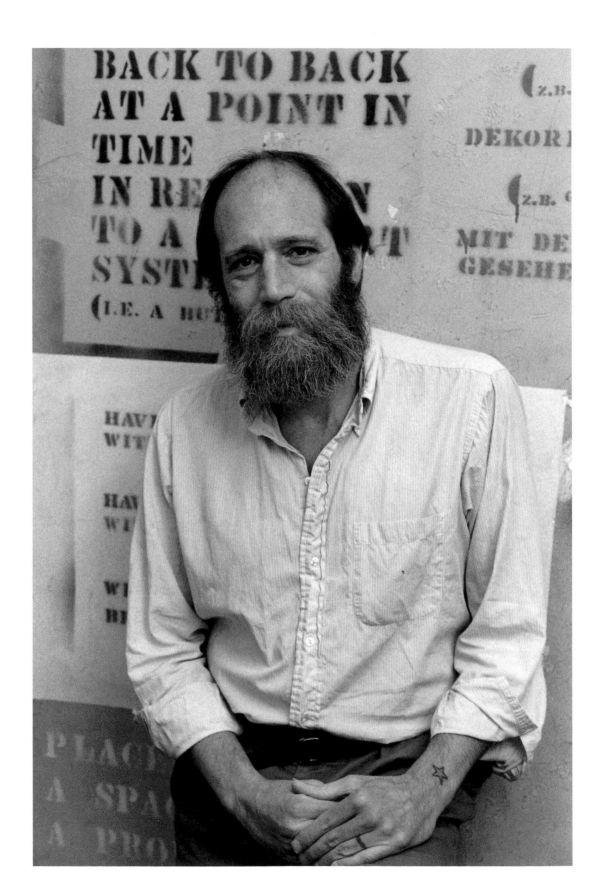

Lawrence Weiner  Conceptual artist

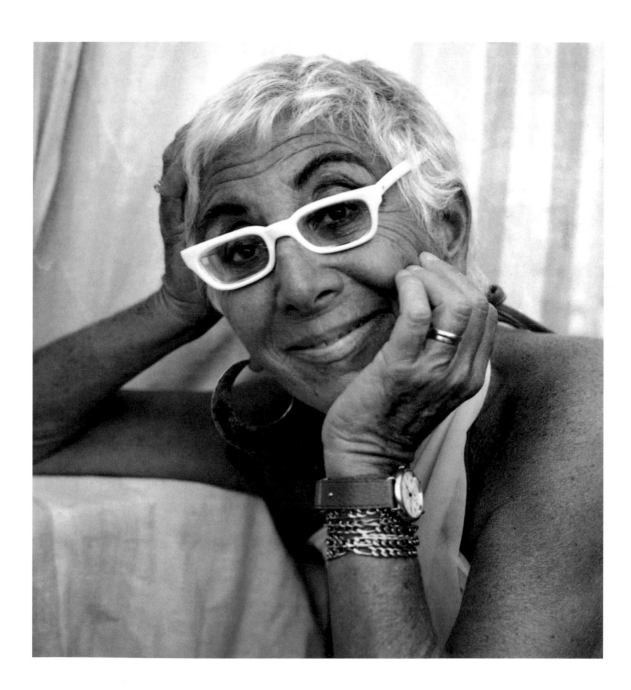

Lina Wertmuller  Italian film director

Tom Wesselman  Pop artist

Cornel West  Intellectual, "prophetic pragmatist," author

Floyd Red Crow Westerman  Indian activist, actor, singer

Philip Whalen  Beat poet, Zen abbot

Edmund White  Novelist, cultural critic, biographer

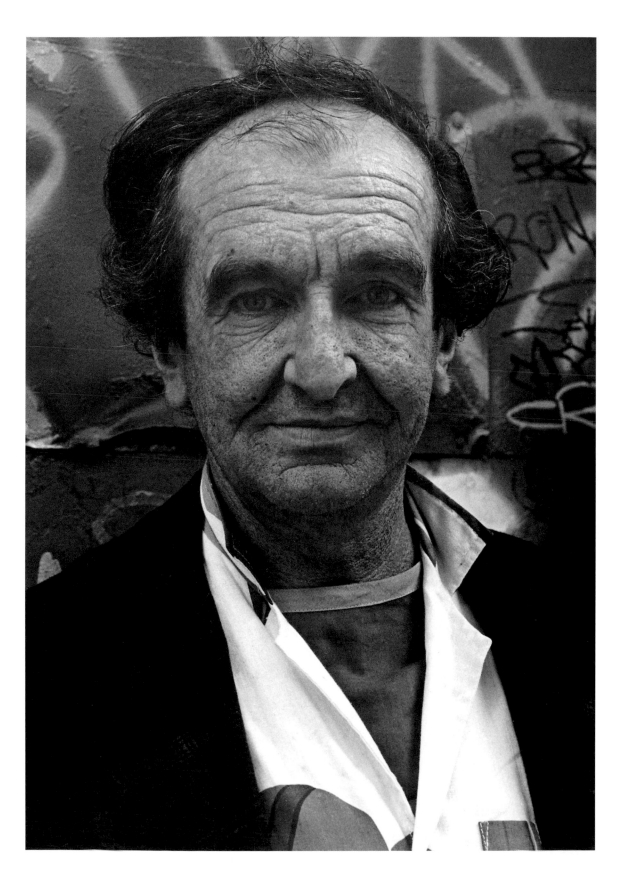

-425-

John Wieners  Black Mountain, Boston poet

William T. Wiley  Dadaist artist

Robin Williams  Oscar-winning actor, comedian

Lanford Wilson  Playwright, Pulitzer Prize 1980

Robert Wilson   Experimental theater impresario, playwright

Terry Winters  Painter, printmaker

Joel-Peter Witkin  Photographer

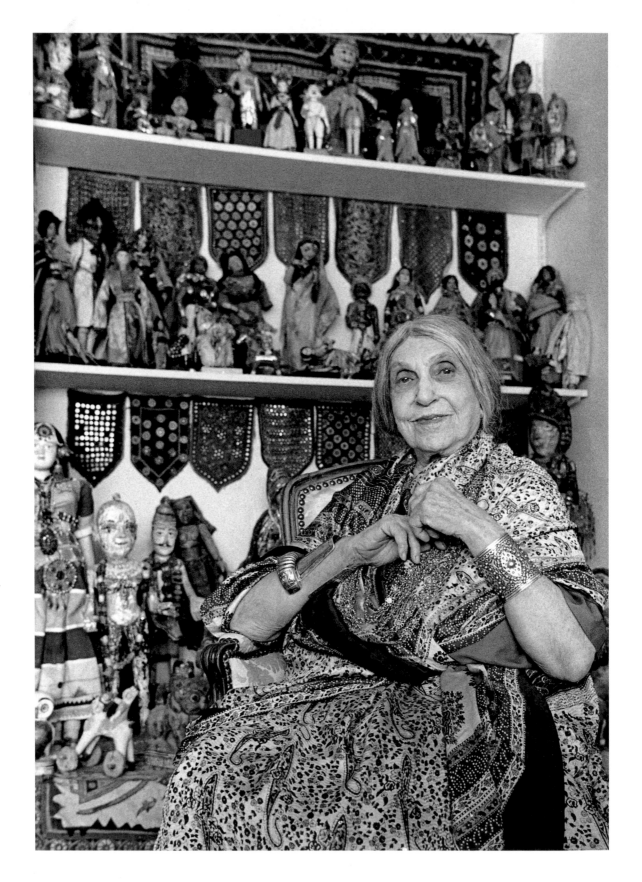

Beatrice Wood   "Mama of Dada," lustre glaze ceramist

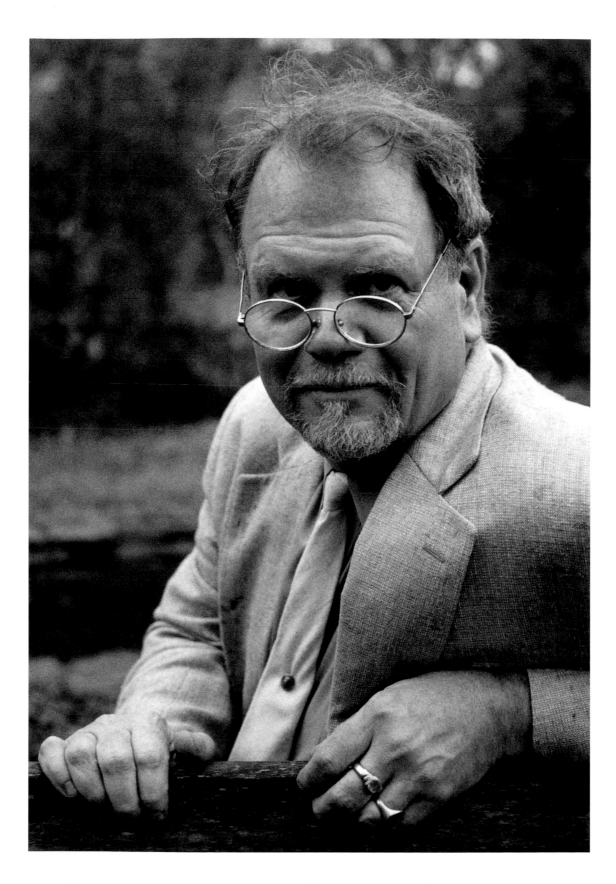

John Wood  Poet, art critic

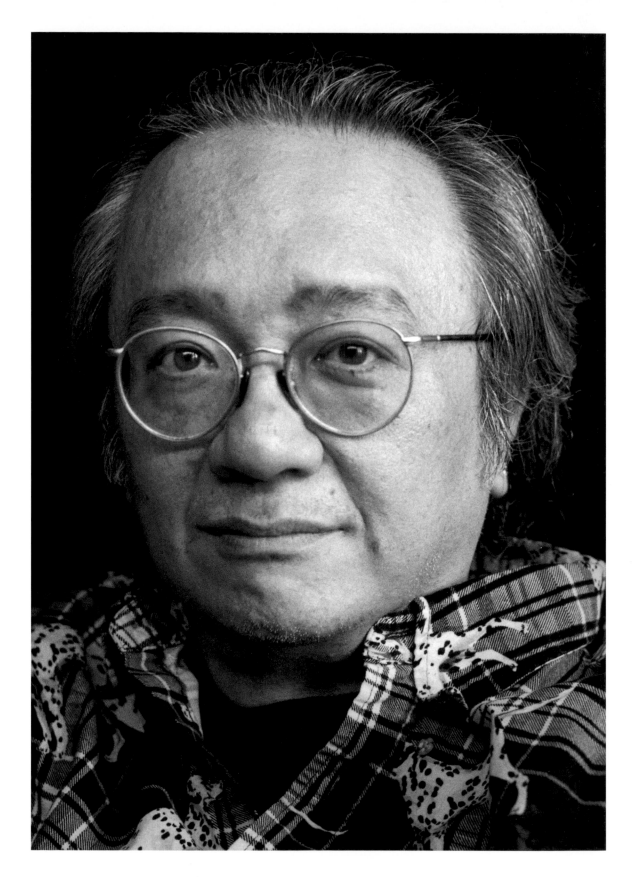

John Yau  Poet, art critic, fiction writer

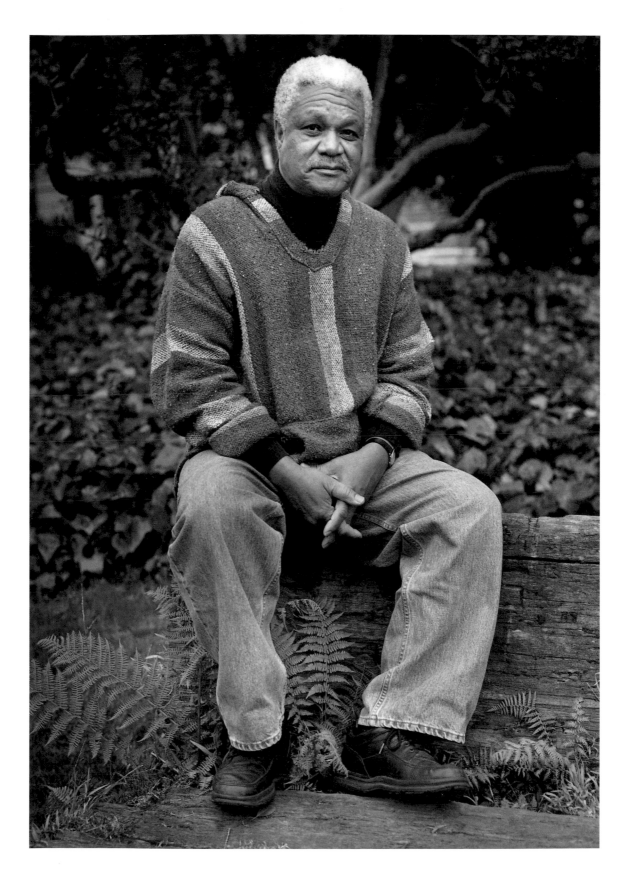

Al Young  Novelist, poet

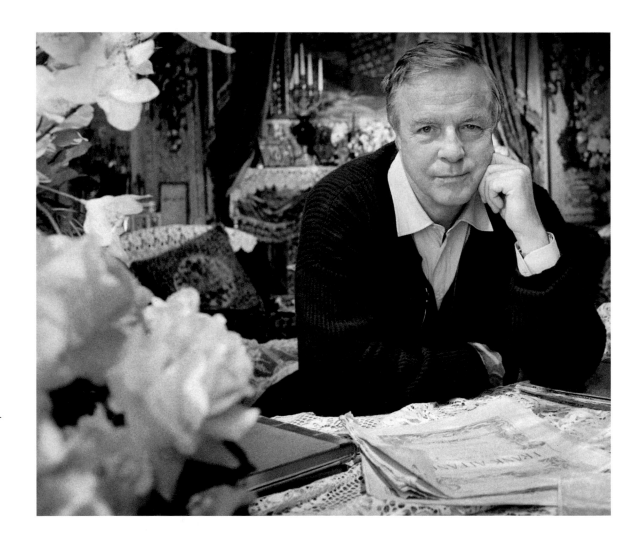

Franco Zefferelli  Film director

# Plate Index

265 Martin, Agnes   Taos, New Mexico, 1994
266 Matthiessen, Peter   Sagaponack, New York, 1995
267 Mayer, Bernadette   New York City, 1985
268 Mazursky, Paul   Beverly Hills, California, 1984
269 McClure, Michael   San Francisco, 1981
270 McCourt, Frank   New York City, 2000
271 McCoy, Ann   Long Island City, New York, 2000
272 McDarrah, Fred W.   New York City, 1995
273 McGovern, George   Washington D.C., 1994
274 McInerney, Jay   New York City, 1994
275 Mead, Taylor   New York City, 1994
276 Means, Russell   San Francisco, 1996
277 Mekas, Jonas   New York City, 1994
278 Merwin, W. S.   Berkeley, California, 1985
279 Merz, Mario   Torino, Italy, 1989
280 Metzner, Sheila   New York City, 2000
281 Michals, Duane   New York City, 1986
282 Middendorf, Helmut   Berlin, 1989
283 Miller, Arthur   Woodbury, Connecticut, 1994
284 Milosz, Czeslaw   Berkeley, California, 1984
285 Misrach, Richard   Berkeley, California, 2001
286 Miss, Mary   New York City, 2001
287 Mitchell, Joan   Paris, 1990
288 Mitchell, Waddie   Colorado Springs, Colorado, 1998
289 Monk, Meredith   Boulder, Colorado, 1994
290 Morris, Robert   New York City, 1998
291 Morrison, Toni   New York City, 1994
292 Morrissey, Paul   New York City, 2000
293 Moses, Ed   Venice, California, 1986
294 Motherwell, Robert   Greenwich, Connecticut, 1989
295 Mullican, Matt   New York City, 1992
296 Muñoz, Juan   New York City, 1990
297 Murphy, Michael   San Rafael, California, 1999
298 Murray, Albert   New York City, 2000
299 Murray, Elizabeth   New York City, 1986
300 Myles, Eileen   New York City, 1995
301 Nash, Graham   Carmel, California, 1998
302 Nelson, Willie   New York City, 2000
303 Neri, Manuel   Benicia, California, 2001
304 Nevelson, Louise   New York City, 1985
305 Newman, Arnold   New York City, 2000
306 Noguchi, Isamu   Long Island City, 1984
307 Noland, Kenneth   Santa Barbara, California, 1990
308 Notley, Alice   New York City, 1984
309 Oates, Joyce Carol   Princeton, New Jersey, 1999
310 Odetta   New York City, 2000
311 Oldenburg, Claes   New York City, 1985
312 Olds, Sharon   New York City, 1985
313 Olsen, Tillie   Berkeley, California, 2001
314 Ondaatje, Michael   Berkeley, California, 1999
315 Oppenheim, Dennis   New York City, 1984
316 Orlovsky, Peter   Boulder, Colorado, 1981
317 Padgett, Ron   New York City, 1985
318 Paik, Nam June   New York City, 1984
319 Paladino, Mimmo   Paduli, Italy, 1989
320 Paley, Grace   Thetford Hills, Vermont, 2000
321 Palmer, Michael   San Francisco, 2000
322 Parks, Gordon   New York City, 2000
323 Pearlstein, Philip   New York City, 1985
324 Pei, I. M.   New York City, 2000
325 Penck, A. R.   Berlin, 1989
326 Pfaff, Judy   Rome, 1989
327 Pinsky, Robert   Boston, 2000
328 Plimpton, George   New York City, 1999
329 Poirier, Anne & Patrick   Paris, 1989
330 Polanski, Roman   Venice, Italy, 1996
331 Polke, Sigmar   Cologne, Germany, 1989
332 Pomodoro, Arnaldo   Milan, Italy, 1989
333 Prince, Richard   Bridgehampton, New York, 1993
334 Prine, John   Hanford, California, 1997
335 Rainer, Arnulf   Vienna, Austria, 1989
336 Rainer, Yvonne   New York City, 2000
337 Randall, Tony   New York City, 2000
338 Rauschenberg, Robert   New York City, 1991
339 Rechy, John   Los Angeles, 1995
340 Reed, Ishmael   Oakland, California, 1995
341 Reed, Lou   New York City, 1997
342 Resnick, Milton   New York City, 1985
343 Rich, Adrienne   San Francisco, 1994
344 Richter, Gerhard   Cologne, Germany, 1989
345 Rickey, George   Berlin, 1989
346 Rivers, Larry   New York City, 1984
347 Rollins, Henry   San Francisco, 1997
348 Rorem, Ned   New Smyrna Beach, Florida, 1984
349 Rosenquist, James   Mount Kisco, New York, 1991
350 Rosenthal, Rachel   Los Angeles, 1999
351 Rossett, Barney   New York City, 2000
352 Rothenberg, Jerome   Berkeley, California, 1984
353 Ruscha, Ed   Los Angeles, 1986
354 Rushdie, Salman   San Francisco, 1999
355 Salinger, Pierre   San Francisco, 1981
356 Sanders, Ed   Berkeley, California, 1985
357 Sante, Luc   New York City, 1991
358 Saroyan, Aram   Bolinas, California, 1981
359 Saura, Antonio   Paris, 1989
360 Schlesinger Jr., Arthur M.   New York City, 2000
361 Schnabel, Julian   Montauk, New York, 1994
362 Schneeman, Carolee   New Palz, New York, 2000
363 Scully, Sean   New York City, 2000
364 Seale, Bobby   Philadelphia, Pennsylvania, 1995
365 Seeger, Pete   Beacon, New York, 1995
366 Segal, George   Venice, Italy, 1988
367 Selby Jr., Hubert   San Francisco, 1994
368 Serra, Richard   New York City, 1992
369 Serrano, Andres   New York City, 2000
370 Shapiro, David   New York City, 2001
371 Shapiro, Joel   New York City, 1998
372 Short, Bobby   Oakland, California, 1999
373 Simic, Charles   Strafford, New Hampshire, 2000
374 Siskind, Aaron   Providence, Rhode Island, 1985
375 Smith, Kiki   New York City, 1999
376 Smith, Patti   New York City, 1995
377 Snyder, Gary   Nevada City, California, 1993
378 Sonnier, Keith   New York City, 1992
379 Sontag, Susan   New York City, 1995
380 Southern, Terry   East Canaan, Connecticut, 1995
381 Spielberg, Steven   New Orleans, 2000
382 Spero, Nancy & Leon Golub   New York City, 1986
383 Steinem, Gloria   New York City, 1992
384 Steir, Pat   San Francisco, 1992
385 Stella, Frank   New York City, 1990
386 Stone, Oliver   Santa Monica, California, 1986
387 Stoppard, Tom   San Francisco, 1999
388 Strand, Mark   New York City, 2000
389 Sun Ra   Oakland, California, 1991
390 Talese, Gay   Ocean City, New Jersey, 2000
391 Tàpies, Antoni   Barcelona, Spain, 1989
392 Taylor, Cecil   New York City, 1986
393 Taylor, Elizabeth   Rome, 1988
394 Terkel, Studs   Chicago, 1994
395 Thiebaud, Wayne   San Francisco, 1986
396 Thompson, Hunter S.   Aspen, Colorado, 1994

397  Trockel, Rosemarie   Cologne, Germany, 1989
398  Troupe, Quincy   San Diego, California, 2001
399  Trudell, John   Alcatraz Island, San Francisco, 2000
400  Turrell, James   Flagstaff, Arizona, 1999
401  Tuttle, Richard   Abiquiu, New Mexico, 1994
402  Tytell, John   New York City, 1999
403  Updike, John   New York City, 1996
404  Van Zandt, Townes   New Orleans, 1994
405  Vedova, Emilio   Venice, Italy, 1990
406  Vercruysse, Jan   Brussels, Belgium, 1990
407  Vidal, Gore   London, 1990
408  Viola, Bill   Los Angeles, 2000
409  Vonnegut, Kurt   Sagaponack, New York, 1994
410  Vosnesenky, Andrei   New York City, 1994
411  Voulkos, Peter   Berkeley, California, 1983
412  Wainwright III, Loudon    New York City, 1999
413  Walcott, Derek   Boston, 2000
414  Waldman, Anne   Boulder, Colorado, 1983
415  Warsh, Lewis   New York City, 1985
416  Wavy Gravy a.k.a. Hugh Romney
       Berkeley, California, 1990

417  Wegman, William   New York City, 1986
418  Weiner, Lawrence   New York City, 1985
419  Wertmuller, Lina   Rome, 1988
420  Wesselman, Tom   New York City, 1987
421  West, Cornel   Boston, 2000
422  Westerman, Floyd Red Crow   San Francisco, 1996
423  Whalen, Philip   San Francisco, 1981
424  White, Edmund   Princeton, New Jersey, 1999
425  Wieners, John   New York City, 1985
426  Wiley, William T.   San Francisco, 1992
427  Williams, Robin   Marin County, California, 1999
428  Wilson, Lanford   Sag Harbor, New York, 1997
429  Wilson, Robert   Delphi, Greece, 1988
430  Winters, Terry   New York City, 1998
431  Witkin, Joel-Peter   San Francisco, 1985
432  Wood, Beatrice   Ojai, California, 1984
433  Wood, John   Lake Charles, Louisiana, 2001
434  Yau, John   New York City, 1998
435  Young, Al   Berkeley, California, 2000
436  Zefferelli, Franco   Rome, 1988

But we live alone in the world
And faces are beautiful objects
that shine behind windows
and it's a beautiful world...
                    —Cole Swensen

I cherish those whose generosity of spirit and hospitality of heart have encouraged my vision: Art D'Lugoff, Craig Bishop, Jim Melchert, Douglas Brinkley, Alex Ivanov, Steve Kotton, Larry Fagin, Robert New Rock, Marilla Pearsall, Ron Horning, Tony Cragg, Scott Gordley, Jay Kugelman, Lyle Christie, Kevin Willey, Jim Marshall, Thomas J. Dillon, Rick DePofi, Desiree Docktor, Bob Snader, John Beritzhoff, Connie Lewallen, Jack Darrow, Susan Johnson, Peggy Parsons, Rita Bottoms, Anthony Bliss, Bill McPheron, Douglas Baxter, Rodney Phillips, Cissy Spindler, Eva Reitspiesova, Mary K. Felver, Cheri Fein, James Szalapski, Tammy Cimalore, Barry Kaiser, David Amram, Mark Baldridge, David Shapiro, Barry Hartnett, Bill Norton, Amiri Baraka, Alice Brock, John Yau, Ray Carney, Jay Rigler, and Ramblin' Jack Elliott. Also, Joyce Jenkins for editorial work on the text, Bill Norton for his feedback, Kirk Anspach and David Spindler for their fine master prints.

And in grateful recognition of James Crump, Elsa Kendall, and especially David Fahey for their direction and support.

Christopher Felver is a photographer and filmmaker. His work was featured in solo exhibitions at the Centre Georges Pompidou in Paris and Torino Fotographia Biennale Internazionale in Italy. His previous books include *The Poet Exposed, Ferlinghetti: Portrait, Seven Days in Nicaragua Libre*—a photographic memoir coauthored with Lawrence Ferlinghetti—and *Angels, Anarchists & Gods*. Chris Felver was a participant in the 53rd Venice International Film Festival. In 2000, a retrospective of his films was held at the National Gallery of Art in Washington, D.C., and *Donald Judd's Marfa Texas* was screened at the Smithsonian. His documentary films also include *John Cage Talks About Cows, West Coast: "Beat & Beyond," Taken by the Romans, Tony Cragg: In Celebration of Sculpture*, and *The Coney Island of Lawrence Ferlinghetti*. Christopher Felver lives in San Francisco.

the world. This was the thing that the photographer Man Ray fell into in Paris with the surrealists. The surrealists believed in commitment, being socially engaged—in being *engagé*. That's the way they functioned. They found like-minded peers who shared their vision. Man Ray titled his grid of photographs *Échiquier surréaliste*—a chessboard. So I like to think of my group of portraits as a rather large checkerboard.

DF: Your subjects include writers, poets, filmmakers, activists, visual artists, among others. Is any one group easier to photograph than the others?

CF: When you make a portrait of anyone, it has to do with calming the scene down and bringing it into slow motion. Slow motion at a fifteenth of a second, anyway. That's where I seem to make a lot of my pictures, because I take most of them in natural light. So you take this big personality and squeeze it into the camera; sometimes the persona wants to fight it and move around. But you have to keep calm and keep the subject calm, because of the very slow shutter speeds. What I want to do is catch the magic in their essence, the light in their eyes. Photographing in New York, the situation seems free and open, but I've never seen openness like that of Europeans. The Italians not only let you photograph them—they present you with gifts, as if you're doing them an honor. I felt ennobled just by being there, and I felt the same way in France and Germany.

DF: So the Europeans offer themselves to you?

CF: In an Old World sort of way. Photographers have always photographed artists, so my kind of photography has been going on for a long time. On the Mediterranean coast, for example, photographers such as Brassai and Lucien Clerque used to seek out people like Miró, Picasso, Dali, and Soulage. Artists were accessible subjects to each other then. There are many pictures that show us the freedom of that artistic life.

DF: Have you ever wanted to portray photographers in your pictures?

CF: Well, of course, they would understand the situation. But I don't specialize in shooting photographers. However, I have taken many pictures of them. I operate in the literary world and the art world. That's my shtick. My subjects are the people I always wanted to meet. As the poet Frank O'Hara put it, I'm "In Favor of One's Time." The ideas and common understandings shared by people in my time are important to me. Now there's so much emphasis on financial reward. A few decades ago, hardly anyone could sell their work for as much as some people do today. They weren't there to make money. They were there because they were committed and couldn't do anything else. This is where their hearts were. I feel simpatico with such people, because that's how I feel about what I'm doing. What else would I do? What else would they have done?

DF: How do your subjects collaborate with you while you're making a portrait? Or what do you expect from them?

CF: My only requirement is that they look me in the eye. But it all happens so fast as it falls into

place. When I was traveling through Europe making these artists' pictures, I prided myself on minimalism. I only took about four or five pictures of each person. That was it—just four or five frames. I'd get into town, having never met the person before, and I would set them up in the best way that seemed to work. At that point I was experimenting with shots taken at a medium distance instead of headshots.

DF: But since they're creative people, are they interested in creatively contributing to the shooting session? I mean, do they suggest location, background, angle . . . ?

CF: Not really.

DF: They leave you to your own devices?

CF: They leave you to your own problem. And you're supposed to solve it because you're creative yourself. That's why you're there. But my whole commitment to them is that I try to make it fast, and I try to make it easy. I'm not into hanging out forever—unless of course they want me to stay—and then I sometimes make friends, with whom I'm still in touch years later, because we've had an enjoyable experience. I haven't bored them with my ideas of what a photograph should be. I try to keep it simple.

DF: How do you handle a subject who wants to direct you?

CF: I let them direct me. I understand their concerns. Some people may want to direct, and in most cases they're high-profile people. For instance, when I was a visiting artist at the American Academy of Rome, Elizabeth Taylor was there making the film *Young Toscanini* with the director Zefferelli. After scheduling some time with her, I had imagined it would be a long session, but it wasn't at all. She took me on the set and directed where I should stand to make the picture. And she was right!

DF: But do such people also know how to take directions?

CF: Yes they do, but they also know how to keep you in line. In Boston the other day, I went to see the novelist Saul Bellow. He said, "I brought my hat." I had asked him to bring his hat because I knew it would be typical of him. I wanted to make the best picture I could, in as short a time as possible. I asked him to straddle a chair in a certain way. And he said, "Here we go." It had taken me some time to make the appointment with him, but when we did the session, he was extremely accommodating, gracious, and kind. It was beautiful. But he also understood that I was trying to make him look good, which I think is the first commandment for portraits. So I was compelled to give my best performance—and not disappoint him. When you're taking portraits, you really want your subjects to have a positive glow. What could be worse than looking at a portrait that projects negativity?

DF: So could you say that creative people are easier to photograph than others?

CF: Well, they might be. Perhaps it's easier to see into a creative person. Noguchi said of the face

that "thoughtfulness seems to show." Every face is a calling card. Creative faces, obsessive faces are the faces of people who are thinking. It's not just nine-to-five with them; their work is a twenty-four hour commitment.

DF: The sheer volume of the work that you've created is somewhat overwhelming. Can you describe the logistics involved in making so many portraits in different parts of the world?

CF: Some days I travel five hundred miles by myself. Then I show up somewhere and make a picture and leave. But I don't spend much time thinking about the fact that I've traveled so far. I'm peripatetic by nature, so the idea of being mobile comes easily to me. I'm not obsessed with travel, but I am obsessed with making pictures.

DF: How can each subject connect you with the next subject? How valuable are these sorts of introductions?

CF: They're the thread sometimes. When I was doing my book *The Poet Exposed*, poets introduced me to other poets. Everyone wanted to put their friends in the book. That worked well enough in New York. But introductions are invaluable in Europe—I never would have found the European painters had it not been for certain key people in each city. For example, when I went to Rome I met the painter Mario Schifano, who was represented in New York by Leo Castelli. Schifano had been a friend of the poet Frank O'Hara. I gave him a picture of O'Hara that had been given to me by the San Francisco poet Bill Berkson. So Schifano introduced me to the Italian art scene. That's how I got started making my documentary film *Taken by the Romans* in 1988, and Schifano organized the troop that worked on it.

When I left Rome, I traveled to Berlin, and the sculptor Ed Kienholz introduced me to Rudolf Springer. He was the oldest gallerist there—the first one to get started again after the destruction of World War II. When I met him, he introduced me to the painters Baselitz, Penck, Lupertz, and then to Gerhard Richter. So it helps to have someone who can give you the rules of the road. In London, the sculptor Tony Cragg was very important in helping me get around. So it all happens for me in a very mercurial way. I like to think of these sorts of connections as the result of *arrangiarsi*—the Italian concept of how to flow in society.

DF: Do you see the faces in your pictures as a record of the creative revolution that began in the latter half of the twentieth century?

CF: Well, creative revolution isn't about decoration. These people are seriously committed, as I said before, and they have the idea that they can change the world by what they do. But if poets, for example, didn't feel committed, how could they be revolutionary? Mayakovsky said, "All a poet needs is a pencil, a piece of paper, and an umbrella." That's what it takes to be a poet. To be a poet means to make. Art starts with the hands and the brain. The idea of art is to create something. It's non-utilitarian. Art isn't about monetary reward. The difference between commercial photography and my type of work is that in my case I pick which subject I'm passionate about. Do you think Louise Nevelson lived her life—or de Kooning—thinking about how their work was going to sell? They were

just committed to doing the work and seeing what would happen. Because they were living it. And that's what I find in these people that I photograph—that they've been living similar sorts of lives. It's a delicate balance to feed yourself and continue on. But aside from being able to persevere, there's something else. The poet Jack Micheline said, "The role of the artist is to raise the light." I'm with that.

DF: How much can a portrait mean to a viewer? Can a photographic image of a creative individual reveal our collective thoughts? Can we perceive the person's philosophical bent or sense a valid message by looking at a picture?

CF:  I hope a portrait gives someone inspiration. Sometimes you can see the collar they're wearing. Or the pen that's there. Or what's in their pocket. Or the way their hair is. Or just the intensity of their look. And often that you tells you something. Today I was looking at some of Man Ray's pictures, which are always fantastic. The Parisian surrealists were important to me, and Man Ray made pictures of so many artists of that time. He photographed Gertrude Stein, Jean Cocteau, Max Ernst, Constantin Brancusi, Tristan Tzara, and others such as Virginia Woolf and Meret Oppenheim. He also recorded Antonin Artaud, André Breton, and Marcel Proust on his deathbed. These photographs are valuable as historical documents, and there can never be too many. I think they're all important because you get a brief message of what the person was really like. You don't always get a full understanding of them. De Kooning might say the visual artist is just "slipping glimpses." In other words, we see just a fraction of what the subject might actually be. And that's my passion—to try to capture some glimpse of that ephemeral personality.

DF: Well, apart from that, I'm approaching your work from the viewer's standpoint. The pictures are a document, a record of that person in a certain time and place. But they can also serve as a source of inspiration. I'm curious as to whether a person who sees the photograph can perhaps feel a connection to the philosophy or the work of the artist in front of them. Do you think that's so?

CF: Isn't that what art's about? You do feel a connection. All art is communication. It depends at what level you perceive it. Abstract art is no less a communication. The question is just, how do you understand it? The artist puts forth an idea. But communication is what he's trying to accomplish. Whether you understand the idea is not important. Someone will understand it. Critics can argue about it. But if the idea touches one person, something valid has happened. Of course, an artist like Jackson Pollock can touch the whole world. Everyone gets it. That's high art, because he's hit a home run.

DF: So how do you manage to get your subjects to reveal themselves? How do you manage to penetrate the public face or public persona of these well-known people?

CF: If I don't know the person I have to be on top of my game. When I speak to them, I have to overcome their initial apprehension. I try to be reassuring and not make it a big deal—that is, can we get together for a few minutes? If they are curious enough to say okay, I go to see them. When I knock on the door, that's my moment to set the tone.

When we meet, I try to say something that puts everyone involved at ease. It's all spontaneous—who knows what I will say? But I have to do something that makes them feel calm, because I'm on their home court. I go through this sort of thing all the time, but being social comes easily to me. Feeling out what the person wants very quickly is important. They might want to talk for a while, find out about what I'm up to. We could start becoming friends.

DF: Is it difficult to encourage them to release their guard and be as natural as possible?

CF: Yes. But I don't want them to be on guard. I don't want to overdo it in the beginning, because I want a private face. I don't want them to go public on me. It doesn't take long before I get the camera out. We sit down, and I try to get them to open up. The initial moment is the moment of truth. Once you hit the person's door, you're onstage. In most cases, you only have a certain amount of time; they're busy people. When I make the initial contact, I try to keep things light, the way people interact when they know and like each other. Then we'll snap a few. That's all. There's nothing formal about it. There are no lights, just a tripod. A friend comes by with a camera to make a picture. I try to keep it that simple. And it is that simple.

DF: But do you have any special tricks?

CF: Every now and then I use a little makeup to take the shine off their faces. But, no. I don't use tricks.

DF: Is it possible to make a transcendent moment happen in a photograph?

CF: I know that everybody looks good for a second. For a perfect second, the bum on the street looks absolutely gorgeous. He looks heavenly. I try to see the beauty in everyone. For years I took pictures of all the poets dead straight on, because of Man Ray's influence on me. I wanted to make a similar sort of picture. Then, if you step back from the situation, you begin to see that some people have another side. You have to have a quick take on them. So the picture becomes a puzzle, a proportional thing in three dimensions. To see it, you have to know the right place to be. Because I'm not shooting four or five different angles, I'm basically taking one picture. I want to make sure that it's fail-safe, that it works, which requires not having to be there too long. If you're there too long, you lose it.

DF: Susan Sontag said, "To be really good is to be odd." Dickinson is odd, and Shakespeare is odd. Do you have to be odd to be a great artist?

CF: I don't know if artists have to be odd, but they certainly need an individual view of the world. Any artist is communication personified. Art comes from individuals who have their own vision, who can create in a concrete way what they see. In the case of William Burroughs, who used the cut-up method of writing, words became spontaneous in a different way from what we might expect. Regardless of what we're used to, artists have a vision that is defined and dictated by their own work. They become one with their work; there's no separation. So that may be a little odd. But I'm looking for the crucial oddity.

Interview continues on inside of back cover

First edition published by Arena Editions
P.O. Box 32101
Santa Fe, New Mexico 87594-2101 USA
Phone 505/986-9132 Fax 505/986-9138
www.arenaeditions.com

Publisher James Crump
Art Direction and Design Elsa Kendall
Production Assistance Freddy Cante and Kathleen Sparkes
Picture Editing David Fahey
Text Editing Joyce Jenkins and Peg Goldstein

Distributed by Publishers Group West
1700 Fourth Street, Berkeley, California 94710
tel 510/528-1444 fax 510/528-3444

Printed in China/Palace Press International

First edition, 2001
Library of Congress Control Number: 2001 131976
ISBN 1-892041-48-0

DF: Then what qualities are conducive to being an effective and talented photographer?

CF: An individual spirit. A photographer is alone with his material. Even if he's with a group of people, he still tends to be isolated in his own "seeing."

DF: Have you followed the work of most of the people in your photographs?

CF: I'm aware of their work before I see them. I guess it doesn't hurt that I'm a fan. I want to see the person behind the work, to inform myself. I'm a very interested type. I'm hoping that when I'm in their presence I will see them more clearly. That's the reason I'm there in the first place.

DF: And in your case, would you say that your methodology is not only a disregard for studio techniques but also being open to what is happening?

CF: Yes, of course. You can't make portraits without being open. The whole thing is a tête-à-tête between two people. Somehow it has to go on, though some people can be coyotes. I remember making a photograph of Robert Frank in his studio on Bleeker Street in New York. "Just look at me," I told him. "This will make a perfect portrait." But he gave me an incredulous look and said, "Perfect portrait? What's that?" It actually was the perfect portrait, but he didn't see it. I had to direct him. And he wasn't falling for anything, either. I think the picture is honest, just Robert Frank in his studio with his spotting glasses on the workbench—and a potted palm over his shoulder.

DF: Do you take some of the subject's persona with you after you leave them? Is that the way it is for you? In some way, do you become the thing that they are?

CF: I certainly take something with me that's tangible—the picture. But I wouldn't call myself a Beat poet just because I photographed them. And I wouldn't call myself a writer just because I've been around a lot of writers. But I do think what I take with me is a presence that I can communicate to someone else—generations from now—who might see the pictures I make. Hopefully, people will reach some understanding about the person in a particular photograph. In a certain way, what you are getting at is true. But I'm not the subject's persona—I'm not what I photograph. The people I photograph are helping me by giving me their presence. Because they're making me learn more about them, I'm getting something out of the experience, whether or not I become part of the world of the photograph. I must pick up some of the dust—I'm usually more inspired in my own work by having met them.

DF: Do you see a part of your commitment as adding to the photographic record?

CF: I hope so. Think of Berenice Abbott's picture of James Joyce. We certainly haven't forgotten what James Joyce looked like. And we'll never forget what Hemingway looked like when he was photographed by Yousef Karsh. Of course, after people are gone, what else do we have? What images are there?